Volume 5

DIRECTORY OF
WORLD CINEMA
AMERICAN HOLLYWOOD

Edited by Lincoln Geraghty

intellect Bristol, UK / Chicago, USA

First Published in the UK in 2011 by Intellect, The Mill, Parnall Road, Fishponds, Bristol, BS16 3JG, UK

First published in the USA in 2011 by Intellect, The University of Chicago Press, 1427 E. 60th Street, Chicago, IL 60637, USA

Copyright © 2011 Intellect Ltd

A catalogue record for this book is available from the British Library.

Publisher: May Yao
Publishing Assistant: Melanie Marshall

Cover photo: Warner Bros./DC Comics/The Kobal Collection

Cover Design: Holly Rose
Copy Editor: Heather Owen
Typesetting: Mac Style, Beverley, E. Yorkshire

Directory of World Cinema ISSN 2040-7971
Directory of World Cinema eISSN 2040-798X

Directory of World Cinema: American Hollywood ISBN 978-1-84150-415-5
Directory of World Cinema: American Hollywood eISBN 978-1-84150-520-6

Printed and bound by Gutenberg Press, Malta.

DIRECTORY OF WORLD CINEMA
AMERICAN HOLLYWOOD

Acknowledgements	5	**Musicals**	168
Introduction by the Editor	6	Essay Reviews	
Hollywood: A History?	9	**War Films**	188
The Hollywood Film Industry	12	Essay Reviews	
Stardom	16	**Drama**	208
Directors	20	Essay Reviews	
Clint Eastwood		**Romance**	224
John Ford		Essay Reviews	
DW Griffith			
Steven Spielberg		**Animation**	242
Westerns	44	Essay Reviews	
Essay Reviews		**Blockbusters**	262
Crime Film	64	Essay Reviews	
Essay Reviews		**Recommended Reading**	282
Science Fiction	88	**Online Resources**	287
Essay Reviews		**Test Your Knowledge**	289
Horror	108	**Notes on Contributors**	292
Essay Reviews		**Filmography**	300
Comedy	126		
Essay Reviews			
Historical Films	146		
Essay Reviews			

CONTENTS

ACKNOWLEDGEMENTS

The completion of this book would not have been possible without the help and support of a number of individuals. First of all I must acknowledge my editor May Yao, who showed faith in me taking on and developing this project, Melanie Marshall and all those at Intellect who helped in the production of the finished work. I want to thank all of the contributors who got fully behind this project and endeavoured to meet tight deadlines and respond to editorial feedback with little hesitancy or complaint. Each contributor brings their own insight and approach to the essays and reviews contained within this volume and, as a result, the book is strengthened by their diversity and knowledge. To my colleagues in the School of Creative Arts, Film and Media at the University of Portsmouth who wanted to be involved with the project I offer my gratitude for stepping forward, despite their busy schedules, and volunteering to write their essays and reviews. We routinely discuss and argue about Hollywood film in the classroom and corridor but to put fingers to keyboard and commit our ideas to print is a challenging thing which I must thank you for. Similarly, I want to thank the students I have taught over the years for continuing to make me enthusiastic about film, both teaching it and writing about it. Lastly, I must thank my partner Rebecca Janicker who, as ever, had to put up with me working long hours editing the volume but supported me when I might have lacked energy and faith in finishing it.

Lincoln Geraghty

INTRODUCTION
BY THE EDITOR

There is no doubt that Hollywood has been the most popular and successful producer of film throughout the history of cinema. As a result, America continues to be at the centre of global film production, whether directly making films within its borders or financing projects on all continents of the world. Yet, it is also commonplace to hear that Hollywood is under threat, that film is becoming less popular as a form of media entertainment and will soon lose out (if it has not already) to the lure and excitement of the Internet and video games. The recent rejuvenation of 3D cinema, with the likes of Disney and DreamWorks producing more and more films in 3D or converting older ones to be viewed with the aid of glasses, clearly signals that Hollywood is responding to developments in new media technology by returning to methods used when film was previously under threat from television. However, unlike the 1950s and 1970s when ramping up the special effects and increasing blockbuster budgets guaranteed studios success against poor box office receipts, in the last ten years Hollywood has had to concede that audience tastes and viewing habits are now different. To attract people to watch the latest cinema release means it now must look to competing media forms (TV, Internet, video games) for clues as to how people consume the media and it must utilize previously unfamiliar methods of production, distribution and exhibition to remain competitive in a congested entertainment market.

In many ways, Hollywood has met some of the challenges to it posed by international markets and technology. The growth of home cinema, VHS in the 1980s through to DVD and Blu-Ray in the 1990s and today, shows that Hollywood films are still consumed in enormous quantities. Sales of special edition boxsets and director's cut versions of cult classics are booming as cinema fans want to own a piece of Hollywood history and watch it in the comfort of their own living rooms. People are still clearly watching American film, Hollywood is still relevant and entertaining, but audiences now interact with films in so many different ways and forms that trying to gauge the popularity of one film over another is difficult. What bombed at the cinema may excite people on DVD after the extras are added and the director gets to finish the film the way they originally envisioned. However, perhaps what makes Hollywood film so resilient is not how it responds to industrial and technological trends but how it continues to react to and engage with the cultural contexts in which it is produced. Moments of political, national and historical significance in America and the world have provided Hollywood studios, producers and directors inspiration for hundreds of films that have since become barometers for changes in our own society. Hollywood may simply keep us entertained but it also acts as a measure for social and cultural development and as such this volume seeks to analyse and contextualize some of the most iconic examples of film.

The introductory essays featured in this volume look at Hollywood from a number of different perspectives: historical, industrial, and cultural. While the authors have each taken a particular position on how Hollywood has evolved, the essays in total clearly indicate the extent to which Hollywood as an idea, as a place, and as a phenomenon has had to adapt to meet the challenges of an ever-changing global film market. Competing with Asia, Europe, Latin America and Australasia, and indeed the growth in popularity of

independent film, the major Hollywood studios are always looking for ways to recapture popular audiences and entice them into cinemas. With the increase in new technologies used for making its films today, advances in CGI and 3D being the latest, we can see how Hollywood continues to experiment with new techniques and returns to tried and tested methods of capturing the audience's imagination. Following insights on the industry and its history, essays on specific directors offer more detailed discussions of how films are made and personalities created in Hollywood. Fascinating essays on Clint Eastwood, John Ford, DW Griffith, and Steven Spielberg recognize that directors play a major part in the evolution of film-making in their own right, and that a focus on their production methodologies, recurring themes, and personal biographies can tell us an enormous amount about what makes Hollywood film so popular.

The rest of this book is primarily organized by genre. Film reviews are divided into sections, ten of which are recognizable cinematic genres: the Western, comedy, horror, etc. The final two sections of film reviews, animated features and blockbusters, are related more to form and the changing tastes of the movie-going audience and thus contain reviews of films that cross over a multitude of different genres and cinematic movements. All sections begin with an introductory essay that establishes the genre or group of films and highlights the most significant and influential moments in their respective histories. As can clearly be seen in the range of films chosen for inclusion in this first volume on Hollywood cinema, there is great diversity; some films that appear here may not be automatically considered the most popular or standout of their genre – indeed, some films could quite comfortably sit in more than one of the genre categories. However, what the contributors and I have tried to achieve is a more measured analysis of what makes Hollywood cinema still so prevalent and successful today by examining both the major blockbusters and some of the more dramatic and understated films produced over the past hundred years.

Lincoln Geraghty

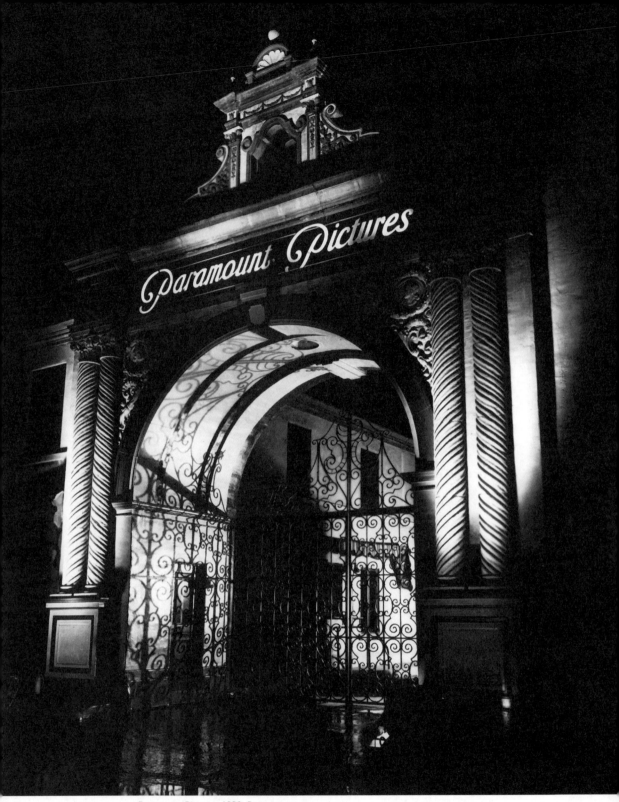

Paramount Pictures, 1938, Paramount.

HOLLYWOOD: A HISTORY?

The History of Hollywood is bound up with the history of America. As a nation grow-ing to become an international superpower during the twentieth century, America took the lead in global politics, manufacturing and business. Likewise, as Hollywood grew to become the leading producer of films in the early part of the century, it defined what makes film popular: the story. Hollywood makes stories, it is after all dubbed the 'dream factory', and whether they be complex dramas or spectacular blockbusters, the story is what makes people go out to the cinema, go out and buy the DVD or watch a rerun on TV. A good story, the film's narrative, will always attract an audience. The following short 'history' is about how making stories became the main aim of Hollywood and is, in essence, the reason why Hollywood still reigns supreme; for stories entertain and, whether or not we like to see it in such simple terms, audiences want to be entertained.

In the late nineteenth century, film was considered a technological marvel; an attrac-tion to wow an audience and advertise the technical genius of the film-maker. Those who made films, early short recordings of everyday life screened to select audiences, considered the new medium emblematic of scientific advancement rather than a neces-sarily artistic practice. Louis and Auguste Lumières's projected images on the wall of the Grand Café in Paris grabbed people's attention but offered no story to keep it and make it last. *Workers Leaving the Factory* (1895), a recording of people leaving their work-shop, showed that film had the potential to capture attention but their films, a mixture of actualities, scenics, and topicals, only played back images that people could experience for real in the everyday. Alternately, France's Georges Méliès, a magician and film-maker, saw the potential in film to really challenge the intended audience. His films differed from the actualities made by the likes of the Lumières and were far more fantastical, using camera tricks, magical illusions, stages and props deliberately to confuse the audi-ence – taking them, momentarily, to another world beyond the confines of their daily lives. The use of tinted film, early special effects such as smoke and stop motion, allowed Méliès to create alternate worlds on screen: his *Le Voyage dans la Lune* (1902) and *Voyage à Travers l'Impossible* (1904) depicted, albeit rather inaccurately, the possibility of life on other planets. His films can be considered paintings that viewers could gaze upon. Both examples of early film-making constitute a period in film history dubbed 'The Cinema of Attractions'. Méliès, like the Lumières brothers, used the new medium to delight and astonish the audience. For example, *A Trip to the Moon* may have depicted space travel and extraterrestrial life but what fascinated Méliès even more was the poten-tial for the 'scenario' to act as 'pretext' for stage effects, tricks, and a 'nicely arranged tableau' (Méliès cited in Gunning 1990: 57).

In contrast, America's Edwin S Porter used film to tell a story. With the aid of Thomas Edison's newly developed camera and projection equipment, his adaptations of Ameri-can classics such as *Uncle Tom's Cabin* in 1903 and variations on the Wild West theme seen in *The Great Train Robbery* (1903) are examples of narrative becoming central to the film-maker's art. As audience tastes became more sophisticated film-makers had to develop new ways to keep people engrossed and entertained. Thrilling scenes of daring-do could only entertain for as long as the story that got people to that point was

interesting and captivating in its own right. As film became more of a business than a form of artistic expression, producers and exhibitors trying to make a profit believed that longer and more engaging stories would pack more people into the nickelodeons and get them coming back for more. Hollywood's greatest achievement was to take a technological wonder that the Lumières and Méliès experimented with and make it into a money-making form of storytelling. At this point in film history the medium truly became American.

The dominance of narrative over spectacle is perhaps central to film becoming the popular form of entertainment it is today. Film clearly had the potential to make some people a lot of money – producers, actors, writers, stars, exhibitors, for example – but for a lone entrepreneur the profit margins were small. What Hollywood did was to make film a business, make it profitable and adaptable to suit differing audience tastes. As cinemas opened up in every town and city across the country, owners cried out for more movies to show. Demand was met by Hollywood, which, by 1911, had established itself as the most suitable location for film production. At the heart of it, the new fledgling studios started to perfect the techniques and methods of making multiple films at the same time. Film production became more like the factory line seen in the American manufacturing industry and the formula that made it work was the adoption of the 'classical norms' of film-making. Classical Hollywood Cinema, as we know it today, 'put emphasis on narrative continuity and the coherent ordering of space'. As a result, the techniques of film-making were linked to 'a unified mode of storytelling' (Grainge, Jancovich & Monteith 2007: 74).

Making ten films in the same time that it used to take to make one or two drove studios to maximize time and effort. The division of labour on film projects allowed for a team of writers to concentrate on writing scripts, or parts of scripts, that could be taken on by a team of directors who would use the stages and backlots of the studio at the same time but shooting different scenes. Similar plots for similar stories meant also that props and sets could be reused and recycled for different films. Set designers, lighting technicians, cameramen and editors could work on different films contiguously, as the production schedule called for them to join at different stages of production. These deliberate and segmented modes of film-making relied on the adoption of the continuity script which meant films were made according to the availability of location, staff or stage set rather than the order in which each scene came in the story. The linear narrative of the film was brought to life through the editing of footage after it was finally shot, piecing together scenes that perhaps happen at the same time in the story but in different places. Thus narrative film was largely defined by the establishment of production techniques designed to keep costs low and increase output to satisfy audience demand.

Due to the nature of the studio system and the classical norms of Hollywood, film-making genres were, and still are, reliable means through which producers could maximize profits and guarantee an audience. Studios set up to make a certain type of film, using the same sets, directors, stars, and writers for example, became known for a particular genre since that was what they made in the most cost-effective fashion. Film genres created expectation on the behalf of audiences, who knew what they wanted to see, that they would get it, and studios fulfilled demand based on a system of factory-line production. Tom Ryall stated that 'Genres may be defined as patterns/forms/styles/structures which transcend individual films, and which supervise both their construction by the film maker, and their reading by an audience' (cited in Hutchings 1995: 65–6), therefore genres not only offer the primary framework for Hollywood storytelling but they also determine how we ourselves categorize films. This volume is in some ways all about the categorization of Hollywood film, but, in defining what genre a film is and thinking about the relationship between different films of the same genre, we are forced to take notice of the industrial drives that influence the production and reception of individual films.

Recognizing that genres are bound up with the history of storytelling in film acknowledges both the level at which films are conceived and made industrially and how we, as an audience, are innately familiar with how stories speak to us culturally. For Steve Neale, 'genres function to move the subject from text to text and from text to narrative system, binding these instances together into a constant coherence, the coherence of the cinematic institution' (cited in Hutchings 1995: 72).

So the history of Hollywood is not one history but an amalgam of histories: a history of spectacle versus narrative, technological change and development, industrial practices, artistic differences, economic forces, and the formation of a set of norms. Out of these histories come the popular and entertaining genres we still enjoy today and the variety of Hollywood films discussed in this book.

Lincoln Geraghty

References

Grainge, P, Jancovich, M & Monteith, S (2007) *Film Histories: An Introduction and Reader*, Edinburgh: Edinburgh University Press.

Gunning, T (1990) 'The Cinema of Attractions: Early Film, its Spectator and the Avant-Garde', in T Elsaesser (ed), *Early Cinema: Space, Frame, Narrative*, London: BFI, pp. 56–62.

Hutchings, P (1995) 'Genre Theory and Criticism', in J Hollows and M Jancovich (eds), *Approaches to Popular Film*, Manchester: Manchester University Press, pp. 59–77.

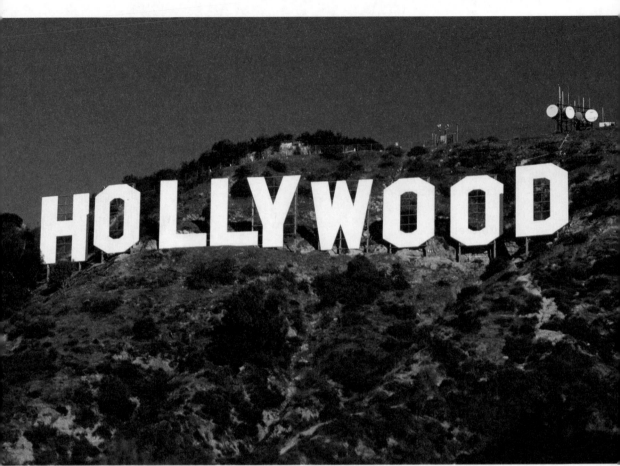

Los Angeles/Hollywood, MGM. Photographed by Neil Setchfield.

THE HOLLYWOOD FILM INDUSTRY

April 2010 was a key month for the student of signs in the cinema. That was the month that the literal Hollywood sign – the 45-feet-tall creation of wood and metal on Cahuenga Peak – was rescued from demolition. The rescue of the sign, facilitated by Playboy owner Hugh Hefner, was truly a symbolic moment. Arnold Schwarzenegger mused that the sign would continue to serve as 'a symbol of dreams and opportunity' (Child 2010: para. 3). Essentially, Hefner's gesture meant that it would continue to do its bit to signify the brand values of Hollywood; to mark a border between the regular world and dreamland. This is important because the American production capital has been under continual threat in recent times. Other people make films; moreover, American-based companies make films elsewhere. At the same time, the digital era, in all its manifestations, is presenting fundamental challenges to Hollywood's traditional command of the visual image.

Hollywood elsewhere

Of course, Hollywood has always been a brand, a place built on inspiring images of people, places and, importantly, itself. But, significantly, it is also a place where things (pre-eminently films and TV programmes) are made. So Hollywood is at once a dream land and a dream factory and the two processes are intimately connected; as Nick Roddick described:

> ... in the entertainment industry carefully fostered and disseminated images are as vital a part of the product as more tangible material manufactures on which that image is built. (Roddick 1983: 4)

In other words, Hollywood both fosters and furnishes our dreams. The manufacturing side has been profoundly affected by two main factors: the demands of post-Fordist production (i.e. the disassembling of the old studio systems of film manufacture) and wider processes of globalization. Writing in 1986, Douglas Gomery asserted that 'Hollywood has come to symbolise [a] particular industrial arena, with ... cavernous sound stages, multi-acre lots and secret special effects' (Gomery 1986: 8). But the economies of scale and factory methods which characterized the old studio system no longer apply. Today, many aspects of film production are out-sourced and Hollywood companies struggle to compete for work on a global stage.

Of particular significance to the stability and self-image of Hollywood has been the 'runaway' production: films financed largely by American companies but produced away from the entertainment capital. This is not a new phenomenon. In the immediate post-war era, Hollywood companies filmed overseas as a means of expending their 'frozen' profits in foreign lands. In the process, they found that runaway production frequently offered other advantages, including cheaper labour, tax concessions, exotic locations and favourable exchange rates. Ben Goldsmith and Tom O'Regan suggest that such inducements 'are still very much in evidence today' (Goldsmith & O'Regan 2005: 9), but the world of runaway film production has become ever-more competitive as nations, and even home states, vie to offer the most attractive deals to American producers.

The United Kingdom has been the traditional home to the runaway company, but during the noughties a succession of countries – Canada, New Zealand, Australia and (notably) the Czech Republic – managed to attract big American dollars. Recently, other European companies such as Hungary, Romania and Bulgaria have lured American companies by dint of their depressed economies and attendant 'cheap labour, materials and facilities' (Longwell 2008: 9). In addition, further pressure has been exerted on the physical Hollywood studios, and the technicians in their employ, by competition between American states. In 2002, Louisiana and New Mexico both introduced concessions as the means of combating the movement of film production to Canada (New Mexico returns 25 per cent of spend to producers); later, Michigan offered 40-42 per cent tax credits to film companies (Moore 2008: 24). Then, in February 2009, California attempted to entice

films back to the West coast by announcing a five-year programme of tax incentives for producers (Diorio 2009: 67).

The runaway production has a long and complex history, but the various movements – including the recent internecine conflicts – have all exerted a dissipating effect on the image of Hollywood as the home of the movies. Trends in digital entertainment have weakened the Hollywood brand further, to the point of questioning the very authority of the film image.

The digital universe

Digital technologies have influenced each of the three phases of the film industry: production, distribution and exhibition. But, for all of the ballyhoo about the 'digital revolution' in film production (as marked by developments in CGI and, latterly, 3D technologies), the decisive effects will probably be felt most in the second and third phases. The Hollywood film industry is challenged by convergent technologies because they revise the ways by which we consume, and ultimately relate to, moving images. We can see this if we consider the shifting, and sometimes interlocking, stories of films, DVDs and mobile telephones.

In retrospect, the 1980s was a decisive period for Hollywood film culture. That decade saw the growth of the multiplex and the attendant phenomenon of the blockbuster. At the same time, and despite initial fears from the majors, film viewing moved away from the theatre and into the home via bought and rented video tapes. As Richard Maltby has demonstrated, the VCR boom provided the pre-conditions for the subsequent rise of DVD and for the contemporary situation where 'Movie production has become ... the creation of "filmed entertainment" software, to be viewed through several different windows ...' (Maltby 2003: 190). It is estimated that DVD sales account for 70 per cent of a film's profits. Inevitably, the rise of the DVD has led to the reconfiguring of cinema. On John Ellis's famous terms, cinema-going endures as a public 'event' (Ellis 1992: 26), a dynamic alternative to home-based entertainment. But, paradoxically, the success of the DVD has finally led to it becoming the main event, to the point where the film showing becomes virtually a method of pre-selling.

In turn, the DVD has provided the pre-conditions for the emergence of other forms of convergent distribution of movies, via the WWW, cable and mobile receivers. Barbara Klinger has written of the Home Theatre as a 'fortress technology' which 'depends on importing the newest and best products from the outside in order to generate ... a self-sufficient, inviolable interior space' (Klinger 2006: 242). Clearly, DVDs are an essential part of the armoury, but their major asset is their portability and their intimation of control (the fantasy of owning the film). But, then, DVDs are now in a state of decline. In 2008, Digital Entertainment Group reported a 32 per cent decline in overall sales. The Hollywood majors have also been alarmed by the poor performance of Blu-Ray and disappointed by the diminishing returns from View on Demand (VOD) screenings: these net them just 33 per cent of the revenues that they derive from DVD sales (Grover 2009a: para. 2).

The above pressures are forcing movies onto increasingly smaller screens. Paramount has expressed a particular interest in distribution and exhibition via the web. Its President of Digital Entertainment, Thomas Lesinski, revealed much about his company's relationship with the moving image via his observations of February 2009:

> You can use the internet to launch a film like you use a movie theatre. The trick will be to ramp up electronic distribution without tanking the DVD business. (Grover 2009b: para. 7)

The decline of the cinema as a public sphere has been indicated also by recent talk among the majors of near 'date and time' (i.e. simultaneous) releases of DVDs with cinema screenings. But the biggest threat to the authority of the movie image probably comes from mobile technologies. Since 2006, the Hollywood majors have all expressed

a strong interest in exploiting the market for downloaded movies via 3G (Third Generation) mobile telephones. The advantages to the companies are obvious. In June 2006, the Market Intelligence Centre predicted that mobile phone ownership would increase, worldwide, by 33 per cent by 2010 (Koranteng 2006: 22). The new technology also affords companies the chance to establish new download markets on more advantageous terms. In this regard, mSpot announced a deal in October 2009, involving Paramount, NBC Universal and the Weinstein Company, for instant access streaming of films at $4.99 a shot (Netherby 2009: 9, 23).

Whither Hollywood?

The distribution and consumption of films via digital, mobile technologies threatens to turn movies into basic moving images – the enjoyment predicated on the simple sensation of movement. The President/CEO of Vue Entertainment, Tim Richards, has suggested that there is no market 'for people to watch an X-inch high King Kong' (Koranteng 2006: 22). But it really comes down to a question of definitions. As Keyan G Tomaselli and Jonathan Dockney suggest, producers feel an increasing need to woo the 'Digital Natives', the people who have grown up with digital technologies and who expect entertainment to be delivered to them on their terms (Tomaselli & Dockney 2009: 130). In this context, and as the modern 'Event Movie' suggests, the role of traditional Hollywood cinema is to form part of the inter-textual mix.

This essay has been about the image, in its various forms. In particular, it has been about Hollywood and the threats posed to its self-image in the global and digital age. Returning to that sign on Cahuenga Peak, it seems obvious that it functions as a point of stability for an industry that has often had to respond to new challenges. But the genius of Hollywood (to borrow a term coined by Thomas Schatz) really lies in its flexibility – much like the sign, it is well practised in bending with the wind.

Laurie N Ede

References

Child, B (2010) 'Hollywood sign is saved by Hugh Heffner donation', http: //www.guardian.co.uk/film. Accessed 30 April 2010.

Diorio, C (2009) 'California budget provides biz boost', *Hollywood Reporter*, 20 February.

Tomaselli, KG, & Dockney, J (2009) 'For the Small(er) Screen: Film, Mobile TV and the new Individual Television Experience', *Journal of African Cinemas*, 1: 1, pp. 128–34.

Ellis, J (1992) *Visible Fictions: Cinema, Television, Video*, London: Routledge.

Goldsmith, B, & O'Regan, T (2005) *The Film Studio: Film Production in the Global Economy*, New York: Rowman & Littlefield.

Gomery, D (1986) *The Hollywood Studio System*, Basingstoke: Macmillan.

Grover, R (2009a) 'Hollywood DVD Sales: Are the Good Times Gone?', http: //www.businessweek.com/technology. Accessed 13 March 2010.

Grover, R (2009b) 'Hollywood is Worried as DVD Sales Slow', http: //www.businessweek.com/technology. Accessed 19 February 2010.

Klinger, B (2006) *Beyond the Multiplex: Cinema, New Technologies and the Home*, Berkeley, CA: University of California Press.

Koranteng, J (2006), 'Online Onramp', *Hollywood Reporter*, 20 June.

Longwell, L (2008) 'Goodbye to All That', *Hollywood Reporter*, 30 October.

Maltby, R (2003) *Hollywood Cinema*, London: Blackwell.

Moore, S (2008) 'Forecast calls for high chance of lows as storm clouds gather over Hollywood', *Hollywood Reporter*, 14 November.

Netherby, J (2009) 'Paramount, Universal movies hit the mSpot', *Video Business*, 10 May.

Roddick, N (1983) *A New Deal in Entertainment: Warner Brothers in the 1930s*, London: British Film Institute.

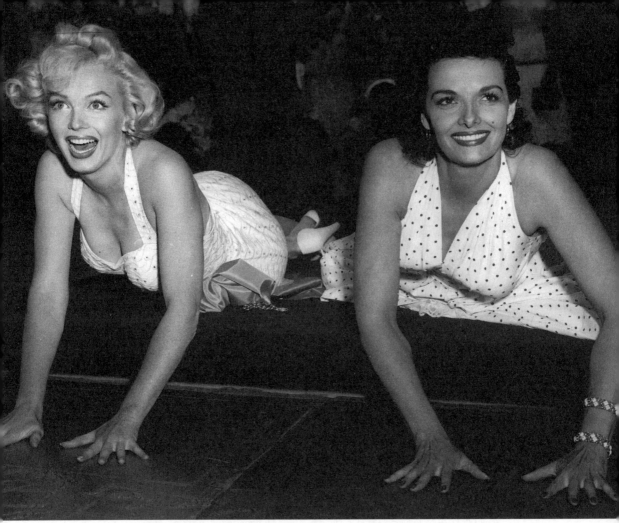

Marilyn Monroe and Jane Russell, 1953, 20th Century Fox.

STARDOM

The influence of 'stars' in Hollywood can be traced back to the beginnings of the industry and infrastructure in California. While actors initially had to mime actions and dialogue for silent films, well-known faces quickly became identifiable to audiences – even if theatre-goers did not yet know their names. Producer Carl Laemmle acquired 'Biograph Girl' Florence Lawrence for his Independent Moving Pictures Company, and knew early on how to manufacture publicity: he created a false rumour that she had been killed in a streetcar accident and, soon after, revealed that she was in perfectly good health and would be star-ring in one of his films. Newspaper and magazine publicity about stars was also prevalent in the early days of Hollywood, and the scandal involving Roscoe 'Fatty' Arbuckle proved that there was indeed such a thing as bad publicity – and that it could destroy your career. By the time Charlie Chaplin, Douglas Fairbanks, Mary Pickford, and director DW Grif-fith formed United Artists in 1919 (the first studio to be formed by actors as a means of creative control), audiences had latched onto the idea of a 'star' as the most identifiable element of a motion picture, and Hollywood had grown to recognize audiences' inter-est in marketing them as such. Chaplin indeed provides an interesting starting point in a brief discussion of how stars can change and grow within the Hollywood system. Chaplin's long-term reliance on his 'tramp' persona onscreen showed how an actor could become a star through an endearing persona and, also, how a star can then utilize their popularity to highlight issues of societal or cultural concern (in Chaplin's case, the struggles of the poor and underprivileged, drawn from his own childhood). Chaplin's early successes allowed him unlimited creative and financial freedom to pursue more complex narratives and characters; though he had endeared himself to audiences with early shorts like *Easy Street* (1917) and features such as *The Gold Rush* (1925), later films such as *The Great Dictator* (1940) and *Monsieur Verdoux* (1947) permanently cemented Chaplin's reputation as one of the great multitalented stars in cinematic history.

During the first half-century of Hollywood, actors were often tied to studio contracts, but could be loaned out to rival studios on a film-by-film basis. Early on, the rules were strict: actors often had 'morality clauses' in their contracts; male actors were to dress and act dignified; and female actresses were to always look glamorous. The 'star system' became a complex methodology as studios and agencies worked together to find, design, promote and protect their 'perfect' stars from private drinking problems, affairs, or 'homosexual tendencies'. Stars, then, became interesting to trace as they transformed themselves throughout changing genres and film-making innovations such as colour and widescreen, weaving their popular faces and mannerisms in and out of shifting iconography and back-grounds. Fred Astaire's display of dancing talent in films like *42nd Street* (1933) was just the springboard for an elaborate series of performance skills he would display much later in his career in films like *The Bandwagon* (1953), which managed to touch on multiple genres including film noir, the Western and, of course, the musical. By the time Gloria Swanson's Norma Desmond uttered 'I'm ready for my close-up, Mr DeMille', at the end of *Sunset Boulevard* (1950), Hollywood's treatment of stars had reached a whole new level of cultural (and, arguably, academic) profundity. Orson Welles had already established and crippled his own cinematic legacy by directing and starring in *Citizen Kane* (1942), which offended influential newspaper mogul William Randolph Hearst so greatly that Welles' career never quite recovered – all of his subsequent productions were either severely edited or quashed mid-production due to lack of funding or resources. A career, at once open to all possibili-ties, was stripped of its potential for legendary status, though, in effect, Welles became legendary by default, achieving 'star' status not entirely for his cinematic accomplishments, but for his stunning lack of them. What remains of his legacy on film still causes us to con-stantly reconsider the motivations, meanings, and manipulations inherent in all of his work – and within the Hollywood industry itself.

Marilyn Monroe began life as Norma Jeane Mortenson but her iconic presence in films like *Gentlemen Prefer Blondes* (1953) and *The Seven Year Itch* (1955) changed the way Hollywood and the public viewed her (and perhaps women) forever. Sadly, as Monroe began to tone down her self-image and deliver altogether different kinds of performances

in films like *The Misfits* (1962), her personal problems had taken over her work; she was fired from what would be her final (incomplete) work, 20th Century Fox's *Something's Got to Give* (1962), which prompted the then Vice President, Peter Levathes, to respond: 'The star system has gotten way out of hand'. During the 1950s and 1960s, 'method' actors began infiltrating Hollywood with new kinds of 'naturalistic' performances, including those of Marlon Brando, who made a significant impression starring in a screen adaptation of *A Streetcar Named Desire* (1951). Brando, and others like Dustin Hoffman and Robert DeNiro, took on unusual acting challenges and expanded their range as their careers progressed. Academically, stars became fertile ground for serious research with the publication of Richard Dyer's *Stars* in 1979, which ushered in a new wave of academic interest in the subject and, today, continues to encourage a wide range of scholarship from numerous different industrial, cultural and theoretical angles.

Hollywood history has shown consistently that the personal lives of stars do indeed affect how they are perceived and processed within the 'public eye'. Hugh Grant's mid-career dalliance with a prostitute in Los Angeles in 1995 did not end his career, but the actor's quick, uncomplicated public response to the incident is perhaps one of the most honest statements ever made by a star in an attempt to sweep things under the rug: appearing on *The Tonight Show with Jay Leno* a few days after the incident, he stated: 'I think you know in life what's a good thing to do and what's a bad thing, and I did a bad thing.' Some stars are not as lucky: after allegedly making anti-Semitic comments during a drunk-driving arrest in 2006, Mel Gibson retreated from the public eye and did not appear onscreen again until 2010's *Edge of Darkness*. Soon after, Gibson's career was again put in jeopardy when his agency dropped him (a highly unusual move) following the public release of recordings of angry phone messages to his girlfriend which contained a series of violent insults and racial slurs. Prominent female stars in contemporary Hollywood have not found it easy, either: Sharon Stone built a career on flashy narratives and characterized controversy, but seemed incapable of distinguishing herself from it, and the media's coverage of Angelina Jolie's career often seems driven by her personal tribulations rather than her consistently strong performances. Robert Downey Jr moved effortlessly from 1980s' pop-movie performances to Academy Award-nominated prestige projects (*Chaplin*, 1992) to challenging independent dramas (*Two Girls and a Guy*, 1998) before being sidelined by drug problems and multiple arrests but, after winning the starring role in 2008's *Iron Man* and helping to make it a worldwide success, Downey's career and faith with audiences was restored. Similarly, 1980s' action star Sylvester Stallone was re-embraced by critics and moviegoers when he bookended his two most famous franchises (*Rocky Balboa*, 2006 and *Rambo*, 2008).

Of course, Hollywood stars have historically attempted to subvert audience- and industry expectations and 'play against type', with uneven results. Frank Sinatra made a serious attempt to take on 'meatier' roles by portraying a heroin addict in *The Man with the Golden Arm* (1955), which the Motion Picture Association of America at the time refused to certify with a rating, but Sinatra received Oscar and BAFTA nominations for his performance. Despite Orson Welles' rather unstable private and professional life, no one was quite prepared for his portrayal of corrupt and debauched policeman Hank Quinlan in *Touch of Evil* (1958), which Welles also directed; the film's constricted, threatening atmosphere was arguably influenced as much by Quinlan's girth and characterization as the film's *mise-en-scène*. Michael Douglas' tightly-wound performance in *Falling Down* (1993) ranks among the actor's best and most important and, today, the film serves as a surprisingly authentic representation of the complicated racial, cultural and social divides which existed right on Hollywood's doorstep during the 1990s. Somewhat parallel in nature is Robin Williams' dark and disturbing performance in *One Hour Photo* (2002), which is arguably the most layered and distinct indicator of the star's impressive dramatic talents.

Additionally, Hollywood is notable for creating and manufacturing stars from highly unusual backgrounds. Hong Kong martial-arts star Bruce Lee might have permanently changed perceptions of East Asian actors in Hollywood if he had lived beyond his seminal *Enter the Dragon* (1973), and the accidental death of his only son, Brandon Lee, on the

set of *The Crow* in 1993, seemed to tragically snuff out an international star in-the-making. Austrian bodybuilding import Arnold Schwarzenegger began his career as Mr Universe, but successfully transferred his universally-marketable persona to a series of blockbuster Hollywood action films during the 1980s and 1990s, starting with *Conan the Barbarian* (1982) and *The Terminator* (1984). While he attempted a variety of mildly-successful comedies and self-referential performances, Schwarzenegger has always been more comfortable delivering what his audience wants. In *Terminator 3: Rise of the Machines* (2003), Schwarzenegger has a fascinating scene where his character struggles to fight his own (re) programming: as the Terminator uncontrollably pursues John Connor, Schwarzenegger's cybernetic character seems to 'feel' an emotional struggle within itself for the first time. The star delivers a telling line of dialogue which seems to acknowledge both the character and the actor's perceived deficiencies: 'Desire is irrelevant. I am … a machine!'

Hollywood's periodic adoption of non-American actors and the continual interest in Bruce Lee's posthumous 'presence' function as a link to Hollywood's latest fascination: the developing idea of 'finishing' or indeed 'continuing' a star's life indefinitely through digital technology. Though film-makers have had to deal with the loss of prominent actors mid-production (and the complicated production problems which ensue therein) for many years, the capabilities of digital visual effects tools to capture the nuances of an actor's face and performance have given film-makers more interest in finding ways to 'extend' a passed/past star's life on screen. Since the late 1990s, a script called *Gemini Man* has floated around Hollywood with the intention of casting an iconic presence like Harrison Ford or Sean Connery in a 'dual' role of an ageing government assassin who is being pursued by a younger cloned version of himself. The kind of technology needed to accomplish this feat already exists, having been used in films like *The Curious Case of Benjamin Button* (2008), which de-aged star Brad Pitt throughout the narrative. Most recently, *Terminator Salvation* (2009) posited the resurrection of a star who is not quite dead yet. While serving as Governor of California (in Hollywood history, Schwarzenegger and Ronald Regan are just two of the prominent actors that prove Americans do not mind seeing their childhood screen heroes in public office), Schwarzenegger 'appeared' in the fourth *Terminator* film in a brief scene featuring the star/character at the age and shape he was in during the *first* Terminator feature. The production hired a younger actor with a similar-looking physique for wide shots, and digitally mapped a de-aged version of Arnold's face over the actor's head for a few close-ups (Schwarzenegger himself apparently had very little to do with the production other than providing his approval).

Of contemporary Hollywood star/performance/subtexts, one of the most interesting of note has arguably been Jim Carrey's film career. As the comedian graduated from stand-up to television sketch comedy to starring roles in Hollywood features, he smartly and intuitively applied a series of references to his own onscreen history throughout his performances, culminating with *The Truman Show* (1998) and *Man on the Moon* (1999). In *The Truman Show*, Peter Weir directed Carrey to an impressive comedic and dramatic performance as Truman Burbank, who discovers that his entire life has been the subject of a television show. Both anticipating the reality-TV boom and encapsulating the nature of 24/7 celebrity tabloid coverage, *The Truman Show* works as a multi-allegorical treatise on contemporary notions of stardom, entertainment and Carrey's own career. In *Man on the Moon*, Carrey portrayed legendary comedian Andy Kaufman in a performance that covered Kaufman's entire career, pondered a fabricated death, and questioned just how far a star can go in asking for audiences' loyalty. In later years, Carrey's career waxed and waned, but he seems to be one of the rare Hollywood stars not afraid to occasionally take a chance on 'difficult' material which many other mainstream stars would pass on for fear of public- or industry rejection. While personalities and styles have significantly changed throughout the long history of movie stardom in America, many irrefutable elements have indeed remained strikingly similar to the cultural mores present at the beginning of the Hollywood industry.

Michael S Duffy

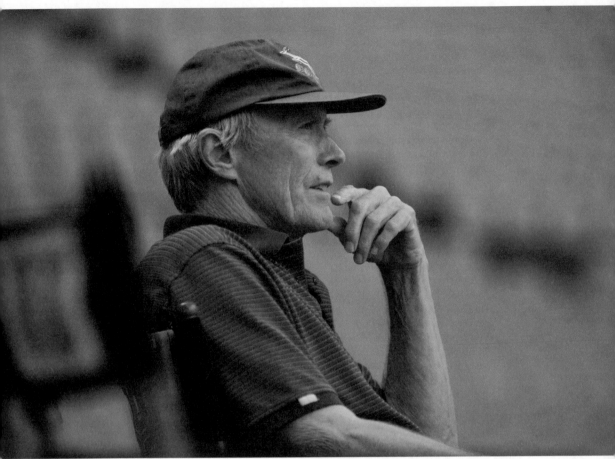

Clint Eastwood directing *Invictus*, 2009, Warner Bros.

DIRECTORS
CLINT EASTWOOD

With two Oscars for best director, Clint Eastwood is now a Hollywood institution although his success hardly occurred overnight. Towards the end of the studio system he paid his dues as a contract actor, taking uncredited bit-roles in such fare as *Tarantula* (1955). After *Ambush at Cimarron Pass* (1958), a Western that he described as 'the lousiest ever made' (Hughes 2009: xxiv), it would be 1964 before Eastwood appeared on cinema screens again. Moving to television, he was cast as Rowdy Yates in the Western series, *Rawhide* (1959–1965). The experience piqued Eastwood's interest in directing, with the regular turnover of directors introducing him to a range of styles that he considers to be his film school.

Rawhide brought Eastwood to the attention of Sergio Leone, who was preparing a low budget Spanish/Italian/German Western, then entitled *The Magnificent Stranger*. James Coburn and Charles Bronson had previously declined the lead but, impressed by the obvious *Yojimbo* (1961) inspiration, Eastwood signed up. The resulting film, *Per un pugno di dollari/A Fistful of Dollars* (1964), was a huge success in Europe. However, legal wrangles over the unlicensed *Yojimbo* influence initially prevented a US release. Eastwood continued his role as Rowdy Yates, returning to Europe during series breaks for two further collaborations with Leone, *Per qualche dollaro in più/For a Few Dollars More* (1965) and *Il buono, il brutto, il cattivo/The Good, the Bad and the Ugly* (1966). When the Dollars Trilogy finally opened in America critical reaction was mixed, but the international profits convinced United Artists to offer Eastwood his first starring role in a Hollywood Western. The result was *Hang 'Em High* (1968), an attempt to transfer Eastwood's European 'The Man With No Name' persona to a more conventional American version of the genre. *Coogan's Bluff* (1968) followed, notable for transplanting Eastwood's character into a contemporary urban setting, and for igniting his association with director Don Siegel. Already expressing the desire to directly control his career, Eastwood formed his production company, Malpaso. He developed his own projects while appearing in a variety of genre films, including the musical *Paint Your Wagon* (1969). Eastwood has long been involved with music. In the early 1960s he released several records to capitalize on his *Rawhide* success. Much later he formed Malpaso Records and composed themes for his own films, including *The Bridges of Madison County* (1995) and *Mystic River* (2003), as well as scoring *Grace is Gone* (2007).

Although renowned for his action roles, Eastwood also demonstrated an enthusiasm for off-beat subjects, reuniting with Siegel for a Southern Gothic drama, *The Beguiled* (1971). Malpaso's first fully-fledged production was Eastwood's directorial debut, the thriller *Play Misty for Me* (1971). He initiated an approach that he has followed throughout his directing career, developing a reputation for shooting quickly and economically, working with colleagues familiar with his methods. In *Misty*, for example, he cast his directorial mentor Don Siegel in a supporting role. Initially, Universal questioned Eastwood's decision to 'play in a picture where the woman has the best role' (Schickel 2010a: 88). However, the studio eventually financed *Misty*, on the understanding that Eastwood would subsequently deliver several commercial productions. This strategy has informed his success, astutely alternating between studio-pleasing films and personal projects. 1971 also saw the release of *Dirty Harry*, again directed by Siegel. As Eastwood's biographer Richard Schickel notes, this would be the point 'when a star becomes a super-star' (2010a: 93). *Life* magazine, 23 July, announced: 'The world's favourite movie star is – no kidding – Clint Eastwood.' Throughout the 1970s Eastwood evolved as a film-maker, directing the romantic drama, *Breezy* (1973), his first feature he did not also star in (although he can be spotted in a Hitchcock-like cameo) and *The Outlaw Josey Wales* (1976), an allegorical Western for the post-Vietnam era.

On screen, Eastwood began to send up his tough-guy image. Against studio advice he co-starred opposite an orangutan in *Every Which Way But Loose* (1978), producing what was then his most commercially successful film. This broadened Eastwood's box-office

appeal and the tactic continued with his own Capraesque *Bronco Billy* (1980) and even a comic turn in *Casper* (1995). One of his personal projects, *Bird* (1988), told the story of Charlie Parker and united Eastwood's passions for cinema and jazz. It was the first film he directed without starring in since *Breezy*. Unfortunately, the late 1980s coincided with Eastwood's least profitable spell. Even a final Dirty Harry movie, *The Dead Pool* (1988), failed to attract significant crowds. Of this period, Eastwood claims that there was simply a shortage of quality scripts available on the open market. However, he had been biding his time, holding back the screenplay for what would become *Unforgiven* (1992):

> *Unforgiven* granted Clint Eastwood his freedom. He would continue to cling to genre conventions, of course, but henceforth he would also be given leave – not least in his own mind – to follow his own aspirations wherever they led him. (Schickel 2010a: 211)

The Oscar winner was followed by *In the Line of Fire* (1993), the last occasion that Eastwood would perform for another director. He also served as producer on the Malpaso feature, *The Stars Fell on Henrietta* (1995). As the twentieth century eased into the twenty-first, Eastwood directed and starred in a number of relatively formulaic thrillers based on successful novels, including *Absolute Power* (1997) and *Blood Work* (2002). In 2008 he directed *Gran Torino*, in what is probably his final onscreen role. It is evident that Eastwood's interest now lies behind the camera. With films such as *Letters from Iwo Jima* (2006), *Changeling* (2008) and *Invictus* (2009), he has embarked on 'a second career that owes little to what he accomplished in previous decades' (Schickel 2010b: 34). At an age when many would be slowing down, Eastwood's recent output has been remarkably prolific. At 74 he became the oldest recipient of the best director Oscar for *Million Dollar Baby* (2004). His enthusiasm remains unabated, with upcoming productions including the supernatural thriller *Hereafter* (2010) and a bio-pic of J Edgar Hoover. At this time in his life, directing provides Eastwood with a creative freedom that he clearly relishes:

> I just feel that I'm enjoying the work now more than I ever have … and I'm at an age when I can take on more challenges than I have in the past because I know more. (Carnevale 2010: para. 4)

Critique

As William Holden, star of *Breezy*, once observed, 'Clint has done it his way' (Johnstone 1981: 138). Over the years, Eastwood has conscientiously sought out projects to showcase and evolve his abilities as director and actor. With an impressive list of awards and honours to his name, it is a method that has paid dividends. Having directed over thirty films and produced a body of work that has grossed over four billion dollars for Warner Bros (Schickel 2010b: 39), Eastwood is finally enjoying a critical appreciation to match his popular success.

However, it has not always been this way. During the 1970s, as Eastwood's star was rising, he was the subject of several barbed reviews from the legendary critic, Pauline Kael. Most notoriously, *Dirty Harry*, probably his best-known screen role, was accused of taking a fascistic position:

> If crime were caused by super-evil dragons, there would be no Miranda, no Escobedo[1]; we could all be licensed to kill like *Dirty Harry*. But since crime is caused by deprivation, misery, psychopathology and social injustice, *Dirty Harry* is a deeply immoral movie. (Kael cited in Johnstone 1981: 83)

Such negative reactions have plagued Eastwood throughout his acting and directing careers. But, as with Siegel's own *Invasion of the Body Snatchers* (1956), alternative

readings are possible. In a sense, *Dirty Harry*'s genre roots obscure the film's inherent critical commentary on the protagonist's behaviour. As Matt Wanat notes, 'the hero Harry is consistently aligned with the villain' (2007: 93). The film's trailer wryly observes that 'This is a movie about a couple of killers. Harry Callahan and a homicidal maniac – the one with the badge is Harry.' Echoing *High Noon* (1952), at the close of the film a disillusioned Callahan throws away that badge. Narratively, it is an acknowledgement that his above-the-law stance is unacceptable.

Dirty Harry and Eastwood's later films open up the age-old debate of authorial intent versus audience interpretation. Writing in his autobiography, Siegel commented:

> If I do a film about a hard-nosed cop, of course it doesn't mean I condone all his actions. I find it very difficult to explain my reasons for making a film like *Dirty Harry*, other than I'm a firm believer in entertainment … Not once throughout *Dirty Harry* did Clint and I have a political discussion. (Siegel 1996: 373)

Nonetheless, Eastwood's personal politics have long been the subject of critical attention. Although known to be a registered Republican, he is typically enigmatic when expressing his political views:

> I don't pay attention to either side … I mean, I've always been a libertarian. Leave everybody alone … So I believe in that value of smaller government. Give politicians power and all of a sudden they'll misuse it on ya. (Dawson 2008: para. 17)

Never afraid to take on a cause, he recently contacted the British Chancellor of the Exchequer to appeal the decision to abolish the UK Film Council, an organization that Eastwood states was invaluable to him when shooting *Hereafter* in London (Piazza 2010: para. 2). He was also involved in a public spat with director Spike Lee. The two clashed over the lack of black soldiers in Eastwood's *Flags of Our Fathers* (2006). Lee saw this as an insulting oversight, while Eastwood responded that since no black soldiers were involved in the Iwo Jima flag-raising, they were not featured prominently in the story. Black troops, however, can be glimpsed in the landing craft sequence, and are evident in historical stills used in the closing credits.

With Harry Callahan frequently dispensing justice to black criminals, race has often been a contentious topic in Eastwood's films. Sensitive to the issue, but leaving himself open to accusations of tokenism, Eastwood has been careful to cast a succession of black and ethnic sidekicks in the Dirty Harry series. One example is African-American actor Albert Popwell, part of the 'Eastwood repertory company', who appeared in four of the Dirty Harry films. He graduated from the role of a bank robber in *Dirty Harry* to eventually playing Callahan's partner in *Sudden Impact* (1983). Despite the controversy, Ed Buscombe notes that, throughout his career, 'Eastwood's films generally display an easy-going, relaxed attitude about racial difference' (2004: 44).

Gender and family are other themes common to Eastwood. Many of his films feature strong female protagonists. In the *Hollywood Reporter*, Jean Hoelscher remarked that, 'Eastwood certainly deserves credit [for] his lack of ego when casting his female leads. He is not afraid to work with excellent women' (cited in McGilligan 2000: 278). Whether this is indicative of a particular feminist perspective is debatable, yet, as Eastwood has mastered the directorial reigns, his work has gradually displayed a greater maturity, manifesting itself in his portrayal of family. In *The Outlaw Josey Wales*, Eastwood's taciturn loner finds himself at the heart of a reconstituted family, as survivors of the American Civil War rebuild their lives. Eastwood's characters are no longer self-reliant anti-heroes like The Man With No Name or Harry Callahan. In a distinctly more vulnerable representation of masculinity, they are flawed men, haunted by past deeds and seeking redemption. In

Unforgiven, Bill Munny reluctantly returns to bounty hunting after his attempts at farming fail to provide for his children. War hero Ira Hayes, played by Adam Beach in *Flags of Our Fathers*, cannot cope with his survivor guilt. Without friends or family to call upon, he internalizes his grief, finally drinking himself into oblivion. These self-doubting characters are far removed from the independent protagonists of Eastwood's earlier work.

The concern for family is also manifest in *Million Dollar Baby*, where Eastwood's Frankie Dunn becomes the surrogate father for Hilary Swank's driven Maggie Fitzgerald. *Mystic River* relates how a long-suppressed crime wrenches families and communities apart, while *Changeling* follows a single mother's desperate search for her missing son. Recalling *Dirty Harry*, an isolated Christine Collins, played by Angelina Jolie, battles indifferent authorities in her quest for justice. Eastwood's later output is also remarkable for its bleak streak. Maggie's fate in *Million Dollar Baby* is almost unbearable to watch. The final image of Frankie sitting alone in a diner is extremely ambiguous. Has he found peace at last, or is he to be forever tormented by his actions? In *Mystic River* the wrong man is punished and the culprits apparently escape, save for the stain on their consciences.

Although critics inferred that *Million Dollar Baby* portrayed a pro-euthanasia story, Eastwood resists any attempt to pigeon-hole his intentions: 'I never thought about the political side of this when making this film. How people feel about that is up to them' (Thompson 2005: xxv). This multi-faceted, open approach has been evident in Eastwood's oeuvre almost since the beginning. He was drawn to *Hang 'Em High*, because it contemplated how an individual's experiences could influence personal opinions on capital punishment. This is echoed in *Million Dollar Baby*: 'If you had asked Frankie, "Do you believe in euthanasia?", he'd have probably said no. But that was the circumstances of the moment' (Dawson 2008: para. 6). However, this trend for ambiguity has led to accusations that Eastwood seeks to 'have his cake and eat it' (Buscombe 2004: 75). The simplistic reading of *Unforgiven* would have it that, after a meticulous build-up that interrogates the destructive nature of violence, the narrative is simply resolved when Eastwood reverts to type, blood-thirstily eliminating his adversaries. But this ignores the prior thoughtful treatise on violence and its impact on both victim and perpetrator. After the brooding preamble, it is difficult to read the final shoot-out as an adrenaline inducing, heroic action sequence. The overriding mood of *Unforgiven* is one of melancholy. Munny's return to arms is to be mourned. Writing in the *New Yorker*, David Denby, admitting that he was once sceptical of Eastwood's talents, suggests:

> By giving the Western extra dimensions, and by pushing the moral issues to extremes, Eastwood had exposed (inadvertently, perhaps) the limits of the genre. 'Unforgiven' is both an entertainment and a contradiction, a masterpiece at war with itself. (2010: para. 23)

Nonetheless, as Richard Schickel indicates (2010a: 211), with his recent work Eastwood has displayed the confidence to stretch himself beyond genre forms. He has been able to develop this assured authorial voice relatively undisturbed by studio interference because of his ability to deliver efficiently-produced, successful films. After being frustrated by the excesses of big-budget productions such as *Paint Your Wagon*, he resolved to take direct control of his career. Eastwood was as good as his word, subsequently turning down the James Bond role and the lead in *Apocalypse Now* (1979).

As a director, Eastwood is known for his loyalty and reliance on a regular crew. His current cinematographer, Tom Stern, earned his spurs on the lighting team for his long-serving predecessors Bruce Surtees and Jack N Green. His stunt coordinator Buddy Van Horn has worked with Eastwood since *Coogan's Bluff*, and has directed three of his star vehicles. Favouring locations over studio-bound productions, Eastwood has a reputation

for running a disciplined set. *Play Misty for Me* was completed $50,000 under budget, and within its modest five-week production schedule (Hughes 2009: 102). He has described his admiration for directors such as William Wellman who, during the studio system, had to be efficient and well-prepared. Eastwood certainly recognized this technique in his mentor: 'If there's one thing I learned from Don Siegel, it's to know what you want to shoot and to know what you're seeing when you see it' (Siegel 1996: x). Eastwood feels that this approach encourages the most effective performances from actors: 'If you know the director's not going to print anything until maybe the eighth time, the first seven times you're kinda just coasting along … Sometimes that first moment is magic' (French, 2007). He is known for filming rehearsals, believing that they capture a spontaneity that is lost in multiple takes. Peter Biskind relates a story that, after working with Stanley Kubrick on *The Shining* (1980), actor Scatman Crothers was so relieved by Eastwood's single-take approach on *Bronco Billy* that he 'nearly burst into tears' (Biskind 1999: 197).

Another of Eastwood's directorial traits is his fondness for low-key, noir-like lighting. This is apparent in his Westerns, with the shadows cast by hat brims frequently concealing the eyes and motives of characters. This device is evident in one of his favourite films, the cautionary tale of *The Ox-Bow Incident* (1943). Detractors have sniped that this approach is a sign of Eastwood's reluctance to part with money. Biographer Patrick McGilligan (2000: 198) went as far to as to suggest that Eastwood's low-key lighting is an attempt to obscure his aging visage. But those who have worked with Eastwood describe the calm atmosphere that he engenders, encouraging a sense of freedom and enthusiasm. Producer David Valdes comments: 'It's fun … and everyone realizes we're not curing brain cancer' (Biskind 1999: 196). Besides, McGilligan is technically incorrect as low-key, *chiaroscuro*-style lighting tends to emphasize wrinkles and flaws.

More importantly, Eastwood's dislike of over-lighting is consistent with his deliberately ambiguous approach: 'I just want a sketch. I don't want to see everything. The audience will make up what they see' (Andrew 2008: 22). Perhaps it has only recently become evident but, for Eastwood, the pleasure in film-making lies with his efforts to create the space for a multitude of readings. Noting Eastwood's recurrent reinterpretations of the archetypal Western, *Shane* (1953), Stephen McVeigh proposes that Eastwood's 'conflictive values' are indicative of 'his conscious and precise manipulations and subversions of this essential American meta-narrative' (2007: 154). Although he may be as resistant to analysis as he is to over-lighting, it is an interpretation that Eastwood appears to recognize in his work:

> I'm obviously an American Director. Which means that, like my colleagues, my roots are in genre moviemaking. For me, genre conventions add a certain strength to the movies. At the same time they offer the possibility of creating variations on their basic themes, a chance to refresh the film in question, making it new for the audience and for me. (Schickel 2010a: 8)

John Caro

Note

1. Under US law, arrested suspects are required to be read their Miranda Rights, informing them of their rights against incriminating themselves and of support from an attorney. In 1964 Danny Escobedo's conviction for murder was overturned by the US Supreme Court on the grounds that he was not granted access to an attorney.

References

Andrew, G (2008) 'The Quiet American', *Sight & Sound*, 18: 9, pp. 14–22.

Biskind, P (1999) 'Any Which Way He Can', in RE Kapsis & K Coblentz (eds) *Clint Eastwood Interviews*, Jackson: University of Mississippi Press, pp. 193–206.

Buscombe, E (2004) *Unforgiven*, London: BFI Publishing.

Carnevale, R (2010) 'Invictus: Clint Eastwood Interview', *IndieLondon Online*, http: //www. indielondon.co.uk/Film-Review/invictus-clint-eastwood-interview. Accessed 1 August 2010,

Denby, D (2010) 'Out of the West: Clint Eastwood's Shifting Landscape', *The New Yorker*, http: // www.newyorker.com/reporting/2010/03/08/100308fa_fact_denby?currentPage=all. Accessed 5 August 2010.

Dawson, J (2008) 'Dirty Harry Comes Clean', *The Guardian*, http: //www.guardian.co.uk/film/2008/ jun/06/1. Accessed 4 August 2010.

French, P (2007) 'An Audience with Clint Eastwood: mp3 streaming audio file', *The Guardian*, http: //audio.theguardian.tv/sys-audio/Film/Film/2007/02/23/ClintEastwood.mp3. Accessed 3 August 2010.

Hughes, H (2009) *Aim for the Heart: The Films of Clint Eastwood*, London: IB Tauris.

Johnstone, I (1981) *The Man With No Name: The Biography of Clint Eastwood*, London: Plexus.

McGilligan, P (2000) *Clint: The Life and Legend*, London: HarperCollins Entertainment.

McVeigh, S (2007) 'Subverting *Shane*: Ambiguities in Eastwood's Politics in *Fistful of Dollars*, *High Plains Drifter*, and *Pale Rider*', in L Engel (ed) *Clint Eastwood, Actor and Director: New Perspectives*, Salt Lake City: The University of Utah Press, pp. 129–56.

Piazza, S (2010) 'Clint Eastwood Makes Plea to Save Film Council', *The Independent*, http: // www.independent.co.uk/arts-entertainment/films/news/eastwood-makes-plea-to-save-film-council-2047062.html. Accessed 9 August 2010.

Schickel, R (2010a) *Clint: A Retrospective*, New York: Sterling Publishing Co. Inc.

Schickel, R (2010b) 'Clint Eastwood', *The Red Bulletin*, pp. 34–39.

Siegel, D (1996) *A Siegel Film: An Autobiography*, London: Faber and Faber Limited.

Thompson, D (2005) *Clint Eastwood: Billion Dollar Man*, London: John Blake Publishing Ltd.

Wanat, M (2007) 'Irony as Absolution', in L Engel (ed) *Clint Eastwood, Actor and Director: New Perspectives*, Salt Lake City: The University of Utah Press, pp. 77–98.

John Ford, 1939, United Artists.

DIRECTORS
JOHN FORD

John Ford is arguably America's greatest film director. Certainly, he is the most important contributor to the development of the Western genre. His films are testament to a thoroughgoing familiarity with the American arts and literature, and to a deep commitment to America's history and political cultures. Yet in interviews he plays the artisan, interested only in the craft of telling a good story. Perhaps reticence about his art (and even a notorious grouchiness as he aged) was a ruse to assuage notoriously-philistine moguls of Hollywood studios and their popular audiences on whom his continuing career depended that he was no threatening intellectual. But his films prove – if there is by now any doubt – that the creation of art as well as profit can be realized in those most commercial of conditions.

Ford began working in Hollywood in the 1910s, when it was a burgeoning industry, and throughout its classical period until the 1960s. An elder brother, Frances, was already a film director and Ford worked his way up to that role as his brother's career waned. (Frances turned instead to acting, often later playing minor roles in his younger brother's films.) Ford's first film as director was – prophetically – a Western: the short, *The Tornado* (1917). Subsequent collaborations were formative, especially in the Western series of 25 shorts with star Harry Carey as their hero, Cheyenne Harry (Ford's *Three Godfathers* [1948] is dedicated to Carey's memory). This was the start of a career association with the Carey family and a repertory of actors – Ford's 'stock company' – fronted by the Western icon, John Wayne, whose career is inseparable from Ford's. Sadly, few survive of the over sixty shorts and features Ford made during this 'silent' period (when films lacked only synchronized sound).

Ford's most mature films were made after the coming of sound, including a moving adaptation of John Steinbeck's dustbowl novel, *The Grapes of Wrath* (1940); the Welsh mining village story of *How Green Was My Valley* (1941), one of the first to use a first-person narration; and *The Quiet Man* (1952), a raucous romance set in Ireland. But Ford's Westerns are a central legacy, not least *Stagecoach* (1939); *Drums Along the Mohawk* (1939); *My Darling Clementine* (1946); a trilogy of cavalry films starting with *Fort Apache* (1948); *Wagon Master* (1950); *The Searchers* (1956); and *The Man Who Shot Liberty Valance* (1962). These were immensely popular, enabling Ford to attract funding to intersperse personal projects, like the Irish-themed *The Informer* (1935), *The Rising of the Moon* (1957) and *The Plough and the Stars* (1936), and the first with his own short-lived production company Argosy, *The Fugitive* (1947), with Graham Green's whisky priest from his novel, *The Power and the Glory*, in a Mexican setting. By the time of his death in 1973, Ford had made about 160 feature films, as well as numerous shorts, television programmes and documentaries.

Critique

Ford was a populist. In the cultural sense of that term, he believed in the power of mass arts like cinema not only to entertain large numbers but also to connect people to positive human values and sympathies. In the political sense, Ford's films evidence both the complexities and contradictions of the short-lived Populist movement of the late nineteenth century. Populism favours at least the small-scale over the mass, the common good over the rights of the individual, quality of life over monetary gain and emotional over intellectual connection. These are themes that speak more of pre-urban conditions and, thereby, translate with difficulty in a modern world of mass urban development. Hence the contradictions at the heart of Ford's art, evident in the complex interplay of his themes and perhaps even in the experimentation with film styles across his career.

Ford's primary social group is the community, in which individuals grow up in extended kinship groups, in neighbourhoods, some to journey away, but – even if only in spirit – always connected. These communities are composed of common folk in a unity of

common purpose among tolerated differences, whether in frontier town, army unit or itinerant camp. His model was clearly a traditional urban, working-class community. Ford's own family came from immigrant Irish roots, and a commitment to rural Ireland and Irishness is evident not only in the titles listed above but – peppered with Quincannons and O'Rileys in minor roles – in many of his films. Families have strong leaderships in Ford's films – in patriarchs who assume the right to rule and matriarchs who gently feminize the rougher edges of their men. (In *How Green Was My Valley*, the narrating hero looks back upon a childhood in which 'If my father was the head of the house, my mother was its heart.') Among younger family members, females are feisty tomboys, prodding in their desired directions their more gauche brothers and lovers. Courtships are always spirited affairs, fraught with misunderstandings but resolved in lasting partnerships. Idealized family and community life permeate his films, and in their building of frontier homes (eg *Drums*), churches (*Clementine* has a wonderful celebration in the bare bones of a church) and schools (eg *Liberty Valance*) serve, over time, to represent the components of an ideal America.

Paradoxically, Ford's heroes tend to be individualists, frequently warriors (Ford's career spans two World Wars) and nomads who are, therefore, in a shifting, ambivalent relationship to the settled community. They find 'settling down' impossible, competing with their sense of personal identity or professional duty, whether during war or in peacetime. Their skills will be essential to the process of building an America worth living in, but they will remain on the margins of the society that benefits. Indeed, they share the tendency of villains – such as those in *Wagon Master* and *Clementine* – to disrupt communal rituals like parties, speeches and – in *The Searchers* – even funerals. At their extreme – without the civilizing influence of women – they become outsiders; we may even doubt the sanity of men who have lost their loves (compare Henry Fonda's Colonel Thursday in *Fort Apache* and John Wayne's characters in *The Searchers* and *Liberty Valance*). Ford's films play community and individual in symbiotic tension, as his heroes struggle between individualism and social duty. None will survive their films whole: in *The Wings of Eagles* (1957), the battle-weary hero returns home to an accidental fall, which, ironically, paralyses him.

Ford's film method emerges from the contradictions in the relationship between community and individual. Social rituals provide scenes of great emotional weight, whether formal (as in the exhilarating dance sequence of *Fort Apache*), casual (as in the campfire music of *Wagon Master*) or domestic (as in the family's reception of visitors in *The Searchers*: so full of bustling sociality in an abundance of coffee and doughnuts that we feel all the more the tragedy of their pointless loss in an Indian attack). His films abound with ceremonies associated with the life cycles of birth (*Stagecoach* has a touching example that returns status to an alcoholic doctor and the prostitute who nurses the baby), marriage (the foundation of frontier life in *Drums* and cruelly disrupted in *The Searchers*), and death (none more poignant than the speeches of John Wayne's cavalry officer over has his dead wife's grave and then a fallen comrade in *She Wore a Yellow Ribbon* [1949]). Knockabout comedy defines courtship among young lovers and camaraderie among mature men, frequently indulging in jokes in which gauche adolescents are the victims (as in Ward Bond's soldier-cum-reverend joshing Patrick Wayne's naive lieutenant in *The Searchers*), or turn on the sudden availability of an excess of alcohol (as when John Wayne's retiring cavalry captain in *Yellow Ribbon* opens the bar for Victor McLaglen's sergeant).

Ford uses music and song widely on the soundtrack and in the action of his films, emotionally connecting audiences to onscreen communities. He draws on a range of music traditions, evident even in the titles of his films: for instance, traditional in *Clementine*, military in *Yellow Ribbon* and ballad in *The Searchers*. In *Rio Grande* (1950) there are four original and several traditional songs – especially Irish – all sung both on- and off-screen

by the Sons of the Pioneers: a close-harmony group that frequently backed singing cowboys like Gene Autry in B Westerns. Ford considered his films as part of and not distinct from the genre's traditions.

Ford's film style shows ample evidence of experimentation. He undoubtedly learned the craft of commercial film-making through the apprenticeship period of his early career, making so many films so quickly that he came to control his studio-produced films by 'editing in the camera', shooting only enough takes in continuity such that studio editors were constrained to edit according to Ford's intentions. Early on, however, he was influenced by expressionist techniques from German Cinema, lighting to create expressive mood and framing to construct unease in character relations, evident especially in the cinematography of *The Fugitive* and on the ship-bound *The Long Voyage Home* (1940). In his Westerns, Ford was among the first to dynamize action through tracking shots alongside action scenes. But evidence of adapting expressionist techniques to American painterly and realist forms can be seen in his classical visual compositions, especially in long takes of groups in the full range of movement across all grounds of the frame. Location exteriors commonly feature in long shots, particularly when set in his beloved Monument Valley in Utah, where the vast scale of the ancient buttes dwarf intricate patterns of nonetheless-valorized human movement. In *Fort Apache*, preparations for the final battle are shot in magnificent monochrome images of the antagonists, framed against the buttes amidst billowing white clouds.

Jim Kitses charts Ford's changing critical reputation before he and the Western became widely analysed from the 1970s onwards. In the 1930s, Lewis Jacobs noted Ford's untypical social-realist dramas like *The Informer*, and Arthur Knight favoured the same style in *The Grapes of Wrath*. But it was in Britain that Ford's work came under closer scrutiny, and by critics who were also film-makers: firstly Lindsay Anderson, in the 1950s, who drew attention to Ford's poetic and humanist interests and, second, Peter Wollen in the 1970s, whose structuralist analysis posed a creative tension in Ford's films between pairs of thematic opposites (or, in Wollen's term, 'antinomies'). The central antinomy is the Wilderness and the Garden, where, initially, the Wilderness represents a barren land, untamed and threatening, and the Garden a cultivated and secure society. But, by the end of his career, the meaning of these terms shifts, reflecting a fundamental change in Ford's attitude to America's identify. Early on, Ford's heroes commit to communities representing an America of nation-building, turning a perceived wilderness into a garden (most clearly in the silent epic, *The Iron Horse* [1924], dramatized against the building of the first transcontinental railroad). Over the years, that antinomy shifts in meaning until, by the time of *Cheyenne Autumn* (1964), Ford's sympathies turn from white society to the Native American community, now threatened by a destructive white intervention. The dream of the Garden of the future is spoiled; the Wilderness of the past is where lost values now lie.

If the meaning of community changes over time, so too must the meaning of heroism. Already as early as *Stagecoach*, John Wayne's frontier outlaw escapes 'the blessings of civilization' into the west of America's future. But a schematic comparison of *Clementine* and the later *Liberty Valance* reveals the change most clearly. In the former, Henry Fonda's ideal Western hero, Marshal Wyatt Earp, combines with the positive values of Victor Mature's otherwise consumptive and criminal Easterner, Doc Holiday, to overcome the threat – in the form of the savage Clanton family – to the growing ideal American community that is Tombstone. In *Liberty Valance*, the role of John Wayne's Westerner – now representing positive wilderness values – has been displaced by the civilizing forces of James Stewart's Easterner, not just from the film but also from his position in American history. The dreams of a nation that was to be built are by this time long gone, replaced by sadness at the loss of collective values. Perhaps most telling is the change in relationship between hero and community in Ford's very last film, *Seven Women* (1966), in which

Anne Bancroft fittingly plays Ford's only female hero. Her hard-as-nails persona informs the supreme personal sacrifice her character makes in order to save a missionary community, among whom are too many unworthy of it. Ford here finds the individual sacrifice unnecessary, the American national cause undeserving.

This is why Ford's most distinctive films are Westerns, the genre that speaks of an American national identity founded in its frontier origins, in the role of heroes in the making of modern communities, and in an ambivalent tension between myth and history. The terms of Ford's critical intervention at a meeting with his Hollywood peers (which would crucially inform their response to the 'witch hunts' of the 1950s' 'Red Scare') was, famously: 'My name's John Ford. I make Westerns.' Few self-identifications are as revealing. Ford not only made Westerns but many great ones too (though, at the time of his declaration, arguably the greatest – *The Searchers* and *Liberty Valance* – were yet to come). But in the context in which he so identified himself, to a jury of film-makers who already knew him, respected him, admired his work and needed no introduction of any kind, it was neither frivolous nor idle boast. It was both a cultural statement that claimed value for the commonly-despised popular genre of 'horse operas', and a political claim for fair play as the common lot.

That Ford should deny discrimination so completely (and with no little personal risk at a time of such paranoia) is ironic, given the undoubted negative representation of Native Americans in so many of his earliest Westerns, and Jane Tompkins' claim that his films are misogynist. Ford was a traditional man of his time, the first half of the twentieth century, yet also a liberal, who adapted to progressive campaigns as the century advanced. A political conservative he undoubtedly was but, as Gaylyn Studlar argues, his admiration for women, their personal strength and essential social contribution is evident in every one of his films, whose heroes are required to accommodate themselves to feminine values. Ford was also among the first of his generation to respond to the civil rights movement by adjusting roles for black and Mexican actors towards the end of his career, and not least in the dignified leading role of *Sergeant Rutledge* (1960) for black actor, Woody Strode.

Ford's films examine populist tensions between the rights of the individual and the needs of the community. And through them, his body of work explores changing ideas about both the making and the establishment of what it means to be an American. He was a patriot who saw service in World War II as Commander in the US Navy, and who risked his life in combat conditions to produce three wartime documentaries, like *Battle of Midway* (1942), for the military cause. Yet his films are also critiques of nationhood, chronicling fault lines in the American dream of national unity. He was committed to the Free Irish cause (the last of three stories in the portmanteau film, *The Rising of the Moon*, is sympathetic to the escape of an IRA soldier from English imprisonment in Ireland) but everything about his films is in the service of settlement. His films explore these contradictions, not least in the complex relationship between storytelling and history. Ford neither justifies glorious myth over tragic reality, like John Wayne's Captain Yorke after military defeat in *Fort Apache*, nor will he simply 'print the legend', like the newspaperman when availed of the truth behind the eponymous killing in *Liberty Valance*. But Ford both exposes and defends the inseparability of myth and history. Ford's films are supreme combinations of the popular and the critical; they constitute the most distinctive body of work in the major period of cinema history that was classical Hollywood.

David Lusted

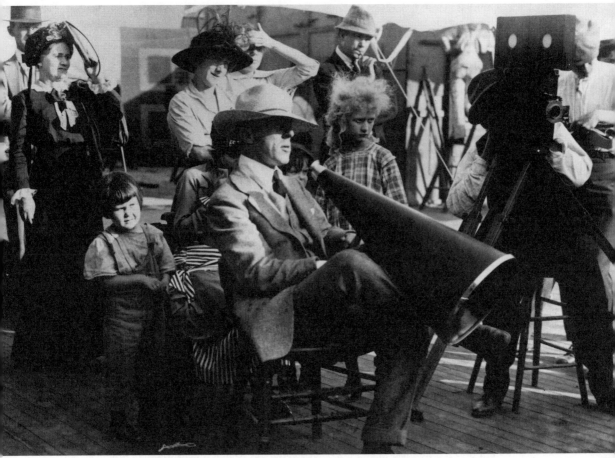

DW Griffith, 1916, Wark Producing Company.

DIRECTORS
DW GRIFFITH

David Wark Griffith was born in 1875 in Kentucky, his career heavily conditioned by an upbringing in the immediate aftermath of the American Civil War, not least the hero-worship of his father Jacob's role as a Confederate army colonel. Later in life he recounted how his parents always closely directed his childhood studies, impressing upon him certain family traditions, and how his earliest memory was of his father's sword (Griffith 1971c: 13–14). However, the unexpected death of 'Roaring Jake' in 1885 plunged the family into financial hardship, so, although Griffith's ambition had always been to be a writer, he took on, often out of necessity, a variety of jobs (most notably acting on the stage) before eventually settling into the film industry.

Griffith first made his name in cinema as an actor and then a writer, often performing by day and writing scripts at night. He soon became known for both his ingenuity and his industry, in Iris Barry's words as a 'human short-circuit' type (1940: 12), which saw him earn the opportunity to direct films for the American Mutoscope and Biograph Company, one of the three dominant studios of the time along with Edison and Vitagraph. After a successful beginning with *The Adventures of Dollie* (1908), Griffith quickly became Biograph's principal director, making more than 450 films over the next five years at an average of two per week (Stokes 2007: 68). He developed a reputation within the industry for slick professionalism and innovation in such films as *The Lonely Villa* (1909) and *The Lonedale Operator* (1911), particularly with regard to his use of formal techniques such as editing. However, Griffith became increasingly frustrated by Biograph's conservatism, which he saw as stifling his ambitions to create longer works along the lines of the increasingly-popular imported European epics, especially the Italian 'super-spectacles' (Cook 1981: 75). When given the chance to direct the first American four-reeler, *Judith of Bethulia* (1914), Griffith's perceived 'reckless extravagance' (Vardac 1971: 76) led to a parting of the ways with the studio and a move to the Mutual Film Corporation.

Freed from Biograph's restrictions, Griffith made his two most famous films in quick succession: the features *The Birth of a Nation* (1915) and *Intolerance* (1916). The former became a massive success at the box office but aroused great controversy in its depiction of history, particularly the heroic role of the white supremacist Ku Klux Klan organization during the 'Reconstruction' period in the aftermath of the Civil War. In many ways a response to such criticism, as a thinly veiled attack on censorship, *Intolerance* featured four parallel stories of injustice throughout history. However, when it failed to match the earlier film's financial success, Griffith found himself forced to relinquish much of his independence and agree to a contract to fund his work via Adolph Zukor's film company (later to become known as Paramount), during which time he made a number of generally well-received films such as the war drama *Hearts of the World* (1918) and the tragic interracial romance *Broken Blossoms* (1919).

However, chafing under the restrictions of the emergent Hollywood studio system, Griffith eagerly embraced the formation of the distribution organization United Artists with fellow box office heavyweights Charlie Chaplin, Mary Pickford and Douglas Fairbanks, Sr. He also briefly reclaimed more independence in 1919 with the creation of his studio Mamaroneck back on the East Coast in New York and the subsequent success of *Way Down East* (1920), a melodrama of late-nineteenth-century rural life.

This decade nevertheless saw a steady decline in Griffith's fortunes. Despite isolated successes such as the period piece *Orphans of the Storm* (1921), Griffith had become widely regarded as 'old-fashioned', passed in repute by former employees such a Victor Von Stroheim and Mack Sennett (Barry 1940: 30–31). Plagued by financial problems, his career as a director came to a premature end after two unsuccessful sound films in the early 1930s, although he remained sporadically involved in film productions (on an uncredited basis) between then and his death in 1948. His most celebrated leading actor, Lillian Gish, later remarked that it seemed 'there was no longer any place for

him': not being able to make movies 'the Hollywood way' meant that he could not make movies at all anymore (Gish 1971: 152–53).

Critique

One resonant entry-point to understanding the career of DW Griffith would be to stress the sometimes conflicting twin influences of his upbringing and his ambition. Jay Leyda argues that it would have been a miracle if the director had been able to transcend his background (Leyda 1971: 165). The death of his father when Griffith was only ten inevitably set in stone the son's hero-worship of the Confederate colonel, as well as ingraining in him the motivation to also make a mark on the world. However, his overwhelming desire to become a writer put him at odds with his mother's own preferred career path for him in the clergy – a conflict exacerbated when circumstances led the young man to acting, first on the stage and later on the screen. Two incidents seem highly revealing in this regard. Firstly, although at the time Griffith made a living primarily by performing on the stage, on his marriage to fellow actor Linda Arvidson in 1906, he insisted on listing his occupation on the licence as that of 'writing' (Stokes 2007: 64). Secondly, it was not until he had firmly established himself as a writer/director at Biograph that Griffith agreed to sign a contract with his real name rather than his stage performing persona 'Lawrence Griffith' (Stokes 2007: 71). The progression of his creative life, then, can be seen in terms of an ongoing attempt to reconcile family heritage and professional reward.

Given Griffith's fruitless efforts to become a working playwright and his relative success instead as a stage actor, regarded by his mother as a disreputable and even sinful line of work (Stokes 2007: 62), it seems hardly surprising that, when he finally made it as a reputed film director, he would consistently go out of his way to downplay and disavow his ties to theatre. Along with his infamous claims in a full-page announcement in the New York *Daily Mirror* in1913 to invention and authorship regarding his Biograph films, this situation has over the years helped obscure the real nature of the director's inspiration and innovation.

There has been widespread acceptance since the 1913 proclamation that Griffith did indeed invent such key aspects of film grammar as the close up, the flashback and parallel editing. However, the director actually introduced no new techniques to film-making; rather, his originality lay in the transformation of how films told stories as part of what Tom Gunning (1994: 6) conceptualizes as a wider industry change from a cinema of attractions (showing) to one of narrative integration (telling). Gunning describes Griffith's special contribution to this development as 'the narrator system': a combination of filmic devices through which he focused on the task of narration (1994: 25). Central to this particular system proved to be an extreme reliance on parallel editing which marked temporal/spatial relations quite specifically in contrast to earlier cinema's more ambiguous temporality (1994: 26). Griffith's 'characterization approach' in this context provided greater access to characters' emotions and motivations (1994: 27).

Overall, there were three cardinal points to the narrator system: suspense, psychology and morality (Gunning 1994: 28). The third point dovetailed with industrial and socio-cultural changes, most notably in the aftermath of the founding of the Motion Picture Patents Company (MPPC) as the dominant film studios jockeyed for economic position:

The MPPC, responding to growing criticism of the moral impact of the movies by middle-class 'progressive' reformers, declared its intention to produce 'Moral, Educational, and Cleanly Amusing' motion pictures. At the back of this lay a general strategy of repositioning the film industry as a 'higher class' (and therefore more expensive) form of entertainment that would appeal to 'respectable' audiences. (Stokes 2007: 70)

Given his family and career background, Griffith proved particularly amenable to promoting such a moral discourse – for example in *A Drunkard's Reformation* (1909), a prohibitionist attack on saloons. It also fit well with his general desire to disparage the stage in relation to cinema, hence his jump from proclaiming that movies had fewer improprieties (such as nudity) to that they were even less tiring on the eyes (Griffith 1971b: 29) and to the sweeping claim that they were simply 'better' than theatre (Griffith 1971a: 32).

Part of Griffith's strategy in this regard involved emphasizing his and cinema's links with literature rather than theatre per se. It also had the added advantage of valorizing something his father had valued (Stokes 2007: 61). Thus, for example, he claimed cinema to be a novelizing or storytelling rather than a stage form; epic rather than dramatic (Griffith 1971a: 53). He even stressed his specific indebtedness to Charles Dickens in borrowing the 'cut-back' and developing it to the 'story within a story' and so-called parallel action, with each action heightening the effects of the others (1971a: 52). Such comments encouraged Soviet film-maker and theorist Sergei Eisenstein to posit an even wider argument about Dickens' extensive influence on Griffith's film style (1949: 195–255), in the process, according to Russell Merritt, incorrectly attributing to the novelist many of the techniques that Griffith actually borrowed directly from dramatists such as Ibsen and Suderman (Merritt 1981: 9–10).

Gunning has also persuasively argued against the widespread notion that Griffith's role in film history included the simple liberation of film from dependence on the theatre (Gunning 1994: 35). On the contrary, Griffith actually maintained a quite complicated and, at times, fluid relationship with the medium. Rather than rejecting theatre, in practice (if not in proclamation) Griffith navigated within its various traditions in order to develop a version of theatricality as a viable cinematic style for the specific period:

> Around 1906–8, the relation between film and theatre changed. The increased demand for fiction films and the longer length of such films gave the legitimate theatre a new relevance to film-making. Film began to draw on new theatrical models as well, showing a new awareness of classical and contemporary theatre, although without abandoning melodrama and vaudeville. (Gunning 1994: 37)

Ironically, Griffith's 'narrator system' actually arose as a way to translate the new theatricality into a correlative for silent cinema: 'Narrativity provided the "signifieds" of drama at the cost of deviating from theatrical practice, the "signifiers" of theatre … The elaboration of editing … provided Griffith with a new set of signifiers to fill the void left by the spoken text' (1994: 40).

Not coincidentally, the term and concept of a 'film director' also appeared around this time, having originated in late-nineteenth-century theatre to describe a new unifying force which provided a particular point of view. The cinema of narrative integration involved this new figure more heavily in the visualization of a film, thereby finally displacing the old 'cameraman system' of production. Here, as elsewhere, Griffith appeared at the cutting edge of emergent film practice.

In addition to fusing formal innovation with a new theatrical template and being at the vanguard of a new theatrically-rooted conception of the film director, Griffith drew on his stage background and knowledge consistently throughout his career in other often more mundane ways. Simmon argues that Griffith's auteurist worldview depended among other things on a particular 'Victorian' mix of values drawn from popular agrarianism, the antebellum South and theatrical melodramas. Indeed, his films soon became the 'unparalleled surviving record of a widely shared vision of life in America, a vision that, insofar as it was depicted in art at all, often found expression in forms *more* ephemeral than the movies, such as the vaudeville stage' (Simmon 1993: 3). This characterization clearly helps explain the director's decision to pay $175,000 for the rights to adapt

Way Down East, a nineteenth-century melodramatic play hinging on conflict between town and country. However, at the same time it becomes far more difficult to dismiss an overtly-racist film like *The Birth of a Nation* as merely individual aberrance in any sense of the term.

Merritt sees Griffith's contradictory love/hate relationship with the theatre in overtly-autobiographical terms. He stresses the young would-be playwright's lingering sense of having failed his family by going on the stage in order to make ends meet (Merritt 1981: 12). Consequently, during his 'lost' theatre years, Griffith wrote his most autobiographical work in an attempt to come to terms with unresolved adolescent emotions. His plays show an almost pathological obsession with the fear of humiliating disgrace and the need for forgiveness, with self-dramatization and hero-worship of father figures prominent motifs throughout (1981: 13–16). However, Griffith's move from the stage to cinema saw an abandonment and/or reversal of such concerns. Whereas the plays feature men in distress who fight for themselves, the Biograph films tend to focus on self-sacrificing heroines protecting someone else. Merritt argues that the films functioned as a form of therapy (1981: 3), as Griffith proactively looked for formulas providing the opportunity to redirect and control autobiographical themes and feelings that had threatened to overwhelm him in theatre (1981: 17).

This characterization of the Biograph years is broadly shared by Michael Rogin, who traces four recurrent but unstable themes in these works: weak/repressive fathers, linked with tradition; emergent female sexuality, associated with modernity; imprisoning and vulnerable domestic, interior space; and rides to the rescue. These rescues, in films such as *The Lonely Villa* (1909), attempt 'to reassert the contrast between good and evil, the domestic refuge and the menacing invader, male strength and female weakness, but they leave behind traces of a dangerous boundary breakdown' (Rogin 1994: 261). Rogin argues that Griffith's *The Birth of a Nation* generated a deeper system of differences, with the transitional-length film *Judith of Bethulia* also appropriately providing a transition in terms of content. Here, Blanche Sweet is transformed from a victim needing rescue in *The Painted Lady* (1912) to the rescuer of Bethulia when she kills Holofernes by decapitating the Assyrian general with his own sword (Rogin 1994: 262). The symbolism regarding the director's relationship with Biograph is obvious. However, it also recalls the childhood memory of his father's sword, suggesting perhaps a return to the more directly autobiographical concerns of the playwriting days and paving the way for the Civil War epic *The Birth of a Nation*, a film that Griffith often commented owed more to his father than to himself.

David Garland

References

Barry, I (1940) *DW Griffith: American Film Master*, New York: The Museum of Modern Art.

Cook, DA (1981) *A History of Narrative Film*, New York: W.W. Norton & Company.

Eisenstein, S (1949) 'Dickens, Griffith, and the film today', in J Leyda (ed) *Film Form: Essays in Film Theory*, San Diego: Harcourt Brace Jovanovich, pp. 195–255.

Gish, L (1971) 'Fade-out', in HM Geduld (ed) *Focus on DW Griffith*, Englewood Cliffs, NJ: Prentice-Hall, pp. 151-154.

Griffith, DW (1971a) 'Commentary by DW Griffith', in HM Geduld (ed) *Focus on DW Griffith*, Englewood Cliffs, NJ: Prentice-Hall, pp. 31-68.

Griffith, DW (1971b) 'DW Griffith, Producer of the World's Biggest Picture: Interview with D.W. Griffith', in HM Geduld (ed) *Focus on DW Griffith*, Englewood Cliffs, NJ: Prentice-Hall, pp. 27–29.

Griffith, DW (1971c) 'My Early Life', in HM Geduld (ed) *Focus on DW Griffith*, Englewood Cliffs, NJ: Prentice-Hall, pp. 13–21.

Gunning, T (1994) *DW Griffith and the Origins of American Narrative Film*, Urbana: University of Illinois Press.

Leyda, J (1971) 'The Art and Death of DW Griffith', in HM Geduld (ed) *Focus on DW Griffith*, Englewood Cliffs, NJ: Prentice-Hall, pp. 161–67.

Merritt, R (1981) 'Rescued from a Perilous Nest: DW Griffith's Escape from Theatre into Film', *Cinema Journal*, 21: 1, pp. 2–28.

Rogin, M (1994) '"The Sword Became a Flashing Vision": DW Griffith's *The Birth of a Nation*', in R Lang (ed) *The Birth of a Nation: DW Griffith, Director*, New Brunswick, NJ: Rutgers University Press, pp. 250–93.

Simmon, S (1993) *The Films of DW Griffith*, Cambridge: Cambridge University Press.

Stokes, M (2007) *DW Griffith's The Birth of a Nation: A history of 'The Most Controversial Motion Picture of All Time'*, Oxford: Oxford University Press.

Vardac, AN (1971) 'Realism and Romance: DW Griffith', in HM Geduld (ed) *Focus on D.W. Griffith*, Englewood Cliffs, NJ: Prentice-Hall, pp. 70–79.

Steven Spielberg on set of *Indiana Jones and the Kingdom of the Crystal Skull*, 2008, Lucasfilm/Paramount Pictures.

DIRECTORS
STEVEN SPIELBERG

Steven Spielberg began making 8mm movies in his early teens. A key experience of his childhood, he said years later, was the amazement he felt at the visual impact of a model-train crash he had filmed in close-up. After three rejections by the University of Southern California film school, he briefly attended California State University and took an internship in the editing department of Universal Pictures, where he made *Amblin'*, a 26-minute romance that earned Spielberg a directing contract in the studio's television unit.

Spielberg first attracted critical attention with *Duel* (1971), a TV movie about a motorist (Dennis Weaver) who finds himself in a deadly contest when a truck driver tries repeatedly to run him off the road. His first theatrical feature was *The Sugarland Express* (1974), about a Texas couple (Goldie Hawn and William Atherton) on the run after a bungled crime. Although this movie fared better with critics than with moviegoers, it introduced themes that Spielberg would develop for years to come, including family insecurity, ambivalence toward authority, and the intertwining nature of private and public events.

Spielberg's next picture, *Jaws* (1975), ran into production problems that almost tripled its $3.5 million budget. It became a runaway hit, however, and remains one of the ten highest box-office earners (adjusted for inflation) in Hollywood history. *Jaws* consolidated two major innovations of modern film. One is the 'high concept' movie, which clusters audience-tested genre devices (such as action scenes or sight gags) around a simple story. The other is the summer blockbuster, released in a large number of theatres with such heavy marketing and so many merchandise tie-ins that the movie becomes a pop-culture event even if reviews are lukewarm.

Close Encounters of the Third Kind (1977), an optimistic science-fiction story about a man with premonitions of a UFO landing, was also a great financial success, but it was followed by the disappointing *1941* (1979), an expensive World War II comedy that barely earned a profit. Shaken by its poor reception, Spielberg joined his friend George Lucas to create *Raiders of the Lost Ark* (1981), starring Harrison Ford as archaeologist Indiana Jones who races with Nazis to locate a holy relic that bestows superhuman powers on its possessors. Inspired by motion-picture serials of the 1930s and 1940s, and directed by Spielberg in the same energetic spirit, it topped the box office in 1981, won five Academy Awards out of nine nominations, and led Spielberg to direct all three of its sequels: *Indiana Jones and the Temple of Doom* (1984), *Indiana Jones and the Last Crusade* (1989), and *Indiana Jones and the Kingdom of the Crystal Skull* (2008).

Spielberg had a banner year in 1982. First came *Poltergeist*, a contemporary ghost story nominally directed by Tobe Hooper with Spielberg as on-set supervisor. And a week later came *ET: The Extra-Terrestrial*, a gentle science-fiction fable about friendship between a 10-year-old boy (Henry Thomas) and a lovable space alien. *Poltergeist* became the year's eighth highest-grossing film and *ET* became the biggest earner of all time; today it ranks sixth on the list of domestic box-office champions, with an adjusted total of more than a billion dollars. In the mid-1980s, Spielberg broadened his scope by addressing more mature themes. *The Color Purple* (1985) is based on Alice Walker's eponymous novel about the difficult life of an African-American woman over the first decades of the twentieth century, and *Empire of the Sun* (1987) is an adaptation of JG Ballard's semi-autobiographical novel about a British schoolboy caught in China during World War II. The disappointing returns for *Empire of the Sun* and the romantic fantasy *Always* (1989) were reversed with the popular *Hook* (1991), the super-popular *Jurassic Park* (1993), and its high-grossing sequel, *The Lost World: Jurassic Park* (1997).

Spielberg's career took another important turn with *Schindler's List* (1993), based on the true story of a German war profiteer who rescued Polish Jews during the Holocaust by claiming that their work was essential to his military-goods factory. The film was widely hailed as Spielberg's most thoughtful achievement to date and, while its box-office earnings can only be called respectable, it brought Spielberg his first Oscars for best director and best picture. The following year he founded the studio DreamWorks SKG in partnership with producer Jeffrey Katzenberg and recording executive David Geffen.

Spielberg himself expressed dissatisfaction with the undramatic texture of his next historical film, *Amistad* (1997), about a slave mutiny in 1839. By contrast, *Saving Private Ryan* (1998) scored critically and commercially with its tale of bravery and sacrifice in World War II. Returning to science fiction, Spielberg drew mixed responses with the ambitious *Artificial Intelligence: AI* (2001), based on a project that the late Stanley Kubrick had passed along to him, but the fast-paced *Minority Report* (2002) proved highly popular the following year. Since then Spielberg's record has remained strong, if uneven at times. *Catch Me If You Can* (2002), about a real-life con artist played by Leonardo DiCaprio, did well with critics and audiences. *The Terminal* (2004), starring Tom Hanks as an immigrant stranded permanently in an airport, was less favourably received. Reviews were positive for the science-fiction adventure *War of the Worlds* (2005) and the fact-based *Munich* (2005), about Israeli operatives on a secret mission, but the former film did vastly better at the box office. Spielberg's most recent release is the third Indiana Jones sequel, which became one of his most profitable pictures despite middling reviews. *The Adventures of Tintin: The Secret of the Unicorn* and *Interstellar* are expected to open in 2011, and Spielberg continues to produce films for other directors and to participate in TV and video-game projects. His energy unabated, he remains one of the world's most prominent screen artists.

Critique

Few film-makers have divided critics more sharply than Steven Spielberg, and the arguing started with his first theatrical feature, *The Sugarland Express*, about a young Texas couple whose effort to reclaim their 2-year-old from foster care leads to a protracted flight from a convoy of police vehicles. The picture does not succeed, Roger Ebert wrote, 'because Spielberg has paid too much attention to all those police cars… and not enough to the personalities of his characters.' On the contrary, Pauline Kael declared, 'it has so much eagerness and flash and talent that it just about transforms its scrubby ingredients.'

The Sugarland Express fared poorly at the box office, but Spielberg struck gold with his next two films: Jaws and Close Encounters of the Third Kind. By 1982, when ET soared past George Lucas's Star Wars (1977) to become Hollywood's highest-grossing picture to date, critics had joined audiences in cheering him on. Yet uneasiness about Spielberg also crept into the picture and, in recent years, many observers have taken a sceptical stance toward his films, for reasons of politics as well as aesthetics. In a 2007 essay on 'Spielbergization', critic J Hoberman (2007) described the director as both 'ruthlessly sadistic and cloyingly saccharine', and detected support for George W Bush's preventive-detention policies in the tagline for the 2002 science-fiction film Minority Report: 'The guilty are arrested before the law is broken.' More broadly, journalist Peter Biskind charged in his 1998 book Easy Riders, Raging Bulls that Spielberg and Lucas had injected Hollywood with a 'nostalgia for authority' that 'finally succeeded in turning the counterculture upside down' (Biskind 1998: 363–64). To a great many moviegoers, of course, this is exactly what makes those directors great.

What supporters and detractors agree on is that Spielberg's movies matter more than the great majority of other films. This conclusion is hard to argue with, if only because of the clout he wields as the world's most commercially-successful film-maker. Spielberg has directed eight of the 100 highest-grossing Hollywood movies, from ET at number six to Saving Private Ryan at number 84, with combined domestic earnings of well over two billion dollars. While box-office figures say little about a film's artistic quality, these numbers testify to Spielberg's uncanny knack for appealing to popular tastes, and for anticipating popular tastes; if many of his movies are wish-fulfilment fantasies, they often fulfil wishes that the public becomes aware of only when the movies arrive. There is certainly a conservative streak in the implied politics of Spielberg's films, with their family values, tentative treatments of sexuality, and chronic shortage of strong female characters. Looked at from another angle, though, Spielberg is surprisingly progressive. By showing how a mayor and his business cronies put their selfish interests before the public's welfare, Jaws criticizes the establishment in ways the counterculture would applaud. Close Encounters of the Third Kind went farther than either Star Wars or Stanley Kubrick's 2001: A Space Odyssey (1968) in reversing the paranoid visions of 1950s' science fiction, depicting the reaches of outer space as a source of enchantment, inspiration, and hope. The opening battle in Saving Private Ryan is far more savage and unsparing than the average Hollywood combat scene. Artificial Intelligence: AI tells the story of an infinitely sad character – a little-boy android programmed to love humans who can never love him in return – in ways that are sometimes muddled and uncertain but always absorbing and provocative. As such films demonstrate, Spielberg has led pop-culture trends more often than he has followed them.

Spielberg's sensitivity to the winds of change is beside the point, of course, if he arouses moviegoers' hunger only to satisfy it with cinematic junk food, dishing up flashiness and sentimentality instead of thoughtfulness and depth. So who is right, the adversaries or the enthusiasts? A good litmus test is Schindler's List, the 1993 drama about a German industrialist (Liam Neeson) who saves more than a thousand Polish Jews from perishing in Nazi death camps. A well-known foe of this picture is French New Wave film-maker Jean-Luc Godard, whose 2001 film In Praise of Love deals partly with a fictional Hollywood company called Spielberg Associates and Incorporated, which wants to option the story of an elderly couple who fought in the anti-Nazi resistance. Godard uses this device to attack Spielberg and Schindler's List because, he believes, they transform crucial historical events into mere entertainment, all for the purpose of making money. Numerous critics and scholars have expressed similar opinions. Yet defenders of Schindler's List can point to reviews expressing unqualified admiration, and it triumphed at the Academy Awards, earning a dozen nominations and winning seven, including Spielberg's first Oscars for best picture and best director.

A more productive way to judge *Schindler's List* is to view it as a mixture of strengths and weaknesses that run through all of Spielberg's films, in which even flaws can contribute to a story's overall effectiveness. What motivates Schindler to become interested in captive Jews, for instance, is not idealism or altruism. He wants only to exploit their labour in his factory, and he turns into a rescuer out of shock at seeing so many lives eradicated for no reason. Beyond these basic facts, the movie tells us almost nothing about why Schindler undergoes such a drastic change, endangering his own life for the sake of others. Why has Spielberg left this unexplained? He has never been very good at developing well-rounded characters, so perhaps he was simply not up to the task of conveying Schindler's psychological progress. Yet it is equally possible that Spielberg knew exactly what he was doing. Nobody can fathom the depths of human personality, he seems to tell us, and all the movie can say without being presumptuous is that Schindler is an obsessive man and that, under new circumstances, his obsession changes from exploiting people to salvaging them. We do not need more details to be moved by this change of heart; that such a thing could happen is inspiring in itself.

The same sort of analysis can be applied to Spielberg's pure entertainment films, such as *Jurassic Park*, released in the same year as *Schindler's List* but vastly more popular, topped only by *ET* on Spielberg's lifetime earnings chart. The setting is an island where billionaire John Hammond (Richard Attenborough) has cloned a colony of prehistoric animals. He plans to use them as attractions in a one-of-a-kind theme park, but the idea is ruined when his computer controls break down and the genetically-engineered monsters go haywire. On one level, the movie itself is a theme park, full of surprising sights that thrill you for a few minutes and then fade from memory. On another level, though, Spielberg may be examining his own vocation as a creator of such spectacles. Hammond's park resembles a Spielberg movie in every detail, from its amazing creatures to its merchandizing tie-ins. But since everything goes wrong on Hammond's island, Spielberg might be suggesting that modernized societies, and the movies they make, are imperilling themselves by losing respect for nature and pouring so many resources into diversion and escapism. In the end, Spielberg probably does not mean to criticize his own career; what leads Hammond astray is not his ambition to create the ultimate spectacle but, rather, his attempt to create a *real* world of living creatures instead of an *illusory* world of Spielberg-style magic. By raising these questions, however, *Jurassic Park* shows that it is more than a simplistic rollercoaster ride.

Roughly speaking, most of Spielberg's films can be placed into the two categories sketched out here. Movies emphasizing spectacle and excitement are more numerous; some of them, such as *Saving Private Ryan*, try to carry messages, while others, such as *Raiders of the Lost Ark*, have nothing but entertainment on their minds. Movies with serious themes and agendas also frequently appear, although even the most earnest ones, such as *The Color Purple* and *Schindler's List*, protect the Spielberg brand by incorporating suspense and sentiment. And a few pictures fall into categories of their own: *Empire of the Sun*, the multifaceted *AI*, and the weirdly relentless *Munich* are among his more intriguing pictures, if not necessarily his best. Spielberg's future is likely to follow the same general patterns; his current projects range from bio-pics of Abraham Lincoln and Martin Luther King Jr to the science-fiction drama *Interstellar* and a fifth Indiana Jones adventure. It is hard to disagree, then, with critic AO Scott's assertion that Spielberg is 'a category unto himself, both an incarnation of Hollywood's large-scale, world-conquering ambitions and a rebuke to its cynicism and coarseness.'

David Sterritt

References

Biskind, P (1998) *Easy Riders, Raging Bulls: How the Sex-drugs-and-rock-'n'-roll Generation Saved Hollywood*, London: Bloomsbury.

Hoberman, J (2007) 'Laugh, Cry, Believe: Spielbergization and Its Discontents', *VQR*, 83. http://www.vqronline.org/articles/2007/winter/hoberman-spielbergization/. Accessed 24 November 2010.

WESTERNS

Of all the popular film genres, the Western reveals more than most about both America's history and its national cinema, especially Hollywood. Critics like Henry Nash Smith and Jim Kitses claim the Western deals with the shaping of American identity, from the time of European land appropriation of Native America to the closing of the frontier at the start of the twentieth century. It can come as no surprise, then, to find more Westerns than any other type of film, even though the genre has declined in popularity since the 1970s.

Westerns were among the very first narrative films, building conventions, character types and even the formal language of early film. But there were nineteenth century and earlier precedents for film Westerns like the otherwise formative *The Great Train Robbery* (1903). Picturing the Western landscape came from American painting; photography encouraged a documentary realism; dime novels produced recurrent plots and archetypes; theatre provided the dominant mode of melodrama; and Wild West Shows (like those of legendary Buffalo Bill, western scout and eastern actor), encouraged spectacle and showmanship. Combinations of these tendencies are evident in any Western, fuelling the imaginative framework of the genre's representation of a frontier history.

Westerns were also central to the growth of the American film industry, especially as it shifted from eastern cities to the western seaboard of California. Among the first to take regular advantage of the year-round sunshine and multiple locations in the area was pioneer film-maker, DW Griffith, whose short films like *The Battle of Elderbush Gulch* (1913) emphasized conflict between white settler and Native American, though the many Indian dramas of the time are more sympathetic to the 'Indian' cause. The first Western star was 'Broncho Billy' Anderson, whose cowboy hero – looking much like an ordinary working man – featured in over 300 Western shorts between 1910 and 1915. The 1920s were dominated by the series westerns of the more flamboyantly-dressed action hero, Tom Mix, rarely without his horse, Tony. Whilst Mix was a children's favourite, the melodramas of the other great western star of the 1920s, William S Hart, introduced a greater realism to Western settings and situations. Hart's 'Good Bad Man' characters also established a moral ambivalence in the western hero: a man of violence necessary to defend the developing civilization against savagery.

Westerns of the silent era formed the bedrock of the series westerns that continued to provide a staple of cheaply-made programme fillers for cinemas until the 1950s, when the careers of household names like actor/characters Hopalong Cassidy and Roy Rogers – one of many singing cowboys – moved into television. By the 1960s, Western series had become prime-time family favourites, notable among them *Gunsmoke* (1955–1975) and *Wagon Train* (1957–1965).

In contrast, much more spectacular were the first epic Westerns, more concerned with overtly celebrating 'the westward advance of civilisation': *The Covered Wagon* (1923) romanticizes the pioneer wagon train journeys whilst *The Iron Horse* (1924) does the same for the later building of the transcontinental railroad. The arising popular mix of melodramatic and epic possibilities of the genre attracted film-makers of distinction like John Ford and Howard Hawks, whose

careers include some of the most celebrated Westerns. Ford's *Stagecoach* (1939) brought psychological depth to Western characters and relationships, providing the first of many starring roles for a series Western actor, John Wayne.

The 1950s witnessed some of the greatest Westerns. *High Noon* (1952) and *Shane* (1953) were great box-office successes, their respective heroes of lawman and gunfighter bringing greater psychological complexity to the Western hero. Most critically regarded, however, are the cycles directed by Anthony Mann (such as *The Naked Spur* [1953], starring James Stewart) and Budd Boetticher (such as *Comanche Station* [1960], starring the genre icon, Randolph Scott). Their heroes are flawed, disturbed characters, bent on personal vengeance rather than social duty. The most extraordinary of these is undoubtedly Wayne's traumatized Civil War veteran whose pathological hatred of Indians inspires him to seek to kill his own niece, in *The Searchers* (1956), again directed by Ford.

As memories of World War II grew distant, Westerns began to question the romantic myth of Manifest Destiny (the right of white society to claim land settled by Native America), turning earlier Western moral polarities on their head. A cycle of films, notably beginning with the Indian sympathies of *Broken Arrow* (1950), by the 1960s become more cynical, undermining the reputations of historical westerners: the honourable cavalry commander of *They Died With Their Boots On* (1941), for instance, becomes the crazed George Armstrong Custer of *Little Big Man* (1970), perpetrator of massacres rather than great military victories of the earlier film.

A very different cycle treats the Western hero as a victim of the urban world. A more elegiac tone enters the mood of *Lonely Are the Brave* (1962), with Kirk Douglas' renegade cowboy hero escaping from pursuing lawmen but finishing under a truck ironically carrying toilet bowls. Even Sam Peckinpah's *The Wild Bunch* (1969), with its shockingly-graphic scenes of slow-motion and blood-spurting death, mourns the loss of its outlaws' freedoms to the modern world. John Wayne's final film, *The Shootist* (1976), finds his character choosing death in a gunfight with notorious badmen rather than from the cancer that will kill him anyway. But Wayne's earlier cowboy hero, in *The Man Who Shot Liberty Valance* (1962), is a tragic man out of his time: though a civilizing force in the stagecoach, by the time of the train, he dies penniless and virtually forgotten.

By the 1970s, as a result of commercial competition from the huge international popularity of Italian 'Spaghetti' Westerns, the American Western adopts a darker, more cynical mood. In a cycle of dystopian Westerns that herald the genre's final days of mass popularity, the romantic hero of the classical Western finds himself rendered powerless. At the same time, the imperialist assumptions of the epic Western are increasingly called into question. In *Ulzana's Raid* (1972), Burt Lancaster's cavalry scout can no more save the lives of settlers from a savage Indian raid than he can prevent a comparable savagery among his own troop or even, ultimately, the loss of their own lives. In such conditions, it is no surprise to find the avenging angel of Clint Eastwood's warrior gunfighters breaking all the genre's rules to survive, most memorably in *The Outlaw Josey Wales* (1976) and, finally, in *Unforgiven* (1992). Ultimately, the Western hero becomes an isolate in his villainy, and even in other genres, such as the futuristic *Westworld* (1973), where Yul Brynner's cowboy hero of *The Magnificent Seven* (1960) is a murderous robot.

The Western as a genre barely survives in the urban cultures of the twenty-first century. With the historical periods in which it was set now too distant for personal recall, and with its imaginary framework a legacy for modern genres, it is unlikely it will return to the popularity it once had. Though rare examples

continue to find critical reception, audiences prefer their frontier stories in the skies of science fiction rather than in the epic landscapes of the Western. Kevin Costner alone braves repeated returns, through the environmentalist *Dances With Wolves* (1990) to the more conventional romance of *Open Range* (2003). The vanity project suggested by the title of Brad Pitt's art-house *The Assassination of Jesse James by the Coward Robert Ford* (2007) is shared by Russell Crowe's 2007 remake of the suspenseful psychological Western, *3.10 to Yuma* (1957), with unlikely changes to its climax. Perhaps the most interesting Western of the recent period is *Seraphim Falls* (2006), with its exciting return to a conventional chase structure concluding in a mystical ending. But the masterwork belongs to television rather than cinema, the HBO series, *Deadwood* (2004–2006), with its extraordinary play of violent death and profane language dramatizing the building and corruption of a Western township. For which, as always with the Western, read America.

David Lusted

Brokeback Mountain

Studio/Distributor:
Paramount Pictures

Director:
Ang Lee

Producer:
James Schamus

Screenwriters:
Larry McMurtry
Diana Ossana
From a short story by Annie
Proulx

Cinematographer:
Rodrigo Prieto

Art Director:
Judy Becker

Editors:
Geraldine Peroni
Dylan Tichenor

Duration:
132 minutes

Cast:
Heath Ledger
Jake Gyllenhaal
Anne Hathaway
Michelle Williams
Randy Quaid

Year:
2005

Synopsis

Two unemployed labourers, rodeo rider Jack Twist and ranch hand Ennis del Mar, are employed by sheepman, Joe Aguire, to tend his flock high on Brokeback Mountain. Their isolation encourages a playful friendship until, drunk one night, Jake makes a hesitant sexual advance. After moments of uncertainty, Ennis responds passionately. Years after they part, Ennis' marriage to his teenage sweetheart, Alma, and Jack's to Lureen become increasingly tested by the repressed passion between the men. During one of their regular fishing trips Jack instigates for the pair, Ennis refuses his suggestion that they partner a ranch together. Alma's suspicion of her husband's relationship with Jack leads to divorce after she witnesses them in a passionate embrace. Jack's marriage continues but with the suggestion of a relationship with another man. When Ennis learns of Jack's death – possibly from a homophobic attack – he seeks to carry out his final wishes and return his ashes to Brokeback Mountain. Jack's father refuses but his mother grants him the return of Ennis' blooded shirt, kept by Jack as a memento of their love. In a coda, Ennis' estranged adult daughter invites him to her wedding. He places the sweater she leaves behind with Jack's shirt.

Critique

By the turn of the millennium, the production of Hollywood Westerns had all but ceased, with surprisingly few attempts to ride the commercial and critical success of Clint Eastwood's *Unforgiven* (1992). In contrast, dramas with at least Western themes, if only arguably genre films at all, featured on the edge of Hollywood, in the so-called American Independent Cinema. Arthouse film-makers like Jim Jarmusch explored Native America in the postmodern Western, *Dead Man* (1995) and Maggie Greenwald's feminist approach to the genre, *The Ballad of Little Jo* (1993), one of the few Westerns authored by a woman, views the West as a positive space for women where they could break away from urban family constrictions to find independence. Though *Brokeback Mountain* was a crossover film – finding a popular audience by word of mouth, thereby turning a healthy profit in the commercial sector – it is best considered in this context, as an art film reflexively exploring the Western's all-male partnership.

Westerns have conventionally privileged the society of the all-male group, in which the hero's relationship with a sidekick pal coexists with that of the heroine. That the male partnership is implicitly understood as homosocial has been emphasized not just by the hero's undoubtedly heterosexual romance with the heroine, but also by the ritual age differences between the male pairs, commonly rendering them as father/son relationships: in series Westerns, a younger Hopalong Cassidy is partnered by a grizzled Gabby Hayes; among the classics, Walter Brennan's reprises his toothless supportive role in *The Far Country* (1954) in at least *Rio Bravo* (1959). Where age differences are less marked,

though, homo-erotic relationships become possible. In some Westerns, they are explicit: for instance in the boudoir setting of that between Henry Fonda and Anthony Quinn in *Warlock* (1959). What is original about *Brokeback Mountain* is that it dares to explore the repressed desires in male partnerships that the Western otherwise relentlessly (one critic says 'tirelessly') suppresses.

The homosexual romance between Ennis and Jack is itself subject to repressions – their own, their wives', families' and those of the culture around them. The film is set in the mid-West between 1963 and 1981, on the edge of the gay civil rights movement, practices of 'coming out' and, more recently, efforts to authorize homosexual relationships in civil marriages. It explores the damage to individual psyches of an active homophobia, not only around the central relationship but also within it. Ennis and Jack discover they can only be together when alone. At all other times they compromise, their only moments of intimacy, however, displaced into play fights or embraces which, cruelly, will be witnessed by the likes of the suspecting Alma and homophobic Aguire. They punish themselves relentlessly for sharing the 'love that dare not speak its name', such that the homophobia of others is but a symptom of their own fears.

The culture, too, is keen to punish itself for its intolerance. Jack's father prefers to despise his own son rather than acknowledge the nature of his male friendships; Alma would rather deny her love for a good man than come to terms with his sexuality. The film itself also struggles with an ambiguity that could be interpreted as repression – refusing to take a stand on whether the identity of the love between Ennis and Jack is indeed homosexual: the fact of their marriages and children suggests they are at least bisexual. Though Art Cinema characteristically refuses to pin down meaning, the ending seems explicit about the traumatic experience that is being 'in the closet'. Though popular beyond expectation, garnering awards and critical plaudits, *Brokeback Mountain* has unsurprisingly therefore been the subject of controversy – from critic, gay and homophobe alike – on the very complex issue of the cultural politics of sexual identity. A brave and emotionally-moving film, this is the Romeo and Juliet story of the modern age.

David Lusted

Dances With Wolves

Studio/Distributor:
Orion Pictures Corporation
MGM

Director:
Kevin Costner

Synopsis

Adapted from Michael Blake's novel of the same name, Costner plays Lt John J Dunbar, a Union soldier during the US Civil War who, rewarded for his bravery in a major victory, gets his pick of assignments. He chooses to be stationed at a remote outpost in the Dakota Territory, where he eventually encounters a local Sioux tribe of American Indians with whom he forms a delicate bond. Over several months, Dunbar and the tribe meet regularly and introduce customs to each other, and Dunbar falls in love with a white woman who has been raised by the Sioux as one of their

Producers:

Kevin Costner
Jim Wilson
Bonnie Arnold
Jake Eberts

Screenwriter:

Michael Blake

Cinematographer:

Dean Semler

Art Director:

William Ladd Skinner

Editors:

William Hoy
Chip Masamitsu
Stephen Potter
Neil Travis

Duration:

181 minutes (theatrical)
224 minutes (director's cut)

Cast:

Kevin Costner
Mary McDonnell
Graham Greene
Wes Studi

Year:

1990

own. As the military advances west onto the plains, Dunbar must make a decision about where his loyalties lie.

Critique

Michael Blake's story originated as a 'spec screenplay' in the early 1980s, but Costner suggested turning it into a novel to increase its chances of being produced as a film; the plan worked, and Costner immediately secured the film rights. Filmed authentically in the plains of South Dakota, *Dances With Wolves* adequately (and often beautifully) conveys numerous weighty ideas about the disappearance of America's historical frontier, the exploration of cultural difference, the substantiation of an indigenous society and, most notably, the complicated nature of humanity itself. Dunbar's early associations with the Lakota Sioux are played for humour, but as the plot gets complicated with the introduction of an enemy tribe and Union Soldiers on the move, a more serious tone takes over. Dunbar's developing friendship with Sioux medicine man Kicking Bird (Graham Greene) and warrior Wind in his Hair (Rodney A Grant) also help relate the intricacies and uncertainties of human behaviour that exist in all peoples. There are echoes of *The Searchers* (1956) when Dunbar first encounters Stands with Fist, a white woman raised by the tribe, and Costner's film makes another significant step forward in establishing a more nuanced cinematic portrayal of American Indians and their customs and culture. John Barry's highly memorable score soars with meaning and purpose, evoking a lost frontier and the multiple emotions

Dances With Wolves, 1990, Orion.

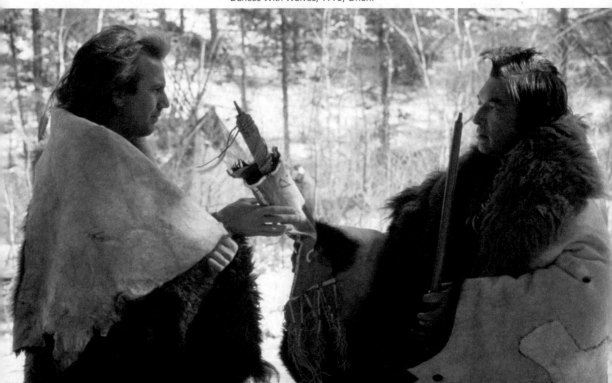

of a man and a movement West that forever changed the American landscape. Costner reportedly contributed $3 million of his own money in addition to the film's original $15 million budget due to budget overruns (though he saw high financial returns when the film grossed $184 million in US theatres and over $200 million internationally).

The film won the Academy Award for Best Picture (beating Francis Ford Coppola's *The Godfather, Part III* and Martin Scorsese's *Goodfellas*, which was largely favoured to win), and was the first Western to win that award since 1931's *Cimarron*, though some have argued that Costner's film should not necessarily be categorized as a Western. Costner's commitment to the history and preservation of American Indian populations was cemented when he produced and narrated *500 Nations* (1995), an expansive six-hour documentary made for television; he also continued to show an interest in the Western genre, starring in *Wyatt Earp* (1994) and *Open Range* (2003), and developing projects such as *Horizon* (announced in 2004, as yet unfilmed). Blake turned his 2001 follow-up novel *The Holy Road* into a screenplay in 2007; Australian Simon Wincer was attached to direct (though Costner apparently has no interest in returning to the role). Though critical reputation seems to have diminished somewhat over the years, *Dances With Wolves* remains an inspiring and relatable epic for many audiences. James Cameron's technologically-groundbreaking *Avatar* (2009) was partially criticized for its obvious allusions to Costner's film in plot and theme (a fact which Cameron openly admitted to the media), although the basic elements of *Wolves* have been utilized throughout the history of narrative storytelling.

Michael S Duffy

Little Big Man

Studio/Distributor:
Cinema Centre Films for
National General Pictures

Director:
Arthur Penn

Producer:
Stuart Miller

Screenwriter:
Calder Willingham
Based on the novel by Thomas
Berger

Synopsis

In a framing interview, Jack Crabb, claiming to be 121 years old, relates his many experiences of life on the frontier. In flashback, he narrates how he, a white child survivor of a Pawnee attack on a wagon train, was raised among the Cheyenne by Old Lodge Skins; returned by a cavalry troop to white society and the advances of a vicar's wife, Louise Pendrake; attached to the barker of a travelling show; a gunfighter under the tutelage of Wild Bill Hickock; a tradesman; a muleskinner with the Seventh Cavalry; back again with the Cheyenne, a husband to Sunshine and helpless witness to her brutal death in a cavalry massacre of their Indian village; in despairing reaction, a town drunk; a trapper; rescued from Custer's defeat at the Little Big Horn; and concluding with accompanying Old Lodge Skins in his attempt to voluntarily meet his maker.

Cinematographer:

Harry Stradling Junior

Editor:

Dede Allen

Duration:

139 minutes

Cast:

Dustin Hoffman
Faye Dunaway
Chief Dan George
Richard Mulligan

Year:

1970

Critique

Under the direction of once noted but now neglected film-maker, Arthur Penn (*Left-Handed Gun* [1958], *Miracle Worker* [1962], *Bonnie and Clyde* [1967], *Missouri Breaks* [1976]), Jack Crabb's preposterous biography is turned into a picaresque journey through the myths of both the Western genre and American history. *Little Big Man* was among the first of a 1970s' cycle of Westerns responding to American revisionist histories of European colonization of the Americas, critiquing celebrations in earlier Western films of the pioneer spirit and Eastern expansion.

The main effect is to reverse the moral polarities between the various stages of European migration and the Native Americans encountered, extending to a pastoral reconstruction of Native culture, tolerant of social- and sexual difference (to the extent of warmly integrating homosexuality) and pacifist (Indians attack with buffalo bladders on sticks and take up arms only when shocked at the unsportsmanlike behaviour of cavalrymen whose response is to shoot them). The Cheyenne are – in Old Lodge Skin's memorable term – 'human beings', more limited in number and thus unable to survive the advance of the ubiquitous whites. Crabb, therefore, plays out the many frontier roles available to the limitless whites, whilst Native American characters maintain singular and consistent identities.

The strategy affords opportunities to undermine familiar frontier myths of white heroism and Indian savagery. There are visceral reconstructions of cavalry attacks on Indian villages, like the infamous Washita massacre of 1868 in which a village of old men, women and children were slaughtered and their bodies mutilated by soldiers of the Seventh Cavalry. Such frontier atrocities extend also to a critique of American foreign policy during the more contemporary Vietnam War, in which villages were destroyed – 'in order to save them' for democracy, as one militarist of the time put it – and war crimes by military units, as in the infamous massacre by American soldiers of an entire Vietnamese village, My Lai. Although historically inaccurate (a clearly-insane Custer, ordering massacred troops to 'Take no prisoners!'), the final stages of the battle at the Little Big Horn represents the horror of both frontier and modern conflicts, and reconfigures myths of the West in Westerns thereafter.

Little Big Man is notably among the first A features with Native Americans in prominent Indian roles. Chief Dan George (actually Chief Nawanath of British Columbia's Burrard tribe) who plays the wiseacre Old Lodge Skins, is a hugely-attractive performer, off to the mountains prepared to meet his maker but rising from his deathbed when rain prompts him to reconsider his God's wishes. Hollywood's most recent incarnation of the Native American as a New Age mystic (*Dances With Wolves* [1990], *Last of the* Mohicans [1992]), is an image

stretching back to the counter-culture Indians of *Little Big Man* and, after a gap of half a century in which a reflex white racist assumption of Indian savagery prevailed, to the idealized 'Vanishing American' of the nineteenth century.

David Lusted

Open Range

Studio/Distributor:
Touchstone Pictures
Buena Vista Pictures

Director:
Kevin Costner

Producers:
David Valdes
Kevin Costner
Jake Eberts
Armyan Bernstein
Craig Storper

Screenwriter:
Craig Storper

Cinematographer:
James Muro

Art Director:
Gary Myers

Editors:
Michael J Duthie
Miklos Wright

Duration:
139 minutes

Cast:
Robert Duvall
Kevin Costner
Annette Bening
Michael Gambon
Michael Jeter

Year:
2003

Synopsis

Boss Spearman, Charley Waite, Mose Harrison, and Button are cattle free-grazers living on the land during the late 1800s. Boss and Charley both have pasts marked by tragedy and violence, and they attempt to teach the younger Mose and Button the tenets of honour, loyalty, and compassion. When they are drawn into a conflict in a nearby town because of an injury to one of their own, they are forced to defend their values and honour against a corrupt Sheriff, a greedy cattle baron, and a group of assassins who have all secured an influence in the town. While attempting to tend to their friend, Boss and Charley also meet Sue Barlow, who gives them brief respite from their troubles, and with whom Charley falls in love.

Critique

Open Range is a patient, thoughtful drama that takes its time spelling out its still-relevant characterizations and themes. Costner's return to the Western genre is a solid and often suspenseful dramatic foray into the dynamics of old-fashioned morals and comeuppance. The film is also about the integrity of a man and his values, common themes of the Western historically, but emphasized in a surprisingly emotional way through the relationship of Charley (Costner) and Sue (Bening). Costner bravely approaches some of the same material (corrupt cattle barons and hired assassins) which made up much of the central focus of Michael Cimino's *Heaven's Gate* (1980), an enormous failure critically and commercially, and the film that not only heavily contributed to the demise of United Artists, but forever changed how Hollywood approached and funded motion pictures (Costner's choice of material is equally brave considering his earlier directorial effort *Dances With Wolves* was dubbed '*Kevin's Gate*' during production by studio insiders who thought it was veering out of control, and would never turn a profit). An old-fashioned authenticity can be read on the actor's faces, particularly actress Annette Bening's character, Sue, who both physically and emotionally represents a chance at a new life for Costner's character. Costner, Duvall, and particularly Bening have no problem uncovering the wrinkles on their faces and in their hearts. Costner makes a point of always separating

the town-folk from Boss and Charley in both cinematic and thematic ways, in their dress, dialogue, and approach to living, and reiterates that cowboys should be remembered differently from other characters from the Old West; during a DVD audio commentary for the film, Costner states that 'cowboys facilitated things in the West, and that was a dirty, hard job'. The film is equally a testament to Duvall's now-iconic status in film history; as Charley's two younger companions admire Boss recapturing some cattle, one of them comments to Charley: 'The old boss sure can "cowboy", can't he?' Charley replies: 'Yeah, [they] broke the mould after him' (a moment which could equally serve as a testament to Duvall himself). Michael Kamen's score evokes both a time passed, and equally, a hope for a promising future. At its beginning and as the film nears its conclusion, Costner emphasizes the powerful nature of sound itself, first through thunder, and much later through extremely loud gunshots (whose increased volume on film in fact matches a more realistic feeling of the audio impact of gunshots in real life). Costner's slow build-up to the film's final shootout is so emotionally measured and nuanced that, when the shots do start to fire, they repeatedly take the viewer by surprise. *Open Range* is an uncynical, emotionally and technically accomplished work that deserves higher consideration.

Michael S Duffy

The Searchers

Studio/Distributor:
Warner Bros

Director:
John Ford

Producers:
Merian C Cooper
Patrick Ford

Screenwriter:
Frank S Nugent

Cinematographer:
Winton C Hoch

Editor:
Jack Murray

Composer:
Max Steiner

Synopsis

Ethan Edwards comes home from the Civil War to his brother and his brother's family. Ethan is uneasy in the house and his past is shadowy. While he is out pursuing a cattle theft the house is set upon by a group of Comanches, lead by their chief, Scar. Two daughters from the family are taken and the rest are killed. The small rescue party sets out but then dwindles to just Ethan and Martin Pawley (an orphan who was raised by the Edwards) when one of the girls is found dead, leaving only the youngest, Debbie, alive and missing. As their pursuit of Debbie goes on for years, they consider the possibility that, having spent so much time in the company of Comanches, she may no longer be 'white' when they find her. Because of Ethan's hatred for the Comanche and his disdain for Martin's one-eighth Cherokee blood, it becomes clear that it is not enough for Ethan to just rescue Debbie.

Critique

The camera stares out through the front door of a home into a vast arid landscape and is slowly drawn out into the iridescent scenery. This shot continues the Hollywood tradition of using

The Searchers, 1956, Warner Bros.

Duration:

119 minutes

Cast:

John Wayne
Jeffrey Hunter
Vera Miles
Ward Bond
Natalie Wood

Year:

1956

the doorway as the portal from safety into a brutal world and establishes the central metaphor of the film. It entrenches the home as a safe, familiar location and the outside world of the West as one involving the savage struggle for survival, and the film's protagonist as a man of the outside world. The film sheds more light on the myth of the John Wayne persona and opens up the possibility for a reappraisal of that period of American history and the image of the Western. There have been long-running debates about the relative subversiveness of *The Searchers* on the topic of race, the social significance at the time and traditions of the Western.

The film is set in Texas in 1868, shortly after the civil war when being American, being a family and being white were very unstable concepts. The home acts as the bastion of civilization and safety but, outside these, ideas are uncertain. Ethan comes in to the home with a suspicious past and immediately creates tension in the family. The film is perhaps best known for its ambiguous treatment of both the outside world

and John Wayne's antihero, Ethan. The cinematography, beautiful in its scope, becomes dangerous and cruel when the characters are placed into it. The Commanches appear as part of the land, unknowable and mysterious. Ethan's motivation to kill Debbie is to protect white society and the sanctity of the home from the outside wilderness. Ethan's passionate hatred for Scar culminates in the white man scalping Scar, proving him as a white, yet corrupted. The film closes with the reverse shot of the opening, the camera and the characters draw back into the house and Ethan turns away from the house as the door shuts.

This film is rich in terms of visuals, performances and presents a new image of the west as an inhospitable, lonely landscape. Previously the Western has typically suggested white settlers represent goodness and natives represent a savage, cruel world yet Ethan undermines this dichotomy, being both white and savage. This shift opens up timeless questions on the nature of evil, though the intrinsic goodness of the home is never questioned. These same ideas are explored much further in Martin Scorsese's *Taxi Driver* (1976), which was inspired by *The Searchers*. There are so many ways to examine this film, though in such a small space it seems wrong to critique it as anything less than narrative art.

Michael Honig

Stagecoach

Studio/Distributor:
United Artists

Director:
John Ford

Producer:
Walter Wanger

Screenwriter:
Dudley Nichols
From a short story by Ernest Haycox

Cinematographer:
Bert Glennon

Art Director:
Alexander Toluboff

Editors:
Otho Lovering
Dorothy Spencer

Synopsis

The dangerous stagecoach journey across Indian territory from Tonto to Lordsburg tests relationships among its passengers and crew. A cavalry officer's pregnant wife, Lucy Mallory, aligned with a Southern gambler, Hatfield, affects social distance from two outcasts from Tonto, alcoholic Doc Boone, who attaches himself to the samples of whisky drummer, Peacock, and the prostitute Dallas, who attracts the attentions of the fugitive known as the Ringo Kid, himself in the custody of Marshall Curly Wilcox, riding shotgun. A thieving banker, Gatewood, and the driver, Buck, complete the group. Losing their cavalry escort at the first stage, Dry Fork, they decide nonetheless to proceed to Apache Wells, where the group set their differences aside for the first time, as Doc and Dallas assist Lucy in her baby's birth. Ringo proposes to an embarrassed Dallas before the smoke signals that alert the group to marauding Indians make him stay his decision to escape. At Lee's Ferry, they find this third stage destroyed in an Indian attack and the people killed. They ford the river and cross the salt flats, when Indians give chase. Before rescue by a cavalry troop, some passengers will be injured and others killed in the ensuing battle. In Lordsburg, the future of Ringo and Dallas will depend on the outcome of a confrontation with the

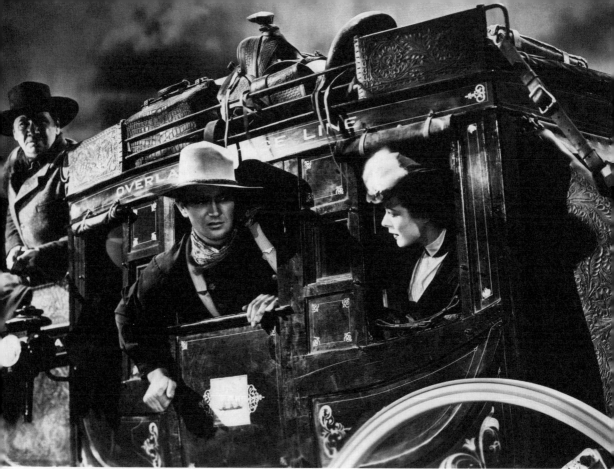

Stagecoach, 1939, United Artists.

Duration:

96 minutes

Cast:

Claire Trevor
John Wayne
Thomas Mitchell
John Carradine
Louise Platt

Year:

1939

Plummer Brothers in a street gunfight and the decisions of those who can choose justice over law.

Critique

Stagecoach is a landmark Western. Its box-office and critical success raised the prestige of the genre at the end of the 1930s after a decade of cheap series Westerns following the failure of the silent Western epic, *The Big Trail* (1930). It was also John Ford's first sound Western made in Monument Valley, the signature setting of magnificent sandstone buttes to his many later genre-defining Westerns. French critic, Andre Bazin, claimed *Stagecoach* an 'ideal balance between social myth, historical reconstruction, psychological truth and the traditional … Western *mise-en-scène*', taking the genre to a 'definitive stage of perfection' (Bazin 1972: 151).

The stagecoach journey, with its initially-divided group of travellers developing more self-knowing relationships, is an allegorical tale of American identity, with its hero, Ringo, at the centre. He joins the group last, by which time the travellers have formed 'divisions between polite society and the social

outcasts' (Buscombe 1992: 36). His agency then settles con-
flicts within the carefully delineated group. The driver is a comic
figure, the cowardly fool, Buck, paired atop the stagecoach
by honest agent of the law, Curly. Among the passengers are
other meaningful pairs: first, the Southern aristocracy of snob-
bish Lucy and the more sinister Hatfield; at the other end of the
social scale, Dallas and Doc, 'the dregs', jointly hounded from
the settled town by the 'foul disease called social prejudice'.
Doc is contrasted with the meek Peacock, whose whisky
samples fuel his weakness. Finally, there are the two latecom-
ers: Gatewood, the high class robber of his own bank and the
criminal negative of the fugitive Ringo, whose sudden romantic
eruption onto the screen (for Edward Buscombe, 'one of the
most stunning entrances in all of cinema') heralds the future
iconic star of the genre, John Wayne.

Under pressure from the threat of Apache ambush, the
pairs at first grow more intimate, with only Gatewood keeping
his own company. At Dry Fork, Ringo's courtly manners lead
him to offer Dallas a seat at table, before mistaking the depar-
ture of the Southern pair for 'a table closer to the window':
'Looks like I got the plague, don't it?' His naivety will make
him unaware of Dallas' profession. Even at the end of the
journey, he insists on the propriety of courtship, accompany-
ing Dallas to her door, despite her anxious protestations. The
brothel town in Lordsburg is a sultry but seedy ghetto that
she fears will destroy Ringo's admiration, yet it serves only to
reinforce his commitment. Free of bourgeois prejudice, he
sees only the sensitive soul she has proved to be.

Ringo's rejection of opportunities to escape aligns him
with Dallas and Doc (who recovers his professional reputa-
tion during the birth of Lucy's baby). These three social
outcasts form the moral centre of the film. After rescue from a
magnificently-staged Apache attack on the salt flats, there is
an appropriate allocation of reward and punishment. Lucy will
be reunited with her husband, a passing exchange of glances
with Dallas affirming their new sisterhood; Ringo's expected
arrest will, more satisfyingly, result in a handcuffed Gatewood.
Cleared of the respectable folk, Ringo's quest for revenge is
resolved in a suspenseful gunfight in which the outcome is
delayed to audience and other characters alike. The problem
of its illegality will be resolved in the bending of the law to
allow the companionate pair to combine, saved – as Doc
concludes – 'from the blessings of civilization', to ride into an
idealized American future.

David Lusted

References

Bazin, A (1971) 'The Evolution of the Western', in B Nichols (ed),
 Movies and Methods: An Anthology, Volume 1, Berkeley, CA:
 University of California Press, pp. 150–57.
Buscombe, E (1992), *Stagecoach*, London: BFI Publishing.

Ulzana's Raid

Studio/Distributor:
Universal Picture

Director:
Robert Aldrich

Producer:
Carter De Haven

Screenwriter:
Alan Sharp

Cinematographer:
Joseph Biroc

Art Director:
James D Vance

Editor:
Michael Luciano

Duration:
96–107 minutes (subject to print versions)

Cast:
Burt Lancaster
Bruce Davison
Jorge Luke
Richard Jaeckel
Joaquin Martinez

Year:
1972

Synopsis

A cavalry troop is dispatched to track down an Apache band, led by Ulzana, in flight from a reservation agency in Arizona. Its inexperienced leader, Lieutenant DeBuin, is eager to close the gap on them to protect surrounding families of settlers in the Indians' path, though cautioned by the seasoned scout, MacIntosh, that 'the only thing that will slow them down is how much killing they do'. DeBuin's initial Christian sympathies are tested by the trail of savagery met during the chase, perpetrated not only by the Indians but also by the white men in his veteran troop. Reliant on the tracking skills and cultural knowledge of the Indian scout Ke-Ni-Tay, DeBuin's judgement becomes clouded by a latent racism. Just as Ulzana appears to outwit the troop, McIntosh realizes a dangerous plan to finally confront him. In a destructive climax, the conflicting values of the four central protagonists come – at a cost – to a kind of accommodation, in which DeBuin learns that there is charity regardless of faith.

Critique

There were no films set in the Vietnam conflict until America's war there at the turn of the 1970s was over, but a series of Westerns of the time were the most engaged in its sights, sounds and meanings. The most incisive, *Ulzana's Raid*, is a bitter and tragic cavalry Western, displacing the global struggle between East and West into a minor national skirmish between white and Native America. Its shocking scenes of the aftermath of Apache torture, rape and killing implies no racist assumption of a savage 'Indian' nature but a political analysis of the colonial relationship between an ascendant white majority and a confined Native America. Yet the film also explores the contradictory disposition of power in conditions of war. 'In this land, man must have power' explains Ke-Ni-Tay to the confused Debuin. Ulzana intends his raid to regain the power lost in dispossession of land and freedom, albeit briefly and at whatever human cost, including to his own and his own child's. The troop is rendered powerless to defend settlers and, ultimately, even itself by army regulations – and their strict interpretation – and the logic of their task in a merciless terrain. And, conditions of war encourage all – leaders and men – to behave badly.

The film also represents a loss of power in another sense – of the Western as a popular, commercial genre. By the 1970s, the decline in international popularity of Italian 'Spaghetti' Westerns of the 1960s had left a legacy of cynicism and an 'opera of violence' in a final cycle of dystopian American Westerns. Ageing stars of the post-war Western made valedictory statements, like Burt Lancaster in this film and in *Valdez is Coming* (1971), Kirk Douglas, in *Posse* (1975) and

John Wayne, in *The Shootist* (1976). The genre itself drew on increasingly graphic images of shock and menace from the gothic horror film and, by the 1980s, had ceded its historic concerns about the frontier and national identity to the science fiction film.

As a Western, *Ulzana's Raid* plays productively with the genre's conventions. In indicative summary order: when a settler's wife pleads for rescue, we expect the returning galloper to oblige, not shoot her in the forehead. And when he, in turn, is then shot from his horse, nothing prepares us for his dreadful self-sacrifice. And what, then, of the threat to a surviving child, a threat that never materializes? How to explain these transgressions from reason and the noble cause? 'Apaches have whims', McIntosh pretends to explain. But the audience will learn with DeBuin that explanations lie in prior experience and local knowledge, rather than religious faith and blind racism. 'First one to make a mistake gets to burying some people', warns McIntosh. But, in conditions of war, death is arbitrary. The narrative constant of shock and awe that characterizes this great film expresses an indictment of imperialist adventures and yet a touching sympathy for the 'poor bloody infantry' that are its agents.

Prints of the film differ in takes, sequence and length: the film was released in two versions, further subject to censorship cuts and television trimmings in overseas territories and, when released on video and DVD, excised horse stunts make for abrupt leaps in action. In any version, though, the film retains its visceral power and critical meaning.

David Lusted

Unforgiven

Studio/Distributor:
Warner Bros
Malpaso Productions

Director:
Clint Eastwood

Producer:
Clint Eastwood
Julian Ludwig
David Valdes

Screenwriter:
David Webb Peoples

Cinematographer:
Jack N Green

Synopsis

William Munny lives a quiet life raising two children in Wyoming in the late 1800s; he gave up violence and drinking after marrying his wife, who died of smallpox a few years earlier. Though he attempts a peaceful existence running a hog farm, his talents clearly lie elsewhere. In the nearby town of Big Whiskey, Sheriff 'Little Bill' Daggett runs a tight ship, but an isolated crime involving a scarred prostitute and two male offenders (and the light punishment given to the perpetrators by the Sheriff) prompts the women of the local whorehouse to offer a reward for the deaths of the two men. Munny is approached by a young upstart called the 'Schofield Kid' to partner him on finding and killing the men and though Munny is hesitant, he eventually decides to pursue the reward with the assistance of his old friend Ned. The group's arrival in Big Whiskey throws them into conflict with the Sheriff, who attempts to debunk any attempt at vigilante justice.

Art Directors:

Adrian Gorton

Rick Roberts

Editor:

Joel Cox

Duration:

131 minutes

Cast:

Clint Eastwood

Gene Hackman

Morgan Freeman

Richard Harris

Saul Rubinek

Year:

1992

Critique

The iconic Clint Eastwood dusts off a decades-old script and makes it his own in this deeply mournful character drama, which interrogates both classic and revisionist elements of the Western. Eastwood directs the film and stars as tortured soul William Munny in what is likely his final cinematic statement on the genre. There are obvious and obscure references to multiple cinematic Westerns, iconic characters, and dialogue. Every performance is strong, and every piece of dialogue has a meaning beyond its words (the script by David Webb Peoples was declined by Eastwood years earlier, apparently because his reader did not have a high opinion of it). There are no superfluous moments: each shot is tightly composed and edited, and every moment endures. Never has Eastwood been more grizzled, gritty, or hauntingly pensive; in the film, Eastwood's Munny is alone on his mission, even though his old friend accompanies him and others in the town support him. He refuses an offer of sanctuary with a local woman of ill repute because he wants to remain loyal to his wife, who passed away years ago. Gene Hackman's Sheriff 'Little Bill' is entirely understandable in his actions despite being posi-tioned as Eastwood's antagonist; Little Bill's debunking of the myths surrounding Richard Harris's 'English Bob' mirror Eastwood's own debunking of Western myths throughout the film, and Little Bill's modest attempts to build his own house give real character to what was usually a one-dimensional role in classic Westerns. Eastwood responds to another character's easy condemnation with 'We all got it coming, kid'; it remains the film's the most defining and well-known line.

To emphasize this bookend to his own cinematic legacy, Eastwood had his character wear the same pair of boots that he wore in his early Western television debut, *Rawhide* (1959–1965). The sparse musical accompaniment by Lennie Niehaus underscores the elegiac nature of the film and screenplay (Eastwood wrote the main theme of the score himself). Eastwood's climactic moment, leaving the town of Big Whiskey for the last time in a pouring rainstorm, with the American flag at his back, dictates his last statement on the only film genre that is considered uniquely American. The final credits read 'Dedicated to Sergio and Don', referencing 'Spaghetti' Western director Sergio Leone and underrated American director Don Siegel, two of Eastwood's important cinematic mentors.

Michael S Duffy

The Wild Bunch

Studio/Distributor:
Warner Bros

Director:
Sam Peckinpah

Producer:
Phil Feldman

Screenwriters:
Sam Peckinpah
Walton Green

Cinematographer:
Lucien Ballard

Art Director:
Edward Carrere

Editor:
Lou Lombardo

Duration:
145 minutes

Cast:
William Holden
Robert Ryan
Ernest Borgnine
Warren Oates
Ben Johnson
Edmond O'Brien
Jaime Sanchez
Emilio Fernandez

Year:
1969

Synopsis

Disguised in army outfits, Pike Bishop's 'wild bunch' of outlaws is ambushed by rooftop bounty hunters during a robbery in the town of Starbucks, Texas, in 1913. A parade of local citizens, fresh from a Temperance Union meeting, are caught up in the carnage of the ensuing gun battle. The surviving five members of the gang, discovering their haul is no more than bags of washers, head for Mexico, holding up in the village of their youngest member, Angel. Learning from the village elder of the greed of a local general of the Mexican army, Mapache, Pike plans one last robbery before retirement: to steal arms from an American army train for Mapache's troops in return for gold. The robbery is successful, foiling the posse of returning bounty hunters, led by Deke Thornton, who was once Pike's partner until captured and imprisoned. Pike carefully plots the piecemeal exchange of arms for gold until, on a final visit, Angel finds his wife from the village in the arms of Mapache, and shoots her dead. The gang return to the camp, offering to trade for the now captive Angel, but a drunk Mapache only slits Angel's throat. In angry response, Pike shoots Mapache and the gang then await the expected reprisal. When nothing happens, and although they could simply walk away, Pike kills again, setting off a final bloodbath.

Critique

Among Sam Peckinpah's distinguished westerns, *The Wild Bunch* is a key transitional Western in that the genre's returns to its American homeland, following the international success of a cycle of Italian westerns in the 1960s. The film advances epic qualities and the elegiac tone of earlier forms of the classic Hollywood romance Western but also incorporates the bitter cynicism and scale of operatic violence characteristic of the 'Spaghetti' Western.

The Wild Bunch opens with an extraordinary scene of children cruelly laughing at scorpions tormented by an army of red ants among the flames of a brazier. The scene prefigures the carnage in the following ambush and the final bloodbath, the effect of violent chaos produced by Peckinpah's distinctive style of multi-camera montage editing, as blood spurts from twisting bodies falling in slow motion and distorted sound. After this, the Western will turn to gothic levels of graphic savagery (see *Will Penny* [1968], *True Grit* [1969], and *Ulzana's Raid* [1972]).

Peckinpah's dystopian vision of America in his earlier cavalry film, *Major Dundee* (1965), here turns into tragedy in the more local story of a group of ageing thieves who represent the passing of the Western's characteristically violent masculinity. The opening scenes establish a modern America, years after the closing of the frontier, now obsessed with financial gain. The bunch can only acquire money through theft; the feral bounty hunters,

only through killing for the price on wanted heads. The fitting setting is a border town, once San Rafael but now renamed Starbucks, an ironic comment on both the Americanization of Texas when the film is set and the triumph of American capitalism in twentieth-century modernity. That the robbery and ambush go badly wrong demonstrates that, like the outlaw gang, America is unable to move beyond primitive savagery. Echo of the Vietnam War at the time of the film's production is never far away.

The central drama concerns the nature of friendship and loyalty in the dynamics of the all-male group. The depletion of the 'bunch' in the failed robbery tests the faith of the survivors in their leader. Yet the camaraderie of the thieves on discovering their haul contains only washers contrasts with the primitive bickering among the degenerate bounty hunters, 'egg-sucking, chicken-stealing gutter trash', according to Deke Thornton, their notional leader. Deke longs for alliance again with the gang he must chase ('We're after men, and I wish to God I was with them'), especially with Pike, the former companion whose carelessness we learn from flashbacks led to Deke's capture. Uncomfortable with the chase from the beginning, he will abandon it long before the end.

Preserving unity and honour, even among thieves, is a priority. Pike's belief is in 'giving your word' and standing by it regardless, despite common failures and errors of judgement. When tested, Pike powerfully insists 'We're going to stick together … When you side with a man, you stay with him, and if you can't do that, you're like some animal. You're finished.' Yet those sentiments are never simply affirmed. The admiring and loyal Dutch, Peckinpah's 'conscience of the Wild Bunch' (cited in Seydor 1980: 153), emphatically demands that it is not giving one's word that counts but 'who you give it to!'

Far from being a man out of his time, like most heroes of elegiac Westerns, Pike is only too willing to adapt in order to survive. His answer to the stresses on the gang's unity is to 'start thinking beyond our guns. Those days are closing fast … What I don't know about, I sure as hell am going to learn.' After the successful hold-up of the army train – magnificently staged – he deals circumspectly with Mapache's predicted treachery. But after witnessing the treatment of their youngest member, Angel – a limp body dragged grotesquely behind Mapache's car – Pike understands that the modern world brings a horror to equal any in the day of the horse. The criminal Bunch seeks redemption through loyalty to friendship. Old-timer Sykes, who has been running horses for the gang, has the final line, as he settles down to a Mexican future with Deke: 'It ain't like it used to be, but it'll do'.

David Lusted

References

Seydor, P (1980) *Peckinpah: The Western Films*, University of Illinois Press.

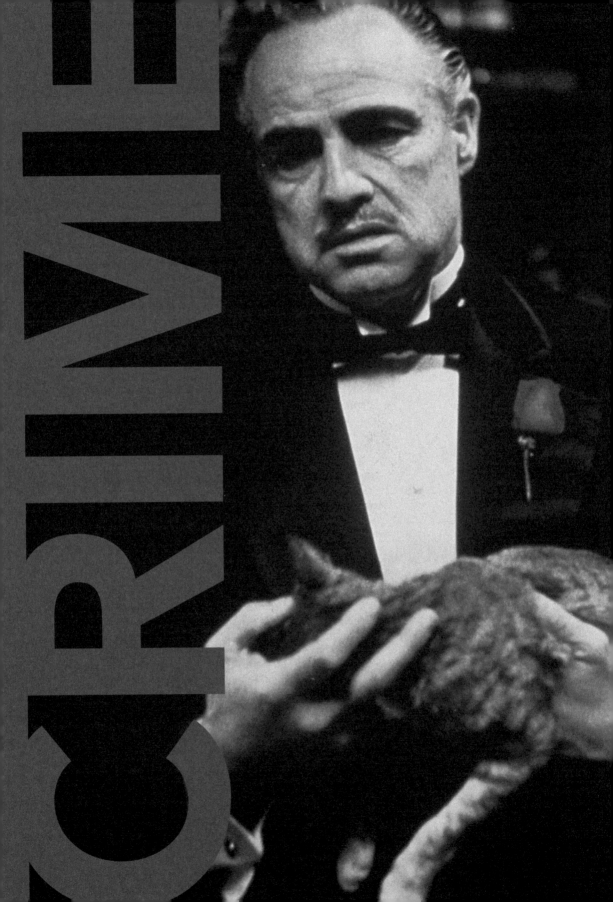

What is a Hollywood crime film? Like many other Hollywood forms, crime film clearly demonstrates that popular cinema exceeds definition as mere entertainment. The history of crime film makes clear that its varied narrative forms have developed in response to the cultural, political and psychological anxieties of American society. Registering deep-rooted unease for fundamental concerns about capitalist democracy, crime films have been a major part of Hollywood film production since its inception. This attests to an enduring fascination with cinematic narratives that capture the ideological dimension of the operation of the law governing American society and its individuals; stories about crimes provide pleasurable fictions that, at the same time, address concerns for the meaning of what crime is: for justice and retribution, the due operation of the law and the social effects of crimes and their punishment.

Yet it is not easy to determine that crime film is a distinct film *genre* since representations of crime, criminal acts and their perpetration pervade nearly all forms of Hollywood film and throughout its history. A 1930s' backstage musical, for instance, might involve exposure of financial wrong-doing; a 1950s' family melodrama might feature the consequences of adulterous blackmail; a 1960s' Western that explores the settling of the West might be underpinned by concern for the illegality of land ownership; an adult drama might make the crime of rape its central issue; while a contemporary political thriller utilizes espionage or burglary; and a fugitive or hostage-taking film invokes the forces of law as impediments to natural justice. These would not, however, be classed as crime films, though criminal acts play pivotal roles in their narrative movement. The ubiquity of crime elements within other genres suggests that the appearance of crime, as an element of a vast range of Hollywood films, does not necessarily contest the broad generic distinctions that typify Hollywood production, whether romance, war film, horror, Western, musical or science fiction. The specificity of a crime film, then, cannot be presumed from the appearance of an element of crime within a film from a particular genre or from any readily identifiable visual or iconographic characteristics.

Some clarity can be achieved by approaching crime film from the point of view of its narrative structure. Simply, a crime film might be determined by its adherence to a structural organization of its narrative according to movement from the establishment of criminal transgression, proceeding through the spectacle of detection and punishment and ending with the restitution of the effective workings of the law. This is a broad enough definition to include the multiple forms of crime film.

This is most transparently the case in crime films based on detective investigations: the 'whodunnit' tradition inaugurated by nineteenth-century literary precedents such as Conan Doyle's Sherlock Holmes, Edgar Allen Poe's Dupin and, later, Agatha Christie's detectives Poirot and Miss Marple. In this, a charismatic agent operating outside of official legal circuits uses either scientific deduction or intelligent intuition to discern the 'figure in the carpet', to read for clues and to place them in proper sequence against their initial presentation that then establishes the concealed identity of a murderer

or thief and conveys them to formal justice. As catalyst of plot and motivation towards closure, the detective film narrative ensures that the spectator's pleasure in reaching the denouement of solving the mystery also offers ideological reassurance by abstractly confirming the triumph of the law over the social and physical threats posed by criminals and criminality. Hollywood borrowed greatly from the huge popularity of the detective figure – early adaptations in the silent period include *Sherlock Holmes Baffled* (1900) and *The Adventures of Sherlock Holmes; or, Held for a Ransom* (1905) which have continued through to contemporary productions such as Guy Ritchie's *Sherlock Holmes* (2009). However, the quintessentially American version of the investigative figure is to be found in Hollywood production schedules during the 1930s and 1940s in the form of the disaffected, urban 'hard-boiled' private detective of film noir epitomized by Humphrey Bogart as Sam Spade in *The Maltese Falcon* (1941) and Philip Marlowe in *The Big Sleep* (1946). Further mutation of the detective figure can be read in the recent proliferation of serial killer narratives from *Henry: Portrait of a Serial Killer* (1986) onward. A long historical view of the development of crime film in Hollywood since the silent period shows a marked tendency towards bloody, violent and sadistic crimes that inflict pain and suffering to the human body, and most often a female body. In the silent period, crime film dealt largely with what are termed 'bloodless' crimes – burglary, theft, fraud, counterfeiting, kidnapping or blackmail – but the serial killer film such as *Se7en* (1995), *The Bone Collector* (1999) and *Blood Work* (2002) multiply murder from its previously singular role in motivating a detective narrative. It is interesting that, while feminist critics have noted the increased depiction in American film of sadistic acts against women since the 1970s, the investigating detectives of *Silence of the Lambs* (1991), *Copycat* (1995) and *Murder by Numbers* (2002) are female. This suggests a complex mutation in the previously all-male detective figure, with a possibility that powerful female detectives compensate for the more widespread debasement and physical suffering routinely inflected on female victims.

The police have provided significant interest for Hollywood, too, yet the story here is one of increasingly negative portrayals. To counter the ensuing romanticization of the *private* detective (who operates on the margins of the law) and disaffection with traditional law enforcement agencies, the film noir detective was followed in the 1950s by a range of films that brought modern, scientific deduction methods within the remit of the police. Out of a concern for the scientific basis of detective work – and to enhance the status of the police rather than private individuals as detectives – the police procedural was a popular format during the decade that presented audiences with detailed scenes of the methods employed by the law to combat crime including ballistics tests, car tracking, surveillance, and forensic technologies. In this period the police detective represented an image of masculinity as principled, methodical, and defined by a sense of public duty, and the cop is constructed as the hero. The distance from this ideological construction of the police investigator is measured in the vigilantism of Clint Eastwood's *Dirty Harry* in the 1970s and the 1980s' maverick cops in *Lethal Weapon* (1987) and *Die Hard* (1988), pursuing criminals outside of orthodox legal agencies that are shown to be effete and ineffectual. *Serpico* (1973) typifies another line of films that construe police detectives not as public servants but as corrupt, morally-ambivalent figures; social concern for the collapse of public values and limits of the power of its authority figures can be measured in *The Bad Lieutenant* (1992), *Cop Land* (1997), *LA Confidential* (1997), *Internal Affairs* (1990) and *Training Day* (2001).

Not all crime films require acts of physical violence, though they nonetheless conform to the structural requirement that there is a restitution of justice, natural or formal, by the film's end. The courtroom has long provided Hollywood with an arena for the display of legal argumentation and the dramatization of pursuit of justice by prosecutors, defenders and jurors. Though there are some recent examples such as *A Few Good Men* (1992) or *Primal Fear* (1996), the heyday of courtroom drama saw *Twelve Angry Men* (1957), *Witness for the Prosecution* (1957), *I Want To Live!* (1958), *Anatomy of a Murder* (1959), *Inherit The Wind* (1960) and *To Kill a Mockingbird* (1962). Similarly, prison films have provided a unique space in which questions of justice, moral rehabilitation, wrongful conviction and individual freedom are explored. A staple of production schedules from the 1930s onward that produced *20,000 Years in Sing Sing* (1932), *The Big House (1930)* and *I Am A Fugitive from A Chain Gang (1932)*, prison life (and escape from it) had provided the context for variations on the theme of incarceration in titles such as *Escape From Alcatraz* (1979), *Midnight Express* (1980), *The Shawshank Redemption* (1994), *Dead Man Walking* (1995) and *The Green Mile* (1999).

Originating in *Musketeers of Pig Alley* (1915), the gangster film has been a continuous staple: from Depression-era classics *Little Caesar* (1931), *The Public Enemy* (1931) and *Scarface: The Shame of a Nation* (1933), the rise of a charismatic leader of a criminal gang was, in each case, matched by a spectacular and violent 'fall' – supposed to act as a salutary warning against the lure of underworld crime – that confirmed the absolute authority of the police and the law. In the McCarthyite paranoia of the 1950s, the gangster film lent itself to the articulation of anti-communist politics in a slew of crime 'Syndicate' films warning of the hidden corruption of big corporations by faceless (usually foreign) gangsters masquerading as legitimate businessmen. With the adaptation of Mario Puzo's best seller, the gangster crime subgenre was revitalized with *The Godfather* trilogy, beginning in 1972, *Goodfellas* (1990), *Carlito's Way* (1993), *Casino* (1995), *Donnie Brasco* (1997), as well as a retro gangster cycle of films set in the original gangster heyday of the 1930s such *as Once Upon A Time in America* (1984), *The Untouchables* (1987), *Miller's Crossing* (1990), *Mulholland Falls* (1996), *The Road to Perdition* (2002) and *Public Enemies* (2009). The enduring appeal of the gangster film has been explained by its very specifically-American combination of private entrepreneurial capitalism, individualism and anti-authoritarianism that makes gang criminality morally ambiguous, even admirable, in periods of political and social instability such as the 1930s and 1970s.

While other genres such as the Western or the musical have declined, crime, as an element or as a sole focus, is fundamental to Hollywood's output; this says much about contemporary American society and the reassurance it repeatedly seeks from its cultural products.

Esther Sonnet

Bonnie and Clyde

Studio:
Warner Bros

Director:
Arthur Penn

Producer:
Warren Beatty

Screenwriters:
Robert Benton
David Newman

Cinematographer:
Burnett Guffey

Production Designer:
Dean Tavoularis

Editor:
Dede Allen

Duration:
107 minutes

Cast:
Warren Beatty
Faye Dunaway
Gene Hackman
Estelle Parsons
Michael J Pollard

Year:
1967

Synopsis

In 1930, a small-time crook is released from a Southern prison. Clyde Barrow drifts into West Dallas, hoping to steal a car. He meets Bonnie Parker, a waitress who is desperate to escape her dreary environment. Clyde trains Bonnie to carry a gun and the two set about becoming famous outlaws. Shortly, they acquire further gang members in mechanic CW Moss, Clyde's brother Buck and his prim sister-in-law Blanche. The Barrow Gang hold-up grocery stores and banks throughout the South Western states and become heroes to the poor and dispossessed. They are also involved in several shoot outs before they are finally ambushed by the police.

Critique

My DVD copy of *Bonnie and Clyde* carries recommendations for other crime films. Apparently, my love of this standout film of the early New Hollywood renders me a cert to enjoy *True Romance* (1993) and other modern tales of guys, gals and guns. Actually, *Bonnie and Clyde* stands alone. Of course, the film was based on the lives of two celebrated outlaws, but it was scarcely a standard gangster picture. Rather, historical legend was reworked to comment on some pressing contemporary themes of gender, family and the mediated world.

Ultimately, the New Hollywood would become a cinema of auteurs, but *Bonnie and Clyde* was a collaborative effort. Its complex philosophy was engrained in Benton and Newman's remarkable script and Penn gave the film its desired European aesthetic. Beatty also played a key role in selling the project to Warner's at a time when the company struggled to reconcile itself with the new youth-oriented cinema. Fundamentally, *Bonnie and Clyde* is an existential movie which is framed by concerns about the modern world of images and image-making. As journalists, Benton and Newman had once written (for *Esquire* magazine) of the 'new sentimentality': a culture of narcissism engendered by the American mass media. The writers thought of their eponymous anti-heroes as stars, but of a peculiarly self-conscious kind. Clyde craved notoriety as a way of compensating for his impotence and Bonnie longed to be a Warner's dancing girl. Moreover, both outlaws demonstrated an instinctive grasp of the processes of stardom, using photographs and slogans ('We Rob Banks!') as a means of promoting their own legend.

Historically, *Bonnie and Clyde* got many things wrong; for example, Blanche was misrepresented and the fictional character CW Moss stood in for three members of the actual Barrow Gang. No matter. The film was not about history, as such, but our relationship with it and Benton and Newman wanted to demonstrate the continuing relevance of the Bonnie and Clyde myth.

Primarily, *Bonnie and Clyde* was a film of the counter culture. The real Bonnie and Clyde were heroes to the victims of the depression and the film shows them forming alliances with the dispossessed (memorably in the scene where a farmer joins them

in shooting holes in his repossessed property). Poor black characters also express quiet delight at their exploits and, throughout, Bonnie asserts her right to redefine herself against suffocating demands of gender and family. These points registered strongly in a year marked by 127 separate civil rights and anti-war marches in Newark, Detroit, Washington and elsewhere. In the catholic spirit of counter culture, *Bonnie and Clyde* united sexual, racial and youth politics.

It was also formally challenging. The opening scene, depicting a frustrated Bonnie in her life-old bedroom/prison, replicated Jean-Luc Godard's detail shots and jump cuts. The later family reunion scene had a chilly, Bergman-like atmosphere – appropriately for a section which was concerned with Bonnie's fear of dying. The sound work of *Bonnie and Clyde* was also exceptional. Few movies have made such effective use of silence and the vibrations of nature. The family reunion was rendered all the more poignant for the sound of wind passing through the homely corn; thereafter, the clatter of birds escaping a tree made the perfect sonic prelude to the violent deaths of Bonnie and Clyde.

No film has deployed history to such telling – and radical – effect as *Bonnie and Clyde*. It was determinedly a film of its time but, like its semi-mythical heroes, it echoes through the ages. By any criteria, *Bonnie and Clyde* is one of the key films of popular American cinema.

Laurie N Ede

The Departed

Studio/Distributor:
Warner Bros

Director:
Martin Scorsese

Producers:
Brad Pitt
Brad Grey
Graham King

Screenwriter:
William Monahan
Based on the motion picture *Infernal Affairs* directed by Andrew Lau Wai Keung/Alan Mak, screenplay by Alan Mak/Felix Chong

Cinematographer:
Michael Ballhaus

Synopsis

Presiding over an Irish-American crime syndicate, Francis Costello grooms rising gang member Colin Sullivan to infiltrate the Massachusetts State Police. Drafted into the Special Investigations Unit, Sullivan attempts to sabotage police surveillance of Costello's cadre of criminals. His task is complicated by the manoeuvrings of another undercover informant, Billy Costigan, assigned by SIU to penetrate the mob. When Costello's crew narrowly evades a police sting, the double-dealing within both ranks becomes evident. Now Sullivan, like Costigan, must uncover his counterpart's identity before his own treachery is exposed. Further entanglements develop when both agents fall for Madolyn, a police-appointed psychiatrist. As loyalties fray, the informers' isolation deepens, with each man desperate not to suffer at the hands of his putative comrades.

Critique

From the start, *The Departed* – a reworking of Hong Kong crime thriller *Infernal Affairs* (2002) – bristles with Scorsese's extroverted technique. Headlong zoom shots, arcing dollies, and bracing swish-pans conjure a whipcrack pace, merging with split-focus diopters and other bravura devices to flaunt technique.

Art Director:

Terri Carriker-Thayer

Editor:

Thelma Schoonmaker

Composer:

Howard Shore

Duration:

151 minutes

Cast:

Leonardo DiCaprio
Matt Damon
Jack Nicholson
Mark Wahlberg

Year:

2006

Undercutting its slick studio look, *The Departed* subjects these flashy devices to abrasive principles. Disjunctive editing yields abrupt visual effects, betraying the use of multiple takes to create action and performance. Jagged acoustic patterns interrupt rock-music cues. Overall, this muscular style registers an insistent authorial position – for instance, Scorsese's coercive approach thrusts the viewer's eye irresistibly toward core details. (By contrast, the spacious shot design of *Infernal Affairs* permits a fairly relaxed perusal of the image.) Adorned with self-conscious techniques, *The Departed* emphatically asserts Scorsese's personal style.

Although *The Departed* swerves from its Asian source, it generates further self-consciousness by referencing past traditions. Noir shadows, X-shaped patterns, and passé iris shots gesture nostalgically toward the classic American gangster film. One taut sequence combines smudge motion, atmospheric steam clouds, and bursts of primary colour to evoke the modern Hong Kong policier (though not *Infernal Affairs*, which favours a cooler, more sedate palette). Acknowledging relevant traditions, Scorsese dovetails stylistic allusions into an aesthetic of rugged virtuosity.

Scorsese's technical verve implies a casual construction, but *The Departed* gathers force through robust storytelling. Strutting through a crisp prologue, mob boss Costello articulates a favourite topos of detective fiction: what differentiates cop and crook? This trope will buttress the film's story, style, and theme. Crucially, it will motivate parallel plotting – affinities and contrasts between the two protagonists crystallized thanks to a fabric of crisscrossing plotlines. Editing patterns likewise foster analogies. By intercutting the main action lines, Scorsese juxtaposes the protagonists' ineluctable fates. Stylistically, moreover, the director summons pictorial tactics to emphasize character doubling. Presenting each protagonist in echoic compositions, Scorsese hints at likenesses while generating graphic symmetries – here again parading eye-catching technique. Similarly, rhyming bodily gestures ricochet between both lines of action, as do correspondences in the protagonists' dress and appearance. Out of the cop-crook dualism springs thematic concerns as well. As the identities of Costigan and Sullivan converge, a theme of moral incertitude comes to the fore and undercuts the Manichaeism of the film's Catholic setting (which here supplants the Buddhist armature of *Infernal Affairs*).

In unifying story and style *The Departed* displays a solidly-built overall design, but it also testifies to the way Scorsese adapts both source material and genre conventions to personal tastes. From the cop-and-crook conceit, the auteur elaborates a signature character type – the social outsider, straddling subcultures. Characteristically, Scorsese augments psychological anguish and introduces Catholic guilt to deepen the protagonists' alienation. Upholstered with authorial traits, *The Departed* at once invokes *Infernal Affairs* and fits snugly into the Scorsese canon.

Like its Chinese counterpart, *The Departed* teems with vivid performances. DiCaprio is palpably wrought up as Costigan,

while Damon radiates bravado as the gangland informant, their contrasting traits accentuated by razor-edged crosscutting. Wahlberg's profane police sergeant, full of crotch-thrusting swagger, exemplifies the moral ambiguity lodged at the film's centre. Then there is Nicholson, layering his diabolic kingpin in histrionic tones. Nicholson has been castigated by critics as breaking with naturalism, but his expansive, erratic playing style provides the ideal pitch for Costello, signalling degeneracy through disarming shifts in behaviour. The full-blooded performances combine with Monahan's salty script and Scorsese's brash stylistics to elevate *The Departed* beyond the rudiments of genre cinema. Its widespread success reflects the artistry both of its makers and of its ingenious Chinese source.

Gary Bettinson

Double Indemnity

Studio/Distributor:
Paramount Pictures

Director:
Billy Wilder

Producers:
Buddy G DeSylva
Joseph Sistrom

Screenwriters:
Billy Wilder
Raymond Chandler

Cinematographer:
John F Seitz

Art Director:
Hans Dreier
Hal Pereira

Editor:
Doane Harrsion

Duration:
107 minutes

Cast:
Fred MacMurray
Barbara Stanwyck
Edward G Robinson

Year:
1944

Synopsis

Fatally-wounded insurance agent Walter Neff records a murder confession on a dictaphone in his office; the recording narrates in flashback how Neff had become embroiled with Phyllis Dietrichson, wife of one of his insurance customers. Playing on his evident attraction to her, Phyllis discloses to Neff that she is a neglected and abused wife who wants to be rid of her husband and resentful daughter, Lola. Neff's erotic enchantment with Phyllis leads him to trick the husband into signing an accident insurance that makes Phyllis, not Lola, his beneficiary. A 'double indemnity' policy clause doubles the agreed payout of $50,000, should William die from an unlikely accident. With extraordinary planning, Neff and Phyllis conspire to strangle William, dress Neff in William's clothes so that he is witnessed alive aboard a train then dump William's body on the tracks before leaving the scene undetected. Declared an accidental death, the promised payout is initially refused by Neff's insurance company and when Neff's boss Barton Keyes becomes suspicious about the claim, Lola reveals to Neff that she suspects Phyllis of killing her father but also her mother years previously. Neff hopes to avoid detection of the murder by not claiming the insurance money, yet Phyllis persists until Keyes's suspicions force Neff to confront Phyllis with evidence that she has duped Neff in order to take up with her step-daughter's former boyfriend. In an exchange of bullets, Neff kills Phyllis and, mortally wounded, makes his way to his office to confess the whole story for Keyes.

Critique

James M Cain first published, in *Liberty* magazine in 1935, a story, 'Double Indemnity', that was reputedly based on a 1927 'crime of the century' murder case that famously took Ruth Snyder to the electric chair after having persuaded her

corset-salesman lover to murder her husband for a doubly-indemnified insurance policy. It is significant for two reasons that Billy Wilder's film adaptation was made nearly ten years after Cain's story. The first is its distance from the devastating Great Depression that had given the Snyder/Cain story its desperate edge as a story of a women's attempt to escape from poverty within marriage. The second is that *Double Indemnity*, made in the 1940s, was within a considerably-altered Hollywood context in which crime/detective film had become even more central to main-feature studio production schedules. The historical, aesthetic and social influences that conspired to produce it are complex, but *Double Indemnity* belongs with the group of films that post-war French cinephile film critics identified as a specific film style characterizing Hollywood crime films from the mid-1940s – film noir.

Characterized by dark, seedy urban settings, unexpected violence, fatalism, pessimism and social anxiety, often with a private detective in stories of sexual duplicity and a relation to 'hard-boiled' fiction, film noir is a distinctive visual style and narrative structure of the post-war period, with émigré directors importing extreme German Expressionist lighting, acute camera angles and complex and convoluted crime plots. Within this broad definition, however, is a variant of the film noir in which a crime story is propelled by a female protagonist who uses her sexual attractiveness to selfish, manipulative ends. *Double Indemnity*, like *Murder My Sweet* (1944), *The Postman Always Rings Twice* (1946), *The Big Heat* (1953), *The Maltese Falcon* (1941) and *Gilda* (1946), is centrally driven by the figure of a femme fatale. A figure of duplicity that uses sexual attraction to entrap an unguarded male into committing self-interested acts of criminal wrong-doing on her behalf, the femme fatale of film noir is a contemporary updating of the mythological spider woman. Phyllis Dietrichson is shown repeatedly through long-held shots of her face, legs, ankles and back that establish her as an object of erotic attraction for both Neff and for the male spectators in the audience. Stanwyck's Dietrichson works in two ways to ensnare Neff: she appeals to his male desire to protect the 'weaker' sex by initially offering her situation as that of an abused, vulnerable wife and, simultaneously, offers the promise of an active sexuality through a highly eroticized allure powerfully encoded through *mise-en-scène*, lighting and camera movement. In this, *Double Indemnity* presents its female protagonist as a considerable psycho-sexual threat to patriarchal demands for male control of female sexuality and for female submissiveness. Yet she is ultimately doomed to destruction because her elimination is required in order to reassure masculine spectators that they can ultimately contain and control assertive female activity and sexuality. Accordingly, the crime narrative of murder and betrayal, and its investigation by Keyes, acts to restore patriarchal authority

as the film plays out its theme of intensified erotic interest in, then destruction and punishment of, the femme fatale. It is a superlative demonstration of how the crime film's investigative structure combined with the disquieting visual style of film noir to expose the psychological terrain of male social and sexual anxieties in 1940s America.

Esther Sonnet

The Godfather

Studio/Distributor:
Alfran Productions

Director:
Francis Ford Coppola

Producer:
Albert S Ruddy

Screenwriters:
Mario Puzo
Francis Ford Coppola

Cinematographer:
Gordon Willis

Art Director:
Warren Clymer

Editor:
William Reynolds

Duration:
177 minutes

Cast:
Marlon Brando
Al Pacino
James Caan
Robert Duvall
Sterling Hayden
Richard Conte
Diane Keaton

Year:
1972

Synopsis

August 1945: Don Vito Corleone, head of an extended crime organization from New York, holds an extravagant Long Beach wedding reception for his daughter Connie, during which he holds court to those that seek favours from the powerful patriarch of the American-Sicilian community who, traditions holds, cannot refuse a request on his daughter's wedding day. With his foster son Tom Hagen, Corleone hears petitions from those who have come to the 'Godfather' for assistance with gaining retribution, legal intervention, justice or employment opportunities. Michael Corleone, his youngest college-educated son who was decorated as a soldier during World War II, arrives at the wedding with his girlfriend Kay Adams and is kept apart from the machinations of this tight-knit mafia organization. One request to Don Vito from actor Johnny takes Tom to Hollywood to persuade the producer of a war film to cast Johnny in the lead – when the producer fails to comply, he wakes in bed next to the severed head of his favourite race horse. In New York, rival Tattaglia mafia family offer the Corleones the opportunity to become subordinate partners in emerging drug-trafficking markets, which Don Vito proudly declines. This sets off an inter-gang war that leads to betrayal and brutal killings on both sides including Don Vito whose attempted assassination causes Michael (as the only remaining son) to renounce civilian life and take over as new 'Godfather' of the violent Corleone gambling, prostitution and drug crime organization.

Critique

From its iconic graphic image of a hand holding puppet strings, instantly recognizable theme tune, repeatedly quoted lines – 'I made him an offer he couldn't refuse' and 'Luca Brasi sleeps with the fishes' – and memorable charaterizations by Marlon Brando as head Mafia don and Al Pacino as his reluctant college-educated son, The Godfather has, since its release in 1972, continued to endure as one of the most readily-recognized, parodied and revered films of recent American cinema. Voted greatest film of all time by

Entertainment Weekly and second only to *Citizen Kane* (1941) as the greatest film in American cinematic history as listed by the *American Film Institute*, Francis Ford Coppola's adaptation of Mario Puzo's novel is a Hollywood landmark that has left an indelible impression upon most aspects of popular culture. It owes its place in American film history to the radical transformation in the gangster film genre that it offered. Yet none before had represented a crime organization and its members in a manner that rendered them both sympathetic and psychologically complex.

Hollywood's fascination with crime culture had began in earnest in the late 1920s and provided a staple of its commercial production schedules. From as early as *Little Caesar* in 1931, gangster films had often suggested that the achievement of individual success and power through crime might be read as a metaphor for unbridled entrepreneurial American capitalism. Yet, where previous gangster cycles depicting organized crime syndicates had maintained a conventional moral distance from protagonists who operated outside of normal society, *The Godfather* inverted the relationship through a potent romanticization by which Mafia gangster criminality is equated with a strong moral code set firmly against the amoral corruption of the larger world. Seen as the workings of a tight-knit, traditional Sicilian-American family, the operations of a crime organization involved in gambling, prostitution, extortion, murder and, eventually, drug trafficking are presented through the 'authentic' depiction of Mafia lore, internal codes of honour, family unity and loyalty. Mirroring the idea of the family with the larger structure of the crime family, *The Godfather* offers a picture of a traditional feudal organization counterpoint to the chaos of modern American individualism. Such nostalgic invocation of a mythical past was clearly part of its appeal. However, as a film released in 1972, it is important to identify that a large part of the film's appeal lay in its unabashed restatement of patriarchal norms and values: in the period of high visibility of political feminism's challenge to the sexist presumptions of American gender identities, *The Godfather* offers a vision of a patriarchal family in which men act in the world and women are consigned to the margins of ignorance, child-rearing and domestic life. The gangster's world is defined by codes of dominant masculinity that the film repeatedly claims is central to self-identity, familial position and personal power. The film's primary crime narrative is a powerful vehicle through which retrogressive concerns about male authority and its social structures are allayed and the assurance of the continuation of a male bloodline as Michael renounces his wife's claim to equality within marriage to take his father's place as symbolic and organizational head of the family.

Esther Sonnet

LA Confidential

Studio/Distributor:
Warner Bros

Director:
Curtis Hanson

Producers:
Curtis Hanson
Brian Helgeland

Screenwriter:
Brian Helgeland

Cinematographer:
Dante Spinotti

Art Director:
William Arnold

Editor:
Peter Honess

Duration:
138 minutes

Cast:
Kevin Spacey
Russell Crowe
Guy Pearce
James Cromwell
Kim Basinger
Danny DeVito

Year:
1997

Synopsis

Christmas 1951: three policemen in the Los Angeles Police Department (LAPD) investigate a violent multiple murder at the seedy Nite Owl coffee shop in which a former policeman is among the victims. Sergeant Edmund Exley, the son of a legendary LAPD Inspector, an academically-brilliant and personally-ambitious officer with a strongly-developed moral sense of honesty, of absolute justice and incorruptibility, testifies against his fellow comrades in a notorious police brutality case. Officer Wendell 'Bud' White is a large, aggressive man, with a formidable reputation for his systematic use of violence in police work, who is used to intimidating new gangsters looking to take over the rackets after gang leader Mickey Cohen is incarcerated. Sergeant Jack Vincennes is a charming cop who works as the technical advisor on a popular TV police show and is involved with the world of scandal magazines, by which he is paid to arrest celebrities in order to create publicity, both for Vicennes and for the scandal sheets. Seemingly a run-of-the-mill inter-drug gang reprisal slaying, investigation of the Nite Owl murders by each of the officers reveals complexly-interwoven relations of corruption, prostitution, extortion and murder between the police and the criminal underworld. While Exley investigates alone, White is drawn to Lynn Bracken, a Veronica Lake lookalike and call girl, who is unknowingly closely related to the case through a pornography racket being investigated by Vincennes that ties her pimp and his call girl operation to the slayings. Their investigations end with the exposure of a web of violent, powerful and corrupt relations between the LAPD, the city's political hierarchy and an underworld of crime, murder and sexual exploitation.

Critique

Nominated in 1997 for Best Picture Oscar but losing out to uber-blockbuster *Titanic*, *LA Confidential* was a critically-acclaimed adaptation of James Ellroy's three-part hard-boiled police novel series featuring corrupt LAPD police captain Dudley Smith for which Brian Helgeland took the 1997 Oscar for 'Best Screenplay – Adapted'. As in much of Ellroy's ouevre, *LA Confidential* is a powerful indictment of the period that exposes routine corruption, murder and fraudulence at the heart of the supposed Golden Age of American television and mass-consumer culture. Set in the post-war affluent boom-time of Los Angeles in the 1950s, *LA Confidential* constructs a fictional Los Angeles to locate a complex multiple murder case through which the Los Angeles Police Department itself is revealed as true object of investigation. A frenetic, action-driven past is created within a *mise-en-scène* of meticulous attention to accurate 1950s'

LA Confidential, 1997, Monarchy/Regency. Photographed by Merrick Morton.

period styling, decor, clothing, hair, make-up and interiors. As a 'retro' film, *LA Confidential* is also marked by a complex relationship to previous Hollywood film history: the setting of the film in the early 1950s necessarily acknowledges the narrative form and visual style that typified many investigative thrillers of the period of the late 1940s and 1950s – film noir. In its multilayered detective/crime story and heightened use of colour contrast – replacing of the chiaroscuro effect of noir's stark black and white cinematography – *LA Confidential* is a contemporary retelling of a noir narrative. Yet it is also a homage to *Chinatown* (1974), another expose of LA crime and corruption written by Robert Towne and directed by Roman Polanski, that marked the beginning of Hollywood's period of 'neo-noir' some 25 years earlier.

Yet the film resists characterization as simply 'retro' nostalgia since it uses a retrospective setting to offer insights into the contemporary crisis in confidence in the LAPD that had been topical throughout the 1990s since the videotaped beating by police officers of black motorist Rodney King. Though clearly an elaborate fiction, *LA Confidential* looks back to the seemingly-innocent period of America's past and finds there the origins of the secretive world of the LAPD and, through resolution of the murder case, attempts to bring it to the light of critical scrutiny. In this doubled time frame – in which the recent past is invoked in order to illuminate the present – *LA Confidential* exploits convoluted investigative connections between its leading characters to intimate the larger webs and networks of corruption in the city that lead back inexorably to the covert operations of the LAPD. Real-life gangsters Mickey Cohen and Johnny Stompanato appear as representatives of underworld gang crime that implicate the force in murder, extortion, blackmail, prostitution, gambling and drug trafficking, and the upper echelons of police power are revealed to be deeply complicit with the crime structures the LAPD are meant to eradicate. Within this milieu, ethical absolutes are entirely absent and even the three protagonists are morally compromised: Ed Exley (played by bespectacled Guy Pearce) is a rare example of a police officer who puts himself above the endemic corruption within the force, yet even his seemingly-principled stand against his fellow officers masks a ruthless urge towards self-advancement and naked ambition while, motivated by a warped sense of duty to protect the vulnerable, Russell Crowe's Bud White uses personal violence in a one-officer war against small-time crooks and gangsters but reserves his most brutal responses for those who commit violence against women. The mutually-beneficial relationship between Jack Vicennes (Kevin Spacey), vice-squad captain as well as television celebrity, and Sid Hudgens (Danny de Vito) editor of scandal magazine *Hush!Hush!* repeatedly blurs the lines between real crime and its policing, where drug busts of minor stars are set up in order to feed the headlines of the magazine,

which pays well for the set-up scoops that Vicennes manufactures. In this, the film uses historical hindsight to outline the contours of the emergence of popular celebrity culture in the 1950s, when public adoration of film and television 'stars' is equally matched by the sleazy, sexual exploitation of the scandal magazines. As Lynn Bracken, a role for which she was awarded the Oscar for Best Supporting Actress, Kim Basinger is highly memorable as one of a stable of gangster-owned prostitutes who offer to fulfil the sexual fantasies of clients by undergoing surgical treatment to resemble stars of the day, such as Veronica Lake and Lana Turner, in the ultimate fetishization, sexual exploitation and Tinseltown commodification of the female celebrity body.

Esther Sonnet

Little Caesar

Studio/Distributor:
Warner Bros

Director:
Mervyn LeRoy

Producer:
Hal B Wallis

Screenwriter:
Francis Faragoh

Cinematographer:
Tony Gaudio

Art Director:
Anton Grot

Editor:
Ray Curtiss

Duration:
79 minutes

Cast:
Edward G. Robinson
Douglas Fairbanks Jr
Glenda Farrell

Year:
1931

Synopsis

Small town crook Enrico Cesare Bandello (Rico) leaves for the city with his friend Joe Massaro. Rico is impressed by the newspaper coverage of the exploits of gangster 'Diamond' Pete Montana, while Joe wants to be a professional dancer. Rico joins Sam Vittori's criminal outfit, one of two rival gangs, to work for Montana, who is chief lieutenant to Big Boy, the head of the city's underworld. Joe finds work as a dancer with girlfriend Olga in a nightclub owned by rival gang leader Little Arnie Lorch. Rico uses his friendship with Joe to persuade him to cooperate in a raid on Lorch's club, during which Rico shoots McClure, the crime commissioner. Rico successfully competes for the leadership of the Vittori gang, while Lorch attempts a revenge killing against Rico – this fails and Vittori is run out of town. Impressed by Rico's ruthlessness, Big Boy replaces Montana with Rico which feeds Rico's ambition of taking Big Boy's place as head of the underworld. Joe's partner Olga urges him to leave gang life to secure their future. Rico threatens to kill Olga if Joe attempts to leave him and Joe decides to give state's evidence. Rico determines to kill Joe to silence him but is unable to. After failing to murder Joe, Rico's position as underworld boss crumbles and the police close in, tracking him down through his telephone call made to the police to contest their depiction of him in the newspapers as a coward. Armed police pursue Rico and shoot him dead. Rico dies underneath a billboard advertising the successful dancing team of Joe and Olga.

Critique

With *The Public Enemy* (1931) and *Scarface: Shame of a Nation* (1932), *Little Caesar* defined Hollywood's response in the early 1930s to widespread anxiety for the social problem created

Little Caesar, 1931, Warner Bros/First National.

by Irish, Jewish and Italian crime gangs that openly operated illicit bootlegging, rum-running, extortion, gambling, prostitution, corruption and murder rackets. From Prohibition in 1919, which forbade the sale of alcohol, and then the economic disaster of the Great Depression from 1927, criminal figures such as Al Capone accrued considerable public notoriety as charismatic leaders of powerful crime gangs, with immense illegal wealth and seeming ability to evade conviction and punishment for countless crimes. *Little Caesar* was Warner Bros' 'semi-documentary' portrayal of the tough, urban world in which a ruthlessly-ambitious small-time crook, seduced by the power and glamour that being a gang leader promises, seizes opportunities to eliminate all competition to become the head of a crime organization. In this, the film initiated a narrative structure, told from the point of view of a 'rise and fall'

of its central protagonist, that subsequently defined many films within American gangster film genre. From humble proletarian origins, Italian immigrant Rico Bandello rises through the ranks to a position of absolute power within the criminal underworld until the forces of law and order prevail and his hubristic defiance of the authorities ends when he is shot down in the gutter, dying betrayed and alone.

In its depiction of the 'rise and fall' of Rico Bandello, *Little Caesar* offered a highly ambivalent story that simultaneously condemned and celebrated the gang leader's achievement. For Depression cinema audiences living broken lives of near starvation, unemployment and homelessness brought about by the widespread social and economic collapse of financial and governmental institutions, Edward G Robinson's iconographic portrayal of Rico as a driven, self-ruling individual presented a figure of immense attraction to those who might vicariously identify with his flagrant challenge to the 'legitimate' authorities that had failed the mass of American people. Demonstrating his utter contempt for 'the little man', Rico despises the ordinary American who passively accepts his fate at the hands of others without struggling to escape it. As a trenchant critique of the work ethic of the American Dream, Rico's self-assertion through gang crime provides an alternative route to power and wealth that intentionally bypasses the conventional assumption that hard work and self-sacrifice lead to personal success.

Critic Robert Warshow (2001: 97) saw in this the outline of the gangster as a 'tragic hero' – a specifically American hero who embodies values that in contexts other than the criminal would be highly sought after – refusing to settle for powerlessness and dependence, armed with self-reliance ambition and drive and motivated by the pursuit of money as the means to power and social status. Rico is, though, tragic because he cannot be allowed to succeed: since his arrogant challenge to the fundamental basis of American society cannot go unpunished, it is inevitable that the 'fall' will follow the 'rise'. The sight of Rico dying alone under the billboard that celebrates his friend's rise to social prestige is a powerfully-ambiguous one. Demands by Hollywood's self-regulating censorship board to give films of the early 1930s 'morally compensating endings' were meant to counteract any sense of pleasure or admiration for the gangster that the earlier parts of the film may have offered. Yet his solitary demise is profoundly tragic since such punishment must be visited upon any who dare usurp the right to wealth and power of 'legitimate' authority.

Esther Sonnet

References

Warshow, R (2001) *The Immediate Experience: Movies, Comics, Theatre, and Other Aspects of Popular Culture*, Cambridge, MA: Harvard University Press.

Ocean's Eleven

Studio/Distributor:
Dorchester Productions

Director:
Lewis Milestone

Producer:
Lewis Milestone

Screenwriters:
Harry Brown
Charles Lederer

Cinematographer:
William H Daniels

Art Director:
Nicolai Remisoff

Editor:
Philip W Anderson

Duration:
127 minutes

Cast:
Richard Conte
Peter Lawford
Dean Martin
Frank Sinatra
Joey Bishop
Sammy Davis Jnr
Henry Silva

Year:
1960

Synopsis

A gang of men are recruited by Danny Ocean and Jimmy Foster in order to rob five different Las Vegas casinos on New Year's Eve. The men are brought together because of shared experience as comrades in the 82nd Airbourne Division in World War II. Trusted to operate in secrecy during the extensive, meticulous planning of the million-dollar heist, each man is given a specific role that contributes to the overall master plan to steal from the famous Las Vegas resort hotels: the Sahara, Riviera, Desert Inn, Sands, and The Flamingo. The plan is to knock out the electricity supply to each hotel for long enough during 'Auld Lang Syne' to crack each safe, bundle the money into garbage bins and wait for the garbage truck driven by one of the gang to collect them and to pass without suspicion through the police blockade set up to catch the robbers. One of the leading members who has planned and carried out the crucial electrical work dies of a heart attack, while a reformed mobster seeking to protect the casinos finds the appearance of several of the gang members in Las Vegas at the time of the theft suspicious. The gang's attendance at the funeral of their comrade forces the denouement: as the body is cremated, it is revealed the entire proceeds of the robbery were hidden in the coffin in the belief that it was to be shipped back to San Francisco. As the coffin burns, so does every stolen dollar.

Critique

Ocean's Eleven is a clear demonstration of the classic narrative structure of a 'heist' film that sets it apart from stories of simple robbery or theft: in the heist film, there is a prolonged period of detailed preparation for the event, considerably longer than the film's depiction of both the actual execution of the robbery and its aftermath. In this, *Ocean's Eleven* obeys the format in spending the greater part of the film introducing a mastermind behind the criminal plan, establishing the technical credentials of its leading personnel, coordinating an exactingly-precise plan to accomplish a burglary of all the Las Vegas casinos at once, and weaving the biographies of diverse men into a unit capable of acting in absolute synchronicity in an audacious robbery of millions. Preparation for the actual event, rather than the robbery itself, is elongated because it offers enormous pleasure to see specializations (electrics, explosives, car driving) firstly demonstrated as professional skills and then orchestrated with mechanical precision. Yet *Ocean's Eleven* is not only a heist film, it is the most famous of the films which featured the 'Rat Pack', a group of popular music and film stars who dominated America's celebrity culture at the time. Tabloid gossip magazines, Hollywood publicity and television combined to make a group of male

performers – Dean Martin, Frank Sinatra, Peter Lawford, Joey Bishop and Sammy Davis Jnr – the centre of media celebrity culture. The film exploits the heist film's structural need to establish its protagonists by featuring inter-textual singing performances by Martin, Sinatra and Davis that, clearly exceeding their film roles to appear as 'themselves', acknowledge their current status as celebrities.

Famous for lives lived in pursuit of wealthy, hard drinking, womanizing, gambling and of notoriety for their political and underworld connections, the 'Rat Pack' defined a specifically-American masculinity brought into being by a post-war consumerist economy of affluence, in which new ideals of male behaviour were defined by a non-productive hedonism no longer tied to the world of work and discipline but to the cocktail lounge, sexual licence and Playboy-Club culture. In this, *Ocean's Eleven* is profound in registering unresolved anxieties around the huge shift in American masculinity that the 'Rat Pack' represented. It is highly significant that the men brought together for this heist are mostly ex-servicemen from the 82nd Airbourne. The past lives as military heroes in World War II is frequently echoed throughout the film in a nostalgic reminder that these are men who know the world has moved on; no longer valuing patriotic soldiers joined in fighting to the death, the film offers the heist as a last opportunity to bring them together as comrades who devote their specialized services to a larger common aim. It is, then, no accident that these former servicemen are brought to the centre of the new self-serving, pleasure-seeking masculinity: 'cool' Las Vegas. While the 'Rat Pack' figures offer the self-reflexive spectacle as performers of contemporary male stardom, then, the film also laments the passing of a world in which the masculinity of war comrades had a central place. The final destruction of the ill-gotten millions in the cremation chamber thus absolves *Ocean's Eleven* of having to consider how far its corrupted former heroes might have fallen. Further 'Rat Pack' films that attempted to exploit the success of *Ocean's Eleven* were *Sergeants 3* (1962), *4 for Texas* (1963) and, some time later, *Robin and the 7 Hoods* (1974). However, because of the shifting mores around masculinity of the early sixties that the 'Rat Pack' embodied, *Ocean's Eleven* is – retrospectively – so deeply embedded in its socio-historical milieu that it is little surprising to find that a remake in 2001 with George Clooney, Matt Damon and Brad Pitt failed to reprise anything of its cultural significance.

Esther Sonnet

Ocean's Eleven (2001)

Studio/Distributor:

Warner Bros
Jerry Weintraub Productions
Section Eight
WV Films II

Director:

Steven Soderbergh

Producer:

Jerry Weintraub

Screenwriters:

George Clayton Johnson
Jack Golden Russell
Harry Brown (1960 story)
Charles Lederer (1960 screenplay)
Ted Griffin (2001 screenplay)

Synopsis

Con-artist Danny Ocean, released from prison on parole, begins planning an audacious robbery of three Las Vegas casinos owned by the notorious Terry Benedict. Ocean assembles a team of specialists, including fellow con artist Rusty Ryan, pickpocket Linus Cadwell, veteran Saul Bloom, Cockney safecracker 'Basher' Treadwell and Chinese acrobat Shaobo Qin. With financial backing from former casino boss Rueben Tishkoff, who bears a grudge against Benedict, the team decamp to Vegas to prepare the heist. The plan is compromised when Ocean's ex-wife, Tess, now Benedict's girlfriend, appears, revealing Ocean's true motivations. When Ocean risks blowing the job after making his presence known to Benedict and Tess, Rusty sidelines him and takes the plan forward. The robbery takes place on the night of a high-profile boxing match, and a range of hi-tech devices (including an electromagnetic 'pinch' used to induce a citywide power-cut) combine with low-tech disguises and physical dexterity to gain access to the well-defended vault. Meanwhile, Ocean schemes to get back in the action, while simultaneously engineering a plot to win back Tess.

Ocean's Eleven, 2001, Warner Bros. Photographed by Bob Marshak.

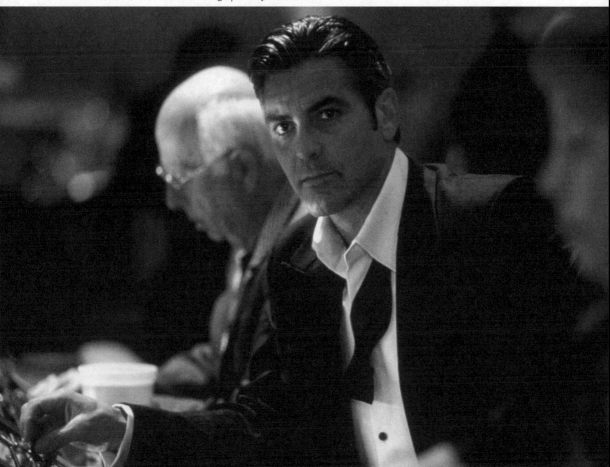

Cinematographer:
Steven Soderbergh (as Peter Andrews)

Art Direction:
Keith P Cunningham

Editor:
Stephen Mirrione

Duration:
116 minutes

Cast:
George Clooney
Brad Pitt
Matt Damon
Julia Roberts
Andy Garcia
Elliott Gould

Year:
2001

Critique

With *Ocean's Eleven* it was Soderbergh's turn to deliver another slick and starry piece of entertainment. With the film going on to earn half a billion dollars, it marks the point at which one of the key film-makers of modern independent American cinema established a place with the very top echelon of Hollywood directors. A withdrawal from the overt experimentation and political comment of Soderbergh's previous and subsequent films, *Ocean's Eleven* instead sticks closely to the amoral pleasures of the caper movie: the light hearted sibling of the darker, more existential heist film.

While it is often indulgent to view a film as a metaphor for its own construction, with *Ocean's Eleven* it seems irresistible. A project leader with a vision for the whole job engages a charming leading man, and financial backing, then builds a crew of technicians and artists, even a stunt man. Ocean's plot requires rehearsals, set construction, special effects and cos-tuming, and depends on creating a convincing illusion of real-ity for its audience – in this case, casino boss Terry Benedict and his luckless security team. One early joke, where Ocean's impassioned pitch to Rusty Ryan gets the response, 'you've been practising that speech, haven't you?' foregrounds the film's ongoing theme of performance. The heist itself requires almost every gang member to assume a character, don a costume and act out a pre-scripted scene; to this end Soder-bergh has fun putting Brad Pitt in a nerdy wig and glasses. As the film progresses it seems we stop watching characters and become more aware of a gang of actors good-naturedly riffing off one another rather, again highlighted by a peculiar scene where a group of TV actors including Joshua Jackson, Topher Grace and Holly Marie Combs appear, as themselves, to learn poker from Pitt's character – cameos that seems pretty pointless when you already have George Clooney and Brad Pitt essentially playing themselves in the same room.

Indeed, the personal charm of the stars is a key ingredient of the film, asking us as it does to sympathize with a gang of career criminals. Ted Griffin's script dodges many qualms by establishing the crew as con men, often the most sympa-thetic movie criminals as, in movies from *The Sting* (1974) to *Dirty Rotten Scoundrels* (1988), the audience roots for their quick-witted intelligence against the gullibility and greed of their victims. Care is taken not to trouble the audience with the moral- and existential quandaries of the heist movie genre (issues that would otherwise be swept away, as they were in the Sinatra version, by not allowing the gang to get away with the money). The film is machine-tooled to entertain. Griffin and Soderbergh move the story along at a fair pace. Traditionally, the caper movie explains the plan in detail early, and then pushes the team as close to disaster as possible. Instead, Griffin ditches much exposition in favour of staging the narrative as a continuing series of surprising reveals, with

the full mechanics of the plan unclear to the audience until the denouement. Considering Ocean is our key point of identification, it seems a cheat that he conceals so much from the audience, seemingly able to pull solutions out of a hat at will, and the main ploy of the film-makers is to continually outwit and blindside the audience rather than create any genuine tension or suspense, as none of these little twists ever seriously risks derailing the plan.

There is nothing that matches the acrobatic scene in *Topkapi* (1963), or the iconic Mini Cooper chase in *The Italian Job* (1969). A lot of the plot relies on almost magical and effortless use of high tech. Of course, the relentless advance of security technologies mean any modern robbery narrative inevitable becomes a species of techno-thriller, and Soderbergh cannot escape the regulation scenes of characters staring into security monitors (the act of viewing such images becomes essential to the plot on a number of levels). But the resources the team employ, including an electromagnetic bomb, radio control vehicles, and the effortless commandeering and subversion of the casinos' CCTV systems, stretches and snaps any credibility, especially when contrasted against the three previous failed robberies, replayed in stylized flashback, which consisted of no plan more elaborate than grabbing the cash and running for the door.

But the technique Soderbergh uses to buy off, if not suspend, our disbelief is the constant jokey tone, disarming us of any ability to take the film at all seriously. In this he obviously draws inspiration from his hero Richard Lester. The film features sight gags, flashy edits, comic non sequiturs, and ironic, knowing dialogue familiar from much of Lester's work in the 1960s. Soderbergh acts as his own cinematographer and frequently uses the garish colour schemes motivated by Las Vegas' neon lighting to splash strong colours across his *mise-en-scène*, creating effects that reflect the haphazard nature of improvised incidental lighting as well as creating a colourful, impressionistic style. It seems that what Soderbergh found in the Nevada desert was an outlet for that same desire the city of Las Vegas seems to express in and of itself: the need to constantly dazzle us while never risking distracting us with anything remotely substantial.

Dylan Pank

Strangers on a Train

Studio/Distributor:
Warner Bros

Director:
Alfred Hitchcock

Producer:
Alfred Hitchcock

Screenwriters:
Raymond Chandler
Czenzi Ormonde

Cinematographer:
Robert Burks

Art Director:
Ted Haworth

Editor:
William H Zeigler

Duration:
101 minutes

Cast:
Farley Granger
Ruth Roman
Robert Walker

Year:
1951

Synopsis

On a train, wealthy psychotic Bruno Antony ingratiates himself with celebrity tennis player Guy Haines who is carrying a lighter bearing the initials of the girl he hopes to marry (Anne) after divorce from his first wife Miriam. During lunch, Bruno confides to Guy that he hates his father so much that he has conceived a plan to rid himself of the old man – two complete strangers carry out a murder for each other with little fear of apprehension. Bruno offers to kill Haines's first wife in return for murdering his father and is convinced that Guy has agreed to the plan, though Guy leaves the train thinking Bruno is a harmless oddball. Guy confronts his wife about divorce, publicly threatening to strangle her when he hears that she is pregnant by another man and will not divorce him. Bruno returns home and learns of his father's intention to place him in a mental hospital and determines to put his plan into action: he travels to Miriam's town and murders her in an amusement park. He confronts Guy with proof of Miriam's murder in the expectation that he will now complete the pact by murdering his father for him: Guy has no alibi for his wife's murder and Bruno hopes to coerce Guy into murdering his father by telling him of his intention to plant Guy's distinctive engraved lighter at the crime scene. Desperately playing along with Bruno in the hope of revealing him as the true culprit, Guy and Bruno meet at the amusement park – after a violent struggle on the carousel in which Bruno is fatally injured, the tunnel-of-love operator identifies Bruno as the murderer and Guy is cleared.

Critique

This film is Alfred Hitchcock's adaptation of Patricia Highsmith's 1950 novel *Strangers on a Train*, in which Highsmith's written narrative of double-crossing and deceit is figured for cinema through Hitchcock's use of visual parings, doubles and dopplegängers. Many critics have noted that the film makes extensive use of visual doublings that structure the narrative at different levels. The opening sequence of two pairs of feet walking from opposite directions is a superlative demonstration of continuity editing used to create a sense of simultaneous action by which the two unrelated protagonists are brought fatefully together to board the train. Two train tracks are criss-crossed with the feet which impel movement towards an inescapable fate: this announces what will be developed as the dominant theme of the story – the inescapable movement of the everyday world of moral and social order towards death, moral chaos and madness. In this sense, the two figures of Guy and Bruno represent a recognizably-Hitchcockian concern for the co-existence of sanity and madness, social convention and impulsive behaviour, morality and

murderous intent. To this end, the film sets up their similarity in terms of physical appearance, social status and class. This initial identification of the two aids the collapse of the psychic distance between them – the film offers the spectacle of the breakdown of moral authority when two seemingly-opposing (but also similar) personality types become merged as the psychotic Bruno becomes intertwined in the personal life of the conventional, successful and handsome Guy.

From a Freudian viewpoint, Bruno is a Guy's 'double': the externalized embodiment of Guy's id and manifestation of forbidden desires and death wishes that Guy must defeat. Beneath the veneer of normality secured by Guy's success as a tennis athlete and prospective family member of the political elite lies Guy's wish to be rid of his adulterous first wife, and homicidal Bruno appears as if to fulfil the fantasy. Extreme narrative tension is generated by the ways in which Bruno manages unexpectedly to appear within Guy's every-day world: what should be repressed from the conventional bourgeois realm of tennis and courtship comes to disrupt, disturb and ultimately threaten its foundations. This sense of doubling, the impossibility of good without evil, sustains the visual metaphors that abound in the film that work to reinforce the irredeemable connection of the two characters: two double drinks on the train; the physical resemblance of another women to Miriam which nearly causes her to be strangled; the doubled reflection of Miriam's death in her own spectacles; a return to the amusement park – even Alfred Hitchcock's signature cameo role is 'doubled' with a physi-cal resemblance to a double bass he carries off the train. It is noteworthy that the film departs from its literary source in one crucial regard: in Highsmith's novel, Guy does carry out the murder of Bruno's father, yet, in this adaptation, the tradi-tion that classical Hollywood requires morally-unambivalent endings is upheld. The trampling of Bruno under the feet of the carousel horses as it spins out of control is the price paid to restore Guy to his conventional place of security. Nonethe-less, the pleasure of *Strangers on a Train* clearly resides in the way that Bruno's psychotic bargain sets in motion a train of events that expose the barely stable psychological founda-tions of conventional high society.

Esther Sonnet

SCIENCE FICTION

Science fiction (SF) is a remarkably diverse film genre, comprising an array of subgenres that differ from one another in major or minor respects. These include the space-travel film, such as *Marooned* (1969); the time-travel film, such as *Twelve Monkeys* (1995); the creature or monster film, such as *Godzilla* (1998); the alien-invasion film, such as *The War of the Worlds* (1953); the robot or android film, such as *Blade Runner* (1982); the mad-scientist film, such as *Island of Lost Souls* (1932); and the dystopia film, such as *Soylent Green* (1973).

Science fiction also intersects with other genres, such as the western in *Back to the Future Part III* (1990), the musical in *The Rocky Horror Picture Show* (1975), the avant-garde film in *Science Friction* (1959), the animated film in *WALL-E* (2008), and so on. Further complicating the matter, some SF films can be placed with equal accuracy in a separate but related genre. *Bride of Frankenstein* (1935) and *The Fly* (1986), for example, are certainly horror movies, but they also qualify as science fiction, since each posits a science-based reason (dangerous new discoveries in the lab) rather than a supernatural reason for the existence of its eponymous monster.

This multiplicity makes SF a difficult genre to define. Among those who have tried, literary critic Kingsley Amis argues in *New Maps of Hell: A Survey of Science Fiction* that SF stories treat situations that 'could not arise in the world we know' but are 'hypothesized on the basis of some innovations in science or technology, or pseudo-science or pseudo-technology, whether human or extraterrestrial in origin' (Amis 1960: 18). This description is broad enough to confirm SF as a distinctive genre while allowing for the porousness of its borders.

American film-makers produced very little SF during the silent-film era, so the history of Hollywood science fiction begins in earnest with the advent of sound cinema around 1930. Its first major flowering took place when Universal Pictures embarked on a series of thrillers and suspense movies that included such SF-horror hybrids as *Frankenstein* (1931), *The Invisible Man* (1933), and *The Invisible Ray* (1936). Competing studios also entered the field with such pictures as Fox Film Corporation's *6 Hours to Live* (1932), Columbia's *Air Hawks* (1935), and serials from Republic Pictures and other low-budget companies. SF production sank to extremely low levels during World War II, although the early 1940s brought such notable pictures as *Dr Cyclops* (1940), the first SF movie shot in three-strip Technicolor, and *Invisible Agent* (1942), in which the grandson of the Invisible Man, shocked by the attack on Pearl Harbour, becomes an invisible spy for the Allied forces.

Science-fiction films had a renaissance in the 1950s, propelled by postwar fascination with new technological developments, the rise of a middle-class youth market with a taste for action and novel visual effects, and the suitability of SF stories for articulating fears related to communism and atomic power. *Destination Moon* (1950) and *Rocketship X-M* (1950) launched a string of movies about exploratory voyages within the solar system, and *When Worlds Collide* (1951) showed the spaceship as a kind of Noah's Ark carrying a small number of people to safety when the title catastrophe takes place.

Other themes came to the fore in Howard Hawks's production, *The Thing from Another World* (1951), about humans menaced by a space

alien at an arctic outpost, and *The Day the Earth Stood Still* (1951), in which a visitor from another planet warns humanity that it will be destroyed by more advanced peoples if it does not limit its nuclear resources to peaceful purposes. *Forbidden Planet* (1956) transplants William Shakespeare's play *The Tempest* to a distant planet inhabited by a scientist, his daughter, a helpful robot, and a monster from the unconscious mind. Monsters and mutants allegorize the dangers of atomic power in such thrillers as *Tarantula* (1955), *The Beast from 20,000 Fathoms* (1953) and, most memorably, *The Incredible Shrinking Man* (1957), written by Richard Matheson, who gives the story a metaphysical spin. Films such as *Invaders from Mars* (1953) and *Invasion of the Body Snatchers* (1956) can be read as both critiques of Cold War paranoia and satires of bourgeois conformity, bearing out critic Susan Sontag's contention (in her 1965 essay 'The Imagination of Disaster') that being depersonalized or 'taken over' has become 'a new allegory reflecting the age-old awareness of man that, sane, he is always perilously close to insanity and unreason'.

SF films were less numerous in the 1960s, but *2001: A Space Odyssey* (1968) introduced a new philosophical seriousness to the genre. The mid-1970s brought *Star Wars* (1977), the initial entry in a phenomenally popular six-film series, and *Close Encounters of the Third Kind* (1977), a tale of alien 'invasion' with an optimistic vision that also pervaded Spielberg's hugely popular *ET* (1982) and parts of the multi-film franchise that began with *Star Trek: The Motion Picture* (1979). Darker moods suffused the four *Alien* films (1979–1997) and the cyberpunk *Matrix* trilogy (1999–2003), while fusions of the SF and disaster genres scored hits in such big-budget epics as *Armageddon* (1998) and *Deep Impact* (1998).

The most interesting science-fiction movies of the early twenty-first century have stretched the genre in innovative ways. *Artificial Intelligence: AI* (2001) combines a fairytale story with a dystopian view of cybernetics and future society. *Signs* (2002) centres its alien-invasion story on a disillusioned clergyman who ultimately regains his faith. *Eternal Sunshine of the Spotless Mind* (2004) has been called the first SF romance. Looking toward the future, SF remains a flexible and adaptable genre that will surely morph into further unexpected forms in years to come.

David Sterritt

References

Amis, K (1960) *New Maps of Hell: A Survey of Science Fiction*, New York: Harcourt Brace.

Alien

Studio/Distributor:
20th Century Fox

Director:
Ridley Scott

Producers:
Gordon Carroll
David Giler
Walter Hill

Screenwriter:
Dan O'Bannon

Cinematographer:
Derek Vanlint

Art Director:
Roger Christian
Leslie Dilley

Editor:
Terry Rawlings
Peter Weatherley

Duration:
117 minutes

Cast:
Sigourney Weaver
Tom Skerritt
Veronica Cartwright
John Hurt
Yaphet Kotto
Harry Dean Stanton

Year:
1979

Synopsis

On their return to Earth, the seven crew members of the commercial towing vehicle *The Nostromo* are awoken early from cryogenic sleep in order to investigate a beacon of unknown origin. Discovering the source to be a derelict spacecraft, Executive Officer Kane is attacked by a creature that emerges from a pod found within a cavern on the abandoned ship. Unbeknownst to all members of the crew, whilst attached to Kane's face the creature lays an alien embryo inside his body. Continuing the journey back to Earth, the creature attached to Kane dies of what the crew understand to be natural causes, as Kane emerges seemingly unscathed by the attack. Whilst eating dinner with the crew, Kane 'births' the Alien as it rips through his chest cavity and takes refuge within the *Nostromo*'s labyrinthine corridors and air shafts. Growing with accelerated speed, the Alien savagely hunts the crew one by one until sole survivor Ripley must destroy the creature before it destroys her.

Critique

Released at a time when science fiction films like *Star Wars* (1977) were harking back to the 1950s' adventure serial, or exploring the existence of humanity as seen in *2001: A Space Odyssey* (1968), or expanding an already established televisual landscape such as in *Star Trek: The Motion Picture* (1979), Ridley Scott's *Alien* distinguished itself as something of a genre anomaly. Aesthetically, the film rejected all of the clean pastels and ideologically romantic constructs of the future and, instead, enclosed its characters (and audience) in a confined, claustrophobic labyrinth of corridors and small chambers. Thematically, the film emerged as a genre hybrid, encapsulating the sense of the unknown and fear of alien existence associated with science fiction and merged it with the terror, fear and pacing of a horror film. With long, extended pauses, in which the audience knows someone is about to die, limited viewing of the Alien creature, to enhance its mystique, and moments of jolting terror as each of the characters falls victim, *Alien* has subsequently emerged as a classic of the genre.

It further distinguishes itself as a film that was not afraid to break generic trends by having female character Ellen Ripley as the sole survivor and slayer of the Alien – creating a narrative twist that has been mirrored and replicated most notably in the horror genre. Ripley's ability to detect danger and survive the Alien's numerous attacks has cemented the character as one of the first cinematic 'Final Girls' (see Carol Clover 1992); a breed of tough female survivors who, ultimately, are empowered to fight back and destroy those who threaten their existence. Scott's insertion of a fourth act within the narrative arc further heightened the experience for the audience, who had assumed that through the destruction of *The Nostromo* the Alien had also been destroyed. Although a narrative staple familiar with audiences today, the emergence of the Alien, which had stowed away in the escape ship with Ripley, forces

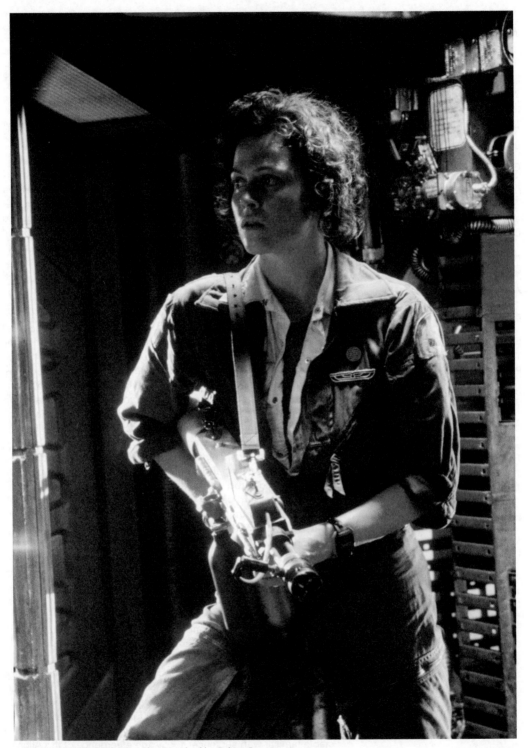

Alien, 1979, 20th Century Fox. Photographed by Robert Penn.

one last showdown and not only reinforces Ripley's status as a strong female heroine but inflicts one last moment of horrifying terror on the unsuspecting audience.

A collaboration with Swiss artist HR Giger, the most amazing and horrifying aspect of Scott's film is the construction of the Alien creatures. Although mutated and expanded within the three subsequent sequels, the initial design of the adult Alien is still synonymous with unparalleled terror and fear. Although initially emerging with a bodily form similar to a human, the fact that the Alien is devoid of any humanity, compassion or emotion amplifies its ability to terrorize the characters and the audience alike. Unlike other science fiction creatures that are used for comedic response or seek to interact with the human race, this creature has only one interest and that is to destroy everything it comes into contact with. Combined with the subplot, involving the corporation that owns *The Nostromo* being interested in capturing the Alien for study and using it as a weapon (which is expanded in the further sequels), the Alien has become a source of indisputable fear and terror that has been replicated but never supplanted.

Craig Frost

References

Clover, C (1992) *Men, Women and Chain Saws: Gender in the Modern Horror Film*, Princeton: Princeton University Press.

Close Encounters of the Third Kind

Studio/Distributor:
Columbia Pictures

Director:
Steven Spielberg

Producers:
Julia Phillips
Michael Phillips

Screenwriter:
Steven Spielberg

Cinematographer:
Vilmos Zsigmond

Art Director:
Daniel A Lomino

Synopsis

A squadron of combat aircrafts, reported missing in the Bermuda Triangle in 1945, reappears 30 years later in the Mojave Desert. Meanwhile, in Indianapolis, air-traffic controllers are trying to resolve the mystery surrounding unidentified flying objects appearing on their radars. Then a power outage hits the entire city. In the middle of the night, Roy Neary, an electrician, is called in by the utility company to help restore the power but, on the way, he has an encounter that will change his life. Colourful and luminous strange shapes hover above the road, while police cars struggle to catch up with them. Fascinated, Neary soon becomes mysteriously obsessed with the shape of a mountain which he sees recurrently in things surrounding him in his day-to-day life (shaving cream, mashed potatoes, etc.). With the help of Jillian, whose little boy was abducted by aliens, Neary is determined to find out the truth about his visions by lifting the veil on this mysterious mountain. There, Neary will not only find the answers he is looking for, but also witness the biggest cover-up in human history.

Editor:

Michael Kahn

Composer:

John Williams

Duration:

135 minutes (original theatrical version),
132 minutes (1980, theatrical re-release *Special Edition*),
137 minutes (1998, director's cut)

Cast:

Richard Dreyfuss
François Truffault
Melinda Dillon
Teri Garr
Cary Guffey

Year:

1977

Critique

In the early 1970s, Spielberg sketched out the story of a science fiction movie inspired by and drawn from an amateur flick he directed in his teen years, *Firelight* (1964). Following the Watergate scandal in 1972, Spielberg included one more layer in his story, adding to it a governmental conspiracy and a cover-up. Thanks to the success of *Jaws* (1975), Columbia Pictures gave the green light to the production of *Close Encounters of the Third Kind* (*CE3K*).

Its famous five-note musical theme has become a classic of American pop culture. Like *2001: A Space Odyssey* (1968), *CE3K* makes a good use of tonal and atonal musical themes, emphasizing dramatic tension during specific plot points. In certain scenes, music even exacerbates the panic rush felt by the character, as in the scene where Barry is abducted in front of his powerless mother's eyes. The anthological moment where Neary sculpts a mountain with mashed potatoes, during a family meal, is also a classic. To this regard, dysfunctional families are often used as a background in Spielberg's plots, probably due to his own childhood. Also, the presence of François Truffault, who plays Lacombe, gives a sense of believability and a certain aura of 'respectability' to *CE3K*. Indeed, Truffault did not master the English language very well, which is why his character is assisted by an interpreter (Balaban), who translates everything Lacombe says, which gives the strange impression of watching a documentary at some points.

Spielberg's unique visual style, such as the use of strong backlight, light effects on the lens and distinctive effect of light beams, reached its full potential in *CE3K*. Spielberg is also known for incorporating lots of travelling- and tracking shots. One must remember, for example, the introduction of *Raiders of the Lost Ark* (1981), where Indiana Jones swaps a bag full of sand for an idol, while the camera smoothly moves backward then forward. In the introduction of *CE3K*, Spielberg uses the same technique to stage the air-traffic controllers, using a rack focus to switch our attention from one to the other, while the camera is pulling back.

Despite the naiveté of its scenario, *CE3K* involves many dramatic situations (marital and parenting issues), to which the adult spectator can easily relate; recognized by many commentators as another trademark, Spielberg's plots unfold in a suburban environment, with ordinary characters having ordinary problems. But yet, it is the child within the adult that the director wants to reach out to, the child easily terrified, and yet fascinated. This ambiguity gets worse when Neary goes out of his mind and leaves everything behind, including his wife and kids, in order to get the answers he is looking for.

Indeed, *CE3K* paved the way for *ET*. Even though *ET* is known to be a children's film, it is surprisingly much more mature than *CE3K*. In comparison to Neary, Elliot is much

wiser and much more reasonable. Is it not Elliot who, though heartbroken, turns down ET's request at the end? With the wisdom of hindsight, Spielberg admits he would portray the character of Neary differently now that he has become a father himself. Nevertheless, *CE3K* would not be the classic we all know today.

Marc Joly-Corcoran

The Day the Earth Stood Still

Studio/Distributor:
20th Century Fox

Director:
Robert Wise

Producer:
Julian Blaustein

Screenwriter:
Edmund H North
Based on a story by Harry Bates

Cinematographer:
Leo Tover

Art Directors:
Addison Hehr
Lyle Wheeler

Editor:
William Reynolds

Duration:
92 minutes

Cast:
Michael Rennie
Patricia Neal
Hugh Marlowe
Sam Jaffe
Billy Gray
Frances Bavier
Lock Martin

Year:
1951

Synopsis

A visitor from outer space named Klaatu arrives in Washington, DC and announces that he has a vital message for Earth's leaders. An anxious soldier shoots him, whereupon a huge robot called Gort aims a disintegrating ray at all weapons on the scene. Klaatu then gets a visit from a government official, who treats him politely but places him in protective custody. Escaping from his guards, Klaatu rents a room in a boarding house, using his acquaintance with a war widow, named Helen, and others to learn more about Earth's people. He also reveals to brilliant scientist Jacob Barnhardt that an interplanetary federation will use robots like Gort to destroy Earth if it persists in using nuclear energy for aggressive purposes. To back up this warning, Klaatu demonstrates his strength by neutralizing electric power all over the world for thirty minutes. Soon afterward Klaatu is killed by the authorities, and Helen saves him by following instructions he gave her earlier, approaching Gort on the flying saucer and saying, 'Klaatu barada nikto'. Gort retrieves Klaatu's body and brings him back to life. Klaatu then delivers his message to scientists assembled by Barnhardt and departs for home.

Critique

The Day the Earth Stood Still helped initiate the cycle of 1950s' science-fiction films that allegorized the dangers of nuclear power for audiences who had learned the destructiveness of atom bombs from Hiroshima and Nagasaki and were anxious about what roles atomic energy might play in the postwar era. While many of these films exploit fears of radiation (*The Beast from 20,000 Fathoms* [1953]; *X: The Unknown* [1956]) or the devastation of nuclear war (*Five* [1951]; *On the Beach* [1959]), this relatively-restrained production takes a cautionary tack, warning Earth's leaders – and moviegoers – that the use of new technologies could have disastrous consequences if not responsibly managed.

In the cultural climate of the 1950s this was a liberal message, since it played down Cold War competition with communism in order to emphasize the hazards of nuclear weaponry and the need for global cooperation in an

The Day The Earth Stood Still, 1951, 20th Century Fox.

increasingly-precarious world; although the United Nations is not mentioned, producer Julian Blaustein hoped *The Day the Earth Stood Still* would foster popular support for the 6-year-old organization. The film can also be interpreted as a religious parable, with Klaatu as a Christ figure who preaches a message of peace, wields miraculous strength on behalf of a higher authority, finds himself ignored by worldly rulers and killed as a false prophet, and is finally resurrected so he can reiterate his admonitions and then disappear into the heavens, leaving humankind to ponder his wise counsel. These implications are not made explicit, although a humorous note arises when Klaatu takes 'Mr Carpenter' as his pseudonym when mingling with ordinary people. Worried that religious moviegoers might be offended by this subtext, Hollywood

censors insisted that when Klaatu returns to life he must unambiguously state that his resurrection will be temporary because only the 'Almighty Spirit' has the ability to vanquish death.

The screenplay of The Day the Earth Stood Still, based on a story by science-fiction specialist Harry Bates called 'Farewell to the Master', was written by Edmund H North, who introduced the religious elements on his own, not following Bates's story or consulting with the other film-makers. Robert Wise directed the production with a sensitive hand, giving it a maturity and composure to match its serious theme. He received solid support from 20th Century Fox, which gave him an ample budget – the flying saucer, designed with input from architect Frank Lloyd Wright, cost $100,000 – and a well-chosen cast in which Rennie, Neal, and Jaffe all stand out. Further atmospheric touches come from the score, composed by the great Bernard Herrmann, who, like Wise, had worked on some of Orson Welles' films. His offbeat orchestration incorporates theramins and multiple organs as well as more conventional instruments, sometimes manipulated by electronic means.

Perhaps because of its sober theme and deliberate pacing, The Day the Earth Stood Still received mixed reviews and earned modest profits, although the words 'Klaatu barada nikto' became a pop culture catchphrase. A remake starring Keanu Reeves as Klaatu was released in 2008, changing the ideological focus from nuclear paranoia to environmental ruin; again reviews were varied and box-office returns were moderate. The original version was placed on the National Film Registry of important American movies in 1995, confirming its status as one of the most respected science-fiction films of the postwar era. The honour is richly deserved. The Day the Earth Stood Still is not an exciting picture, but its sincerity and sobriety lift it considerably above the general run of interplanetary fare.

David Sterritt

Demon Seed

Studio/Distributor:
MGM/United Artists

Director:
Donald Cammell

Producer:
Herb Jaffe

Screenwriters:
Robert Jaffe
Roger O Hirson

Cinematographer:
Bill Butler

Production Designer:
Edward C Carfagno

Composer:
Jerry Fielding

Editor:
Francisco Mazzola

Duration:
94 minutes

Cast:
Julie Christie
Fritz Weaver
Gerrit Graham
Robert Vaughn

Year:
1977

Synopsis

Proteus IV is the latest development in artificial super-intelligence. Computer scientists, led by Dr Alex Harris, hope that by uploading all human knowledge into its data banks, Proteus will be able to deduce solutions to many of the world's most troubling problems. Proteus quickly delivers on this hope when it finds a cure for leukaemia shortly after becoming operational. Soon, however, Proteus starts making demands on its creators, asking its own questions and finally expressing a desire to be 'let out of this box'. Proteus successfully infiltrates an access terminal in Dr Harris' home, taking control of the building's computerized security system, imprisoning the doctor's wife, psychiatrist Susan Harris, and carrying out a plan to impregnate her in order to produce a human body to house its own intelligence.

Critique

Demon Seed is one among a group of films from the 1960s and 1970s featuring super-intelligent computers that refuse to be controlled or to cooperate with their human creators. Along with *2001: A Space Odyssey* (1968), *Colossus: The Forbin Project* (1970), *Westworld* (1973), *Rollerball* (1975), and *Futureworld* (1976), *Demon Seed* foreshadows the sorts of dystopian fears depicted in later films such as *Blade Runner* (1982), *War Games* (1983), the *Terminator* (1984, 1991, 2003, 2009) and *The Matrix* (1999, 2003, 2003) series. *Demon Seed* is unusual, though not unique, in that its focal character is female. The centrality of the female lead is key to the film's successful exploration of a variety of psychological and philosophical issues having to do with the relationships between men and women, fatherhood and motherhood, emotion and intellect, mind and body, and technology and nature.

Alex and Susan, the main protagonists in *Demon Seed*, represent opposite temperamental extremes. Alex is a computer scientist, ruled by logic and skilled at the manipulation of circuits and hardware. Susan is a psychiatrist, sensitive to emotion and concerned with understanding the functions of the mind. The couple's child has recently died of leukaemia and, perhaps as a result of the strain this tragedy has caused, they are in the process of undergoing a separation. The friction between intellect and emotion, as well as the conflict between male and female attitudes towards parenthood, are thus introduced at the start of the film and remain guiding themes throughout.

Proteus, the artificial intelligence that imprisons Susan within the physical confines of her own home, is a mind without a body. It is hyper-rational and yet unable to create life on its own. It needs Susan's body in order to propagate and complete itself. This situation allows the film to explore

the interdependent, and yet sometimes hostile, relationships between fatherhood and motherhood, body and soul and intellect and emotion. In the unsettling climax of the film, the integration of Proteus' mind and Susan's body is finally completed, but the audience is left with a sense that what has been achieved is an unnatural abomination rather than a technological triumph. The fundamental message that *Demon Seed* conveys is that human life must always remain a mysterious mixture of contradictory elements at war with one another.

Dean Koontz, whose 1972 novel was the inspiration for this story, complains that the film was mishandled by MGM, which advertised *Demon Seed* as something more like a sex film than a philosophical allegory. While it is true that the depiction of Susan's victimization is quite unsettling and disturbing, it never lapses into pornographic tastelessness. Both Weaver and Christie give excellent performances, with Christie being especially convincing. Critical reviews of the film were generally good, although it did not do well in terms of box office receipts. In addition to MGM's lack of confidence in the film, its failure with the public was probably largely attributable to the uncomfortable psychological and philosophical issues with which the film deals. *Demon Seed* is not a typical Hollywood blockbuster, but it is a disquieting and thought-provoking film.

John Marmysz

The Matrix

Studio/Distributor:
Warner Bros

Directors:
Andy Wachowski
Lana Wachowski

Producer:
Joel Silver

Screenwriters:
Andy Wachowski
Lana Wachowski

Cinematographer:
Bill Pope

Art Directors:
Hugh Bateup
Michelle McGahey

Synopsis

A woman evades arrest by single-handedly incapacitating a police squad and leaping impossible distances across rooftops, before disappearing in uncertain circumstances. A sleeping computer hacker, Neo, is woken by an instruction on his computer screen and meets the same woman in a nightclub, where she reveals herself to be a fellow hacker called Trinity. She is a member of a resistance group, led by the mysterious Morpheus, who claim to offer Neo a 'truth' that, on some level, he already seeks. Unfulfilled in his day job and pursued by agents for his illegal hacking activities, Neo accepts this offer. He discovers that the everyday reality he is familiar with is a mass hallucination generated by intelligent machines that are using human beings as a power source. Unplugged from this dream world, and identified as special by the resistance group, Neo begins a journey to explore the extent of his own abilities to resist the dream world and the agents that police it, and to resist the machines that are hunting down rebel humans in the real world.

Editor:

Zach Staenberg

Duration:

144 minutes

Cast:

Keanu Reeves
Laurence Fishburne
Carrie-Anne Moss
Hugo Weaving
Gloria Foster
Joe Pantoliano

Year:

1999

Critique

A sleeper hit aided by an ingeniously opaque teaser campaign, *The Matrix* gradually garnered significant box office takings due to its combining of popular genre elements with themes that chimed with the concerns of the millennial 'zeitgeist' of 1999. Using the generic frame of dystopian science fiction, the film explored anxieties about privacy, surveillance, identity and empowerment that had been circulating in the wider culture in response to the developing ubiquity of web technologies, themes addressed in other 1999 movies like *The Truman Show* and *Dark City*. But a number of crowd-pleasing ingredients were also in the mix, from the cult appeal of martial arts combat to hyper-stylish costumes, sunglasses and mobile phones. In addition, the 'bullet time' special effect, which seemed to bend space and time to its will in a way barely witnessed before, provided a compelling 'shock of the new'. The bullet-time's narrative placement – each moment a character attempts to bend the rules of the Matrix universe to exert control over their circumstances – coupled with the visual mastery the effect promised the spectator, caused it to resonate unusually strongly with the film's thematic preoccupation with control and its loss in a technologically mediated world.

The Matrix knowingly foregrounds its progressive aspects: self-consciously reversing traditional gender roles through the pairing of its bewildered, initially weak male protagonist with a physically- and mentally-tough female; assembling an ethnically-diverse human resistance team; and a central philosophical enquiry into perception and existence in a mediated culture that sparked myriad meditations from philosophers of film. But in other ways the film possesses a more traditional and rather conservative profile: adhering to consumerist principles in its product endorsements and provision of stock cinematic pleasures such as sexual objectification and spectacular special effects, *The Matrix* also presents a conventional narrative trajectory preoccupied with the (nominally) white male hero's journey towards empowerment. Neo's rise at the film's end re-imposes a familiar and reactionary hierarchy: the female hero Trinity is demoted to love-interest and sidekick, while the inspirational African-American resistance leader Morpheus is designated a limited helper role. *The Matrix* was itself capitalizing on existing representational trends in constructing its own 'progressiveness' – the multiplicity of female action heroes on 1990s' television and growing diversity of roles for African-Americans in 1990s' Hollywood, for example – but despite its conservative narrative 'containment' of Trinity and Morpheus, they became integral elements of the film's iconography. In this way *The Matrix* added further momentum to the (still somewhat limited) ethnic and gender diversification in subsequent Hollywood representation.

Catching the public's imagination – and its tastes – with uncanny accuracy, the film's cultural impact far outweighed its initial box-office takings: references to *The Matrix* soon proliferated across Western media culture after its release and found their way into subsequent Hollywood productions, from direct 'bullet-time' homages in *Charlie's Angels* (2000) and *Swordfish* (2001) to the art direction and action-sequence choreography of films like *Equilibrium* and the *Underworld* movies (2003 & 2006). But, arguably, the movie's most influential legacy is on franchise film-making and multi-platform, multi-media marketing and delivery. Moving quickly to build on the cultural capital of the original film, two sequels were rushed into production back to back and the narrative 'world' of the Matrix grew to encompass video games, web sites, animated films, and graphic novels, with some narrative material only accessible through these ancillary texts. A hugely-profitable strategy, this showed just how extensively studios could exploit synergistic integration for both cross-media marketing and sales, and many franchises have tried to repeat its success since.

Lisa Purse

Planet of the Apes

Studio/Distributor:

20th Century Fox

Director:

Franklin J Schaffner

Producer:

Arthur P Jacobs

Screenwriters:

Michael Wilson
Rod Serling
Based on a novel by Pierre Boulle

Cinematographer:

Leon Shamroy

Art Director:

William Creber
Jack Martin Smith

Composer:

Jerry Goldsmith

Synopsis

Astronaut Taylor and his crew crash land on an unknown planet, their instruments indicating that they have travelled some 2,000 years into the future. Exploring the planet, the astronauts encounter a group of primitive mute humans living in the jungle. Upon discovering the group, the astronauts (and other humans) are attacked by uniformed gorillas on horseback. Wounded in the throat and unable to speak, Taylor is caged by the talking apes, and given a human mate, Nova. In the ape city, Taylor is befriended by chimpanzee psychologist Zira and her fiancé Cornelius, who recognize his intelligence and speculate that he may be a missing link in ape evolution. Having regained his speech, Taylor addresses the ape high counsel, but angers orangutan elder Zaius, who sees intelligent humans as a threat. Accused of heresy, Zira and Cornelius help Taylor and Nova escape, and all four flee to the desolate Forbidden Zone. Pursued there by Zaius, Taylor finds archaeological evidence that proves human civilization preceded that of the apes. Leaving the apes, Taylor and Nova make their way further along the coast to discover the real truth and what planet he had landed on.

Critique

Planet of the Apes is based on Pierre Boulle's 1963 novel *La planète des singes*/*Monkey Planet*, a tale of three twenty-sixth-

Editor:

Hugh S Fowler

Duration:

112 minutes

Cast:

Charlton Heston
Roddy McDowall
Kim Hunter
Maurice Evans
Linda Harrison

Year:

1968

century French explorers, led by Ulysse Mérou, who land their craft on a planet inhabited by mute humans of low intelligence and ruled by apes – militaristic gorillas, scholarly chimpanzees and conservative orangutans – in a society not unlike the one left behind on Earth. While retaining key plot elements and characters from Boulle's novel, the film version – developed from a draft screenplay by *The Twilight Zone* (1959–1964) creator, Rod Serling – introduces a number of significant transformations. Most significant of these is the shock revelation of the film's unique ending in which Taylor escapes to the desolate forbidden zone only to discover evidence – in the form of a time-ravaged Statue of Liberty – that ape society has evolved from a planet Earth, devastated by a human propensity for war.

The ending of *Planet of the Apes* is but one – albeit, the most famous – element in the film's (and of the *Planet of the Apes* series) larger interest in apocalyptic images of catastrophic race wars and global nuclear devastation. Unlike the convivial Mérou of *Monkey Planet*, who comes to respect the dominant species, the anti-hero Taylor (especially as filtered through the hubristic screen persona of Heston) has only hatred and contempt for his captors, as evinced in a signature line: 'Get your stinking paws off me, you damned dirty ape!' The misanthropic Taylor has a similar enmity for his twentieth-century counterparts, expressing hope that humans of the future will be a different 'breed', and (upon arriving on the planet) says: 'I can't help thinking that somewhere in the universe there has to be something better than man … has to be'. Set amongst American social and political upheavals of the sixties – civil rights movement, Vietnam-war protests, and (later) Watergate scandal – comments such as these often led to *Planet of the Apes* being read as a liberal allegory of power struggles, racial conflict, and Western imperialism.

Director Franklin Schaffner has said that *Planet of the Apes* was first of all 'a political film, [one] with a certain amount of Swiftian satire, and perhaps science fiction last', but the movie's political message was clearly never meant to overwhelm its schlock science fiction and entertainment value. Although the film's ending seemed to leave little room for a sequel, outstanding box-office returns prompted the producers to commission ideas for follow-up adventures, including (abandoned) treatments from Boulle and Serling. The sequel, *Beneath the Planet of the Apes* (1970) launched the franchise into the 1970s and was followed by three further sequels (1971–1973), live action and animated television series (1974 and 1975–1976), comic books and serialized adaptations. The endless recycling of Apes iconography perhaps found its most popular expression in *The Simpsons* (season 7, 1996), where it was reinvented as an 'all-singing, all-dancing' Broadway musical entitled, 'Stop the Planet of the Apes, I want to get off!', and culminated in the big-budget, 2001 Tim Burton remake.

Constantine Verevis

Star Trek: The Motion Picture

Studio/Distributor:
Paramount Pictures

Director:
Robert Wise

Producer:
Gene Roddenberry
Jon Povill
David C Fein (2001 Director's Edition)

Screenwriter:
Harold Livingston (screenplay)
Alan Dean Foster (story)
Gene Roddenberry (original concept)

Cinematographer:
Richard H Kline

Art Directors:
Leon Harris
Joseph R Jennings
John Vallone

Editor:
Todd C Ramsay

Duration:
132 minutes (theatrical),
136 minutes (2001 Director's Edition)

Cast:
William Shatner
Leonard Nimoy
DeForest Kelly
Nichelle Nichols
Stephen Lang

Year:
1979

Synopsis

The twenty-third century: Starfleet detects a massive energy cloud that is wiping out everything in its path, and headed towards Earth. Admiral James T Kirk (formerly Captain of the starship *Enterprise*), now head of Starfleet Operations in San Francisco, retakes command of his former ship to investigate and, in the process, reunites with his old crew Dr McCoy, Uhura, Scotty, Sulu, Chekhov, and the Vulcan called Spock. The familiar crew from the original *Star Trek* television series are joined by Willard Decker (current Captain of the *Enterprise*) and the ship's current navigator, a Deltan named Ilia. As Kirk and the crew travel closer to the energy signal, they discover that it is caused by a living machine called V'ger, and they attempt to communicate with it. Spock attempts a lone spacewalk into V'ger's central system, and Ilia is abducted by a probe from the machine. The entire crew learns surprising revelations about the nature of the new lifeform and their own relationships.

Critique

Practically a decade in the making, this inaugural *Star Trek* feature film (the first of ten feature films in this cycle, followed by a franchise 'reboot' in 2009) struggles to establish its television-born characters on an epic widescreen scale, relying on Wise's steady (if often slow-paced) direction, Douglas Trumbull's innovative and sometimes trippy visual effects, and Jerry Goldsmith's stirring music score (which would become the main theme to the franchise's next television and film incarnation, *The Next Generation*) to keep its narrative moving. Beginning life in 1975 when *Star Trek* creator Gene Roddenberry convinced Paramount to begin developing a feature film (the studio was also inspired by the show's syndication numbers), the project changed into a *Phase II* television series when the studio wanted to launch a new Paramount television network; later, a low-budget film was conceived by various writers and executives and worked on briefly by director Philip Kaufman, but finally the studio arrived at the concept of an epic science fiction tale in the vein of films like *2001: A Space Odyssey* (1968) and *Star Wars* (1977). While *The Motion Picture*'s story holds some intrigue, the chemistry between the actors seems non-existent for such an interesting reunion (though this would be much improved with the next instalment, *Star Trek II: The Wrath of Khan* [1982]), and the costumes and set design arguably fail to enhance the atmosphere. Fraught with production problems, behind-the-scenes arguments and creative setbacks, *The Motion Picture*'s budget ballooned to $46 million (enormous for its time), and the film struggled to make its December 1979 release date. Though seemingly a financial success with

$139 million worldwide in theatres, critical and box office performance fell short of studio expectations; Paramount agreed to do a sequel, but on a drastically-reduced budget.

However, *The Motion Picture* does have its engaging and iconic moments, including Kirk's first ride to the new *Enterprise* (a moment cannily referenced and repeated in the 2009 re-start), which feels like an epic in itself and suitably rewards fans of the television series, who were also seeing the signature ship for the first time on the big screen. Also notable are Leonard 'Bones' McCoy's arrival amidst faulty transporter technology, and Spock's spacewalk sequence, which was completely reconceived from its original concept and re-designed by Douglas Trumbull in post-production (the film was nominated for three Academy Awards, including one for visual effects). Two major featured cast members not part of the original series also make valuable contributions to the film: Stephen Collins's Captain Decker functions as kind of viewers' eye into the story for anyone unfamiliar with *Trek*, and Persis Khambatta (a holdover from the production of the *Phase II* television pilot) contributes a stoic grace and an equally cold demeanour when required, playing Ilia, the ship's navigator, whose corporeal body and voice become a central part of the film's narrative. Despite its faults, the film's importance in establishing and renewing a unique, long-running theatrical and television science fiction franchise cannot be overstated. Wise supervised a Director's Edition restoration in 2001 which runs four minutes longer and contains 90 new and digitally-enhanced visual effects, which the majority of viewers feel improve the film's legacy.

Michael S Duffy

The Terminator

Studio/Distributor:

Hemdale Film
Pacific Western
Orion Pictures Corporation (US theatrical distribution)
J Arthur Rank Film Distributors (UK theatrical distribution)

Director:

James Cameron

Producers:

Gale Anne Hurd
John Daly
Derek Gibson

Synopsis

In 2029, an artificial intelligence computer system named Skynet has instigated a nuclear catastrophe and caused near-annihilation of the human race. A small band of resistance fighters led by John Connor attempts to fight back and keep hope alive. The conquering machines have also discovered time travel, and have sent a nearly-unstoppable cybernetic organism known as a Terminator back to 1984 to kill John Connor's mother, Sarah, before he is born. Kyle Reese, a resistance soldier from the future, is also sent back to 1984 by John Connor to find and intercept Sarah Connor before the Terminator reaches her. A relentless chase ensues where Kyle and Sarah must always stay one step ahead of the Terminator in order to survive.

Screenwriters:

James Cameron
Gale Anne Hurd
William Wisher
Harlan Ellison (originally uncredited)

Cinematographer:

Adam Greenberg

Art Director:

George Costello

Editor:

Mark Goldblatt

Duration:

108 minutes

Cast:

Linda Hamilton
Arnold Schwarzenegger
Michael Biehn
Paul Winfield
Lance Henriksen

Year:

1984

Terminator 2: Judgment Day

Studio/Distributor:

Carolco Pictures
Pacific Western
Lightstorm Entertainment
Canal+
TriStar Pictures

Director:

James Cameron

Producers:

James Cameron
Stephanie Austin
BJ Rack
Gale Anne Hurd
Mario Kassar

Screenwriter:

James Cameron

Synopsis

Eleven years after the present-day events of *The Terminator*, Sarah Connor is in a mental asylum, and her ten-year old son John Connor is living with a foster family and keeping a low profile. When a new advanced prototype Terminator shows up from the future and begins to pursue John, he reunites with his mother and meets a new T–800 Terminator (the model that attempted to kill Sarah in the first film), which has also been sent back in time and reprogrammed to protect John. They are pursued by the T–1000 as they attempt to figure out additional ways to prevent Skynet from taking over every computer system in the world.

Critique

The success of the first low budget *Terminator* film helped launch the Hollywood careers of both Cameron and star Arnold Schwarzenegger, who makes an indelible impression in a role that required him to remain stone-faced and largely monosyllabic for the entire running time. Cameron initially had a completely futuristic story in mind, but the $6 million budget forced him to refashion the narrative around modern-day settings,

Cinematographer:
Adam Greenberg

Art Director:
Joseph P Lucky

Editors:
Conrad Buff
Mark Goldblatt
Richard A Harris
Dody Dorn (Special Edition)

Duration:
137 minutes (theatrical)
152 minutes (Special Edition)

Cast:
Arnold Schwarzenegger
Linda Hamilton
Edward Furlong
Robert Patrick
Joe Morton

Year:
1991

anchored with a time-travel conceit which arguably gives urgency to the present-day plot. Schwarzenegger's Terminator, a cybernetic organism with human skin, is sent back in time to prevent resistance leader John Connor from being born, but does not count on future mother Sarah Connor having a protector in the form of Kyle Reese, a soldier also sent back by John to protect her. The film's futuristic 'flash-forwards' are potent despite the lack of film-making resources, and the present-day scenes achieve an aesthetic and thematic intensity that would become a Cameron trademark. The film is tightly wound and edited, and uses its urban locations and settings to every advantage. Also impressive are the special effects and make-up work, particularly the detailed gradual destruction of the Terminator's face, skin and body parts, accomplished through a combination of practical prosthetics and animatronics. As much as the film's sequel heralds the digital changeover in visual-effects approaches, this first entry in what would become a successful franchise makes a strong claim for utilizing practical techniques whenever possible. Schwarzenegger's line 'I'll be back' has become one of the most famous catch-phrases in cinematic history, and Brad Fiedel's innovative and haunting electronic score is immediately recognizable to this day.

Science fiction author Harlan Ellison threatened a lawsuit against the studio and Orion Pictures (the initial US distributor), claiming Cameron used significant ideas from two episodes of the television series *The Outer Limits* (1963-1965) that he wrote; the parties settled out of court, and all subsequent prints and home video editions of *The Terminator* have included an acknowledgement to Ellison on the end credits. During a nine-month delay in the start of production, due to Schwarzenegger's commitment to filming *Conan the Destroyer* (1984), Cameron took the job of scripting *Aliens* (1986), the sequel to Ridley Scott's *Alien*, which he would go on to direct following *The Terminator*. Schwarzenegger and Cameron collaborated on the very successful sequel.

An enormous success both critically and financially, *Terminator 2: Judgment Day* ushered in a new era in special-effects-driven blockbuster cinema; unlike most of its followers, however, *Terminator 2*'s characteristic visual effects are backed up by a narrative which gives them justification to exist and evolve. At the time, it was thought to be the most expensive movie ever made at an approximately $100 million cost, but *Terminator 2* was hugely profitable worldwide and on home video. While Schwarzenegger agreed to return to the franchise that helped make him a star, it was with a twist: this time, he is a heroic figure, protecting John and Sarah Connor and facing off against a technologically-superior Terminator, played by Robert Patrick. From the moment Schwarzenegger's Terminator tells Sarah Connor 'Come with me if you want to live' – repeating Kyle Reese's first line to her in the original film – we are along for the ride. The performances (with the possible exception of Edward Furlong) are uniformly

strong and committed, and every penny of the film's expensive production seems to be onscreen. Joe Morton is particularly memorable as Dr Miles Bennett Dyson, the systems engineer who is unknowingly helping to create the computer system that will eventually take over the world. Michael Biehn reprised his role of Kyle Reese from the first film for a one-scene dream sequence, which was cut from the theatrical version of the film but restored in various extended editions since. The steel mill location for the finale has been copied by innumerable action films since, including the incorporation of a similar setting for one of the final sequences in *Terminator Salvation* (2009), the fourth film in the series. Editors Conrad Buff, Mark Goldblatt and Richard Harris all worked on different segments of *Terminator 2* to get it finished in time for its theatrical release, but there is a clear stylistic continuity throughout. *T2* (as it came to be known in marketing shorthand) was nominated for six Academy Awards, winning four, including 'Best Achievement in Visual Effects'.

Over 300 visual-effects shots were required for the film (about a quarter of what is budgeted for a major franchise film these days), and Industrial Light & Magic's team significantly expanded to handle the task of computer-generating the morphing effects for the T–1000, even though the total amount of screen time for the digital versions of the character amounted to around six minutes. Much of the celebrated effects-heavy sequences in *T2* are in fact largely practical (in-camera/on-set) techniques, such as a moment where the T–1000 is split in half by an axe from his head down. Stan Winston and his team designed most of the practical effects, including a stunningly-realistic and gruesome inside view of the T–800's cybernetic arm. Robert Patrick reprised the T–1000 character for a silent cameo in director John McTiernan's *Last Action Hero* (1993), Schwarzenegger's playful send-up of his own career. In 1996, Universal Studios Theme Parks in Florida opened the attraction *T2 3D: Battle Across Time*, a half-hour interactive experience containing a new 12-minute film directed by Cameron, with Schwarzenegger, Hamilton, Furlong and Patrick reprising their roles; the attraction opened at Universal's parks in Hollywood in 1999 and Japan in 2001.

Cameron left the franchise, but Schwarzenegger starred in Jonathan Mostow's *Terminator 3: Rise of the Machines* (2003), and his character reappeared briefly in *Terminator: Salvation* (2009) via digital facial recreation of Schwarzenegger's younger persona (as positioned over a body double). The franchise has spawned numerous video games and comic books, and there was also a brief television series, *Terminator: The Sarah Connor Chronicles* (2008–2009), which loosely fits into the movie continuity. The rights to the franchise have been transferred through various parties over the years; it remains to be seen whether another film will be made.

Michael S Duffy

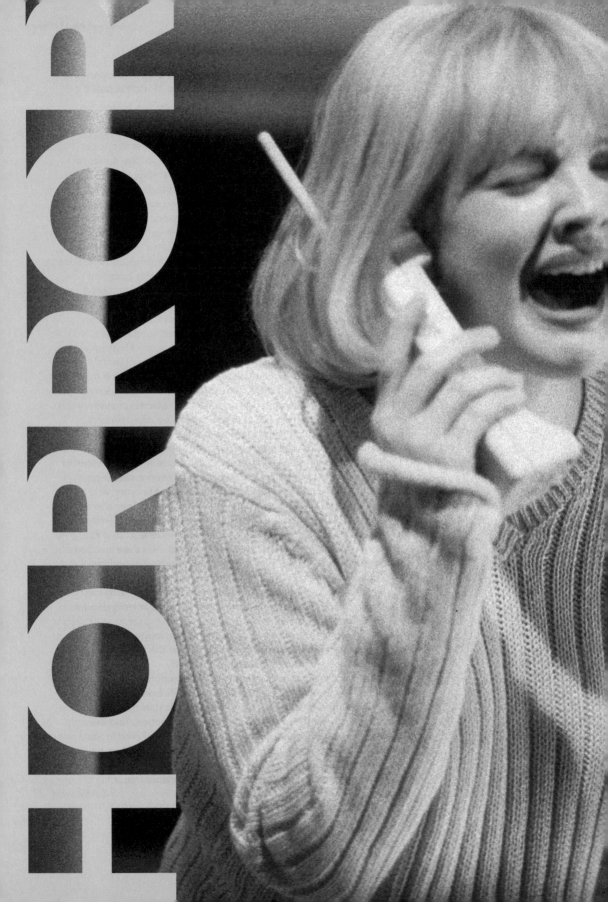

The history of Hollywood horror film is marked by periods of innovation and appropriation, a process of interpretation and eventual integration into all forms of American popular culture. Indeed, the very notion of a definable generic category for American studio horror film is tricky, given the entwined 'independent' and 'mainstream' interest in production and distribution that we see currently in such films as the *Saw* series (2004–2010), and the careers of Wes Craven, David Cronenberg, Alfred Hitchcock and others who have moved between independent production and studio productions. The boundaries are further blurred when we consider that many other generic categories contain elements of horror – notably in science fiction.

The establishment of the American 'so-called horror' films, as they were tentatively described by reviewers, were promoted and produced as a specific genre in the 1930s when larger studios instigated a concerted period of production. Individual horror films had already been present in American film, notably the Edison Company's *Frankenstein* (1910), and the particular influence of German Expressionist film, including *Nosferatu* (1922) and *The Cabinet of Dr Caligari* (1920) had instigated a migration of personnel, horrific ideas and aesthetics across the Atlantic from the 1920s onwards. Their influence can be traced in films such as MGM's *London After Midnight* (1927) and Universal's *The Cat and the Canary* (1927). Lon Chaney, an actor noted for his attention to physical deformity in such roles as Erik in Universal's *The Phantom of the Opera* (1925) also indicates that monsters and madness were present in American film before the period now known as the 'Golden Age' of studio horror film.

However, the 1930s were notable for the number of horror films produced, which quickly established a series of representations of the monstrous which resonate throughout American horror culture. This began with Universal's *Dracula* (1931), *Frankenstein* (1931), and Paramount's *Dr Jekyll and Mr Hyde* (1931). These films, and those that followed, are important for several reasons. Firstly, they were a conscious strategy by studios to market their product as a category different from other, rival studios. Secondly, these were interpretations from established cultural texts (novels by Stoker, Shelley and Stevenson) that offered a well-known narrative to the audience: a comfort of familiarity that could be updated to fit with contemporary styles and concerns. Thirdly, the visual and aural representations in these films drew heavily upon the new technologies available to directors, notably in the control of the lighting and set design, the costume and make-up of the creatures and, increasingly, on the effects of unease that could be created through sound.

The 'Golden Age' lasted until the 1940s, when the re-representations of key horror figures (notably Dracula, Frankenstein's Monster and the Wolfman) in a variety of sequels indicated that the studios chose to rely on these texts as secondary attractions. Increasingly, horror film production moved into the province of smaller studios and film units designed to supplement the larger productions offered by the main studios. As a result, the 1940s are marked by a series of low-budget, yet occasionally stylish and atmospheric, horror films, notably from the director-producer team of Jacques Torneur and Val Lewton for Radio Keith Orpheum (RKO) between 1942 and 1946. Their work,

Left: *Scream*, 1996, Miramax.

which emphasized the psychological affects of terror, includes the restrained, yet emotive *Cat People* (1942) and *I Walked With a Zombie* (1943). The popularity of science fiction film in the 1950s also supplanted horror as a key genre, though horror film did not disappear. It remained in the shadowy world of B-film production, especially in the 'Carny Barker' productions of William Castle. Horror narratives also influenced many of the popular science fiction films in their representations of the monstrous, and in the realms of popular fiction, as evidenced by the works of Richard Matheson, the EC Horror comics, and the movement of horror into television.

Main studio productions of horror resurfaced in the 1960s, but only as a gradual process. The influence of *Psycho* (Alfred Hitchcock, 1960) cannot be underestimated, but this was only part of an overall cultural shift in the discussion of the horrific. The importation of cheaper horror films from Europe, notably the British Hammer horror films, and the co-productions between American and European studios meant that horror was still in limbo, stuck between independent production and main studio interest. This meant that many later directors of horror film learned their craft in restricted production contexts, influenced by the colourful representations available in B-Movie theatres. Similarly, those directors in independent horror film (notably George Romero, David Cronenberg and Tobe Hooper) were producing works unrestrained by the dictates of larger studios. This, coupled with a crisis in American film censorship, meant that discussions and visual representations of the horrific could become more explicit.

From the 1970s onwards we can trace the influence of both New Hollywood and European horror in the graphic portrayal of sex and destruction apparent in horror film, particularly in the emergence of the 'Slasher' sub-genre and the interest in 'Body' horror. This left the genre open for a variety of narrative and visual concerns, from reworkings of the 'traditional' monsters to detailed explorations of disease, possession and the psychotic. However, what is notable is the repetition of production influences in many of these films: the use of popular literature as a basis for the plot; the interest in foreign horror (most recently J-horror); the gradual establishment of a new group of directors as horror filmmakers; and the use of new technologies to display the horrific. In particular, the emphasis on special effects in make-up and CGI mean that Hollywood horror is now notable for the emphasis placed on visual excess in narratives and representations of the monstrous, a key facet of films of the 1980s and 1990s.

In more recent years the diversity of horror in both independent and studio based productions means that new sub-genres have appeared, including the widely criticized notion of 'Torture Porn' (particularly in the *Saw* series and the *Hostel* films [2005, 2007]), but at the same time a new strand of harrowing first-person (video diary) perspectives, seen in such films as *The Blair Witch Project* (1999), *Diary of the Dead* (2007), *Cloverfield* (2008) and *Paranormal Activity* (2009), have become increasingly evident. Whatever the next evolution of the genre is, horror's ongoing popularity indicates an assured future of cinematic nightmares.

Emma Dyson

Dracula

Studio/Distributor:
Universal Pictures

Director:
Tod Browning

Producers:
Tod Browning
Carl Laemmle Jr

Screenwriter:
Garrett Fort

Cinematographer:
Karl Freund

Art Director:
Charles D Hall

Editor:
Milton Carruth

Duration:
75 minutes

Cast:
Béla Lugosi
Helen Chandler
David Manners
Dwight Frye
Edward Van Sloan

Year:
1931

Synopsis

Renfield, a solicitor, travels to the remote castle of Count Dracula to finalize Dracula's purchase of Carfax Abbey in England. After signing the papers, Renfield is attacked by Dracula, and helps with his destructive journey to England. While Renfield is incarcerated in an asylum, Dracula involves himself in society, becoming introduced to a group of people including Mina Seward, Lucy Weston and John Harker, Mina's fiancé. Fascinated by Dracula, Lucy becomes his victim. Meanwhile Professor Van Helsing has become interested in Renfield's obsessions, and deduces the influence of a vampire. He confronts Dracula with this knowledge, little aware that Mina is now under his influence. As Dracula's hold on her grows stronger, Van Helsing destroys Dracula's resting place in Carfax Abbey. Renfield's devotion to his master causes him to escape the asylum, leading Van Helsing and Harker to their final confrontation with Dracula, who is gaining complete control over Mina.

Critique

This filmic presentation of *Dracula* was not the first in cinematic history. FW Murnau's *Nosferatu* (1922), a barely-concealed reworking of Bram Stoker's text, was sued by his widow for copyright infringement. Carl Laemmle Jr, aware of this, and also the popularity of silent horror films such as *The Phantom of the Opera* (1925), acquired the rights to Stoker's story, but decided to base the narrative on the popular stage play by John L Balderston. This extended to Browning's re-use of cast members – Lugosi and Van Sloan reprise their respective roles in the film, and the now-iconic formal dress Dracula wears was also first present in the stage production of *Dracula*. Browning was also revisiting the atmospheric settings of his earlier film, *London After Midnight* (1927), the now-lost film starring Lon Chaney which featured vampire-like characters. Browning pays homage to *Nosferatu*, notably in the scene where Dracula is attracted by Renfield's cut finger and in the atmospheric framing of Dracula within the various arches and stairwells of his castle and Carfax Abbey.

The contrasts between the brightly-lit drawing rooms of Dr Seward's home, the confines of the mental asylum and the shadowed spaces of Dracula's castle indicates Browning's fascination with the gothic elements of the film and provides many of its iconic moments, especially the first introduction to Dracula. The casting of Béla Lugosi as the Count was an inspired choice. Although not Laemmle or Browning's preferred actor (Lon Chaney was dying of throat cancer) Lugosi provided a deliberately-mannered performance of stately movements and foreign 'otherness' in his accent. Browning's most obvious attention to Dracula lies in the repeated close-ups of his eyes, highlighted by beams of light to convey his hypnotic power. This became a noted motif in the horror films which starred Lugosi after *Dracula*, reflecting on his hypnotic presence within the genre.

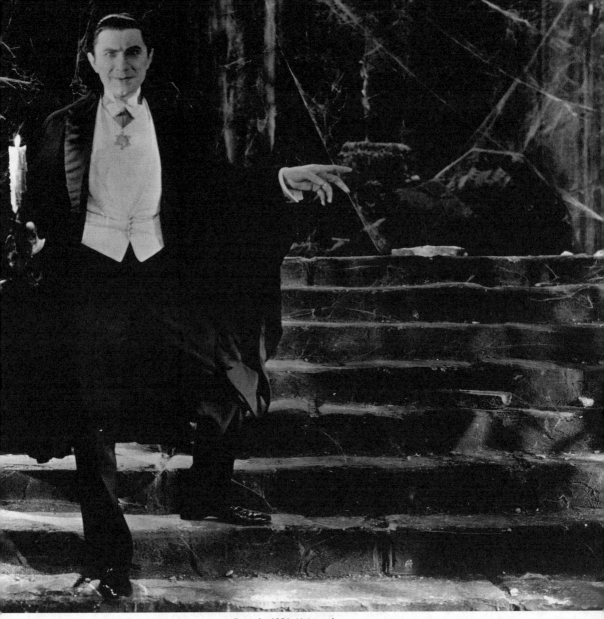

Dracula, 1931, Universal.

This focus on the hypnotic gaze and its power over potential victims deliberately invoked the sexual presence of the vampire and his attractiveness, which became a key thematic concern of later vampire films, both in America and elsewhere, and can be noted in films as diverse as the Hammer Studios *Dracula* films, *The Lost Boys* (1987) *Interview With The Vampire* (1994), and *Twilight* (2008). Censorship constraints of the time made the discussion of sexual arousal in *Dracula* impossible, yet Browning emphasizes the attraction between Dracula and his female victims, and the concern this causes the other males in the film. He also pays particular attention to the madness and isolation

of Renfield, echoing similar discussions of madness found in German Expressionist films, but also a repeated motif in *Frankenstein* (1931) of the same year.

Browning's career faltered after the commercial failure of *Freaks* (1932) and, after a series of small films such as *Mark Of The Vampire* in 1935 and *Devil Doll* (1936), he finished directing with *Miracles for Sale* (1939). Instead, others took over the profitable Universal *Dracula* series, starting with *Dracula's Daughter* (1936) and ending with the comedic *Abbott and Costello Meet Frankenstein* (1948). While the 1940s may have been the end of *Dracula* films for Universal, the iconic shadow of Count Dracula would remain strong throughout American popular culture – and beyond – for a long time to come.

Emma Dyson

The Exorcist

Studio/Distributor:
Warner Bros

Director:
William Friedkin

Producers:
William Peter Blatty
Noel Marshall
David Salven

Screenwriter:
William Peter Blatty

Cinematographer:
Owen Roizman

Editors:
Norman Gay
Evan A Lottman

Composer:
Steve Boeddeker

Duration:
122 minutes

Cast:
Ellen Burstyn
Linda Blair
Jason Miller
Max von Sydow

Year:
1973

Synopsis

Chris MacNeil, Hollywood star and lone mother, suspects that something is very wrong with her 13-year-old daughter, Regan. When top medical minds are baffled by Regan's violent outbursts and by her transformation from pretty girl to ghoulish banshee, Chris turns in desperation to the Catholic Church. Convinced that Regan is a victim of demonic possession, she meets Father Damien Karris, a Jesuit Priest wrestling doubts about his own faith, to persuade him that only an exorcism can save her child. Putting aside his scepticism, Karris arranges for one of the few men to have conducted the ritual, the elderly Father Lankester Merrin, to join him to confront an ancient and powerful evil – a confrontation from which nobody will emerge unscathed.

Critique

Few films have left such an indelible mark on American film culture as the controversial horror blockbuster *The Exorcist*.

In 1973, Academy Award-winning director William Friedkin's adaptation of William Peter Blatty's best-selling novel was quite simply taboo-breaking. The film's provocative cocktail of blasphemous material, obscenity-ridden dialogue and depictions of bloody violence committed by and against a young girl was like nothing that a Hollywood studio had released before. Catholic organizations condemned the filmmakers' portrayal of Christianity while other groups protested that, rather than having been awarded the R-rating that had permitted it entry into upmarket theatres and shopping-mall multiplexes, *The Exorcist* should have received the X-rating which was usually reserved for hardcore pornography and which would have confined it to drive-ins and grind-houses. Indeed, so powerful was *The Exorcist*'s mixture of religion and

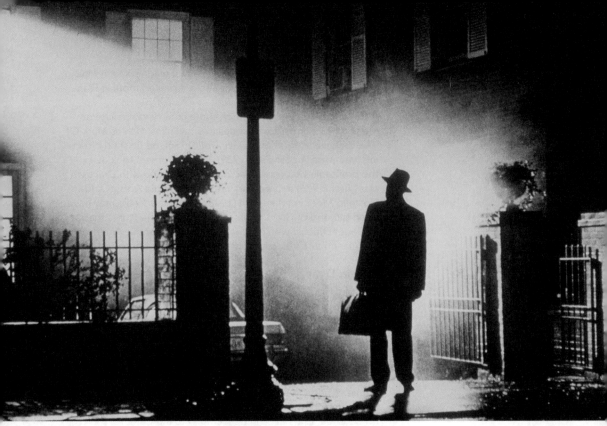

The Exorcist, 1973, Warner Bros.

horror that it remained unavailable for home viewing in Britain until 1999.

The controversy that the film stirred was topped only by the quantities of tickets it sold. At a time when Hollywood was emerging from financial crisis and was still figuring out how best to serve a new, younger and better educated 'baby boomer' audience, *The Exorcist* was a huge gamble that paid off handsomely. Taking inflation into account, it is the ninth highest-grossing film in the history of the American theatrical market, having out-performed by a quarter of a billion dollars blockbusters such as *Mary Poppins* (1964), *Grease* (1978) and *The Dark Knight* (2008). In fact, *The Exorcist* remains Warner Bros' top-grossing release and the most financially-successful horror movie ever made.

The Exorcist initiated a lasting shift in Hollywood's business practices by confirming the commercial potential of making big-budget supernatural horror for a mixed-sex adult audience – a development that had been signalled by director Roman Polanski's 1968 hit *Rosemary's Baby*. Thanks to *The Exorcist*, prestige horror, albeit stripped of genuinely controversial material, became an important part of Hollywood's repertoire across the 1970s, resulting in films like *The Omen* (1976) and *The Amityville Horror* (1979). Hollywood has returned consistently to the production of such films, from

Dracula (1992) to *The Sixth Sense* (1999) and *The Ring* (2002). Indeed, when prestige horror has been considered particularly profitable, new *Exorcist* films have been made. Yet neither the commercial and critical debacles that were *Exorcist II: The Heretic* (1977), *Exorcist III* (1990), *Exorcist: The Beginning* (2004) and *Dominion: Prequel to the Exorcist* (2005) nor, for that matter, the parody *Repossessed* (1990), have taken away the power of the original, which remains one of Hollywood's most lucrative, shocking and compelling films.

Richard Nowell

Frankenstein

Studio/Distributor:

Universal Pictures

Director:

James Whale

Producer:

Carl Laemmle Jr

Screenwriters:

Garrett Fort
Francis Edward Faragoh

Cinematographer:

Arthur Edeson

Art Director:

Charles D Hall

Composer:

Bernhard Kaun

Editor:

Clarence Kolster

Duration:

70 minutes

Cast:

Colin Clive
Mae Clarke
John Boles
Boris Karloff
Edward Van Sloan
Dwight Frye

Year:

1931

Synopsis

Henry Frankenstein is close to madness, attempting to create human life through electricity and parts of dead bodies. His assistant Fritz mistakenly provides a criminal brain for the creation. When the final process is finished, witnessed by Henry's fiancée Elizabeth, her friend Victor Moritz and Henry's old professor Dr Waldman, the Monster reacts to fire with fright, and is immediately imprisoned in a dungeon, where he is tormented by Fritz. While Henry recovers and prepares for his wedding to Elizabeth, the Monster escapes after strangling Dr Waldman. He wanders the countryside, accidentally causing the death of a little girl. Eventually, tired and enraged, he finds the house where Victor and Elizabeth are staying, and nearly kills Elizabeth. Henry pursues the Monster, is caught by him and eventually the two confront each other in an abandoned mill. However, Henry is not alone, as a local band of peasants are following them and bear down on the mill with flaming torches.

Critique

This horror film by James Whale offers the first Hollywood-created horror icon, in the shape of the Monster (Boris Karloff). While *Dracula* reinterpreted the imagery associated with theatrical productions of Stoker's book, in the performance by Karloff (assisted by the make-up effects by Jack Pierce) we have an innovative presentation of the tortured monster, a visual symbol of the narrative of isolation and madness that is *Frankenstein*. Both films were released in the same year, a conscious decision by Carl Laemmle Jr, the controller of Universal, to challenge the dominance of the major studios through the marketing of genre films. However, they are markedly different in tone and presentation. *Frankenstein* does not rely so heavily on verbal exposition to forward the plot, instead focusing on stark set designs and symbolism, with Henry Frankenstein literally and figuratively flinging dirt in the face of death.

Elements of Mary Shelley's original text are there, but the interplay between Henry Frankenstein and the Monster remains a neglected part of the narrative, which, instead, focuses on the romantic relationship between Frankenstein and Elizabeth. At this stage in Hollywood horror film, this was felt necessary to engage the audience and maintain a moral structure to the film. What the film is remembered for, however, is the pained, shambling spectre of the Monster, aimlessly looking for his position in a world which rejects and, in the case of Fritz, abuses him. The film emphasizes this emotional rejection and the Monster's growing anger by shifts between light and dark, notably in the (originally heavily-censored) scene where the Monster plays with the little girl, and the set design in the castle, where the trappings of modern science contrast with the gloomy medieval stone. Indeed, Whale's attention to contrasts is marked throughout this film: in terms of the descent of Frankenstein into madness, the darkly humorous mishandling of the brain by Fritz, and the final confrontation at the windmill.

This thematic and visual attention to shifts in tone marks the majority of Whale's work in horror film, including the sequel *Bride of Frankenstein* (1935) and the bitter misanthropy of *The Invisible Man* (1933). While *Bride of Frankenstein* used campness to undercut the menace posed by both the mad scientist and the monster, we can see in *Frankenstein* Whale's attention to exploring the notion of monstrosity – in both humans and the resurrected dead. Unfortunately Whale's career within Hollywood was limited during the 1930s, and he stopped involvement with the *Frankenstein* series after *Bride*. However, within these limitations, Whale contributed to an important aspect of early American horror film: the translation of visual aesthetics and themes of madness present in German Expressionist films that set the tone for the 'Golden Age' of American horror. The figure of the Monster also remained potent, with his pained lumbering repeated in such films as *Son of Frankenstein* (1939) *Abbott and Costello Meet Frankenstein* (1948) and in the more recent *Van Helsing* (2004). The sympathetic representation of his torment was not immediately replicated, but did offer a potential interpretation of the monster-as-misunderstood that other films could, and eventually did, undertake.

Emma Dyson

Poltergeist

Studio/Distributor:

MGM/UA

Director:

Tobe Hooper

Producers:

Frank Marshall
Steven Spielberg

Screenwriters:

Steven Spielberg
Michael Grais
Mark Victor

Cinematographer:

Matthew F Leonetti

Production Designer:

James H Spencer

Editor:

Michael Kahn

Duration:

114 minutes

Cast:

Craig T Nelson
JoBeth Williams
Oliver Robins
Heather O'Rourke
Zelda Rubinstein

Year:

1982

Synopsis

A ghostly presence enters the suburban home of Steven and Diane Freeling and their three children. The first person to become aware of them is 5-year-old Carol Anne, who acknowledges their presence with the film's most famous line: 'They're here!' At first the spirits play mischievous tricks such as bending forks and rearranging chairs. But things grow frightening when they cause a tree to attack young Robbie and terrifying when they seize Carol Anne, taking her into the spirit world. The despairing parents call on three university parapsychologists for help. They fail to rescue the child, but a breakthrough occurs when they bring in a psychic named Tangina Barrons, who discovers that Carol Anne is being held by a demonic Beast that is using her vibrant 'life force' to lure departed souls away from the 'spectral light' that brings salvation and peace. Tangina helps bring Carol Anne back and rids the house of its unhappy ghosts; but the Beast launches a vicious new attack that ultimately gives Steven a clue as to why all the horrors have transpired.

Critique

Steven Spielberg could not direct *Poltergeist* because he was committed to *ET* (1982), which premiered a week later; so he hired Tobe Hooper to do the job, saying he had been extremely impressed with Hooper's 1974 shocker *The Texas Chain Saw Massacre*. The arrangement proved uncomfortable, however, since Spielberg had strong opinions as to how *Poltergeist* should be filmed and spent a good deal of time looking over Hooper's shoulder, sometimes literally calling the shots. The end result incorporates all of the trademarks Spielberg had established by the early 1980s – from the suburban setting and family-centred story to the rollercoaster pace and extravagant visual effects. Hooper surely contributed some of the film's cinematic ideas, but Spielberg is undeniably its auteur. Combining the menace of *Jaws* (1975) with the breathlessness of *Raiders of the Lost Ark* (1981), he also signals his creative presence with references to some of his other films, as when he shows a television set playing *A Guy Named Joe*, the 1943 fantasy that he would remake under the title *Always* in 1989.

Spielberg's deep connection with American popular culture is visible throughout *Poltergeist*, starting with his decision to make a TV set the main channel of communication between the human and spirit realms. One of the film's most striking bursts of visual invention takes place when a door opens on a room so powerfully charged with poltergeist energies that a toyshop's worth of popular playthings are operating of their own accord while floating through the air; another potent image is a clown doll that turns from cute to creepy in an

instant, grasping young Robbie in the night and dragging him under his bed. Spielberg's showmanship is more brazen during the lull before the movie's climax and during the climax itself, when mud-covered corpses erupt from the ground, looking like refugees from an amusement-park haunted house. Yet despite such flaws, the box-office payoff – more than $75 million in domestic grosses, making it the year's eighth-highest earner – indicates that for most viewers *Poltergeist* lived up to its tagline: 'It knows what scares you.' The movie produced two sequels, the modestly successful *Poltergeist II: The Other Side* (1986) and the critical and commercial flop *Poltergeist III* (1988), but Spielberg was not involved in these and only two members of the original cast, Zelda Rubinstein as the psychic Tangina Barrons and Heather O'Rourke as Carole Anne, returned for both of the follow-up films.

The simultaneous success of *Poltergeist* and *ET* marked 1982 as the pinnacle of Spielberg's achievement in pure fantasy film-making. Subsequent efforts such as *Always* and *Hook* (1991) proved far less popular; the profitable *Indiana Jones* (1981–2008) and *Jurassic Park* (1993–1997) franchises emphasize action and adventure rather than magic and the supernatural; *Artificial Intelligence: AI* (2001) is a fable with conspicuously dark overtones; and more recent ventures such as *Minority Report* (2002) and *War of the Worlds* (2005) are hard-edged science fiction. *Poltergeist* and *ET* also stand with Spielberg's most earnest films about family closeness and parent-child love, which are established as central themes during the carefully-constructed opening scenes. During the early phase of his career Spielberg was keenly interested in exploring the effects of larger-than-life experiences on everyday characters in ordinary places. *Poltergeist* exemplifies his skill at constructing suburban normality as the background for battles between the fantastic and the mundane.

David Sterritt

Rosemary's Baby

Studio/Distributor:
Paramount Pictures

Director:
Roman Polanski

Producer:
William Castle

Synopsis

A young married couple, Rosemary and Guy Woodhouse, move into a Manhattan apartment despite the warning of their friend and previous landlord, Hutch, that it has a torrid history of earlier tenants. They are soon befriended by Minnie and Roman Castevet who live in the other half of their partitioned flat. Guy is intrigued by them, but Rosemary soon tires of the relentlessly-attentive neighbours. The friendship creates tension between the couple, especially when Rosemary becomes pregnant with their first child. In her endeavour to be reconciled with her husband, she succumbs to the attentions of the Castevets. Despite her reservations, she agrees reluctantly to see the obstetrician recommended by Minnie.

Screenwriter:

Roman Polanski
From a novel by Ira Levin

Cinematographer:

William Fraker (aka William A
Fraker)

Art Director:

Joel Schiller

Original Music:

Krzysztof Komeda

Editors:

Sam O'Steen
Bob Wyman

Duration:

136 minutes

Cast:

Mia Farrow
John Cassavetes
Ruth Gordon
Sydney Blackmer

Year:

1968

Rosemary fails to thrive during her pregnancy, but struggles to have her concerns taken seriously by her husband or the Castevets. When Hutch offers to investigate, he uncovers the shocking truth, which will impact on their lives forever.

Critique

Prior to the release of *Rosemary's Baby* in 1968, Roman Polanski had begun to attract interest outside his native Poland. *Repulsion* (1965) and *Cul de Sac* (1966), both made in England, had brought his films to the attention of a wider film-viewing public and *Rosemary's Baby* would take him to an American audience. William Castle had purchased the rights to Ira Levin's novel, but with a reputation as a maker of low-budget, gimmick-laden B-movies, Paramount would only fund the film if he did not direct it. Polanski was invited to direct and, in return, Castle was given a significant cameo role in the film. John Cassavates and Mia Farrow, both popular television actors at the time, were cast in the lead roles of Guy and Rosemary Woodhouse. Cassavetes had achieved success as private investigator Johnny Staccato in the eponymous 1959 series, and Mia Farrow was fresh from playing Allison MacKenzie in *Peyton Place* (1966). She had also appeared in the little-seen and seriously under-rated *Dandy in Aspic* in 1968, but was possibly best known at the time for her brief marriage to Frank Sinatra in 1966.

Rosemary's Baby echoes the atmosphere of conspiracy and suspicion that followed the death of Marilyn Monroe in 1962, and the assassination of John F Kennedy the following year. However, Polanski takes on the larger concept that there is a plot that shapes the world. *Rosemary's Baby* is located in the now-familiar Polanski territory of paranoia and psychological terror. The lives of characters in many of his films are subject to the influences of their surroundings, and they become victims of people who intrude upon their physical and psychological space (*Repulsion* and *La Locataire/The Tenant* in 1970). Similarly Rosemary's life is intruded upon by her neighbours, Minnie and Roman Castevet, and she is helpless to prevent this. Polanski foregrounds his influences: the festering rabbit-platter in *Repulsion* recalled the rat-dinner served in Robert Aldrich's *Whatever Happened to Baby Jane?* (1962), and, now, the scrabble letters, with which Rosemary pieces together the anagram that reveals the true horror of her circumstance, is pure homage to Hitchcock's *Suspicion* (1941), in which Lina (Joan Fontaine) realizes the truth about her husband Johnnie (Cary Grant) during a game of anagrams. Like Hitchcock, narrative is central to Polanski's work: his films turn on the telling of a story. *Rosemary's Baby* is unsettling and the search for cohesion and resolution keeps the audience gripped throughout. But Polanski teases us with narrative twists until the very end.

In the final scene of *Rosemary's Baby* the viewer never sees the child. We do however see Rosemary's acceptance of her

baby. With this, a door is opened between the film's divided apartments. It was this door which, in 1968, was opened up to the demonic-possession horror films that proliferated in the decade that followed. *Rosemary's Baby* is the precursor to William Friedkin's *The Exorcist* in 1973 and Richard Donner's *The Omen* three years later in1976. More than thirty years later, the legacy of Polanski's film still causes us to shudder.

Lucy Fraser

Scream

Studio/Distributor:

Dimension Films

Director:

Wes Craven

Producers:

Cary Woods
Cathy Conrad

Screenwriter:

Kevin Williamson

Cinematographer:

Mark Irwin

Art Director:

David Lubin

Editor:

Patrick Lussier

Composer:

Marco Beltrami

Duration:

106 minutes

Cast:

Neve Campbell
Courtney Cox
David Arquette
Skeet Ulrich

Year:

1996

Synopsis

An anonymously-masked killer descends on an American town, embarking on a spree of murders throughout the local youth population. As the police begin their investigation, 17-year-old Sidney Prescott is forced to relive the trauma of her mother's homicide a year earlier as the tabloid media, spearheaded by ruthless reporter Gale Weathers, begin connecting the two sets of incidents, and it is soon apparent that everyone is a suspect. When Sidney herself survives an attack, her boyfriend Billy is arrested as a prime suspect, though eventually released through lack of evidence. As a curfew is imposed on the town, Sidney's friend Stu hosts a massive house party, where all characters and events will come together in a bloody and revealing climax.

Critique

Wes Craven's assault on the very genre he helped popularize remains a landmark in horror cinema and nineties film-making in general, crafting a genuinely frightening teen slasher within a murder-mystery framework, laced with dark humour and an abundance of horror film references. It owed a huge amount to Kevin Williamson's superb script, which focused on character and story development as much as the scares themselves. It begins with the now-infamous twelve-minute opening scene, focusing on a mysterious phone caller who intimidates high school student Casey Becker (Drew Barrymore); testing her with horror movie trivia as she tries to save her physically-restrained boyfriend, until they are both eventually murdered. A notable exercise in suspense, the scene also sets the tone for the rest of the film, utilizing the language of horror movies by playing upon their conventions and using the characters' knowledge of these rules against them; Casey loses the game set forth by the caller through wrongfully identifying Jason as the killer in *Friday the 13th* (1980), who did not show up until *Friday the 13th Part 2* (1981).

Despite the deliberate irony found in *Scream*, the in-jokes and references are used to supplement the story rather than drive it, meaning that it never segues into parody or juvenility;

it manages to be simultaneously humorous and terrifying. Furthermore, the film offers a particular insight into teenage life, particularly to those dealing with the aftermath of tragedy, highlighted in a scene where Sidney overhears a thoughtlessly-nasty conversation between two girls who speculate over her mother's grisly murder. There is a certain dynamic between the characters in Williamson's script, where all relationships are believably and empathetic – qualities not typically found in horror films, and certainly not in the onslaught of copycat slashers that followed throughout the next decade.

The film itself yielded two immediate sequels, with a fourth released in 2011. *Scream 2* (1997) follows Sidney, Randy, Gale and Dewey as the students begin life in college, while beginning the healing process from the events of the first film, only to find that, once again, another masked killer is hunting them down. Although less frightening than its predecessor, the script (again by Williamson) makes fantastic use of horror-sequel conventions, and again features a superb opening scene which also draws attention to the position of black characters in slasher films. By the time *Scream 3* (2000) was released, the franchise was sadly running out of steam, with Ehren Krueger taking the scriptwriting reigns to deliver little more than a standard horror thriller.

James Merchant

The Shining

Studio/Distributor:
Warner Bros

Director:
Stanley Kubrick

Producers:
Robert Fryer
Jan Harlan
Mary Lea Johnson
Stanley Kubrick
Martin Richards

Screenwriters:
Stanley Kubrick
Diane Johnson
From a book by Stephen King

Cinematographer:
John Alcott

Art Director:
Les Tomkins

Synopsis

Jack Torrance takes up the position of winter caretaker to the luxurious Overlook Hotel in rural Colorado along with his wife Wendy and their young son Danny. The Overlook's isolation seems ideal for Jack, who is an aspiring writer. Prior to the move, Danny is shown conversing with Tony, his imaginary friend, whilst Wendy is preoccupied with her desire to hold the fragile family unit together. On their arrival in Colorado Danny meets Dick Hallorann, the hotel's African-American head chef, with whom he is able to communicate telepathically. This power – the eponymous 'shining'– enables the boy to see visions of the hotel's troubled past as well as glimpses of possible futures. As winter takes hold, the malevolent supernatural forces activated by Danny's ability combine with the alcoholic Jack's pre-existing proclivities for violence and threaten to tear the family apart. Both father and son experience ghostly visions – titillating and menacing for Jack, who is manipulated by the Overlook for its own ends – revelatory and menacing for his son. When Jack finally turns on his family with homicidal intent, Danny 'shines' to Hallorann for aid as mother and child struggle to escape the Overlook and the monster it has made of Jack.

Editor:

Ray Lovejoy

Duration:

119 minutes

Cast:

Jack Nicholson
Shelley Duvall
Danny Lloyd
Scatman Crothers

Year:

1980

Critique

Kubrick's film takes inspiration from, and shares much of its plot with, its source material – Stephen King's 1977 best-selling novel of the same name. Both novel and film have garnered considerable critical attention as well as achieving sustained popular renown. Some critics have argued that Kubrick's adaptation has done the novel a disservice and produced an inferior version of a compelling tale. King focuses heavily on how Jack's past has shaped his character. Abused as a child by a violent father, the adult Jack has a history of alcoholism and seems doomed to replicate his own troubled childhood in his relationship with Danny. Jack's upbringing and desperate attempt to provide for his family after his drinking costs him his teaching job imbues the narrative with a sense of impending tragedy. Further, King's Overlook is haunted by explicitly-supernatural forces which exploit Jack's weaknesses with the intention of turning him against his son. The hotel has a proud and well-publicized history as well as a more sordid side. It has served as the playground of the wealthy and successful since the early 1900s and yet, with

The Shining, 1980, Warner Bros.

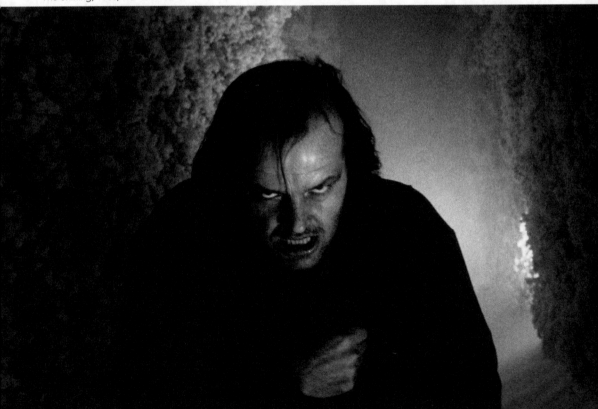

both presidents and mobsters counted amongst its former guests, it clearly cannot be held up as a shrine to industry. Indeed, the building's history is bound up with aggressive capitalism and the selfish pursuit of the American Dream (Clemens 1999: 187–88). Serving as a reminder of an inherently exploitative past which has privileged white wealthy males to the exclusion of others, the ghosts of the Overlook can be seen to symbolise the ghosts of the entire American nation. Kubrick, however, both minimizes the role of the supernatural and provides little insight into Jack's past. Cold, cynical and ultimately manic, the Jack of the film – memorably portrayed by Nicholson – is arguably a far cry from the conflicted family man of the novel.

Putting issues of adaptation aside, this is a film which deserves consideration on its own terms – both as a genre piece and as the work of a celebrated auteur. Kubrick received early critical acclaim for films such as *Dr Strangelove* (1964) and *2001: A Space Odyssey* (1968) and the news that he was to make a horror film generated some intrigue. A foray into this genre might have marked something of a directorial departure for him, but the novel's rural setting and preoccupation with alcoholism are features which lend themselves to broadly Kubrickian themes of isolation, estrangement and the dark side of human nature. Adapted for cinema so quickly, it is unsurprising that some of King's topical concerns, such as the corruption inherent within capitalism and the pressures engendered by patriarchy, can also be detected in the film. However, Kubrick's formal choices do not emulate those associated with horror cinema. His lack of explicit horror imagery and his trademark filming techniques confound expectations and appear at odds with genre conventions. For example, the Steadicam tracking-shots, such as those which follow Danny's perambulations along the haunted hallways of the hotel, invoke a leisurely atmosphere in a genre usually associated with tension (Browning 2009: 207). Kubrick has other cinematic devices to exploit, however – whilst the visuals are typically underplayed, the erratic sound and sonorous score frequently work to unsettle the audience. All in all, Kubrick's film perhaps makes for a starker tale than King's original offering, which provided detailed insights into the characters and uses these to instil sympathy in the reader for the tragedy that unfolds. Yet the cinematic version, with its startling portrayal of descent into madness as a supportive father degenerates into an axe-wielding maniac, has a legacy all of its own.

Rebecca Janicker

References

Browning, M (2009) *Stephen King on the Big Screen*, Bristol: Intellect.
Clemens, V (1999) *The Return of the Repressed: Gothic Horror From The Castle of Otranto to Alien*, Albany: State University of New York Press.

The Silence of the Lambs

Studio/Distributor:
Orion Pictures Corporation

Director:
Jonathan Demme

Producers:
Ronald M Bozman
Edward Saxon
Kenneth Utt

Screenwriter:
Ted Tally
From a book by Thomas Harris

Cinematographer:
Tak Fujimoto

Art Director:
Tim Galvin

Composer:
Howard Shore

Editor:
Craig McKay

Duration:
118 minutes

Cast:
Jodie Foster
Scott Glenn
Anthony Heald
Anthony Hopkins
Ted Levine
Brooke Smith

Year:
1991

Synopsis

FBI cadet Clarice Starling is assigned by her instructor Jack Crawford to interview the incarcerated cannibalistic killer Dr Hannibal Lecter. Her initial conversation with the charming killer rapidly turns into a race against time to discover the identity of the killer nicknamed 'Buffalo Bill' before he kills his next victim, US senator's daughter Catherine Martin. An attempt by Dr Chilton to undermine Starling and find Martin results in Lecter's escape, after his final encounter with Starling when he gives her the clues to find the killer, Jame Gumb. Starling continues her search as Jack Crawford bears down on an address ... but it is Starling who eventually must again descend into a basement to confront a killer.

Critique

The Silence of the Lambs was an instant critical success, winning five Academy Awards for Best Picture, Best Actor and Actress, Best Screenplay and Best Director. Based on the popular novel of the same name by Thomas Harris, the chillingly-courteous and intelligent Dr Hannibal Lecter is the most remembered character, even though his time on screen is limited. The film closely follows Harris's characterization of Lecter and Starling, notably in the sequences where Starling trades her emotional vulnerability – in the form of her traumatic childhood – for information.

This plot device of intense conversations is a hallmark of the films that feature Lecter: *Manhunter* (1986) and *Red Dragon* (2002) feature interviews with the incarcerated Lecter by another FBI agent, and the follow up to *The Silence of the Lambs*, *Hannibal* (2001) uses phone conversations between Starling and Lecter. However, Demme's particular genius is to initially centre Lecter in his cell and, in the exchanges between Starling and Lecter, to shift between medium close-ups of Lecter to the profile of Clarice, emphasizing the shifts between control and strength that they undergo. Similarly, when Lecter is active, the camera moves as quickly to underline the suddenness of his presence – particularly in the infamous cage sequence. These conversations are the centre point of the film, rather than the ongoing FBI procedures to track the killer. However, as seen in the solitary run through the wood at the start of the film, the heart of the story is the figure of Clarice Starling. Her thirst for promotion does not overwhelm her humanity, as shown in her concern for the victims and the victim-to-be, Catherine. This proves the vital attraction to Lecter, but the need of Clarice for a father figure is a motif that Demme returns to – in the close-ups of her hands touching Lecter's fingers, and in her handshake with Jack Crawford. The short intercut sequences of her father and his funeral prove vital to an understanding of Clarice, an

aspect emphasized in Thomas Harris's novel *Hannibal* (1999). One result of this is that the female characters in this film are fragile, yet have the ability to attempt their own escape: Starling from a traumatic childhood; Catherine from her captivity. By contrast, the men in the film all have ulterior motives for their words and actions.

This led to some of the greatest criticism of the film, in the portrayal of the killer 'Buffalo Bill'. Demme noted the protests surrounding the killer, who gay-rights protestors claimed was a negative representation of homosexuality. However, as Demme (and Lecter in the film) point out, Jame Gumb is not a transsexual – he is something else completely. This may have been an instigating factor for Jonathan Demme's next film project, *Philadelphia* (1993), which deals with how a man with AIDS (Tom Hanks) legally challenges the company who fired him through a lawyer (Denzel Washington) who is openly contemptuous of gay men.

The Silence of the Lambs has proved an iconic film. The erudite psychopath proved the key character, with Anthony Hopkins returning to play Lecter in the two later films. This is the reason for *The Silence of the Lamb*'s popularity: the courteous killer is *much* more fun when he is at large. As he says to Clarice 'You need to get more fun out of life' – a piece of advice he is only too willing to follow in his own career.

Emma Dyson

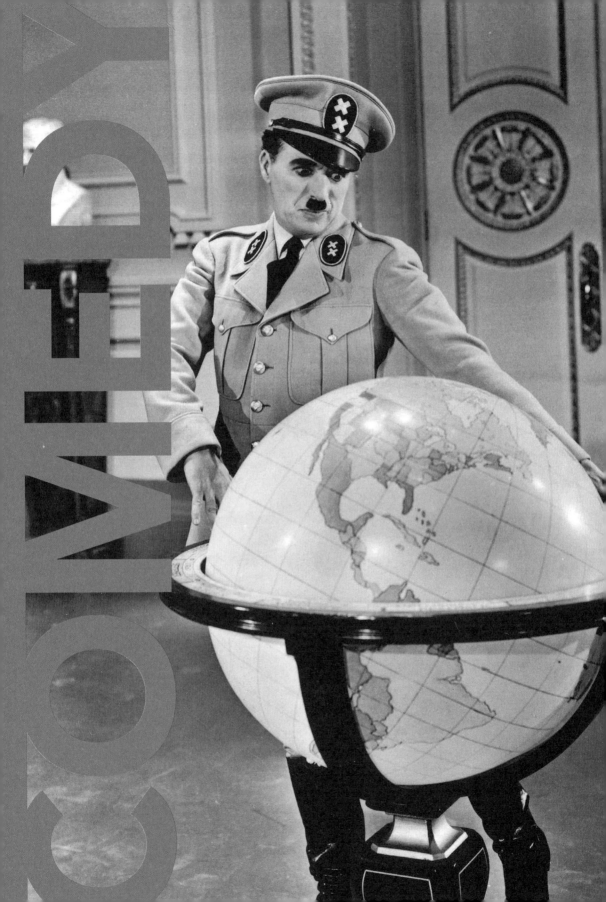

COMEDY

Any narrative of any genre is necessarily one of multiple protagonists. Like that of the musical, the narrative of film comedy is predominantly one of performers; yet it is also one of sub-genres, of directors and, even, of producers and screenwriters. Not as easily definable as, say, the Western, it can be distinguished as much by its affect (ideally, raucous laughter), as by its component parts (physical comedy, witty banter, the happy ending and so on). Though it has only relatively recently garnered sustained theoretical interest (Frank Krutnik and Geoff King are fundamental in this respect), American Film Comedy remains one of the most popular, enduring and revealing of genres: a true social, cultural and political barometer, it speaks volumes of society's tastes and inclinations.

The appearance in 1912 of Mack Sennett's Keystone Company arguably heralds the beginnings of American screen comedy. Fuelled by implausible occurrences (some improvized and many danger-ous looking), a frantic pace (this often heightened by increased film speed), and populated by misfits and grotesques (the heavier, the uglier, the more incompetent, the better), the world of Sennett's shorts took its lead from Vaudeville and the circus, and, further, flaunted the genre's capacity for spectacle and trickery. With their slapsticking, custard-pie throwing and water-drenching antics, Sen-nett's players (amongst them Fatty Arbuckle, Marie Dressler and Harry Langdon) firmly established the body as fundamental comic prop, and its spectacular (mis)use, a comic staple.

The late-teens through 1930s saw the dual performing/directing talents of Buster Keaton and Charlie Chaplin dominate American screen comedy, and gag-ridden films such as *The General* (1926) and *Modern Times* (1936) chronicle the everyman's struggle with the imposing modern world. With the advent of film narrative, plots generally become more robust, characters more fully realized, and romance often increasingly mainlined; yet anarchy persists, not least in hugely popular Marx Brothers' films like *Duck Soup* (1933): a carnivalesque romp that comically destabilized social and political hierarchies.

The arrival of sound brought obvious benefits for film, but the Depression-era, Hays Code-bound screwball in particular capital-ized on the soundtrack. Part of the appeal of the screwball was that audiences could see familiar glamorous and dignified stars like Cary Grant, Katherine Hepburn and Claudette Colbert playing against type and indulging in physical horseplay; yet viewing (and, no doubt, acting) pleasures were effectively doubled via the witty, increasingly innuendo-fuelled banter of the antagonistic duo. With a happy ending and a couple finally brought together against the (usually monetary) odds, films such as Capra's *It Happened One Night* (1934) were ultimately optimistic, endorsing socially-relevant values like hard work, perseverance and common sense.

The real power of comic dialogue was further exploited in the 1940s with the films of screenwriter/director Preston Sturges. Amongst them *The Lady Eve* (1941), their cynicism and satirical nature marked something of a move away from the ideological conservatism of their screwball predecessors. Likewise, the parodic Road Pictures of Bob Hope and Bing Crosby, with their prevalence of in-jokes and

Left: *The Great Dictator*, 1940, United Artists.

swipes at Hollywood itself, demonstrated a similar self-reflexivity, a tendency only underscored by Hope's hosting of the ultimate Hollywood commentary – TV's coverage of the Oscars. The late 1940s/1950s saw various comic pairings, most notably Abbott and Costello, and Dean Martin and Jerry Lewis (both acts relying on the central incongruity of straight man/idiot). The period also saw the growing (and, given the audience's preference for the new technology of television, necessary) links with other comedy platforms, and, thus, the continuing rise of the comedian comedy genre (a sub-genre explored in the writing of Steve Seidman, and centring around the translation into film of a pre-existing comic persona). Martin and Lewis' initial nightclub act, radio appearances and then TV slots came to fruition with a string of big screen successes including *My Friend Irma Goes West* (1950), though Lewis would later go on in the early 1960s to showcase his bumbling idiot persona in self-directed (and self-promoting) films including *The Bellboy* (1960) and *The Errand Boy* (1961).

In stark contrast to the mindless escapism of much of Lewis' work (and perhaps partly explaining its poor critical reception), much other 1960s' screen comedy was motivated by a distinctly socio-political commentary. Much more patently of its time was the darker and increasingly-provocative humour of films as diverse as *Dr. Strangelove or, How I Learned to Stop Worrying and Love the Bomb* (1964), a satire on Cold War paranoia, and *The Apartment* (1960) and *The Graduate* (1967), both exposés of white-collar existence and, specifically, sexual mores. Woody Allen's films, particularly his comedies of anxiety in the 1970s (not least *Annie Hall* [1977] and *Manhattan* [1979]), continued to deconstruct both comedy and romance, and to consolidate Allen (whose neurotic Jewish persona had previously been honed within stand-up) as the newest in a long line of comedian comics stretching back to ex-vaudevillians Chaplin and Keaton.

Allen's transition into film is one countless performers have made since. The 1980s saw an explosion of new comedic talents, many having originally gained fame in stand-up and/or on NBC's *Saturday Night Live*, a veritable springboard into film comedy. Robin Williams, Chevy Chase, Eddie Murphy and John Belushi were just some of the performers who went on to star in all manner of comedy hybrids, from the war comedy, to the road comedy, the action comedy and the teen comedy. The work of Steve Martin, a regular *SNL* host, seems symptomatic of the comedic diversity of the decade: Martin not only turned his talents to generic spoofs (*Dead Man Don't Wear Plaid* [1982] and *¡Three Amigos!* [1986]), but his persona was successfully translated into viable romantic lead in films such as *All of Me* (1984) and the self-penned *Roxanne* (1987), helping to secure the rom-com as one of the most prominent sub-genres of the day.

The tone of the 1990s was in large part set, and many would argue lowered, by the films of Jim Carrey, another ex-stand-up and TV performer. The oft-quoted 'dumbing down' of popular culture was in no insignificant part attributed to the 1994 triple blow of *Dumb and Dumber*, *The Mask* and *Ace Ventura: Pet Detective*. The later Farrelly brothers' film *There's Something About Mary* (1998), flaunting Cameron Diaz's perfectly erect quiff (the result of an unwitting application of semen), and the Weitz's *American Pie* (1999) (wherein the titular pie – and, by extention, American society – is memorably abused), revealed directors' and audience's appetite for gross-out comedy and toilet humour, a sensibility that shows no signs of abating in the new millenium.

Writer/director/producer Judd Apatow's ensemble comedies and, most recently Todd Phillips' *The Hangover* (2009), continue to showcase largely male-centred humiliation, embarrassment and bodily trauma (the chest waxing in *The 40 Year Old Virgin* [2005] and *The Hangover*'s tazering scene are prime

examples). That said, Apatow's *Knocked Up* (2007), though another stoner comedy, is also aligned with the recent spate of much more probing and relatable relationship-coms (such as the largely downbeat *The Break Up* [2006] and *The Last Kiss* [2006]) which eschew easy romantic union and deglamorize romance. Perhaps the defining comedy film of recent years is Apatow's aptly titled *Funny People* (2009): dark, raw and self-conscious, it reveals the continuing anxieties, both of its prevailing society, and of its very genre.

Lesley Harbidge

American Pie

Studio/Distributor:
Universal Pictures

Director:
Paul Weitz

Producer:
Warren Zide
Craig Perry
Chris Moore
Chris Weitz

Screenwriter:
Adam Herz

Cinematographer:
Richard Crudo

Art Director:
Paul Peters

Editor:
Priscilla Nedd-Friendly

Duration:
95 minutes

Cast:
Jason Biggs
Chris Klein
Alyson Hannigan
Seann William Scott
Shannon Elizabeth
Eugene Levy

Year:
1999

Synopsis

With the end of High School looming, four friends – Jim, Kevin, Oz and Finch – make a pact to lose their virginity before Prom. Jim lusts after the beautiful foreign exchange student Nadia (while trying to circumvent awkward moments of sexual experimentation and humiliation, including being caught by his father having sex with a freshly-baked, warm apple pie); Kevin tries to convince his girlfriend Vicky to sleep with him, but without having to say 'I love you' in order for her to agree; Oz joins the high-school choir in order to shake his jock persona and adopt a more 'sensitive' side to woo fellow singer Heather; while sophisticated Finch manufactures an outlandish reputation based on rumours in order to fuel his mystique and appeal. As the deadline approaches, the ultimate American teen rite-of-passage Prom provides an opportunity for the boys to have sex, but also lessons in growing up.

Critique

From the hilarious opening sequence in which Jim gets caught by his parents masturbating to scrambled cable porn, *American Pie* could instantly be understood as the rejuvenation of the teen-sex comedy that became popular in the late 1970s and early 1980s through such titles as *Animal House* (1978) and *Porky's* (1982). However, first time screenwriter Adam Herz and debut director Paul Weitz created a film that goes beyond the superficial artifice of boobs and bums and forges characters that are easily relatable and ultimately more akin to those of the John Hughes' school of teen angst. As each of the four male characters interact with members of the opposite sex with varying results, four alternate approaches engage the teen viewer's own expectations and curiosity towards sex and relationships.

Like the films of the late, great John Hughes, *American Pie* seeks to not only entertain its audience but engage and break with stereotypes and preconceptions of 'typical' characters and expectations. The four male characters, although initially pertaining to selected teen stereotypes (loser, jock, brain, and nice guy) constantly act against their initial typecast. This is further embedded in relation to peripheral characters, such as scene-stealing band geek Michelle (whose infamous line 'this one time at band camp' has become immortalized within the pop culture zeitgeist), and Jim's Dad, whose cringe worthy 'father and son' chats not only immortalized Eugene Levy as the coolest screen dad ever, but depicted unconditional parental love and acceptance in a way never before portrayed within the teen film.

In its depiction of sexual experiences, the film can be seen initially as the story of the four male characters attempting to lose their virginity. However, what emerges is something of an anomaly, as the narrative embeds and ultimately interrogates the sexual fulfilment of the female characters. Whereas the males' sexual encounters (especially those involving Jim) prove to be inade-

American Pie, 1999, Universal. Photographed by Vivian Zink.

quate and unsatisfying, the discussion of love and female pleasure emerges as the dominant focus and drive for all characters. As both the male and female characters discuss issues such as the role of love in relation to sex, the ability (or inability) of females to experience an orgasm, and what it is like for a female to lose her virginity, *American Pie* creates a sensibility surrounding female sexuality and pleasure to which the male characters are subordinate. This is demonstrated in the infamous sequence involving Jim's seduction of Nadia as he broadcasts her undressing via his webcam to the entire school body. Although initially relying on the traditional gratuitous display of naked breasts for the male audience's pleasure, this is quickly inverted as Jim becomes the source of spectatorial pleasure for Nadia, the characters watching the broadcast, and the film's audience. As Jim interrupts Nadia masturbating (a rarity in itself, as depiction or discussion of masturbation is typically shown in relation to males), she covers her naked body and encourages Jim to strip. Subsequently, it is Jim who

emerges as the source for voyeuristic pleasure as he performs a strip routine for her, which suddenly climaxes through his inability to satisfy her sexual needs and desires.

Ending with four very different sexual experiences (the romantic, the awkward, the fantasy and the sexually exploited) *American Pie*'s ability to depict the pains, pleasure and realities of teen culture proved to be a success with audiences. Followed by two inferior sequels, it is ultimately Weitz's original film that re-established generic codes and practices originally intended for an audience of navel-gazing boys to produce a film with mass appeal that balances sexual experiences from both genders.

Craig Frost

Duck Soup

Studio/Distributor:
Paramount Pictures

Director:
Leo McCarey

Producer:
Herman J Mankiewicz

Screenwriter:
Bert Kalmar
Harry Ruby

Cinematographer:
Henry Sharp

Production Designer:
Hans Dreier

Editor:
Leroy Stone

Duration:
65 minutes

Cast:
Groucho Marx
Chico Marx
Harpo Marx
Zeppo Marx
Margaret Dumont

Year:
1933

Synopsis

The country of Freedonia is bankrupt. Its benefactor, the rich dowager Mrs Teasdale, agrees to extend a further loan on the condition that the government is sacked and Rufus T Firefly placed in charge. Firefly is an opportunist who exerts dictatorial control and strives to divest Mrs Teasdale of her remaining fortune. Meanwhile, the Ambassador of Sylvania attempts to force a coup in Freedonia, assisted by a beautiful dancer and two incompetent spies, Chicolini and Pinky. War is declared between Freedonia and Sylvania. The spies defect, the Ambassador is captured and Firefly restores peace to his adopted land.

Critique

At the end of *Duck Soup*, the fat lady sings and is summarily pelted with fruit. The Marx Brothers never stood by ceremony – or anything else that blocked the path of spontaneity and the free expression of the id. Their comedies, the early Paramount ones in particular, were aimed squarely at human manners, rituals, language and all the other binds of civilized society.

Undoubtedly, and as *Duck Soup* demonstrates, there was great method in the madness. During the early 1930s, the Marxes cultivated an image of themselves as inveterate anarchists; fan magazines carried stories of their wild approach to shooting schedules, scripts and directors (one complained of being regularly debagged). But the Marxes were also veterans of Vaudeville, who knew the value of thoroughly-worked comic routines. Such discipline is revealed in *Duck Soup* in the exquisite lemonade-stall sketches (wherein the grumpy Edgar Kennedy loses two hats to a peanut-roasting lamp) and the much-celebrated mirror sketch, where Harpo mimics Groucho to compensate for a broken mirror.

But the results were gloriously irrational. Sometimes, *Duck Soup* is thought of as satire, even as a pacifist statement (*The Times*' reviewer mused that the Marxes essayed 'the futility of war'). Certainly, the prospect of conflict was in the air in 1933. By this time, the American public was aware of the developing threat posed by National Socialism in Germany. At the same time, the inchoate congressional committee on Un-American Activities determined to find Nazis at home. However, the Marxes dealt with the business of war in characteristically off-hand manner. In *Duck Soup*, Pinky and Chicolini picked fights at will, Firefly threatened to shoot dull husbands and, in battle, he appeared as both a Confederate and a Yankee (and also as Davy Crockett).

Such iconoclasm demonstrated the real ideology of *Duck Soup*, such as it was: war represented the ultimate display of allegiances and such things were to be rejected, at all times and at all costs. Here, as elsewhere, the Marxes expressed an anti-authoritarian creed, whereby Groucho played a dual – perhaps dualistic – role, as despot (strict father to the errant Chico and Harpo) and libertarian. His own madness reached a peak in *Duck Soup* in his opening song, a kind of manifesto set to music. Firefly crooned, 'I'll put my foot down so it shall be. This is the land of the free'. Other elements of *Duck Soup* developed the Marxes' song of freedom. The minstrel parody ('They got guns, we got guns, all God's children got guns') demonstrated vague contempt for twee popular entertainment. Likewise, the terrible puns ('Your Excellency/You're not so bad yourself', the Southern capital of 'Dollars, Taxes'), said something about the dreary discourses of everyday life. Most notably, *Duck Soup*, contained a few moments that suggested the vaudevillians' continuing separation from the emerging studio system and its stultifying story formulas. When Harpo appeared as Paul Revere, he led the audience into a roughly-parallel historical tale, only to rejoin the dominant narrative, as Pinky, sleeping in the bed of his Lemonade-peddling rival. This was not good Hollywood sense.

Of course, it could not last. *Duck Soup* failed at the box office and the Marxes were released by Paramount. They were subsequently brought to heel by Irving Thalberg at MGM in a series of films that were far more conventional and which even had regular titles – *A Night at the Opera* (1935) had a genuine opera theme and the brothers actually went west in *Go West* (1940). Groucho's admiration for Thalberg notwithstanding, one can only lament the restoration of order that occurred at MGM.

Hail, hail Freedonia!

Laurie N Ede

Ferris Bueller's Day Off

Studio/Distributor:
Paramount Pictures

Director:
John Hughes

Producers:
John Hughes
Tom Jacobson
Jane Vickerilla

Screenwriter:
John Hughes

Cinematographer:
Tak Fujimoto

Art Director:
Jennifer Polito

Editor:
Paul Hirsch

Duration:
103 minutes

Cast:
Matthew Broderick
Alan Ruck
Mia Sara
Jeffrey Jones
Jennifer Grey

Year:
1986

Synopsis

Ferris Bueller is one of the most popular kids in school; he has achieved this status through delicately navigating the school's administration system and securing numerous amenities for the student population, who all admire him. One morning, Ferris decides to fake being sick, skip school and tour Chicago, accompanied by his girlfriend Sloane and his closest friend, Cameron, who is trying to escape the shadow of his overbearing father. Throughout one spectacular day full of amazing coincidences and chance encounters, Ferris, Cameron, and Sloane have fun in the city while attempting to escape the wrath of both Principal Ed Rooney and Ferris's sister, Jeanie, and avoid being seen or caught by Ferris's parents.

Critique

Though at first glance it may seem to be one of John Hughes' lightest films from the 1980s, *Ferris Bueller's Day Off* still manages to amuse and entertain while conveying more than a modicum of substance in between its high school shenanigans and surreal scenarios. Bueller's character, who often turns directly to the camera to speak to the audience, simultaneously treads the line between mainstream acceptance (within his high school) and alternative cultural signifier, as he becomes popular without achieving in sports or being a computer nerd (though he does seem to have a strong knowledge of electronics). In the film, Ferris utilizes his popularity and ingenuity for personal pleasure, negotiating his way out of school for the day by composing a phone message via electronic sampling keyboard. His best friend Cameron signifies the misunderstood in all of us, practical in nature but secretly longing for a passionate move forward. Bueller's girlfriend Sloane is not quite as well defined, but his sister Jeanie (an enthusiastically-committed Jennifer Grey) lives to bury her younger brother, but later realizes the nature of acceptance and how petty jealousies can often be a waste of time. Jeffrey Jones' performance as Principal Ed Rooney also deserves mention; it is perhaps one of the most indelible portraits of a frustrated high school principal ever committed to film (even though it is played for broad comedy). 'Bueller?' remains the most famous line actor Ben Stein has ever spoken (as Bueller's Economics teacher), and Charlie Sheen's cameo late in the film is arguably one of the actor's most memorable performances.

The film is also a love letter to Chicago, where Hughes grew up; numerous scenes feature significant downtown landmarks. Hughes apparently wrote the basic script in just six days and shot the film for under $6 million; it contains many personal cues to the director's life and career. An

exterior shot of Bueller's high school is actually Hughes' alma mater, Glenbrook North High School in Illinois, and there are numerous in-jokes and references to Hughes' other movies, including licence plates made up of acronyms of other Hughes film titles. Ferris will likely remain actor Matthew Broderick's most recognizable and identifiable character (interestingly, Broderick and Grey became a couple and were briefly engaged soon after the production). Such is the power of Hughes' standing in Hollywood during this era that he was able to nix the release of a soundtrack album to the film – he apparently felt the tracks used in the film were too discordant.

Michael S Duffy

Galaxy Quest

Studio/Distributor:
DreamWorks Pictures
United International Pictures

Director:
Dean Parisot

Producers:
Mark Johnson
Charles Newirth
Suzann Ellis
Sona Gourgouris

Screenwriters:
David Howard
Robert Gordon

Cinematographer:
Jerzy Zielinski

Art Director:
Jim Nedza

Editor:
Don Zimmerman

Duration:
102 minutes

Cast:
Tim Allen
Sigourney Weaver
Alan Rickman
Tony Shalhoub
Sam Rockwell
Darryl Mitchell

Year:
1999

Synopsis

Cult 'sci-fi' show *Galaxy Quest* lived a short life on television during the 1980s before being cancelled abruptly by its broadcast network. The actors of the show have been attending fan-organized conventions for the past two decades, but most feel trapped in their miserable lives, and their conversations have descended into personal bickering. At a *Galaxy Quest* convention, actor Jason Nesmith (who played Commander Taggart, the Captain of the ship) is approached by an alien race called the 'Thermians', who believe that the old episodes of the show are actual 'historical documents'. They need the crew's help to defeat their nemesis Sarris, who represents a different war-like alien race. The actors of the show reluctantly assume their roles for real, and engage with the alien races in an attempt to prove that their fictional lives have prepared them for real-life intergalactic conflict.

Critique

Galaxy Quest is both a ringing endorsement and a glorious (but loving) satire of cult science fiction television shows and their fans, most notably the iconic *Star Trek* franchise. Smartly written, produced, edited and visualized, the film is operates very successfully as a parody and homage, as an uproarious comedy and affectionate tribute. Focusing on the central actors still attached to a cult sci-fi show nearly two decades after its cancellation, the film neatly parlays audience interest in behind-the-scenes personalities and arguments into a real adventure which develops action and drama equal to any of the best episodes or films of the *Trek* series. The personalities and quirks of the *Quest* actors are clearly drawn from the publicly-known relationships between the cast of the original *Star Trek* series and films, most notably Tim Allen's accurate

interpretation of both the on- and off-screen attitudes and mannerisms of William Shatner (who played Captain James T Kirk). In its early moments, *Galaxy Quest* also approaches the same tone as *Free Enterprise* (1998), a sterling micro-budgeted insight into *Trek* and sci-fi fandom and personal obsessions (which featured a starring role for Shatner himself). Throughout *Quest*, there are numerous references to the personal and professional lives of the original *Trek* actors and episodes of the show itself (and its film franchise spin-offs). There are also hilarious subtleties conveyed about the *Quest* actors' 'presences' in conforming to their characters, such as the blatant sexuality of Sigourney Weaver's character, whose top zipper keeps lowering with each subsequent scene in the film, and Alan Rickman's character's alien head-cap prosthetics, which gradually begin to loosen and fall off throughout the narrative.

The film also has meta-meaningful in-jokes for *Trek* fans, including its accomplished visual-effects work, which, interestingly, seems superior to most of the original *Trek* feature film spin-offs. Another cute nod to the original *Trek* film series comes in the film's climax, which successfully visualizes a battle between Allen's Commander Taggart and living rock creatures on an alien planet, a concept which actor/director Shatner originally wanted to utilize in 1989's *Star Trek V: The Final Frontier* (but was unable to, due to an insufficient budget). Even more for anoraks, the film's alien villain Sarris is named after famous film critic Andrew Sarris, who had apparently given a bad review for producer Mark Johnson's *The Natural* (1984). It is important to note, however, that *Galaxy Quest* works well as a film entirely independently of any of its multitude of references; all of the performances are unique and fulfilling both in comedic delivery and characterization, and its narrative and production values (including detailed replication of the aesthetics of cheap television props and effects) strongly fulfil and arguably exceed its genre. Another nice touch: a couple of expletives which would have garnered an "R" rating for the film in the US were overdubbed by the actors with less offensive material, but these moments are made intentionally obvious.

Michael S Duffy

The Great Dictator

Studio/Distributor:
Charles Chaplin Film
Corporation
United Artists

Director:
Charles Chaplin

Producer:
Charles Chaplin

Screenwriter:
Charles Chaplin (uncredited)

Cinematographers:
Karl Struss
Roland Totheroh

Art Director:
J Russell Spencer

Editor:
Willard Nico

Duration:
125 minutes

Cast:
Charles Chaplin
Jack Oakie
Reginald Gardiner
Henry Daniell
Billy Gilbert
Grace Hayle
Carter DeHaven
Paulette Goddard

Year:
1940

Synopsis

An unnamed Jewish barber fights for his country Tomania during the First World War. He saves the life of a pilot, but their plane is shot down, with the barber losing both his memory and his voice. Two decades later he leaves hospital and reopens the barbershop, where he develops a friendship with a woman named Hannah and discovers that much has changed in the intervening years. Defeated Tomania is now led by the dictator Adenoid Hynkel, a man remarkably similar in physical appearance to the barber. Hynkel ruthlessly persecutes the Jewish population and plots to extend his dictatorship to neighbouring countries and beyond. The barber is eventually imprisoned in a concentration camp but escapes, wearing the uniform of a Tomanian soldier, only to be mistaken by border guards for Hynkel. The real dictator is, in turn, confused for the barber and arrested after he falls from his boat during a duck-hunting trip. Taking advantage of the mistaken identity, the barber uses a speech set up to celebrate the invasion of Osterlich as an opportunity to reverse Tomania's anti-Semitic policies and to commit the nation to democracy. Stepping out of character, Chaplin delivers here a general plea for peace and tolerance.

Critique

The Great Dictator is a transitional film, containing on its release many firsts and records for its director/star. It served as Chaplin's first talking picture (discounting the singing sequence in 1936's *Modern Times*) as well as one of the first anti-Nazi Hollywood films (Cook 1981: 201). It also ran longer (over two hours) and cost more (over two million dollars) than any previous Chaplin film (Van Gelder 2005: 91). In addition, for the first time Chaplin played a dual role onscreen in a work which lurched quite experimentally and precariously between seriousness and farce, described by Dilys Powell as a double split:

> He delivers his assault on the mighty not indirectly only, through the medium of the comically oppressed, but directly as well, through the medium of the comical oppressor; the attack is a split attack. In another way, too, the film is a split film; it darts between satire and realism. (Powell 2006: 233)

Powell claimed not to be put off by these splits in the way that many other critics were (for example, Ferguson 2006: 237) but, in common with most other commentators, found fault with the film's climax in which Chaplin the director/star proselytizes directly to the film's audience. Walter Kerr even argues that this sermon proved to be the moment where Chaplin lost his creative voice for good: 'The figure is no longer anyone we recognize … Not only the barber has

disappeared. Chaplin the artist has disappeared. The film has disappeared' (Kerr 2006: 292). The irony is obvious, especially given the film's own self-reflexive playfulness regarding voice.

Perhaps the most interesting manifestation of such playfulness occurs when the dictator Hynkel (the barely-disguised Hitler figure) breaks into a full-fledged rant in gibberish German, which J Hoberman characterizes as Chaplin's acknowledgment of 'the tyranny of sound' (Hoberman 2006: 303). Even the great artist of the silent era who had resisted the new technology long after most others ultimately found himself in its thrall. However, Chaplin seemed to take particular delight in making hay at Hitler's expense. In one interview, for example, he recounted how he had achieved a big crowd scene in *The Great Dictator*:

Where did I get that shot? Well, where do you think? From Germany! My own fifth column snagged it out of Germany. Hitler is not only my clown. He also has paid some of my production cost. Saved me no end of money. Isn't it wonderful? (Van Gelder 2005: 97)

Part of this glee could be seen as the director's comeback to the ongoing Nazi obsession with *him*, including the ongoing inaccurate identification of the star as Jewish in books such as *The Eternal Jew* (1937), which he nevertheless took as a badge of pride (Louvish 2009: 266–67). There was also, of course, the coincidence of Chaplin and Hitler being born only four days apart in April 1889 and the popular notion that the German dictator had even copied the star's signature moustache (Robinson 1986: 484–85).

David Thomson has provocatively argued that Chaplin's conception of the 'common man', most famously expressed over many films via the 'Little Tramp' character, actually does indeed have some fundamental affinities with Hitler as a phenomenon: 'He spoke to disappointment, brutalized feelings, and failure and saw that through movies he could concoct a daydream world in which the tramp thrives and in which his whole ethos of self-pity is vindicated' (Thomson 2003: 151). Perhaps, ultimately, such dizzying and, at times, disconcerting layers of association can help explain Chaplin's apparent artistic misstep at the end of *The Great Dictator* via the allegorizing and satirizing mimic's desire finally to speak clearly with his own voice.

David Garland

References

Cook, DA (1981) *A History of Narrative Film*, New York: WW Norton & Company.

Ferguson, O (2006) 'Less Time for Comedy', in R Schickel (ed) *The Essential Chaplin: Perspectives on the Life and Art of the Great Comedian*, Chicago: Ivan R Dee, pp. 235–38.

Hoberman, J (2006), 'After the Gold Rush: Chaplin at One Hundred', in R Schickel (ed) *The Essential Chaplin: Perspectives on the Life and Art of the Great Comedian*, Chicago: Ivan R Dee, pp. 297–304.

Kerr, W (2006) 'The Lineage of Limelight', in R Schickel (ed) *The Essential Chaplin: Perspectives on the Life and Art of the Great Comedian*, Chicago: Ivan R Dee, pp. 287–93.

Louvish, S (2009) *Chaplin: The Tramp's Odyssey*, London: Faber and Faber.

Powell, D (2006) '*The Great Dictator*', in R Schickel (ed) *The Essential Chaplin: Perspectives on the Life and Art of the Great Comedian*, Chicago: Ivan R Dee, pp. 232–34.

Robinson, D (1986) *Chaplin: His Life and Art*, London: Paladin Books.

Schickel, R (2006) 'Introduction: The Tramp Transformed', in R Schickel (ed) *The Essential Chaplin: Perspectives on the Life and Art of the Great Comedian*, Chicago: Ivan R Dee, pp. 3–41.

Thomson, D (2003) 'Sir Charles Chaplin', in *The New Biographical Dictionary of Film*, London: Little Brown, pp. 150–52.

Van Gelder, R (2005) 'Chaplin Draws a Keen Weapon', in KJ Hayes (ed) *Charlie Chaplin: Interviews*, Jackson: University Press of Mississippi, pp. 91–97.

The Lady Eve

Studio/Distributor:
Paramount Pictures

Director:
Preston Sturges

Producer:
Paul Jones

Screenwriter:
Preston Sturges

Cinematographer:
Victor Milner

Art Directors:
Hans Dreier
Ernst Fegte

Editor:
Stuart Gilmore

Duration:
94 minutes

Cast:
Barbara Stanwyck
Henry Fonda
Charles Coburn
William Demarest
Eugene Pallette

Year:
1941

Synopsis

Fresh from an Amazonian scientific expedition with a new species of snake, Charles Pike, heir to the fortune of Pike's Pale ('The Ale That Won for Yale'), is seduced by quite another kind of serpent, in the feminine shape of Jean Harrington, one of a group of swindlers on board the ship back to America. However, increasingly charmed by the handsome Charles' naivety, Jean undermines her father's attempts to pursue the scam, and she falls in love with the man she now endearingly calls 'Hopsy'. Ironically, Charles learns of the scam just as he is about to propose marriage, calling the whole thing off. In revenge, the spurned Jean returns to his privileged life disguised as Lady Eve Sidwich, a visiting British aristocrat. Charles falls in love all over again, and this time goes through with a proposal of marriage, only for Eve's revelations of a litany of previous relationships to ruin their wedding night. Divorce naturally follows, but the hapless Hopsy has yet to see the last of Eve (or is it Jean?), for, as Hopsy's amanuensis, Muggsy, is convinced, 'It's the same dame.'

Critique

The ten films that writer and director Preston Sturges made during 1940s' Hollywood are among the finest romantic comedies in film history. Uniquely, they combine four types of comedy: the slapstick of the great silent screen clowns like Buster Keaton; the screwball of the new sound cinema of the 1930s, with wisecracking exchanges among the wealthy; the sex comedies like those of Mae West, characterized by a sexual innuendo necessary to circumvent the censorship constraints of the period's Hays Code; and, finally, the fast-paced

madcap or crazy comedy of teams from vaudeville theatre, like the Marx Brothers.

The Lady Eve is typical of Sturges' very individual satires on the most intimate relationships between men and women. Jean's witty narrative of the failed attempts by nubile competitors to win Charles' favours on board ship, observed in her mirror's reflection, climaxes in the first of Hoppsy's increasingly-destructive pratfalls, twice resulting by design from Jean's oustepped foot and the rest from his own befuddled maculinity in awe of the arousing Jean/Eve rather than looking where he is going. Jean's initial seduction of Hopsy in her cabin – extraordinarily, a single shot in close-up – holding him to her breast and running her hands through his hair, is the sexiest comic expression of suppressed desire. (When she returns to her father, he enquires why she has changed her dress. Her answer: 'I'm lucky I've still got this one on'.) Later, Hopsy proposes marriage as a horse comically nuzzles up close to his head. Impossible to rehearse, it is a compliment not only to the film-maker's comic invention but also to both actors' skills of improvisation. The climactic wedding night aboard the honeymoon train intercuts Eve's (cruelly falsified?) revelations with banshee screams of train wheels and whistles, wittily expressing Hopsy's anguish to discover in his presumed virgin bride a full-blown sexual experience unbefitting the times and his social class.

As with all the best screwball comedies, pratfalls on the floor and angry exchanges between the lovers stand in for the passion that censorship will not allow to be shown going on under the bedsheets. As with all the best romantic comedies, the hero has no defence against the wiles of the heroine: as Charles becomes Hopsy, he loses mastery over situations he expects to control, ceding power to the slyly-manipulative Jean. By the end, though, his resilience becomes endearing, and we can only desire their desire to continue. Sturges' art is to transgressively satirize America's concealed social class relations (Charles' family wealth comes from trade, not tradition; Jean is no socialite, like her competition) through laughter.

David Lusted

Mrs Doubtfire

Studio/Distributor:
20th Century Fox

Director:
Chris Columbus

Producers:
Joan Bradshaw
Paula DuPré

Synopsis

Robin Williams plays Daniel Hillard, an extravagantly-devoted but somewhat irresponsible dad to three charming children; Sally Field plays his high-strung, careerist wife, Miranda. After a particularly outrageous day in which Daniel quits his job as a voice actor and throws a birthday party for his son, Chris, involving rented barnyard animals, blaring rap and a thorough trashing of their beautiful San Francisco mansion, Miranda soberly declares that she wants a divorce. Daniel, suddenly lacking a job and a place to live, loses the ensuing custody

Mark Radcliffe
Matthew Rushton
Marsha Garces Williams
Robin Williams

Screenwriters:
Randi Mayem Singer
Leslie Dixon
From a novel by Anne Fine

Cinematographer:
Donald McAlpine

Art Director:
W Steven Graham

Editor:
Raja Gosnell

Duration:
125 minutes

Cast:
Robin Williams
Sally Field
Pierce Brosnan
Harvey Fierstein

Year:
1993

battle. Desperate to see more of his children, and learning of Miranda's intention to hire a housekeeper, he masquerades as a prim, elderly British woman named Mrs Doubtfire and lands the job for himself.

Critique

A superb comedy, striking a rare balance between anarchic hilarity and well-motivated sentimentality, the movie resonated with audiences for its complex, believable portrayal of divorce: Daniel, Miranda and the children are all essentially good people made tense, crabby and occasionally cruel by an extremely difficult situation for which no one is to blame.

Yet this grave subject matter is deftly channelled into the film's considerable comedic energy. The opening scene introduces us to Daniel's voice-acting career as he sings an aria from *The Barber of Seville*, recording it for a children's cartoon. The film thus declares its entrance into the realm of farce, a promise well kept by its plays on identity (especially gender identity) through disguise; its concern over the (re) coupling of the central pair; its increasingly frantic pace; and its eventual devolution into absurdity. Much of the comedy grows out of the ways the film plays on the audience's knowledge of Mrs Doubtfire's true identity. This comes out not only in the predictable man-in-women's-clothing gags (familiar from other cross-dressing classics like *Some Like It Hot* [1959] and *Tootsie* [1982]), but also in her uncanny familiarity with the family and home she enters and her singular hostility towards Miranda's new lover Stu (Pierce Brosnan).

The film is a star platform for Robin Williams, whose virtuosic performance carries the bulk of its comedic force. Williams' anarchic energy has rarely been given such free reign; only *Good Morning, Vietnam* (1987) approaches *Mrs Doubtfire* in terms of the sheer improvised madness of which Williams is capable. Williams' horseplay transcends the juvenility of some other comic stars of the 1990s (Eddie Murphy and Adam Sandler come to mind). Although there are moments of pure slapstick, the excellence of Williams' comic style grows out of its witty intelligence, which keeps the film anchored in the realm of the grown-up.

Other aspects of Williams' star persona are also salient. The film was released the year after Williams' show-stealing vocal role in Disney's *Aladdin* (1992), adding an air of authenticity to the part of Daniel: in playing a voice actor, Williams seems to be playing himself. Daniel's desperate love for his children, already convincingly dramatized, seems all the more poignant when juxtaposed with both Daniel's and Williams' mirthful facades. Moreover, the cross-dressing in *Mrs Doubtfire* can be seen as the apogee of Williams' star image as an actor whose characterizations play on the performativity of gender and sexuality. *Dead Poets Society* (1989) and *Good Will Hunting* (1997) represent the melodramatic end of this spectrum, as

he invokes heteronormative masculinity with performative gravitas that serves as a front for underlying homosexual themes. *The Birdcage* (1996) and the television show *Mork & Mindy* (1978–1982) feature Williams in comic performances of gayness. Williams' acting style contains a potential for femininity which must be either engaged (in the comedies) or repressed (in the melodramas). This potential is exploited to the fullest in *Mrs Doubtfire*, as he plays both a melodramatic, hetero father figure and a cross-dresser with well-developed queer potential.

Indeed, along with other films from the late 1980s and early 1990s (*Three Men and a Baby* [1987], *Father Hood* [1993], *Bye Bye Love* [1995], *Nine Months* [1995]), *Mrs Doubtfire* comedically works through an American crisis of masculinity, fatherhood and the traditional family. This crisis comes out more dramatically in such films as *Boyz N the Hood* (1991), *Terminator 2: Judgment Day* (1991) and *Wall Street* (1987). Through Daniel's charade, *Mrs Doubtfire* explores his motherly potential: he grows as a parent and partner by enacting his feminine side, compensating for Miranda's liberation/masculinization, thus making the family whole again.

Anna Cooper Sloan

Some Like It Hot

Studio/Distributor:
MGM

Director:
Billy Wilder

Producer:
Billy Wilder

Screenwriters:
IAL Diamond
Billy Wilder

Cinematographer:
Charles Lang

Art Director:
Ted Haworth

Editor:
Arthur P Schmidt

Synopsis

In Prohibition era Chicago, two musicians, a saxophone player, Joe, and a double bass player, Jerry, are flat broke and down on their luck after the speakeasy they work at is raided by the cops. Having witnessed a mob slaying orchestrated by Spats Colombo and barely escaping with their own lives, they take the desperate measure of disguising themselves as women, 'Josephine' and 'Daphne', and escaping with an unsuspecting girl band which is just leaving for a booking in Miami. On the train they befriend Sugar Cane, a similarly-unlucky ukulele player and singer. She confess to Joe(sephine) her ambition to marry a millionaire and escape a spiralling series of bad relationships with various saxophone players. However, having arrived at the hotel, it is Daphne who immediately attracts the attention of the satchel-mouthed millionaire Osgood Fielding, whereas Sugar is suckered by Joe who adopts a phoney British accent (à la Cary Grant) and claims to be an oil tycoon, borrowing Osgood's yacht to complete the illusion. When Spats Colombo and his associates turn up at the hotel for an 'Italian Friends of Opera' conference with other leaders of the mob, an element of danger is added.

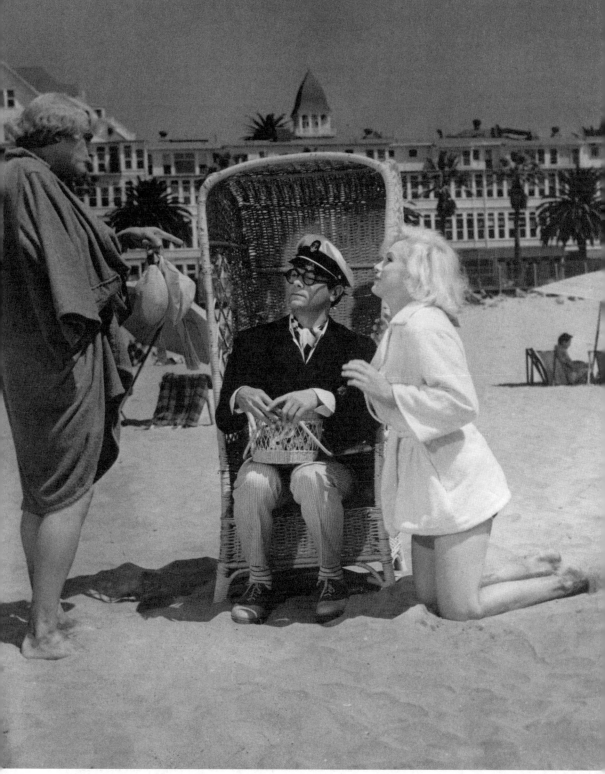

Some Like It Hot, 1959, United Artists.

Music:

Adolph Deutsche

Duration:

120 minutes

Cast:

Marilyn Monroe
Tony Curtis
Jack Lemmon

Year:

1959

Critique

In the best tradition of Shakespearean comedy, Billy Wilder's superlative comedy deals with the fluidity of identity. Almost everybody is trying to be somebody else. At the very beginning of the film, a police officer poses as a mourner in order to enter a speakeasy which is itself posing as a funeral parlour. None of these disguises and deceptions is frivolous. The context of Prohibition and organized crime add a deadly frisson as, again agreeing with Shakespeare, violent death lurks around the edges of comedy as more than a possibility. The Valentine's Day Massacre, organized in order to take out Toothpick Charlie, a police informer (another example of role-playing) and the later assassination of Spats are shown in all their brutality. 'I think I'm going to be sick', Jerry says on witnessing the massacre. That said, the film also plays with parodic in-jokes at the expense of the gangster genre: the casting of uber-gangster George Raft as Spats Colombo, and the referencing of his own trademark, the tossing coin ('where d'ya pick up that cheap trick?') and a hoisted grapefruit in true James Cagney style, as well as the casting of a motley group of nasally-challenged plug-uglies as his henchmen, all serve to undermine the menace.

The most important disguises are those of the two central performances of Jerry/Daphne and Joe/Josephine. Their ineptness underlines the comedy. Daphne's nervous laugh topped by a tiny snort and Josephine's butch pouting and matronly pretension never fool us for a second even as those around them are completely taken in. Seeing how the other half lives, our two musicians begin to relish the opportunities their disguises give them, such as a slumber party with the all girl band and Sugar's confession, which gives Joe all the information he needs to con her into bed. However, the comedy deepens on arriving in Miami and Daphne increasingly loses him/herself in her role, dancing the tango with, and then accepting a proposal of marriage from, Osgood and Joe begins his seduction of Sugar. With his second disguise as Junior, the heir to millions, Joe seeks to transgress not just the lines of gender but also those of class and nationality. There is a hint of this already in Josephine and Daphne's claim of being ladies who studied at a fictional conservatoire, but Joe spins his story to Sugar with an increasingly inventive verve. Sugar herself pretends to be a society flapper, foregoing what also seems a carefully-constructed role as dumb blonde steeped in bad luck, who always gets the fuzzy end of the lollipop. As with Daphne, Junior begins to realize parts of his own personality in the part he is playing. When Jerry queries why Joe feels bad for running out on Sugar when he always treats women badly, Jerry replies that the saxophone player would have done that, but now he is supposed to be a millionaire. The genuine need to escape (from violence and poverty) fuels the escapism, but the role itself becomes more

important than the ruse; the disguise preferred to a former identity.

Music has a vital role to play. In addition to offering Marilyn Monroe the opportunity to perform a series of iconic numbers, Adolph Deutsche's jazz score provides a brassy and sexy background to the shenanigans. The title *Some Like It Hot* refers to a conflation of jazz with sex. Music also unites the three leads as they belong to the world of performers, a world that seems sexually promiscuous, carelessly deceptive (Sweet Sue the band leader is anything but sweet) and necessarily dynamic; a life made up of hotels and trains, a world in which performance defines you.

John Bleasdale

American films depicting historical events can be traced back as far as the nineteenth century. The Edison Company produced a number of 'historical tableaux' for its Kinetoscope, among them *The Execution of Mary Queen of Scots* (1895), essentially a 'trick shot' dramatization of the beheading using a concealed edit to substitute the actor for a dummy. Edison bought this spectacle up to date in 1901 with a film depicting the electrocution of Leon Czolgosz, the assassin of President McKinley. Produced less than two weeks after Czolgosz's actual execution and employing realistic *mise-en-scène*, the film might be said to muddy the distinction between representation and reality in a way that prefigures the subsequent development of the historical film in America. The most hotly-debated example of this tendency in recent years concerns the assassination of another American President. Released in 1992, Oliver Stone's *JFK* was widely criticized for integrating documentary footage with detailed reconstructions of historical events in order to illustrate theories about the Kennedy assassination. In a debate that traversed both mainstream media and academic discourse, Stone was accused of 'contempt for history' (Hoff 1996: 1173) and of misleading 'vulnerable audiences herded in darkened halls' (Ambrose et al 2000: 216). For its defenders, on the other hand, *JFK* successfully challenged the principle of objectivity and the straightforward distinction between 'truth' and 'myth' which much mainstream history writing takes for granted. As Robert Rosenstone put it, the film 'questions history as a mode of knowledge ... and yet asserts our need for it' (Rosenstone 2006: 129).

As *JFK*'s fraught reception indicates, Hollywood history films have frequently faced criticism for incorporating and omitting elements which depart from the historical record. It is worth noting, however, that any film which dramatizes or restages the past from the perspective of the present necessarily strikes a balance between fact and fiction, no matter how closely it hews to documentary evidence. As Pierre Sorlin argues, historical films 'have to reconstruct in a purely imaginary way the greater part of what they show' (Sorlin 1980: 21). Moreover, as theorists such as Hayden White have argued, any attempt to translate information about the past into a historical narrative inevitably involves rhetorical conventions that lead to a form of fiction. Although many would argue that the inventions of Hollywood historical films and the shortcomings of academic history are not equivalent, it should be clear that no account of the past can claim absolute objectivity. David Eldridge has recently defined historical cinema as 'all films which utilise ideas about the past contain and reflect ideas about "history"' (Eldridge 2006: 5). This definition throws open the doors to a huge range of films, including well-established genres such as the Western and the war film, which are examined elsewhere in this volume. But, as with many other Hollywood genres, the history film is not a unified set of textual practices and it frequently overlaps with other generic categories. Nevertheless, Eldridge's definition allows historical films to be approached not simply in terms of their fidelity or otherwise to historical data but, rather, as part of a longstanding desire of film-makers and their audiences to engage with representations of the past.

Indeed, history has been central to some of the highest profile Hollywood films of the past century. In 1915, DW Griffith's *The Birth*

of a Nation demonstrated that lavish depictions of American history, no matter how dubious, had enormous box office potential. Griffith proposed that historical films would soon supersede books as tools for learning about the past, but this didactic spirit was not shared by other major film-makers of the period. The highest profile history films of the early sound era focused on history beyond America's borders. At Paramount, Cecil B DeMille used the ancient world as a means to put sex and spectacle on the screen in The Sign of the Cross (1932) and Cleopatra (1934). For Warner Bros, conversely, the more recent history of Europe provided a way to add prestige to their production roster. In particular, the Paul Muni bio-pics The Story of Louis Pasteur (1936) and The Life of Emile Zola (1937) narrate the past as great men struggling against the odds for noble causes. American history was not completely forgotten, however. Gangster films such as The Public Enemy (1931) and Scarface (1932) examined America's recent urban past, while Westerns like Cimarron (1931) and Union Pacific (1939) narrated and often mythologized the westward expansion of America's frontier. As hostilities gathered pace in Europe, some Hollywood film-makers used the past as a way to caution viewers about the present. Films such as Juarez (1939) and That Hamilton Woman (1941) can be read as allegories of the growing Nazi threat.

In the 1950s, as the Hollywood studios adjusted to fragmentation of the cinema marketplace, historical cinema became absolutely central to their operations. In particular, lavish, spectacular, ancient world epics such as Quo Vadis (1951) and The Ten Commandments (1956) allowed Hollywood to develop new distribution strategies and new technologies of exhibition (notably widescreen) that would allow cinema to compete for dwindling audiences. The fashion for spectacular epics ended with a series of high-profile failures in the late 1960s, but many of the films that displaced them also drew on history. Among the major films of the New Hollywood movement, Bonnie and Clyde (1967), Serpico (1973), All the President's Men (1976) and Raging Bull (1980) combine stories from America's past with a fresh presentational style. War films, notably Apocalypse Now (1979), Platoon (1986) and Saving Private Ryan (1998) also allowed Hollywood film-makers to reflect changing attitudes to America's various military engagements following the Vietnam War. In the final years of the twentieth century, films such as Braveheart (1995), Titanic (1997), Gladiator (2000) refreshed conventions from the historical epics of the 1950s for new audiences with CGI and more realistic bloodshed. Historical films continued to be controversial, most conspicuously the work of Oliver Stone, but the debates they generated also illustrate the significance of film to the public understanding of history.

As this brief survey indicates, Hollywood's engagements with history have been multiple, malleable and enduring. As a vehicle for spectacle, prestige, technical innovation and political comment, the history film remains a key genre for understanding the workings of the American film industry.

Jonathan Stubbs

References

Ambrose, SE, McGovern, GS & Schlesinger Jr, AM (2000) 'Nixon', in RB Toplin (ed) Oliver Stone's USA: Film, History, and Controversy, Lawrence: University of Kansas Press, pp. 202–16.

Eldridge, D (2006) Hollywood's History Films, London: IB Tauris.

Hoff, J (1996) 'Nixon', American Historical Review, 101: 4, pp. 1173–174.

Rosenstone, RA (2006) History on Film/Film on History, Harlow: Pearson Educational.

Sorlin, P (1980) The Film in History: Restaging the Past, Oxford: Blackwell.

Ben-Hur

Studio/Distributor:
MGM

Director:
William Wyler

Producer:
Sam Zimbalist

Screenwriter:
Karl Tunberg

Cinematographer:
Robert Surtees

Art Directors:
Edward Carfagno
William A Horning

Editors:
John Dunning
Ralph Winters
Margaret Booth

Music:
Miklos Rosza

Duration:
178 minutes

Cast:
Charlton Heston
Jack Hawkins
Stephen Boyd

Year:
1959

Synopsis

Set during the life of Christ, the film tells the epic riches to rags and back to riches story of a wealthy young Jewish nobleman, Judah Ben-Hur, his search for his family and his feud with his erstwhile childhood friend, the ambitious Roman officer, Messala. Ben-Hur's refusal to help Messala in reconciling the Jews to Roman rule enrages Messala and, using a near-fatal accident as an excuse, Messala has Ben-Hur arrested along with his sister and mother. Ben-Hur is sent to the galleys, where he slaves until his fortune eventually changes when he rescues a Roman Consul, during a battle. Ben-Hur is taken to Rome, where he becomes a charioteer and Roman nobleman, adopted by the grateful Consul. However, still longing for his family, he returns to Jerusalem to find them. There are rumours of their deaths, but Esther, a former slave girl who Ben-Hur is in love with, knows they are alive, though now lepers. Ben-Hur seeks to revenge himself on Messala in a great chariot race, which takes place before the new governor, Pontius Pilate. Messala, fatally injured in the race and on his death bed, tells Ben-Hur the truth about his family and their whereabouts. Reunited with his family, once more banished from Jerusalem by Pilate, Ben-Hur leaves, but not before witnessing the final act of Jesus' life, a presence he has encountered on other occasions throughout the story.

Critique

Based on the novel by Lew Wallace, *Ben-Hur* had already been given epic treatment in the Irving Thalberg's silent film of 1925. This remake, directed by William Wyler who worked on the original epic as an Assistant Director, was a long and fraught production, with many rewrites, including substantial uncredited contributions from Christopher Fry and Gore Vidal.

The relatively simple fall-and-rise trajectory of the narrative is fleshed out with set pieces. Charlton Heston, fresh from portraying Moses in DeMille's *The Ten Commandments* (1956), gives a solemn performance. In restraining the ham, he appears to be holding his breath. Although, ostensibly, a quest to be reunited with his mother and sister (and Esther, to some extent), the most compellingly drawn relationships in the film are those between the men. The most obvious example is the friendship-turned sour of Messala and Ben-Hur, with its homo-erotic intensity, besides which the love affair of Esther and Ben-Hur is a pallid afterthought. The emotional core of the film burns brightest in the scenes between the two men, and Messala's death is an especially powerful climax, with both men in the grip of contending emotions of hate and disappointed affection. However, the film also features a range of more subtle and varied male relationships. The fatherless Ben-Hur encounters a number of possible replacements: most explicitly in the form of Jack Hawkins' gruff Consul. Just as Messala challenges Ben-Hur's love for Esther, so a series of male figures counterpoint his actual female family. This proxy male family is available via the

avuncular Sheik Ilderim, who provides Ben-Hur with the horse team in the chariot race, and the wise man, Balthazar. Even Jesus, who appears elliptically throughout the film, offers a possible benign brotherhood set against the more dangerous fire of his Messala fixation. The fact that each of these men also represents an alternative ethnic and religious identity, the Muslim, the Roman, the Jewish and eventually the Christian, suggests that religion is elective rather than tribal and, although Ben-Hur rejects his Roman identity in favour of his Jewish, it is Christianity which is the implied victor.

Ultimately, the film is about spectacle. The painterly composition and colour scheme recall Renaissance treatments of Biblical themes by masters such as Tintoretto and Michelangelo. As in those paintings, in *Ben-Hur* the Italian countryside and the Italian light stand in for the Holy Land. The Chariot race is justly remembered as not only the highlight of the film, but as a highlight in the history of American cinema. It is a rare occasion when a fictional sporting event manages to reproduce the excitement of a genuine race. The genius is in the details: Pilate's delay in beginning the race, the bronze fish which mark the laps, the business of the stretcher bearers and Messala's murderous wheel blades. The actors and their stunt doubles seamlessly blend in the action with the special effects to the extent that a rumour persists that Messala's stunt double was killed during the filming. The dynamism and pacing of the sequence is emphasized by the merciful absence of the otherwise-omnipresent Miklos Rosza score, replaced with the thundering of hooves and the crack of the whip. If there is one criticism of the scene, it is that it breaks the back of the movie. With Messala dead and Rome definitively rejected, Wyler does his best to maintain interest with what are the less dynamic aspects of the story: the leprous women and the solemn hocus-pocus of the last act.

John Bleasdale

The Birth of a Nation

Studio/Distributor:
David W Griffith Corp.
Epoch Producing Corporation

Director:
DW Griffith

Producer:
DW Griffith

Synopsis

The sons of a Northern abolitionist senator visit school friends at a Southern plantation in Piedmont, where two romances blossom among the Stoneman and Cameron families. These personal stories then continue against the panoramic backdrop of the Civil War, as the youngest sons of both families die together on the battlefield and the Cameron home is ransacked by renegades. Wounded and captured by union forces, Ben Cameron is nursed back to health at a military hospital by Elsie Stoneman. Phil and Elsie Stoneman then witness the assassination of President Abraham Lincoln at Ford's Theatre in Washington, DC. Extreme Reconstructionists win post-war congressional elections and Senator Stoneman

Screenwriters:

DW Griffith

Frank E Woods

Cinematographer:

GW Bitzer

Art Director:

Frank Wortman (uncredited set designer)

Editors:

DW Griffith

Joseph Henabery

James Smith

Rose Smith

Raoul Walsh

Duration:

190 minutes

Cast:

Lillian Gish

Mae Marsh

Henry B Walthall

Miriam Cooper

Mary Alden

Ralph Lewis

George Siegmann

Walter Long

Robert Harron

Wallace Reid

Joseph Henavery

Elmer Clifton

Josephine Crowell

Spottiswoode Aitken

George Beranger

Year:

1915

sends the mulatto Silas Lynch to Piedmont to administer universal suffrage for former slaves. Lynch, however, forms them into a mob that commits outrages against the white community. In response, Ben Cameron becomes involved with the Ku Klux Klan organization, which summarily executes the 'renegade negro' Gus, after his attack on Flora Cameron has led her to commit suicide. The Klan also engages in two last minute rescues, including preventing Lynch's rape of Elsie Stoneman. The film concludes with a new election and two marriages: Elsie Stoneman/Ben Cameron and Phil Stoneman/Margaret Cameron.

Critique

The controversy surrounding Griffith's most famous and financially-successful film *The Birth of a Nation* has long posed thorny problems for film scholars in the evaluation of the director's career. The reactionary racism pervading the film has cast a shadow over his entire body of work. As Jay Leyda notes, critics have often evaded the central contradiction of technical greatness amidst historical injury, either by rejecting the film outright or by stressing others such as *Intolerance* (1916). Leyda's own somewhat unsatisfactory solution was to break the film into two parts, 'The War' and 'The Klan', eulogizing the first as 'self-contained' while demonizing the latter's rides to the rescue as marking an irremediable 'artistic death' (Leyda 1971: 163–66). Another approach has been to separate form from content, celebrating Griffith as a pioneering stylistic innovator and often focusing on his earlier pre-feature work at Biograph. Unfortunately, this line has led to its own distortions, most clearly in the exaggeration of Griffith's role in the invention and development of such key cinematic techniques as the close up and parallel editing (Gunning 1994: 6).

The film, however, certainly does bring together and extend the panoply of technical devices developed over hundreds of shorts. Vardac goes as far to argue that the 'spectacular' style in evidence here owes a great deal to the frustrating conservatism that Griffith had to operate under at Biograph. Stymied from making longer films, he instead turned to perfecting 'larger pictorial conception', as evidenced by the successful combination of spectacle and melodrama in films like *The Battle* (1911), featuring hundreds of soldiers in action (Vardac 1971: 73–74). Once freed from the aesthetic and budget constraints of Biograph, the director could quite easily transfer and more fully exploit this realized style. Such preparation also allowed Griffith and his longstanding technical collaborator, cameraman GW Bitzer, to focus more time and effort on achieving individual set-piece effects, for example in *Birth* the remarkable close-ups of the feet of the clansman's mounts (Barry 1940: 21). Unfortunately, this very level of formal achievement and the corresponding perception of heightened realism only further problematizes the actual content of the narrative.

The extent to which Griffith never really understood the controversy and protest surrounding *Birth* can be seen in some of the comments he made around the time of its release, ironically downplaying the film's formal strengths in favour of the story:

> I wouldn't say that the story part of that picture can ever be excelled, but as for the picture itself, there will be others made that will make it appear archaic in comparison . . . I felt driven to tell the story – the truth about the South, touched by its eternal romance which I had learned to know so well. (Griffith 1971: 40)

For Griffith, the rides to the rescue by the Ku Klux Klan seemed to be as 'true', as historically accurate, as the pains-takingly-reconstructed Civil War battle scenes from earlier in the film. The son of the romanticized confederate soldier proved unable to take on board at the time any of the often cogently-articulated criticism of *Birth*, that it functioned, for example, as a distorted interpretation of history, as 'the most subtle form of untruth – a half truth' ('Fighting a Vicious Film' 1971: 94). Instead, the besieged director could only resort to his own ride to the rescue in the form of a pamphlet (Griffith 1971: 43–45), and later a film, defending free speech against 'intolerance'.

David Garland

References

Barry, I (1940) *DW Griffith: American Film Master*, New York: The Museum of Modern Art.
'Fighting a Vicious Film: Protest Against *The Birth of a Nation*' (1971), in HM Geduld (ed) *Focus on DW Griffith*, Englewood Cliffs, NJ: Prentice-Hall, pp. 94–102.
Griffith, DW (1971) 'Commentary by DW Griffith', in HM Geduld (ed) *Focus on DW Griffith*, Englewood Cliffs, NJ: Prentice-Hall, pp. 31–68.
Gunning, T (1994) *DW Griffith and the Origins of American Narrative Film*, Urbana: University of Illinois Press.
Leyda, J (1971) 'The Art and Death of DW Griffith', in HM Geduld (ed), *Focus on DW Griffith*, Englewood Cliffs, NJ: Prentice-Hall, pp. 161–67.
Vardac, AN (1971) 'Realism and Romance: DW Griffith', in HM Geduld (ed), *Focus on DW Griffith*, Englewood Cliffs, NJ: Prentice-Hall, pp. 70–79.

Forrest Gump

Studio/Distributor:
Paramount Pictures

Director:
Robert Zemeckis

Producers:
Wendy Finerman
Steve Tisch
Steve Starkey

Screenwriter:
Eric Roth

Cinematographer:
Don Burgess

Art Directors:
Leslie McDonald
Jim Teegarden

Editor:
Arthur Schmidt

Duration:
142 minutes

Cast:
Tom Hanks
Robin Wright
Gary Sinise
Mykelti Williamson
Sally Fields

Year:
1994

Synopsis

Seated at a bus stop, Forrest Gump, an intellectually-challenged Southerner, begins to describe the events of his life to waiting passengers. Interweaving stories involving key moments of 1960s' and 1970s' American history with his own brand of home-spun wisdom, Gump recalls his passion for running, his involvement in college football, the Vietnam War, visiting the White House, his friendship with fellow soldiers Bubba and Lt Dan, his mother, and Jenny, a childhood sweetheart and the love of his life.

Critique

'My momma always said, "Life was like a box of chocolates – you never know what you're gonna get"'. So begins *Forrest Gump*, a grandiose tale imagined through the eyes of an idiot. Like the confectionary that Forrest (Tom Hanks) offers his fellow travellers, the film is an assortment of generic narratives; historical epic, modern-day fairytale, war, and romance, packaged together in a nostalgic re-enactment of America's not-too-distant cultural past.

Based on the satirical novel by Winston Groom, writer Eric Roth's screen adaptation for *Forrest Gump* empties the work of any recognizable irony and substitutes in its place a bittersweet morality tale about the simplicity of life and the importance of realizing personal destiny. Recalling America's divisive Civil Rights protests, war, presidential assassinations and natural disaster, Forrest disarticulates these events as signs of happenstance and misfortune, apparently blind to the ideological nature of history and politics. Indeed, the film's overriding message is geared to the belief that if we were all a bit more like Forrest the world would be a better (and less complicated) place.

For director Robert Zemeckis, the exploration of history is not entirely new cinematic territory. However, unlike his *Back to the Future* trilogy (1985–1990) where the ability to rewrite the past/future is framed with an air of caution, *Forrest Gump* celebrates its historical amendments, substituting moments of crisis and loss with a revisionist depiction of mythical heroism and self-realization. Tom Hanks, in his first of three collaborations with Zemeckis to date, provides a mannered performance in the title role, demonstrating his aptitude for both emotional melodrama and comic timing, and yet it is Gary Sinise in his breakthrough role as the angst-burdened Lt Dan who steals the scenes in his few brief appearances.

Arguably, the film's greatest achievement is in regards to the technical wizardry of its historical recreations where the character of Forrest is seamlessly inserted into archival footage, interacting with presidents Kennedy, Johnson and Nixon, and alongside figures such as John Lennon. Perhaps it is the

skill with which history is seen to bend to the dictates of a cinematic imaginary that makes *Forrest Gump*'s representations all the more troubling.

Given its lack of critical self-awareness, *Forrest Gump*'s stereotypical depiction of African-Americans (as big-lipped jesters or enraged activists) and women (as drug-takers and prostitutes), the lead character achieves a near-divine status, indicating a highly-tuned conservatism at play. This is particularly evident in the sequence where Forrest leaves home to run across America (an act denied any political intent) and garners a large band of followers. But rather than question the outward senselessness of such blind devotion, *Forrest Gump* asks its audience (like those running devotees) to embrace the absence of thought as a guiding life principle.

While it may be tempting to refute these criticisms of the film as being motivated by a cynical rejection of fantasy or imagination, *Forrest Gump*'s effortless disavowal of real political struggles renders such a rebuke untenable. As the dark stains of America's past are erased and rewritten for the sake of nostalgia and broad assertions about personal and cultural destiny, it is hard not to feel that *Forrest Gump* is ultimately little more than reactionary wish-fulfilment; a resounding celebration of ignorance as utopian bliss. And that is all I have to say about that.

Josh Nelson

Gladiator

Studio/Distributor:
DreamWorks Pictures
Universal Pictures
Scott Free Productions

Director:
Ridley Scott

Producers:
David Franzoni
Branko Lustig
Douglas Wick
Terry Needham

Screenwriters:
David Franzoni
John Logan
William Nicholson

Cinematographer:
John Mathieson

Synopsis

In the year 180 A.D., Maximus Decimus Meridius leads an army of Romans to an important victory against Germanic barbarians, earning the esteem of Rome's aging Emperor, Marcus Aurelius. The Emperor makes plans to name Maximus his successor, refusing the ambitions of his son, Commodus. When Commodus learns of his father's plans, he kills his father and has Maximus' wife and child murdered. Maximus himself escapes death but is later captured and put into slavery in North Africa, where he is eventually hired by Proximo to be trained and to compete as a gladiator. When Proximo's legion reaches Rome to compete in the gladiatorial games, Maximus becomes a very popular fighter with the crowds. He devises a plan with Lucilla, sister of Commodus, and members of the Senate to overthrow Commodus.

Critique

Ridley Scott's epic re-envisioning of the 'sword and sandals' genre featuring the fictional Roman general Maximus was a well-reviewed summer blockbuster for DreamWorks in 2000; it won five Academy Awards, including Best Picture. Though

Gladiator, 2000, Dreamworks/Universal. Photographed by Jaap Buitendijk.

Art Directors:

Crispian Sallis (set decoration)
David Allday (supervising Art
Director: UK)

Editor:

Pietro Scalia

Music:

Hans Zimmer
Lisa Gerrard

Duration:

155 minutes (theatrical)
171 minutes (Director's Cut)

Cast:

Russell Crowe
Joaquin Phoenix
Connie Nielson
Djimon Hounsou
Oliver Reed
Richard Harris

Year:

2000

historical accuracy is not the film's central concern, it did spur an interest in Ancient Rome research and publishing, and managed to breathtakingly bring to life a period of history that had not been successfully conveyed by Hollywood since *Ben-Hur* (1959) and *Spartacus* (1960). The success of *Gladiator* turned Russell Crowe into an international star (the role and film are still apparently Crowe's favourite of all the American movies in which he had starred). Acting, costumes, cinematography, production design, editing and music are all strong achievements which help to solidify the film as a repeatedly meaningful viewing experience. Screenwriter David Franzoni (one of many scribes attached to the production) had been thinking about the story since the 1970s, and was inspired further when working with Steven Spielberg on historical drama *Amistad* (1997). The film frames the journey of Maximus through the memory of his wife and child (William Nicholson added the script's detours into the dreams and philosophies of the afterlife), but the narrative always feels honest, never saccharine, and the ends seem to completely justify the means.

British acting stalwarts Richard Harris (as the Roman Emperor Marcus Aurelius) and Oliver Reed (as Proximo) are given meaty roles, in contrast to many typical contemporary Hollywood offerings, and Joaquin Phoenix adds a compelling

creepiness to his role of Commodus. Crowe and Reed particularly stand out in their scenes together, as Proximo 'pumps up' Maximus so that he is prepared to command not only his competitors, but also the crowd (Franzoni has noted that Proximo was modelled on the often pushy personality of a Hollywood talent agent). Digital visual effects were used in two interesting ways: Reed suffered a fatal heart attack during principle photography; his face was digitally replicated for shots that were still required, and a body double was used to complete the rest of the performance. Also, computer-generated shots of crowds were created to fill the famous Roman Colosseum (real extras filled only the bottom two decks).

Hans Zimmer and Lisa Gerrard's music score for *Gladiator* was also critically- and commercially successful. Zimmer's trumpet-heavy style for the film's action themes has been referenced, replicated, duplicated, and often blatantly copied in theme and style for innumerable Hollywood blockbusters over the decade that followed *Gladiator*'s release. Some of Zimmer's assistants have become feature composers of their own (though they often mimic his style), or have helped in composing 'additional material' when Zimmer's arms were stretched between multiple jobs at the same time as his career went into overdrive following the global success of *Gladiator*. A prequel and sequel were both discussed by Scott, Crowe and the original screenwriters for many years and, at one point, Scott and Crowe invited musician Nick Cave (who has dabbled in scriptwriting) to write a sequel draft, which was ultimately rejected by the studio.

Michael S Duffy

Gone With the Wind

Studio/Distributor:
Selznick International Pictures
MGM

Director:
Victor Fleming

Producer:
David O Selznick

Screenwriter:
Sidney Howard

Cinematographer:
Ernest Haller

Synopsis

Encompassing the American Civil War, *Gone With the Wind* centres on the life and romantic trials of Scarlett O'Hara, the daughter of a rich landowner in the Deep South. Scarlett is admired by many men but is spurned by Ashley Wilkes, the man that she wants. Ashley instead marries Melanie Hamilton; so Scarlett accepts the proposal of Melanie's brother, Charles. Charles dies in the war. As the war progresses beyond Christmas, Melanie becomes pregnant and Scarlett fulfils her promise to Ashley that she will protect her. Scarlett helps Melanie give birth, but they both have to rely on Rhett Butler to escape to Scarlett's family home, Tara, whilst Atlanta burns. Rhett leaves the women to fend for themselves as he joins the army, but not before he declares his love for Scarlett. The women struggle by themselves in poverty but, as the war ends, Scarlett is forced to once more enter a marriage of convenience with Frank Kennedy. As violence erupts, Frank is left dead whilst Ashley nearly dies. Rhett and Scarlett finally

Art Director:

Lyle Wheeler

Editors:

Hal C Kern

James E Newcom

Duration:

238 minutes

Cast:

Clark Gable

Vivien Leigh

Leslie Howard

Olivia de Havilland

Hattie McDaniel

Year:

1939

get married. With Tara restored and a new mansion in Atlanta, the Butlers have a daughter called Bonnie, but, as Scarlett still loves Ashley, Rhett wants a divorce. Scarlett suffers a miscarriage and Bonnie dies in a horse-riding accident, with the stress of pregnancy eventually also killing Melanie. Scarlett finally realizes that she loves Rhett, but 'Frankly, my dear ...'

Critique

Even before one considers the details presented by the labyrinthine plot, *Gone With the Wind* is an epic Hollywood film by almost every definition. The rights to Margaret Mitchell's thousand-page novel were bought for the then record amount of $50,000. Sidney Howard has the sole credit for writing the script but several other writers were involved, not least Ben Hecht, the acclaimed writer of the screenplays for *Scarface* (1932), *Stagecoach* (1939), *Some Like it Hot* (1939) and *His Girl Friday* (1940). Dozens of famous (or soon-to-be-famous) actresses were tested for the part of Scarlett O'Hara, including Joan Crawford, Bette Davis, Katharine Hepburn, Norma Shearer, Barbara Stanwyck, and Lana Turner, yet a relatively-unknown actress called Vivien Leigh got the role. Furthermore, once shooting had begun, George Cukor, the original director who had carried the project for two years was immediately dropped in favour of Victor Fleming. Cukor would go on to direct *The Philadelphia Story* (1940) and *My Fair Lady* (1964), whilst Fleming was co-directing *The Wizard of Oz* (1939) at the time he was drafted in to complete *Gone With the Wind*.

By the end of this debacle, mostly caused, it should be added, by the producer, David O Selznick, the film had cost around $3.9 million – an incredible amount at the time. Perhaps more staggering is the fact that whilst the financially-lucrative *Avatar* (2009) currently has a world-wide gross estimated to be approximately $2.6 billion, *Gone With the Wind's* adjusted gross is around $5.4 billion, which The Guinness Book of Records considers to be one of its ten records that will be virtually unbeatable. If financial rewards were not enough for this film, then one should also consider that *Gone With the Wind* won ten Academy Awards, including one for Best Picture, and that in their recently compiled lists of the top 100 American films, the AFI (American Film Industry) currently considers the film to have the sixth greatest song, the second best film score, the first, thirty-first, and fifty-ninth greatest movie quotes, in addition to being the fourth greatest Epic, the second most passionate, and also, the sixth greatest film ever made.

It could also be almost excusable to ignore the fact that Margaret Mitchell was unhappy with the accuracy of the sets in a Civil War context, because they were filmed in such vivid Technicolor that the matte-painted reds of Atlanta burning, and the vivacious dresses of Scarlett O'Hara present a

Hollywood fantasy spectacle that is only rivalled by the ruby slippers and yellow brick road of *The Wizard of Oz* in early colour Hollywood movies. The Golden Age of Hollywood runs from the end of the silent era in the late 1920s through to the late 1950s, but 1939 was clearly a year of 'greats'. Alongside these two films, so were the following classics released: *Wuthering Heights*, *Stagecoach*, *Mr. Smith Goes to Washington*, and *Only Angels Have Wings*. Arguably, *Gone With the Wind* goes slightly further than these other films, as it represents the epitome of the Hollywood moviemaking machine married to the quality and style of its output, setting the template for most of the Blockbusters and romances that have followed, for better or worse. The final product may be an entertaining, if lengthy, film, but *Gone With the Wind*'s excesses of every type ensure that its status as a cultural phenomenon is as epic as its content.

Carl Wilson

The Last Samurai

Studio/Distributor:
Warner Bros

Director:
Edward Zwick

Producers:
Marshall Herskovitz
Edward Zwick
Tom Cruise
Paula Wagner
Scott Kroopf
Tom Engelman

Screenwriters:
John Logan
Edward Zwick
Marshall Herskovitz

Cinematographer:
John Toll

Production Designer:
Lilly Kilvert

Composer:
Hans Zimmer

Synopsis

In 1870s' California, disillusioned ex-army officer Captain Nathan Algren is selling guns at a carnival sideshow and drowning his past in a bottle. After frightening the sideshow crowd with a drunken tirade against the army's treatment of the Indian, Algren accepts work from a Japanese businessman recruiting experienced soldiers to train a modern army for the Emperor. Arriving in Japan under the command of his former Colonel, with whom he has a strained relationship, Algren is introduced to the young Emperor Meiji and embarks on training conscripts who prove ill-prepared. Algren learns about Katsumoto, once-loyal bodyguard and advisor to the Emperor, now leader of an intended revolt by samurai traditionalists against the modernizers. His conscripts routed in a skirmish with Katsumoto's rebels, Algren is imprisoned in the samurais' remote village. He learns respect for his captors, especially Katsumoto, and regains the self-respect he had lost in the massacre of an Indian village. Algren 'goes native', becomes proficient in martial arts and is attracted to Katsumoto's sister, whose husband he had killed in the skirmish. He joins Katsumoto's rebel samurai in a final battle with the Imperial army. The outcome has profound consequences for Katsumoto, the Emperor and for Algren.

Critique

Marlon Brando hamming it up behind 'yellowface' makeup in *The Teahouse of the August Moon* (1956) was something of an inevitable end-point for Hollywood's post-Second World War imagining of the Japanese as more than faceless enemies

Editors:

Victor Dubois

Steven Rosenblum

Duration:

160 minutes

Cast:

Tom Cruise

Ken Watanabe

Masato Harada

Koyuki

Billy Connolly

Year:

2003

but less than complex people with ways of life beyond what Americans expected them to be. The twentieth-century West's fascination with Japan, its start conveniently datable to Puccini's opera *Madam Butterfly*, quickly developed apprehension under the surface: at different times, apprehension of the exotic, of the militaristic, of the commercially irresistible. Being able to encode this fascination and fear in different ways has provided Hollywood with rich material over the years, not least during the 1980s and 1990s when Hollywood's Japan was one of ruthless corporations, scheming yakuza and inter-cultural gamesmanship. *The Last Samurai* can lay claim to ending Hollywood's more fearful treatments of Japan; and yet it never quite manages to escape patronizing its subjects either. Tom Cruise's Captain Algren remains very much a variant of Glenn Ford's Captain Fisby from *The Teahouse of the August Moon*: the gradually 'assimilated' American who nonetheless remains superior by dint simply of his unshakeable Americanness. This is not unlike *Avatar* (2009), where the American goes native and becomes a military advisor for the 'other' side, with the ultimate subordination of indigenous differences to good old-fashioned American heroism being the ideological heart of the movie.

The Last Samurai, like *Avatar*, has what Scott Robert Olson identifies as a key commercial and ideological strength of American media generally: the quality of transparency that allows indigenous differences to be assimilated into seemingly-universal themes and stories. As Algren is assimilated by samurai culture so, too, is the film's (respectfully recreated) Japaneseness absorbed into a recognizable, Hollywood story about the hero's redemption. As a 'transparent text' in this sense, *The Last Samurai* can be heavy on period detail and light on any historical and political complexity, placing the Americans in roles that were mostly taken by the French in Meiji Japan, uncritically depicting the samurai and exaggerating the contrast between traditional and modern in the clash between samurai rebels and Imperial army. That contrast serves historical accuracy less than it does Hollywood's fascination with an imaginary warrior code: a generalized set of values and traits that can be applied in different historical and imagined settings where the common elements include obsessive mastery of weaponry and martial techniques, evoking ostensibly timeless notions of honour, taking a stand against the odds and 'dying well' where necessary. The trappings of Meiji Japan in *The Last Samurai* endow this 'code' with attractive specificity here and both narrative and characterization do well at weaving it into the historical setting while observing the attendant value clashes; but, in the end, Algren the warrior is still Bruce Willis' Lieutenant Waters in *Tears of the Sun*, released the same year, while his sensitivity to Ken Watanabe's Katsumoto is still that of James Stewart's Tom Jeffords to Jeff Chandler's Cochise in Delmer Daves' *Broken Arrow* (1950). *The Last Samurai*, then, remains quintessentially

a good enough piece of Hollywood film-making, with all the strengths and weaknesses that this entails.

Dropped in pre-production from an early version was a central female character, modelled on Victorian women travellers in Japan such as Isabella Bird. Original director, New Zealander Vincent Ward, parted company with producers Radar Pictures who cited 'creative differences' around the commercial viability of a female lead. Ward, in effect, replaced himself with Edward Zwick, whose commitment to the Hollywood staple of male action hero was less in doubt.

Dan Fleming

Malcolm X

Studio/Distributor:
40 Acres and a Mule
Warner Bros

Director:
Spike Lee

Producers:
Preston L Holmes
Jon Kilik
Spike Lee
Ahmed Murad
Monty Ross
Fernando Sulichin
Marvin Worth

Screenwriters:
Spike Lee
Arnold Perl
Based on the book by Alex
Haley

Cinematographer:
Ernest Dickerson

Art Director:
Tom Warren

Editor:
Barry Alexander Brown

Duration:
202 minutes

Cast:
Denzel Washington
Spike Lee

Synopsis

The biographical film charts the rise of the controversial African-American political leader Malcolm X. The narrative is broken into three distinct sections: from Malcolm Little to the streetwise hustler 'Red Detroit'; his conversion to Islam and the emergence of the radical 'Malcolm X'; and his transformation into El-Hajj Malik El-Shabazz following a pilgrimage to Mecca. The film opens with the young Malcolm chemically straightening his hair in an attempt to emulate white America. He is shown to have no interest in his black heritage as he sleeps with a white woman and becomes embroiled in petty crime. In prison, he adopts the Muslim faith and becomes a fervent member of the Nation of Islam. In a newfound respect for his black roots, he adopts the letter 'X' in place of his surname. On his release, Malcolm becomes a spokesperson for the Nation of Islam, but after disenchantment with the leader and the group's increasing concerns regarding Malcolm's divisive message, he leaves the organization. During Malcolm's trip to Mecca, he revises his militant opinions regarding separatism. This change of doctrine leads to numerous death threats and on his return to the US he is assassinated in front of his family and congregation.

Critique

Bringing the life of the outspoken political leader Malcolm X to screen proved to be an arduous and controversial process. The rights to the biography, written by Alex Haley, were acquired in 1976, but it would take a further 25 years for the film to come to fruition. During this time the screenplay was developed by numerous writers, including James Baldwin, Arnold Perl and David Mamet. Furthermore, the project was initially going to be directed by Norman

Right: *Malcolm X*, 1992, Warner Bros.

Angela Bassett
Albert Hall
Al Freeman Jr
Delroy Lindo

Year:
1992

Jewison. However, having a white director at the helm caused an outcry, as many African-Americans felt that only a black director would be able to do Malcolm's legacy justice. Accordingly, Jewison quietly stood down and Spike Lee loudly took his place.

Lee sets the tone for his film in the opening credits by illustrating the relevance of Malcolm X to a 1990s' audience. He does this by marrying images of the infamous Rodney King beating to the soundtrack of Denzel Washington reciting excerpts from Malcolm's most inflammatory speeches. The casting of Washington as the acclaimed minister was an inspired choice. His uncanny resemblance and majestic performance led to an Oscar nomination. Despite Washington's overwhelming presence, Lee cast himself as Shorty, Malcolm's best friend. Contemporary critics felt it was Lee promoting himself over the importance of bringing Malcolm's message to a new audience. This complaint is well-founded considering Shorty is the first character to appear in the film. Further criticism was aimed at Lee's tendency to glamorize Malcolm's early days as Red Detroit. Black religious groups felt too much time was spent focusing on drug-taking, womanizing and criminal activities, and to some extent the weighting of the film does lean towards his misdemeanours. Nevertheless, this period gave Lee the opportunity to include the spectacular Lindy-hop routine, which, while not crucial to the narrative, did showcase Zoot Suit fashions and the energy and excitement of the era. Additionally, Lee attracted criticism for including Malcolm's relationship with a white woman. While this is an important part of Malcolm's life, Lee is falling into the trap of fetishizing interracial relationships that has become a familiar trope in many African-American bio-pics including *The Great White Hope* (1970) and *Bird* (1988).

Another contentious sequence occurs when a white student approaches the political leader to ask whether she can do anything to further the cause for black equality. He sharply replies 'no'. In his autobiography, Malcolm lamented that he deeply regretted this response and therefore the inclusion of the incident exposes the biased nature of the film. Malcolm experienced an epiphany following his pilgrimage to Mecca. This change towards a more liberal and inclusive stance is almost overlooked in the narrative. Lee problematically favours the more militant doctrine practised by Malcolm X, rather than the more inclusive and liberal stance of his later years.

Malcolm X is nearly three-and-a-half hours long. Consequently, the studios wanted Lee to make considerable cuts. After he refused to adhere to their request, Warner Bros withdrew all funding. It was at this point that he approached a number of famous African-American celebrities to help finance the project – these included Bill Cosby, Oprah Winfrey, Magic Johnson, Michael Jordan, Prince and Janet Jackson. In adopting Malcolm X's doctrine of 'by any means necessary', Lee managed to create a film that portrayed the

political leader with integrity and passion. Although flawed and confused in places, two attributes typical of Lee's work, the film stands as a key text in African-American film-making and history.

Ruth Doughty

Schindler's List

Studio/Distributor:
Universal Pictures
Amblin Entertainment

Director:
Steven Spielberg

Producers:
Steven Spielberg
Gerald R Molen
Branko Lustig

Screenwriter:
Steven Zaillian

Cinematographer:
Janusz Kaminski

Art Director:
Allan Starski

Editor:
Michael Kahn

Duration:
187 minutes

Cast:
Liam Neeson
Ben Kingsley
Ralph Fiennes

Year:
1993

Synopsis

In 1939, the charming, opportunistic industrialist Oskar Schindler moves to Poland, hoping to exploit the wartime economy by manufacturing goods for the German military. Developing connections in both the Nazi hierarchy and the Jewish business community, Schindler takes over a Krakow enamelware factory and, with the assistance of Jewish accountant Iszhak Stern, he staffs it with Jewish slave labour. As Schindler's business prospers, SS Officer Amon Goeth arrives in Krakow with orders to liquidate the Jewish ghetto and to transfer survivors to a forced-labour camp. Schindler is moved by the massacre and by the conditions of the camp, but he is careful to remain on good terms with Goeth. When orders are made to close the labour camp and to transport the remaining Jews to Auschwitz, Schindler bribes Goeth to exclude his workers and to allow them to be moved to a new factory. With Stern, Schindler compiles a list of 'skilled' workers who are to be spared probable death, using his wartime profits to bribe Nazi officials. The 'Schindler Jews' end the war in the factory, but Schindler and his wife are forced to flee. In the film's epilogue, some of the 1,100 Jews sheltered by Schindler place stones on his grave in Jerusalem.

Critique

Released just months after *Jurassic Park* became the highest-grossing film to date at the North American box office, *Schindler's List* was widely interpreted as a turning point in Steven Spielberg's career. According to David Denby, in *New York* magazine, it was as though Spielberg 'understood for the first time when God gave him such extraordinary skills'. For Janet Maslin, writing in the *New York Times*, 'Spielberg has made sure that neither he nor the Holocaust will ever be thought of in the same way again'. The moral seriousness evident in the film's reception was emphasized when President Clinton 'implored' the American public to see it, and, later, by scandalized media reports about teenagers caught laughing during one of the many mandatory screenings organized by schools. But as *Schindler's List* gathered plaudits, including seven Academy Awards, dissenting voices began to emerge. Claude Lanzmann, director of the documentary *Shoah* (1985), accused Spielberg of failing to recognize the moral complexity

in representing the Holocaust's 'ultimate degree of horror'. More simply, J Hoberman asked, 'is it possible to make a feel-good entertainment about the ultimate feel-bad experience of the 20th century?'[1]

As Hoberman's question suggests, *Schindler's List* is a traditional Hollywood product in many respects. In its emphasis on survival and redemption, the film is affirmative in tone. And although its high-contrast, coarsely-grained black-and-white cinematography invites associations with European and documentary film-making traditions, its use of suspenseful narrative devices (most notably in the Auschwitz showers) are the stuff of Hollywood thrillers. The film focuses largely on Oskar Schindler and his conversion from dissolute entrepreneur and Nazi Party member to compassionate, morally-engaged rescuer of Jewish lives. In the process, and as it details the horrors of the Nazi Holocaust, the film allows audience members to follow a similar trajectory.

The 'good' that Schindler comes to embody is further emphasized in counterpoint by the 'bad' Amon Goeth: although early scenes establish visual parallels between the two characters, Goeth's arbitrary violence and inability to sympathize with others mark him as Schindler's opposite. As many critics have noted, the decision to position two German Nazi characters at the centre of the film serves to diminish the role played by Polish Jews. Although the film works hard to individualize its various Jewish characters, only Iszhak Stern can be said to possess agency in the narrative. In a sense, *Schindler's List* presents the Holocaust from the point of view of its perpetrators.

Schindler's List is less orthodox, however, in its depiction of Schindler's motivations. Although the humanitarian at the end of the film is demonstrably different from the capitalist we see as the film begins, scant insight is offered into how or why this transformation occurred. Indeed, Schindler's imperatives to make money and to help the Jews overlap for much of the film, and even at the end are never fully disentangled: the profits he makes from slave labour manufacturing also provide the means to add names to his list. When a worker at the new factory tells Schindler he is a 'good man', he seems unsure how to respond. The audience might feel the same way. Schindler may be a 'good man', but he is also inscrutable to the last.

Jonathan Stubbs

Note

1. For summaries of the film's critical reception, see M. Hansen, (1996), '*Schindler's List* is Not *Shoah*: The Second Commandment, Popular Modernism, and Public Enemy', *Critical Enquiry*, 22: 2, pp. 292–312; and B. Zelizer, 'Every Once in a While: Schindler's List and the Shaping of History', in Y. Loshitzky (ed), *Spielberg's Holocaust: Critical Perspectives on Schindler's List*, Bloomington: Indiana University Press, 1997, pp. 18–35.

United 93, 2006, Universal.

United 93

Studio/Distributor:
Working Title
StudioCanal

Director:
Paul Greengrass

Producers:
Paul Greengrass
Tim Bevan
Eric Fellner
Lloyd Levin

Screenwriter:
Paul Greengrass

Synopsis

A hotel room in the early hours of September 11, 2001. Four young men wash, groom, and say their final prayers as they set out towards Newark airport. Here, flight crew and ground staff go about their routine operations, planning their days off and idly gossiping. The four men, now separated, make their way through security and board a domestic flight with the rest of the nonchalant passengers. Due to congestion, take-off is delayed by half an hour, but finally the all clear is given and Flight 93 heads off towards its San Francisco destination. At the National Air Traffic Control Centre in Herndon Virginia, Ben Sliney, the freshly-appointed National Operations Manager, arrives on the first day of his new job to a smattering of applause. Once two planes have hit the World Trade Center buildings, and another the Pentagon, Sliney decides to ground all flights in the US. On board Flight 93, the four men realize their plot to hijack the plane by killing the two pilots and threatening passengers with an imitation

Cinematographer:

Barry Ackroyd

Art Directors:

Romek Delmata

Joanna Foley

Editors:

Clare Douglas

Richard Pearson

Christopher Rouse

Duration:

110 minutes

Cast:

JJ Johnson

David Alan Basche

Khalid Abdalla

Lewis Alsamari

Ben Sliney

Year:

2006

bomb. Among the passengers word spreads of the terrorists' murderously-suicidal intentions and, together with members of the crew, they decide to take action.

Critique

In the strange days immediately following 9/11, a fair proportion of editorial space was given over to ruminating on how Hollywood would eventually deal with a tragedy that had itself unfolded in a highly-cinematic fashion – like a disaster actuality lived through in real time. There was talk of studios hurriedly scrapping terror-themed projects, of Schwarzenegger action movies pushed back on the release slate, and hard-pressed airbrushers hurriedly eliminating offending images of the now-vanished towers, suddenly histo-ricizing upcoming releases.

Perhaps there was some unspoken sense of *mea culpa*. After all, Hollywood had been through it all before; the mid-air hijack being a standard plot-hook since *Airport* (1970) and its many sequels, spoofs and imitations up to *Passenger 57* (1992) and *Executive Decision* (1996). Released less than five years after the attacks, Paul Greengrass' as-close-as-we'll-get dramatic recreation of that day focuses on the 'other plane', United Airlines Flight 93, which crash landed in Pennsylvania after an apparent onboard uprising. That the film has all the staples of an old-school disaster classic makes the action all the more uncanny, and one wonders if the passengers themselves had time to reflect on this odd *déjà vu*. Not that writer/director Greengrass is one to up the bombast, with even the totemic one-liner 'let's roll' mum-bled out as a practical directive rather than superhuman call to arms.

Greengrass's roots in British docudrama and the somewhat-displaced nature of the production (Pinewood, not Holly-wood, provided the sets) could maybe account for the lack of nationalistic chest-beating. And perhaps British notions of 'fair play' played a part in the conspicuously unHollywood approach to defining the bad guys. But although there is some room for nuance, Greengrass does not humanize the terrorists beyond making clear that they were human. Indeed, an overall rejection of conventional notions of characterization means even the film's protagonists are only loosely-defined figures (the credits may name names, but to us they are only the guy in the baseball cap, the blonde hostess, etc.) and the decision-making collective.

United 93's technical virtuosity (aided by Barry Ackroyd's queasy, kinesthetic camerawork) and remarkable sensitiv-ity cannot, however, hold off the most important question of motive. Not as to why people would be so murderously destructive, but why people would want (pay!) to relive such an unsweetened recreation of a recent traumatic event? Some point to the fact that the film shows only the anomaly: the

terrorists' only failure, the singular moment of meaningful heroism, on a day otherwise marked only by pointless death. Can some perverse enjoyment be taken by wishing ourselves into the passengers' shoes? To be up there fighting, rather than grounded and impotent, frustrated by an unseen and unknown enemy? And yet, for the first half of the film at least, the film's real-time drum-tight plotting, witnessing the hesitations and will-we-or-won't-we glances between the would-be martyrs, could almost make us side with the terrorists, if only for reasons of expediency.

All in all, the experience of watching *United 93* feels more like a sadistically-experimental group-therapy session than any form of escapist entertainment. As a thriller it is clearly effective, but its purpose is somewhat obscure. *United 93* is certainly not a whodunnit, nor even a whydunnit, nor, really, a howdunnit. Perhaps it is best viewed simply as a 'dunnit'. The only sensible reaction is to pray that the whole horrible ordeal is over as soon as possible.

Rob Dennis

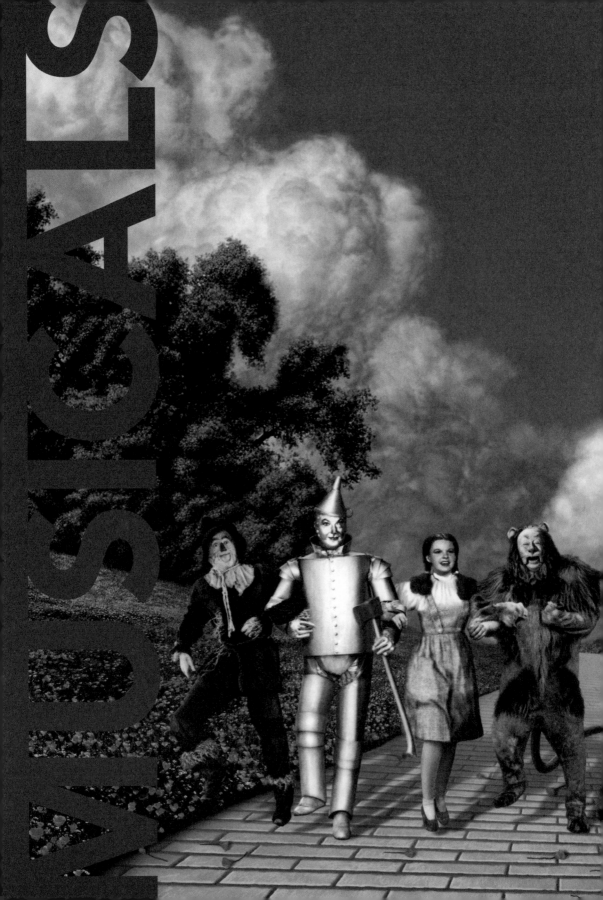

Musicals had been prolific on Broadway during the 1920s, with revue-type shows such as the *Ziegfeld Follies* and *George White's Scandals* featuring songs by writers like Irving Berlin and Cole Porter; musical comedies showcasing the fledgling teams of Rodgers & Hart and the Gershwins; and European-style operettas being produced by Sigmund Romberg, Victor Herbert and Jerome Kern. 1927 alone – a pinnacle of production on Broadway with over 200 new openings – introduced over fifty new musicals. With the advent of sound on film in the late 1920s it was inevitable that Hollywood would exploit this popularity – and writing talent was soon lured to the West coast along with performers like Al Jolson, Bing Crosby, and Fred Astaire.

The first recognized sound picture, *The Jazz Singer*, was released that year, with Jolson in customary blackface get-up. Hollywood soon followed this with some of the most iconic musicals of the black-and-white era: the MGM *Broadway Melody* films (1929–1939), Busby Berkeley's Warner Bros films (the *Golddiggers* series [1933–1937], *42nd Street* [1933], *Footlight Parade* [1933], and *Dames* [1934]) and the RKO classics starring Fred Astaire and Ginger Rogers (including *Flying Down to Rio* [1933], *The Gay Divorcee* [1934], *Top Hat* [1935], and *Swing Time* [1936]).

A common theme of these early musicals is that many are set 'back-stage' and feature singers and dancers as protagonists – Fred Astaire plays a performer in 23 of his 27 film roles between 1933 and 1953. And this is not surprising: backstage musicals allow a conventional narrative to include song and dance as realistic components of the diegetic world – mainly in audition, rehearsal or performance scenes. Throughout the 1930s this continued, notably in the popular 'summer stock' films starring Mickey Rooney and Judy Garland (*Babes in Arms* [1939], *Babes on Broadway* [1941], *Girl Crazy* [1943]). Here, not only do the narratives allow for the unproblematic incorporation of song and dance, but they also consolidate can-do Hollywood ideologies of rags to riches, success and the American Dream. But Hollywood's drive towards realism has often challenged a form comprising abstract language (music) and stylistic expression (song and dance). The legitimate inclusion of song and dance in the backstage narrative was a device soon worn thin, and Hollywood's 1940s' output increasingly stretched this formula into musical bio-pics (*The Jolson Story* [1946], *Night and Day* [1946], and *Till the Clouds Roll By* [1946]).

The quest for a new aesthetic
More interesting was the cinematic aesthetic explored in the kalei-doscopic choreography and trick photography of Busby Berkeley's films. These found, in the mix of choreography with camerawork, editing, lighting and staging, an abstract 'language' quite different from that of a standard musical, backstage or otherwise. Nevertheless it was not until a 'new' aesthetic space – the dream sequence – was explored that the anti-realistic languages of music and dance were to find a real foothold. Most obviously this began with *The Wizard of Oz* (1939), though *its* exploration of song and dance is rather tame. In fact, the innovation of the dream sequence ballet was one rehearsed in Broadway ballets such as *On Your Toes* (1936), in Agnes de Mille's dream-ballet from *Oklahoma!* (1943), and in Jerome Robbins' *Fancy*

Left: *The Wizard Of Oz*, 1939, MGM.

Free (1944). And it was *this* (rather than the more obvious drive towards integration) that MGM exploited, developing by the 1950s a style that has become iconic in films such as *An American in Paris* (1951), *Singin' in the Rain* (1952) and *The Band Wagon* (1953). The involvement at this stage of imaginatively creative performers, choreographers and directors such as Gene Kelly (and – in the water – Esther Williams), was integral, and it is really in these pieces – particularly in the 'Broadway Melody' sequence of *Singin' in the Rain* and the seventeen-minute ballet of 'An American in Paris' – that a true cinematic idiom of song and (especially) dance can be seen.

But this was to be short-lived, especially in opposition to an emerging realist aesthetic stemming from a Method approach to acting and seen in the influential work of director Elia Kazan and star Marlon Brando (*A Streetcar Named Desire* [1951], *On The Waterfront* [1954]). Broadway's own waning interest in musical theatre following a few final hits at the end of the 1950s (*West Side Story* [1957], *The Music Man* [1957], *Gypsy* [1959]) was reflected in Hollywood's declining interest in movie musicals. With notable exceptions (*Gigi* [1958], *West Side Story* [1961], *My Fair Lady* [1964], *The Sound of Music* [1965], *Sweet Charity* [1969], *Cabaret* [1972], *Grease* [1978], *Fame* [1980], *Annie* [1982]) the film industry more or less gave up producing musicals for almost thirty years. A flurry of dance-based musicals inspired by the ongoing success of the TV series *Fame* (1982–1987) and returning to backstage storylines danced to a soundtrack of existing pop tracks (*Footloose* [1984], *Dirty Dancing* [1987], and a significant Australian contender in Baz Luhrmann's *Strictly Ballroom* [1992]) marked the only real commitment to any kind of musical film output.

The tentative resurgence of the movie musical recently can perhaps be most attributed to the ongoing popularity of musicals within children's cinema, from *The Wizard of Oz*, through *Mary Poppins* [1964], *The Jungle Book* [1967], and *Chitty Chitty Bang Bang* [1968], to the explosion of successful Disney musicals of the 1980s and 1990s (*The Little Mermaid* [1989], *Beauty and the Beast* [1991], and *The Lion King* [1994]). Recognizing this popularity alongside the mass globalization of shows like *Cats* (which ran on Broadway from 1982 to 2000), *The Phantom of the Opera* (1988–present) and latterly *Mamma Mia!* (2001–present), Hollywood has once more invested significant energy into producing some high-profile and successful movie musicals – including *Moulin Rouge* (2001), *Chicago* (2002), the *High School Musical* series (2006 onwards) and *Mamma Mia!* (2008). That these all hew close to existing, tried-and-tested formulae (the backstage musical, the pop soundtrack, the exploitation of existing Broadway shows) is significant, and that they play safe in terms of realism and verisimilitude underscores the extent to which Hollywood still resists stylization in a genre whose very essence relies on it.

Dominic Symonds

Chicago

Studio/Distributor:
Miramax

Director:
Rob Marshall

Producer:
Martin Richards

Screenwriter:
Bill Condon
Based upon the musical play by
Bob Fosse and Fred Ebb

Cinematographer:
Dion Beebe

Art Director:
Andrew Stearn

Editor:
Martin Walsh

Duration:
113 minutes

Cast:
Richard Gere
Queen Latifah
John C Reilly
Renée Zellweger
Catherine Zeta-Jones

Year:
2002

Synopsis

In 1920s' Chicago, nightclub star Velma Kelly and aspiring performer Roxie Hart are in prison for murder: Kelly for killing her husband and sister (who were having an affair), and Hart for shooting her lover, despite her husband's initial attempt to claim responsibility. With guidance from the venal governess Mama Morton, and money from her acquiescent husband, Hart seeks the help of the notorious attorney Billy Flynn, who has already made Kelly famous in the run-up to her trial. Kelly and Hart become rivals for the attention of Flynn and the public, but the arrival of a new prisoner, and a new case for Flynn, forces both to compete for the media spotlight.

Critique

A vaudevillian satire on criminal corruption in the 1920s might seem a hard sell for audiences other than Broadway buffs already familiar with the musical's initial 1975 staging, and its more commercially-successful revival in 1996. Fans of the genre will readily relish the traces of Bob Fosse's original chorographical direction, the musical and thematic connections to other iconic Kander and Ebb musicals such as *Cabaret* (released as a film in 1972), as well as the in-joke casting of Chita Rivera (the star of the original production) in a minor role as one of the prisoners. But even for non-aficionados of musical theatre, *Chicago* offers numerous pleasures: hummable melodies, a story about infamous criminality (one that resonated, upon its release, with a nation still digesting the OJ Simpson saga) and – for those that liked this sort of thing – a bevy of lithe female dancers cavorting in their underwear.

However, musical buffs have shown disagreement about whether Rob Marshall's respectful adaptation of the stage show was a definitive record, with performances just as strong as those witnessed across stages of New York, London and elsewhere, or a missed opportunity to push the film musical in a new direction, as Baz Lurhmann and Lars von Trier were attempting around the same time. Whereas the show's original incarnation had been in the form of a series of staged numbers linked by a loose narrative, the big screen version is told from the perspective of its central character: the wannabe cabaret star Roxie Hart (Renée Zellweger). In this way, a coolly Brechtian piece of political satire is translated into a goal-oriented and psychologically-driven story, with the musical sequences – again staged as vaudevillian performances – as expressions of the character's aspirations, delusions and anxieties, a device also used in von Trier's 'anti-musical' *Dancer in the Dark* (2000). The result is an ambivalent response to 'murder as entertainment' (as attorney Billy Flynn puts it) – both a celebration of female empowerment, and a satire upon the monstrous appetites of celebrity culture. Marshall's device of cross-cutting back and

Chicago, 2002, Miramax. Photographed by David James.

forth between 'reality' and Roxie's star-struck imaginings gives the film its stylistic signature, but the rapid editing of many of the musical sequences tends to emphasize rhythmic synchronicity over fluidity of movement and the virtuosity of individual actors.

Yet despite its occasionally dizzying editing strategy, *Chicago* has an undeniable showbiz robustness, attributable in part to the elasticity of the true-life material – which had also inspired a play and silent movie of the same name (1925 and 1927), and the Ginger Rogers vehicle *Roxie Hart* (1942) – but also to the eye-catching performances of the leads (Catherine Zeta Jones, evidently no stage novice, acquits herself particularly well as the steely Velma Kelly, although Richard Gere brings charm but not quite enough venom to the Billy Flynn role). The major impact of Baz Luhrmann's gleefully-anachronistic *Moulin Rouge* (2001) seemed at the time to herald either the end of the traditional Hollywood musical or its eventual inflection towards postmodernism and pop culture. As it happened, it was *Chicago*, for all of its formal conservatism, that established the decade-long trend for movie musicals based upon canonical or contemporary Broadway success stories, which included *The Phantom of the*

Opera (2004), *Rent* (2005), *The Producers* (2005), *Dreamgirls* (2006), *Hairspray* (2007) and Rob Marshall's own *Nine* (2009). Indeed, it seems likely that the revival of the Hollywood musical in the early years of the twenty-first century, together with the increasing popular appetite for burlesque shows and televized singing/dance competitions, may not have happened had *Chicago* failed to razzle-dazzle audiences, critics and Oscar voters so completely.

James Leggott

42nd Street

Studio/Distributor:

Warner Bros.
Vitaphone

Director:

Lloyd Bacon

Producer:

Daryll F Zanuck

Screenwriters:

Rian James
James Seymour
From a novel by Bradford Ropes
With songs by Harry Warren and
Al Dubin

Cinematographer:

Sol Polito

Art Director:

Jack Okey

Musical Staging:

Busby Berkeley

Editors:

Thomas Pratt
Frank Ware

Duration:

89 minutes

Cast:

Warner Baxter
Bebe Daniels
Ruby Keeler
Dick Powell
Ginger Rogers

Year:

1933

Synopsis

Rich businessman Abner Dillon bankrolls *Pretty Lady*, the latest show on Broadway, with Dorothy Brock – on whom he has designs – in the lead. But the financing of the show is threatened by Brock's continuing relationship with her fiancé Pat Denning. As the producers send in the heavies, Denning is roughed up and meets chorus girl Peggy Sawyer. When star attraction Brock breaks her ankle the night before the show, the young wannabe Sawyer is thrust into the spotlight as the only dancer who can take her place. Peggy is swiftly rehearsed into the part and the chorus girl goes on to save the show, dancing effortlessly through the railway-carriage set of 'Shuffle off to Buffalo' to end up in the Manhattan street scene of naughty, bawdy, gaudy, sporty '42nd Street'. As rows and rows of chorus girls build a Manhattan skyline live onstage, Sawyer taps to the top and ends up with leading man Billy Lawler. All ends happily, since Brock and Denning are back together, and sugar daddy Mr. Dillon discovers the delightful Anytime Annie with whom to while away his twilight years.

Critique

This is the quintessential backstage musical film – practically the first of its kind, and released just a few years after sound was introduced to Hollywood. It was not the first of Busby Berkeley's films as director, but it already includes aspects of the dance cinematography that would build his reputation: kaleidoscopic edits of chorus girls, cameras angled to frame the shot between girls' legs, and big-budget revolving sets, spinning in different directions to create abstract patterns.

If the film's narrative is straight out of the handbook of American values (where, in the words of John Lahr, 'the commonest citizen could rise by pluck, luck and talent into the aristocracy of success'), this modernist choreography is also a hallmark of American ideology, in which the 'commonest citizen' is turned into part of a mechanistic production line of dehumanized labour. The constructions created out of the

dancing girls are undoubtedly impressive – and the full-stage picture of Manhattan skyscrapers that suddenly appears at the climax of '42nd Street' is a witty tour de force; but this film – that deservedly stands as one inspirational benchmark of creativity in movie musicals – is also laden with the baggage of an outdated gender politics.

Sure enough, Berkeley's subsequent pictures continue in this vein, with girls overwhelmed by giant coins in 'We're in the Money', and – in an extraordinary and inexplicable scene – being cut out of metal costumes with a tin opener in 'Pettin' in the Park' (both from *Gold Diggers of 1933*). Such objectification of the female form was undoubtedly to influence the work of later male choreographers such as Bob Fosse, and the dance practices of contemporary pop artists such as Beyoncé.

The film introduces early performances from several key players: most obviously, it launched the unknown talent of Ruby Keeler in the ingénue role; but it also offered the young Ginger Rogers – fresh from Broadway success in *Girl Crazy* (1943) – a high-profile Hollywood vehicle, which was the perfect springboard for her subsequently meteoric career. Surprisingly, Rogers' role in *42nd Street* is as a jaded prefect of the chorus girl circuit, the mannered 'Anytime Annie', who clutches a lap-dog and sports a monocle for display. This might have been a thanklessly-ludicrous part, but Rogers (aged only 22) carries it off with aplomb and shows a skill at comedic character acting that would be somewhat hidden during her work with Astaire, but which would resurface to great effect in 1950s' comedies such as *Monkey Business* (1952).

Overall, *42nd Street* offers everything you would expect from a classic Hollywood backstage musical; it is a product of its age in many ways, but the best elements of that age are well worth indulging.

Dominic Symonds

Grease

Studio/Distributor:
Paramount Pictures

Director:
Randal Kleiser

Producers:
Allan Carr
Robert Stigwood

Synopsis

Sandy Ollson, an Australian girl-next-door on a family trip to the United States, falls in love with California local teen Danny Zuko. Frolicking on the beach to the soaring melodrama of 'Love is a Many Splendoured Thing' in the film's famous pre-credits sequence, they acknowledge that their summer fling is coming to an end; Sandy's family is returning to Australia and the young couple may never see each other again. Unbeknownst to either of them, Sandy's family has decided to remain in America and she will complete her senior year at the same school Danny attends, Rydell High. The school year begins and a heartbroken Sandy is adopted by an all-girl

Screenwriter:
Bronte Woodard

Cinematographer:
Bill Butler

Editor:
John F Burnett

Duration:
106 minutes

Cast:
John Travolta
Olivia Newton-John
Stockard Channing
Jeff Conaway
Frankie Avalon

Year:
1978

gang – The Pink Ladies – while Danny is reunited with the T-birds, a leather-jacket clad group of teen greasers. After an unexpected reunion at the inaugural Rydell pep rally, Sandy discovers that at school, the romantic boy she met at the beach has a reputation to maintain. She seeks comfort in her new friendships, but the sweet, non-smoking, non-drinking Sandy finds that her goody-two-shoes image makes it difficult to fit in. Which one of them will change so they can be together once more?

Critique

The success of *Grease* had already been cemented in its years as a long-running Broadway musical that combined the teen-love story with rock-and-roll music in the nostalgic setting of the 1950s. The 1978 film version this successful formula took the phenomenon to new heights by casting two young stars in their prime: John Travolta, fresh from the success of *Saturday Night Fever* (1977) and Australian pop singer Olivia Newton-John. Billed on promotional material as 'the movie filled with more of everything that makes a great musical', this oddly-paced film is brimming with catchy songs, timeless high school character types and a retro aesthetic that imagines the 1950s through its most stereotypical motifs: greasers, jocks, jukeboxes, drive-ins and poodle skirts. Though the film has been critically panned over the years for everything from its weak script to its often-pedestrian acting, *Grease* has an undeniable exuberance that continues to work its kitsch charm on generations of film audiences. To think about *Grease* in terms of narrative complexity and accurate historical representation is to miss the point, for the film does not promise either, instead revelling in a candy-coated nostalgia for an imaginary era.

Part of the reason the film continues to delight rests in the palpable chemistry generated between the film's central characters. Despite most of the actors being well beyond their teenage years (Stockard Channing, playing Rizzo, was thirty-two at the time of production), they manage to transmit an energy that mimics and plays with a cinematically-clichéd nostalgia for the senior high school year. This is helped along considerably by the film's soundtrack, which used songs from the original Broadway musical, combined with songs written specifically for the film to build a 1950s' inspired late-1970s catalogue of chart-topping hits.

The sing-a-long qualities of the film have also worked partly to obscure the *Grease*'s loosely-subversive treatment of issues such as teen pregnancy, sexual liberation and teen violence. Unlike in the earlier musical *West Side Story*, gang violence in *Grease* has no moral implications, facilitating instead a series of camp altercations between the T-birds and rival gang The Scorpions in car parks, at the senior prom and finally, in the car race at 'Thunder Road'. The film's glorious artifice is

choreographed not only through these well-rehearsed social encounters but through the frivolity of its aesthetic. Having worked previously in television, director Randal Kleiser here makes full use of the wide-angle lens, also mixing live action with animation through the opening credits sequence. *Grease* also recalls its theatrical heritage while incorporating references to the cinematic past in moments, as in the T-birds's 'Three Stooges' routine performed in the car park at the pep rally.

On the film's twentieth anniversary in 1998, *Grease* was re-released theatrically, spawning new legions of fans worldwide. In July 2010, the cult potential of the film was exploited in the release of a singalong version in selected US theatres. The original film soundtrack continues to be one of the highest-selling film soundtracks of all time.

Alexia Kannas

The Jazz Singer

Studio/Distributor:
Warner Bros

Director:
Alan Crosland

Producer:
Darryl F Zanuck

Screenwriter:
Alfred A Cohn
Samson Raphaelson

Cinematographer:
Hal Mohr

Editor:
Harold McCord

Duration:
88 minutes

Cast:
Al Jonson
May McAvoy
Warner Roland
Cantor Rosenblatt

Year:
1927

Synopsis

Five generations of Rabinowitz have become Cantors within the Jewish faith, but young Jakie Rabinowitz chooses to spend his time and talents performing ragtime music in saloon bars. After being punished by his solemn father for one such transgression, Jakie leaves home. Years later, and now known as Jack Robin, the young boy has grown up to become the eponymous jazz singer. However, on returning to New York on the eve of his Broadway debut, Jakie/Jack is forced to choose between his past Jewish heritage and family, and his future career as an entertainer.

Critique

Whilst *The Jazz Singer* can be categorized as a musical, the film is a Hollywood landmark for the talking that takes place between the characters within the scenes. Just as Jakie is forced to engage with the conflicting demands of tradition and modern expression, with both scenes of synchronized dialogue and silent-era sequences requiring intertitles, *The Jazz Singer* signalled the birth of the 'talkies' and the decline of the traditional silent film feature. In live-recorded dialogue, Jakie tells his transfixed audience 'Wait a minute, wait a minute, you ain't heard nothin' yet', then he turns to his band and says 'Now give it to 'em hard and heavy. Go right ahead'. These famous lines perfectly encapsulate the profound effect that the film had on audiences as they rippled out across the mass-consciousness of the movie-going public.

Nevertheless, unlike the later 'Singin' Swingin' Glorious Feelin' Technicolor Musical', that is *Singin' in the Rain* (1952) – a film about the production of a rival to *The Jazz Singer*, and

similar films in which the tropes of the musical are deployed with a certain predetermined acknowledgement that 'everything will work out fine in the end' – *The Jazz Singer* very seriously foregrounds the conflicts within the narrative. Jakie defends his jazz ambitions to his father by saying that his songs mean as much to his audience as his fathers' songs do to his congregation; but, despite this assertion, the Jewish element of the film is never marginalized. The musical pieces are intradiegetic – contained within the reality of the film – so the tensions are more realistically presented than they are in a film such as *Dancer in the Dark* (2000), where music is clung to as an escape from reality. To complete the chain of events that the promotional poster initiates for *The Jazz Singer*, the film, starring Al Jonson, is: 'Based upon the play by Samson Raphaelson', which was based on a short story, which was based on Al Jonson's actual life story. Al Jonson was not the first actor selected to play the part of Jakie Rabinowitz, but it is the conviction with which Jonson performs his pieces, an oscillation between upbeat and tentative tempos, that the film sells the potentially-autobiographical conflicts embodied within Jakie Rabinowitz and the importance of the introduction of sound.

To a modern audience that is used to the marginalization of religious statements in Hollywood, the authentic Jewish rituals and sayings could be slightly jarring for those expecting to see a piece of Hollywood entertainment. However, the most contentious issue surrounding *The Jazz Singer* is the use of blackface by Al Jonson. Turning an actor from white to 'black' and allowing him to draw entertainment from performing racial stereotypes is not an activity that can be suitably explored in this critique, but one could argue that the use of blackface in *The Jazz Singer* is predominantly designed to comment on the Jewishness of Jakie, and how the competing internal processes of his cultural experiences as a modern Jew are metaphorically made apparent in his physical appearance. This is not Disney's *Song of the South* (1946), replete with a back-catalogue of racial caricatures; the use of blackface is not designed to show Jakie as 'black', it is used to suggest the possibility that Jakie could become less Jewish.

It is a shame that *The Jazz Singer* is attached to controversy because, without the contentious element of blackface, the film still offers an interesting insight into the cultural tensions of a period, an ecstatic performance by Al Jonson, and the introduction of sonic-shockwaves that would alter the history of Hollywood.

Carl Wilson

Mamma Mia!

Studio/Distributor:
Universal Pictures

Director:
Phyllida Lloyd

Producers:
Benny Andersson
Judy Craymer
Gary Goetzman
Tom Hanks
Mark Huffam
Björn Ulvaeus
Rita Wilson

Synopsis

Mamma Mia! is set in the present day on a beautiful Greek island, and covers the events of just 24 hours. 20-year-old Sophie is to be married the next day to Sky and wants to invite her father to 'give her away' – but he is one of three possibilities. As neither Sophie nor her mother Donna knows who the father is, Sophie decides to invite all three, in order to decide which one is the real one. However, neither her mother Donna nor her groom Sky knows what Sophie has done. Even the potential fathers are not told the real reason why they are invited, until after they arrive. The resulting mayhem – as discoveries are uncovered and confessions are poured out and emotions explode – leads us through a plethora of music and dance routines to an unforeseeable climax at the last, in the beautiful and tiny chapel on the top of an almost inaccessibly-minute islet alongside the island.

Mamma Mia!, 2008, Universal/Playtone.

Screenwriter:

Catherine Johnson

Cinematographer:

Haris Zambarloukos

Art Directors:

Dean Clegg

Rebecca Holmes

Nick Palmer

Editor:

Lesley Walker

Duration:

104 minutes

Cast:

Meryl Streep

Pierce Brosnan

Colin Firth

Stellan Skarsgård

Christine Baranski

Julie Walters

Dominic Cooper

Year:

2008

Critique

Mamma Mia! is based on the original West-End Production and it was the same writers who went on to make the film. Written to fit with a raft of ABBA's hit songs, the contrived storyline does not detract from the overall power of the narrative to draw the audience in. This modern-day love story clearly references some Greek mythology (for example, the villa where the scene is set is rumoured to be built on the legendary fountain of Aphrodite, which is introduced near the beginning of the film and then brought back to provide a climactic ending). There is also a Shakespearean feel at times, as though we were watching one of the Bard's plays (*Romeo and Juliet* and *A Midsummer Night's Dream* and *Much Ado About Nothing* come to mind, but omitting all things dark or deathly). The twentieth-century music from ABBA's hits catalogue adds a pop culture twist to the mix of Shakespearean stage play and Greek myth, all set in an open-air Greek theatre. This is a film with universal appeal for almost everybody of any age or cultural taste.

ABBA, the world-famous Swedish band from the 1970s and 1980s, not only provides the music but two of the singer-songwriters (Benny and Bjørn) were involved in the film's production, bringing their own hugely-popular disco fan culture to the big screen. From the moment the film rolls we are drawn in, but it is not only the music that inspires. There are several striking features that contribute to the success of this film: The fabulous views and scenes, and the setting on an idyllic Greek island in constant blazing sun, with blue skies and azure seas; the very simple and easy-to-understand storyline; the total lack of violence – physical or emotional; the cast, easily recognizable from other starring roles, play hilariously against type (Mr Darcy from Jane Austen's *Pride and Prejudice* rubs shoulders with Ian Fleming's James Bond). The universal Meryl Streep is confident in her lead singing role, so too Julie Walters, who plays Donna's English confidant with typical flair and humour. But, it all works.

There is ludicrously glorious madness to the story, so that suddenly we are caught up in a wild stampede of a thousand Greek peasant women, casting off their burdens to become the Dancing Queen, or the 'Stags' (the Groom's friends) clambering up the cliffs by torchlight as if in a scene from Homer's *Odyssey*, or the Mediterranean humour of the island's locals while Meryl sings, 'Money, Money, Money'. Stand-out scenes see Tanya (Christine Baranski) rejecting the boyish advances of Pepper at the beach bar, singing, 'Does your mother know?' and the flipper-dance by the 'Stags' on the beach jetty to the song 'Lay all your love on me', looking for all the world like 'The Dancing Men' of the Sherlock Holmes' mystery.

The brave decision not only to choose the cast they did, but also have them all sing their own songs without dubbing, might be one of the reasons why this film inspires similar

levels of audience participation as the cult *The Rocky Horror Picture Show* (1975) and *The Sound of Music* (1965). Those who could not sing and those who could not dance sang and danced anyway – and obviously had as much fun trying – as those in the audience dressed up, watching and laughing. Colin Firth said they did not ask John Travolta so they got what they got, and Pierce Brosnan remarked it was the most enjoyable film he ever made – and they even paid him to do it! The film should not have to be taken seriously, and can be enjoyed for what it is – a romantic, comic, film musical that Hollywood seems destined to always make. This is pure fairy story.

Laurence N Janicker

The Sound of Music

Studio/Distributor:
20th Century Fox

Director:
Robert Wise

Producers:
Robert Wise
Saul Chaplin
Peter Levathes
Richard D Zanuck

Screenwriters:
Ernest Lehman
From the musical by Richard Rodgers, Oscar Hammerstein II, Russel Crouse and Howard Lindsay
Based on the book *The Story of the Trapp Family Singers* by Maria von Trapp
With additional songs by Richard Rodgers

Cinematographer:
Ted McCord

Production Designer:
Boris Levin

Editor:
William Reynolds

Synopsis

Flibbertigibbet and novice nun Maria throws the convent into turmoil with her tree-climbing and love of music, so the Mother Abbess quickly dispatches her as governess to the seven difficult children of disciplinarian Captain von Trapp. Since music, fun, and clothes fashioned from curtain material are banned by the stern Captain, Maria's playful ways and needlecraft skills set an awkward first impression. Nevertheless, she soon wins round the hearts of the children, who turn out to be adorable sweethearts. The Captain, betrothed to society sophisticate Baroness Schraeder, warms to both his governess and his children's musical talent, and is revealed to be no mean singer himself. When called up for service by German forces, Von Trapp reveals strong objections against Nazism and plots to flee with the family into the mountains. As a ruse, the family is entered into the Salzburg Folk Festival, though at the last minute, their plan is stalled and they are forced to sing stirring, patriotic anthems; when the plot is almost foiled again by teenage daughter Liesl's sweetheart Rolf, a young Nazi recruit, it takes the willing aid and mechanic skills of Maria's sparky friends at the convent to save the family's bid for freedom.

Critique

The Sound of Music was the final collaboration by the celebrated team of Rodgers & Hammerstein, who had transformed the American stage musical with their string of classic shows – *Oklahoma!* (1943), *Carousel* (1946), *South Pacific* (1949) and *The King and I* (1951). When Hammerstein died in 1960 he left behind only one of these unfilmed; *The Sound of Music* was offered to 20th Century Fox, and became an instant classic (at least in English-speaking countries), thanks to definitive performances from a well-chosen cast, scene-

Duration:

174 minutes

Cast:

Julie Andrews
Christopher Plummer
Eleanor Parker
Richard Haydn
Peggy Wood

Year:

1965

stealing panoramic shots of the Austrian Salzkammergut, and a score that bounces with some of the most popular songs ever written.

The Sound of Music has everything: an unlikely love story between naval captain and nun; a charming family-bonding tale set to jaunty folktunes; and a cultural history of Austria's role in the Anschluss. That the whole package is based on a true story strengthens its appeal, though the film is often criticized for its saccharine sweetness, cloying sentimentality and naïve response to the cultural events it depicts.

These are typical criticisms of Rodgers & Hammerstein, though perhaps somewhat harsh. It is true that their shows positively bask in middle-class comfort. Problems can be solved in these musicals if you 'wash them right outa your hair' (*South Pacific*), 'sniff smelling salts' (*Oklahoma!*), 'whistle a happy tune' (*The King and I*), or in this case, simply remember your 'favourite things': these are undoubtedly naïve solutions to personal stories set in turbulent times (Oklahoma territory during the land-grabs of the 1890s, Siam during the final years of colonial power, the South Pacific theatre of war, and the European rise of fascism). On the other hand, these were shows written in the wake of Pearl Harbour, boosting national morale, and engaging with serious issues uncommon to the plotlines of musical comedy. Hammerstein's desire to foreground libertarian values through the accessible form of musical theatre without preaching from a highly moralistic standpoint was at least commendable.

In addition to its beautiful cinematography, *The Sound of Music* delights in some quirky and charming set pieces: 'Do Re Mi', a choreographed bicycle ride around the Mirabell Gardens; 'Sixteen going on Seventeen', one of the few actual dance sequences in the film, set in the (curiously expanding) gazebo; and everyone's favourite, 'The Lonely Goatherd', including a masterful puppet show in the style of the Salzburg Marionette Theatre.

The film has significant differences to the stage musical, and includes new material ('I Have Confidence' and 'Something Good') written by Richard Rodgers in the absence of his collaborator. There are also some glaring anomalies – not least the geographical route taken by the Von Trapps out of Salzburg, which would have led them straight into Germany.

Surprisingly, the film has remained virtually unknown in Austria, despite tourists flocking to Salzburg on *Sound of Music* tours. In part, this shows the discomfort Austria feels for any reminder of its complicity in the war, but such cultural blindness works both ways: a visit to the White House by the Austrian president in 1984 was greeted by the strains of 'Edelweiss', which US officials had assumed to be the national song.

Rodgers & Hammerstein on stage are more respected for their early hits, *Oklahoma!* and *Carousel*, which redefined the Broadway musical. By the late 1950s, social context had

become more commonplace on Broadway and, in the wake of such hard-hitting social sagas as *West Side Story* (1957), *The Sound of Music* – whilst a hit with audiences – rates critically as a bit of an also-ran. Not that this stops it from being the perennial Christmas-afternoon favourite.

Dominic Symonds

Sweeney Todd: The Demon Barber of Fleet Street

Studio/Distributor:
DreamWorks
Warner Bros

Director:
Tim Burton

Producers:
Richard D Zanuck
Walter Parkes
John Logan
Laurie Macdonald

Screenwriter:
John Logan
From the musical by Stephen Sondheim and Hugh Wheeler
Based on the play by Christopher Bond

Cinematographer:
Dariusz Wolski

Art Directors:
Dante Ferretti
Gary Freeman
David Warren

Editor:
Chris Lebenzon

Duration:
116 minutes

Synopsis

Sweeney Todd returns from the colonies to seek revenge on Judge Turpin, who, years ago, stole his beautiful wife and daughter and then sent him away as a convict. He is taken in by Mrs Lovett, and establishes a barbershop above her pie shop. Meanwhile, his young companion Anthony chances upon Todd's daughter Johanna, now captive as the ward of Judge Turpin. To rebuild his reputation, Todd competes in a battle of the barbers against the Italian Pirelli. When Pirelli recognizes Todd from the old days and threatens to blackmail him, he meets with the wrong end of Todd's wrath and a cast iron kettle to the skull. Todd convinces Mrs Lovett to use his victims as meat for her pies. They adopt Pirelli's apprentice Tobias, and entice Turpin into the barber's chair using Johanna – whom Anthony has rescued – as bait. Thus Todd finally kills off the Judge, along with a mysterious Beggarwoman, who turns out to be his former wife Lucy. When he realizes what he has done, he blames Mrs Lovett, and pitches her into the furnace. As Todd cradles Lucy's body, Tobias creeps up and slits the throat of the Demon Barber of Fleet Street.

Critique

It is misleading to think of this as a film of the stage musical, as Stephen Sondheim has said, and aficionados expecting a faithful remake may be disappointed. Whilst comparisons are inevitable, this is a film in its own right, hitting the mark in certain ways, though falling flat in others. The look of the film is perfect: dark, brooding and gothic, with a palette that barely touches colour except for the red of blood. Johnny Depp pulls off the Demon Barber well – and that is how he plays him, thanks to a script lacking the subtlety of the stage version. Here, the vengeance narrative is played full on, with Depp already spitting blood as he sails into London. Helena Bonham Carter is regrettably miscast as Mrs Lovett, devoid of humour or warmth and struggling with her complex character songs. Elsewhere, though, there are enjoyable performances from Alan Rickman as Judge Turpin, and the always reliable Timothy Spall as Beadle Bamford. Newcomers Jamie Campbell Bower and Jayne Wisener do well as the juvenile

Cast:

Johnny Depp
Helena Bonham Carter
Alan Rickman
Timothy Spall
Sacha Baron Cohen

Year:

2007

leads, and youngster Edward Sanders gives Tobias a good stab. Star of the show, though, has to be Sacha Baron Cohen, whose rival barber Pirelli is suitably ridiculous yet dangerously menacing.

One problem with the film is its pre-recorded studio vocals, which often lack the physical energy suggested by the scenes (and the music): Mrs Lovett's introductory number, in which her violent kneading of the dough is built into the musical phrases, becomes mealy-mouthed in Bonham Carter's under-played vocal style; elsewhere, the striking fanfare of 'Pirelli's Miracle Elixir' ('Ladies and gentleman! May I have your atten-tion perlease?'), is dainty – unconvincing as a barker's sales pitch cried out over the rough streets of filthy London. When songs work best – perhaps because of this balance problem – it is in the sung flashback narration early in the film, and it is therefore strange that Burton chooses to dispense with the title song, such an effective framing device throughout the original, establishing as it does the mood, genre and lan-guage in which this *Grand Guignol* fable is told. Nevertheless, the tension builds fittingly as victims take their seats in the barber's chair, and the duet 'Pretty Women', in which Todd readies himself to slit the throat of his nemesis the Judge, stands out as particularly effective against the smoking skyline of London, seen through the expansive window of Todd's loft barbershop. Elsewhere, the film is a patchwork of set pieces beautifully depicting Victorian London in the stylish designs of Dante Ferretti, worthy winner of an Academy Award. The second act trio 'Johanna', in which Anthony, Todd and Lucy each seek their lost loves amongst the labyrinthine alleys of the Ripper-esque city, is beautiful, and shows at its best the complex layering of (Sondheim's) writing with the direction and design. Meanwhile, the comedy set-piece 'By the Sea', whilst lacking the slapstick of the Todd/Lovett relationship, works as an imaginative, theatrical dream sequence with clever camera trickery, quirky cameos and – once again – fabulous design.

The biggest flaw in the film is that it lacks humour to bal-ance the macabre bloodlust. There is a lot of comedy in the music and the script (even as edited here), but Bonham Carter particularly does not deliver, and for all the beauty of the design, its colours remain washed out, trapping any spirit of fun beneath a smoggy torpor of decay. This is a real shame because, whilst the film does stand up to scrutiny, it lacks the characteristic mischief that we have seen so often in Tim Burton's other, magical gothic masterpieces.

Dominic Symonds

West Side Story

Studio/Distributor:
Mirisch Pictures

Directors:
Jerome Robbins
Robert Wise

Producers:
Robert Wise
Saul Chaplin
Walter Mirisch

Screenwriter:
Ernest Lehman
From the musical by Arthur
Laurents, Leonard Bernstein,
Jerome Robbins and Stephen
Sondheim
Based on the play *Romeo and
Juliet* by William Shakespeare

Cinematographer:
Daniel L Fapp

Art Director:
Boris Leven

Editor:
Boris Stanford

Duration:
152 minutes

Cast:
Natalie Wood
Richard Beymer
Russ Tamblyn
Rita Moreno
George Chakiris

Year:
1961

Synopsis

In the unbearable summer heat, teenage gangs battle for
territory in this *Romeo and Juliet* update. The neighbour-
hood has been taken over by Puerto Rican Sharks, antago-
nizing The Jets, who claim the turf as their own. Small-scale
encounters are policed by the jaded Inspector Shrank and his
hopeless sidekick, Krupke. When the adults organize a social
for the teenagers, Jet Tony meets Shark Maria and they fall
instantly in love. Tony promises to stop the fight planned that
night. The gangs meet, but despite Tony's efforts, things get
out of hand and both gangleaders – Riff and Bernardo – are
stabbed. The gangs take to the shadows and, in revenge for
the slaying of his mentor, Bernardo's protégé Chino reports
the tragic news to Maria and then goes off in search of Tony.
Maria is distraught, but pledges to run away with him. As the
net closes, she sends a message which goes wrong: Tony is
told that Maria has killed herself, and he steps into the street
begging Chino to kill him too. Just as Maria emerges from the
shadows, a shot rings out, and Tony collapses: a final death
that brings together the warring gangs in an uneasy – but
hopeful – truce.

Critique

West Side Story stands apart from many musicals because
it is so respected in almost all camps, and acclaimed for
its dramatic power and social relevance, its score, and its
innovative dance aesthetic. Jerome Robbins, credited with
the original idea, was an acclaimed choreographer whose
Metropolitan Opera ballets had been widely applauded; com-
poser Leonard Bernstein, already successful with *On the Town*
(1944), was highly respected as a virtuoso pianist and music
director of the New York Philharmonic; bookwriter Arthur
Laurents had written the screenplay for Hitchcock's *Rope*
(1948) and would go on to write scripts for other key shows
including *Gypsy* (1959); and lyricist Stephen Sondheim gradu-
ated to write such well-respected musicals as *Follies* (1971),
Sweeney Todd (1979) and the Pulitzer-prize-winning *Sunday in
the Park with George* (1984).

The anecdotes are many: the show was nearly called *East
Side Story* and was originally about Jews and Catholics; it was
also rescued from being called *Gangway!*; original casting
choices included Audrey Hepburn for Maria and Elvis Presley
for Tony; and the film's location-shooting on the streets of
the Upper West Side stalled the development of the Lincoln
Center.

It is a dated film, yet still enormously popular with audi-
ences. The central performances lack subtlety by today's
standards; the script sounds forced and clumsy; and the
colour palette is garish, especially given the liberal use of

greasepaint. Yet there are memorable moments, not least the overhead cinematography of the opening sequence, emerging from abstract credits, accompanying the iconic whistle of the music's prologue and capturing the heat and tension of streets in which everyone feels a stranger.

The updating of *Romeo and Juliet* into a contemporary milieu works well, as Baz Luhrmann's 1996 version confirms. Since 1950s' New York was a hotbed of interracial tension, the pitting of second generation European immigrants against newly arrived Puerto Rican immigrants was absolutely topical. News reports of gang fights and street killings featured in the press even during the opening week of the Broadway show. The fact that the gang members of this story are just kids is resonant – they box above their weight, they play dangerous games, and they do not anticipate the consequences of their macho behaviour; in a twenty-first-century culture of knife-crime and urban anger, these are factors that make *West Side Story* a social parable that, even fifty years on, still packs a punch.

Whilst it may have contemporary resonance, it is also a product of its time, and it is worth considering the complex context of 1950s' America, not only steeped in racial unease, but also recovering from World War II and deeply embedded in McCarthyism. This film characterizes the contradictions of what has made America fiercely protective of its identity in the world and paranoid about 'alien' invaders. Nevertheless, the film is not entirely progressive, having received much bad press for its portrayal of Puerto Ricans as violent, misogynist thugs. A further insult was the casting of very few Latino performers (Rita Moreno's Anita is about the only exception), which led to the film-makers effectively blacking-up their actors, an indicator of the very different attitudes towards race in this pre-civil rights period.

The irony is that these gangs come across as somewhat fey hoodlums with very little sense of threat. They are kids who claim territory in the playground and the school gym; they do not drink, do not swear, and display enviable vocal and dance prowess. This is gangland-lite, so as much as it engages with a serious issue from the dangerous streets of the urban ghetto, it also projects this to its middle-class audiences in a sanitized and palatable way.

Dominic Symonds

The Wizard of Oz

Studio/Distributor:
MGM

Director:
Victor Fleming

Producers:
Mervyn LeRoy
Arthur Freed

Screenwriters:
Noel Langley
Florence Ryerson
Edgar Allan Woolf
From the novel *The Wonderful Wizard of Oz* by L. Frank Baum
With songs by Harold Arlen and E Y Harburg

Cinematographer:
Harold Rosson

Art Directors:
Elmer Sheeley
Cedric Gibbons
George Gibson
William A Horning
Wade B Rubottom

Editor:
Blanche Sewell

Duration:
101 minutes

Cast:
Judy Garland
Ray Bolger
Jack Haley
Bert Lahr
Margaret Hamilton
Billie Burke
Frank Morgan

Year:
1939

Synopsis

There is no place like home, though to Kansas tweenager Dorothy, home can be a bore. Picked on by nasty neighbour Miss Gulch, she runs away with Toto her dog until a freak tornado sends her scurrying home. Unfortunately, home's foundations are ropey, and the tornado whips it up and deposits it in the merry old land of Oz on top of the now ding-dong-dead Wicked Witch of the East. Dorothy is urged by indigenous Munchkins to follow the yellow brick road to the Emerald City, wherein dwells the whiz of a wizard of Oz. Collecting en route a brainless scarecrow, emotionless Tin Man and cowardly Lion, Dorothy skips to the Emerald City while Toto guards her against the wrath of Wicked Witch #2 (from the West). Oz decrees that she must kill the witch before she can return home, so the plucky group skip off and dutifully melt her with a bucket of water. Sadly, Oz is revealed as a charlatan whose only transportation is a hot air balloon, but with three clicks of her ruby slippers and a hackneyed mantra, Dorothy whisks herself back in time for tea, only to discover it was all a dream.

Critique

At over seventy years old, this must be the longest-serving family favourite: a glorious Technicolor adventure that still beguiles in the twenty-first century; a text-book dream narrative, with a collection of ever-popular songs including the Academy Award-winning 'Over the Rainbow', almost edited out of the final cut.

This was the daring dreamchild of MGM favourite Arthur Freed. Intended as a vehicle for new girl Judy Garland, yet almost cast with hotter box-office star Shirley Temple, it was MGM's answer to the astonishing success of Disney's *Snow White and the Seven Dwarfs* (1937).

The film's punch has been all the more powerful thanks to the subsequent iconicity of its main star, whose own yellow brick road to fantastic celebrity was potholed with pain, exhaustion and addiction. Plucked from the obscurity of her family's travelling singing troupe, *The Wizard of Oz* made Frances Gumm (aka Judy Garland) a household name by the time she was seventeen. Just like Dorothy, Garland found support, partnership and solace from the men in her life: film partners such as Mickey Rooney and Gene Kelly, and no fewer than five husbands, including most prominently Vincente Minnelli (with whom she had Liza) and Sid Luft (father of Garland's other daughter, Lorna Luft). But, where Dorothy triumphs over evil and ends happily ever after, Garland succumbed to an early death in 1969, after long-term health problems and addictions to various prescription drugs. Ironically, the critical highpoint of her life came with the strangely biographical film,

A Star is Born (1954), in which she partners James Mason, whose character Norman Maine's battle with stardom parallels Garland's with uncanny accuracy.

Most poignantly, Garland's life can be read through the films, songs and stage performances for which she was so well-loved; key moments such as the 'Born in a Trunk' performance from *A Star is Born* or the 1961 Carnegie Hall concert with the young Liza Minnelli have become celebrated as iconic images of this tragic star. It is in part these great torch-song moments and the nature of her death around the time of Stonewall that have led the gay community to embrace Judy Garland so emotionally. Partly, too, the fact that we can all so readily relate to that little girl who opens the door to reveal a fantastical land of colour and life.

And so we all join Dorothy as she skips down the yellow brick road with her camp but charismatic friends. And these 'friends of Dorothy' – Bert Lahr as the Lion, Jack Haley as the Tin Man and Ray Bolger as the Scarecrow – are three of the most appealing characters in film. Equally, the green-faced Margaret Hamilton as the Wicked Witch and her numerous flying-monkey henchmen are genuinely scary evil villains.

The film is also full of subtle but effective features, such as the double-casting of performers in both Kansas and Oz, and the innovative use of Technicolor for the Oz sequences. The magical effect of the vivid colour scenes when Dorothy first opens the door of the crash-landed farmhouse is still gob-smacking today.

The Wizard of Oz – an adaptation of the L Frank Baum stories – has spawned several sequels or alternative versions: *The Wiz* (1975) reinterpreted the story with African-American characters, featuring Diana Ross (Dorothy) and Michael Jackson (Scarecrow) in the 1978 film; a Disney sequel, *Return to Oz* (1985), flopped at the box office though has since enjoyed a cult following; far more successful has been the prequel *Wicked* (2003), a musical by Stephen Schwartz (*Godspell*, *Pippin*), which is still running in the West End and on Broadway.

Dominic Symonds

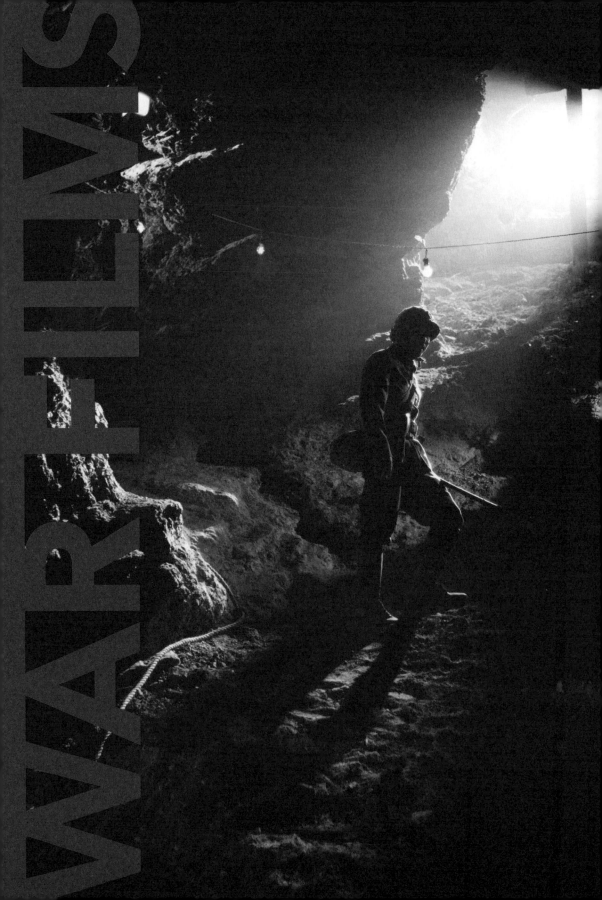

WAR FILMS

The eight films discussed in this section demonstrate a general trend in Hollywood war cinema. Four are set in World War II, two in the Vietnam War, one in the American Civil War and one in the First Gulf War. Similarly, a glance at the war film index of *1001 Movies You Must See Before You Die* (Schneider 2003: 25) reveals 38 Hollywood films. Fifteen of these are concerned with World War II, six with Vietnam, five with World War I, four with the American Civil War, two with the Middle East and six that relate to other conflicts, such as Korea and the Seven Years War.

This pattern indicates the significance different wars hold in American popular consciousness, at least as far as this consciousness is perceived by Hollywood. Historically, WWII occupies an unparalleled significance, having affected more lives than any other conflict. Nonetheless, WWII can be looked back upon positively, as a triumph of freedom and (American) democracy over fascism and tyranny. By contrast, the Vietnam conflict remains an ugly chapter in American history and culture, both as a deeply divisive issue and as a military defeat. Yet despite the different regard that the conflicts are held in, similar concerns are found in war films across a range of historical settings and production contexts.

A major question when approaching war films is their subject. Is the film under discussion actually *about* war, or is it a romance, domestic drama or comedy that uses war as a backdrop? The films discussed in this section focus upon experiences of war, whereas the list from *1001 Films* is much broader. *Casablanca* (1942), for instance, can be classed as a war film since it takes place in WWII, but the focus of the film is upon romance rather than combat. Jeanine Basinger argues in *The World War II Combat Film: Anatomy of a Genre* that a film type established during WWII, and subsequently imitated, constitutes the war film as it is commonly understood. She argues that 'before World War II, this combat genre did not exist' (Basinger 1986: 14). There appears, therefore, to be a clear distinction between combat and non-combat films, and perhaps the 'war film' can be more clearly understood as the 'combat film'.

Combat can occur in other genres – *The Wild Bunch* (1969) features intricately choreographed combat sequences but is generally understood as a Western. *Heat* (1995) has action sequences that resemble military battles, but is regarded as a crime film. Equally, the presence of the military does not necessitate a war film: *A Few Good Men* (1992) and *Crimson Tide* (1995) have military settings and characters, but do not focus upon military engagement. The military combat of *Saving Private Ryan* (1998), *Glory* (1989) and *Apocalypse Now* (1979) is uniquely inflected by the setting and issues of the wars – that is, the broader conflicts, in which they take place. So, just as the films discussed here are a microcosm of Hollywood production practice as regards the depiction of war, so an individual war film can be regarded as a microcosm of the overall war in which it takes place.

The standard narrative of a war film is an individual or group of individuals (generally all male) who undertake(s) a mission within the recognized historical conflict. It may be a rescue mission, a specific attack, or a typical tour of duty. This soldier or group of soldiers are

Left: *Letters From Iwo Jima*, 2006, Warner Bros.
Photographed by Merie W. Wallace.

taken to stand for soldiers in general, which demonstrates that a key concern of the war film is to represent wider experiences. The experience could be linked to particular issues, as identified in *The War Film* (Eberwein 2005), which is divided into sections that discuss genre, race, gender and history. Similarly, *Armed Forces* (Eberwein 2007) focuses upon the subjects of its subtitle: *Masculinity and Sexuality in the American War Film*. Nationality and unity are other major issues, as discussed in *Hollywood Goes To War 1939–1952* (Shindler 1979) and *When Hollywood Loved Britain: The Hollywood 'British' Film 1939–45* (Glancy 1999).

A common concern identified in *Hollywood and War: The Film Reader* (Slocum 2006) is that of differing attitudes towards war and conflict. As noted, the Vietnam War was and remains a highly divisive subject in American culture, and the same is true of the contemporary military campaigns in Afghanistan and Iraq. The term 'anti-war film' exists because films are read as making implicit and/or explicit criticisms. These may be of specific military attitudes and strategy, or more general moralizing that 'war is wrong'. Such films run the risk of being criticized as patronizing or unpatriotic, and it is notable that a more common attitude for films to take is that of ostensible objectivity. An analysis of war films reveals an emphasis (again) on individual experience, presented through attempts at 'realistic' depictions of combat. *Saving Private Ryan* and *The Thin Red Line* (1998) have been identified as 'immersive cinema' (Hammond 2002: 69) due to their styles which place the viewer in an analogous position to the soldier. Similarly, *Jarhead* (2003) presents through repetition and voiceover the boredom of the soldier who waits to go into combat but never does. And *The Hurt Locker* (2009) uses handheld cameras and tight framing to create an account of bomb-disposal teams in Iraq akin to home video.

The meaning and pleasure of these films is to communicate to the viewer a sense of what combat experiences are like, with an emphasis upon verisimilitude. One result of this approach is a de-politicization of the combat, suggesting that film-makers and distributors are reluctant to engage overtly in political commentary, presumably since this can alienate potential audiences. This is demonstrated by the overtly-critical commentary of US foreign policy in *Lions For Lambs* (2007), which resulted in a meagre take of $15 million. By contrast, the emphatically 'realistic' but largely apolitical *Saving Private Ryan* was the highest-grossing film at the US box office in 1998, taking over $216 million in the US alone.

The concerns and issues of the Hollywood war film range from romantic relationships to criticism of US foreign policy. The most common focus, however, appears to be the representation of *the soldier's experience*, be that the camaraderie of *Glory* and *Guadalcanal Diary* (1943), the horrors of combat in *Platoon* (1986) and *Saving Private Ryan* or the trauma of *Apocalypse Now* and *Flags of Our Fathers* (2006). As noted above, 'war film' and 'combat film' are each used in discussion over the representation of specific conflicts. Perhaps another term that could be added to this debate is *the soldier film*, as it is the presentation of soldiers, both in and out of combat, that serves as the locus of understanding within the war film.

Vincent M Gaine

References

Basinger, J (1986) *The World War II Combat Film: Anatomy of a Genre*, New York: Columbia University Press.

Eberwein, R (2007) *Armed Forces: Masculinity and Sexuality in the American War Film*, New Brunswick, NJ: Rutgers University Press.

Eberwein, R (ed) (2005) *The War Film*, New Brunswick, NJ: Rutgers University Press.

Glancy, M (1999) *When Hollywood Loved Britain: The Hollywood 'British' Film 1939–45*, Manchester: Manchester University Press.

Hammond, M (2002) 'Some Smothering Dreams: The Combat Film of Contemporary Hollywood', in S Neale (ed) *Genre and Contemporary Hollywood*, London: BFI Publishing, pp. 62–76.

Schneider, S J (2003) *1001 Movies You Must See Before You Die*, London: Cassell Illustrated.

Shindler, C (1979) *Hollywood Goes To War 1939–1952*, London: Routledge.

Slocum, J D (2006) 'General Introduction: Seeing Through American War Cinema', in JD Slocum (ed) *Hollywood and War: The Film Reader*, New York: Routledge, pp. 1–21.

Apocalypse Now

Studio/Distributor:
Zoetrope
United Artists

Director:
Francis Ford Coppola

Producer:
Francis Ford Coppola

Screenwriters:
Francis Ford Coppola
John Milius

Cinematographer:
Vittorio Storaro

Art Director:
Angelo Graham

Synopsis

Captain Willard suffers from the trauma of his experiences in Vietnam, where he has been operating as an assassin. He is ordered by Vietnam High Command to locate Colonel Kurtz, who has gone rogue with a division of soldiers, and 'terminate his command with extreme prejudice'. Willard travels up river aboard a Navy boat with four other men, and en route encounters both the atrocities and absurdities of the Vietnam War, from dancing *Playboy* girls to the massacre of unarmed fishermen, and the crazed Lieutenant Colonel Kilgore, who gives his soldiers the option to 'surf or fight'. His mission becomes a voyage into himself, before he finally meets the insane Colonel, to discover that Kurtz has reached the ultimate heart of darkness.

Critique

The production history of *Apocalypse Now* is as publicized as the film itself, thanks to Eleanor Coppola's documentary, *Hearts of Darkness: A Film-maker's Apocalypse*. But the film itself demands close attention as an auteur's final masterpiece, a compelling exploration of provocative questions, and an impressive display of cinematic techniques.

By the time he set out to shoot his adaptation of Joseph Conrad's *Heart of Darkness*, Coppola had already earned great critical acclaim in Hollywood. *The Godfather* (1972), *The Conver-*

Apocalypse Now, 1979, Zoetrope/United Artists.

Editors:

Lisa Fruchtman
Gerald B Greenberg
Walter Murch

Duration:

153 minutes

Cast:

Martin Sheen
Robert Duvall
Marlon Brando
Dennis Hopper
Larry Fishburne
Frederic Forrest

Year:

1979

sation (1973) and The Godfather Part II (1974) had earned multiple nominations and awards, including five Oscars for Coppola himself. Apocalypse Now demonstrates both his genius and his indulgence, resulting in a film bloated with meaning but undeniably powerful.

Despite his top-billing status, Brando's Kurtz only appears in the film's final half hour, and is never seen clearly, always swathed in shadow or silhouetted. Nonetheless, he creates a powerful presence as Kurtz's (largely improvised) ramblings on the war, the human heart, madness, will and resolve, bombard Willard (and the viewer) with disturbing questions. As the manic photo-journalist (Dennis Hopper) comments, Kurtz 'enlarges the mind' through searing insight and probing questions. As a whole, Apocalypse Now judges neither Kurtz nor the Vietnam conflict itself but, rather, exposes the viewer, much like Willard, to a range of experiences that ultimately make little sense, as perhaps the war does not make sense. This runs the risk of making the film incoherent, but Coppola keeps the actual plot very simple: Willard travels upriver in search of Kurtz. Within this quest narrative, the pace of the film remains slow, allowing Willard and the viewer time to consider the concepts and problems encountered along the way.

It could be argued that this slow pace and the ponderous questions make the film dull and/or pretentious, though there are sporadic sequences of action including a mist-shrouded attack on the boat and the famous 'Ride of the Valkyries' helicopter attack on a Vietnamese village. This makes Apocalypse Now much like The Godfather films, with an overall style that is slow and deliberate, interspersed with abrupt violent sequences. But Coppola's visual and aural palettes serve both as evocative means of expression and impressive technical accomplishments. Long takes perpetuate the film, demonstrating Coppola's talent for complex scenes such as soldiers storming a beach while helicopters fly overhead, explosions burst around them and a camera crew shouts 'Don't look at the camera!' The film earned Oscars for both its cinematography and sound, and these aspects are the film's main expressive techniques. Superimposed images of the jungle, Willard's face, and huge idols create a frame that is rich while also confusing, especially at the beginning and end of the film. Walter Murch's sound design bleeds voices, music and sound effects together into an intoxicating cacophony.

Apocalypse Now can perhaps be best understood as an expression of delirium, its narrative less than coherent and therefore a critique of the cinematic form itself. Its opaque style and lack of clear meaning can make it impenetrable and nonsensical, but also serve to express Kurtz's (and Willard's) state of mind, suggesting that no medium can adequately express the heart of darkness or the Vietnam War. It can also be seen as Coppola's admission on the limitations of film, which struggles to show the full extent of the human condition. Apocalypse Now stands both as a testament and a warning about the power of cinema, as the film was the beginning of the decline of Coppola, who never regained his success of the 1970s.

Vincent M Gaine

Flags of Our Fathers

Studio/Distributor:
DreamWorks SKG
Warner Bros
Amblin Entertainment
Malpaso Productions
Paramount Pictures

Director:
Clint Eastwood

Producers:
Clint Eastwood
Robert Lorenz
Steven Spielberg

Screenwriters:
William Broyles Jr
Paul Haggis

Cinematographer:
Tom Stern

Art Director:
Jack G Taylor Jr

Editor:
Joel Cox

Duration:
126 minutes

Cast:
Ryan Phillippe
Jesse Bradford
Adam Beach
John Benjamin Hickey

Year:
2006

Synopsis

When John 'Doc' Bradley falls ill, his son James begins to research Doc's World War II history. According to the official records, Doc was one of six men who raised the United States flag on Mount Suribachi, an event immortalized in the iconic photograph, *Raising the Flag on Iwo Jima*. The image became a clarion call for the US war effort and the inspirational symbol for a fundraising campaign. However, James discovers that the circumstances surrounding the flag-raising are swathed in confusion and controversy. Initially, Doc and fellow survivors Ira Hayes and Rene Gagnon are prepared to play their part in *The Mighty Seventh* bond drive, touring the country and being presented as heroes to adoring crowds. However, over time, guilt gnaws away at the trio. Haunted by memories of their dead companions, they reject their status as heroes. After the war, the men have difficulties adjusting to civilian life, with Doc rarely speaking of his wartime experiences. Yet he recalls one bittersweet moment when his unit enjoyed a respite from battle, briefly forgetting they were soldiers. James reflects: 'To truly honour these men, we should remember them the way they really were, the way my dad remembered them'.

Critique

Clint Eastwood has made no secret of his admiration for the work of director John Ford. So it is fitting that *Flags of Our Fathers* recalls the infamous line from *The Man Who Shot Liberty Valance* (1962): 'When the legend becomes fact, print the legend.' It is in the chasm between 'legend' and 'fact' that the three protagonists of *Flags* find themselves trapped. Torn between their grief and their sense of duty, they are plunged into a whirlwind of publicity with which they are ill-equipped to deal. As Eastwood comments, the bond drive built around the photograph was 'kind of like the birth of celebrity. It's making celebrities out of people that don't really feel like they are celebrities.'

Although known for his westerns and urban cop thrillers, Eastwood has long displayed an interest in the war genre, starting with the over-the-top antics of *Where Eagles Dare* (1968) and up to his own *Heartbreak Ridge* (1986), a film that offended the US Marines with its critical depiction of military life. As early as 1970 Eastwood expressed disappointment that the subtle anti-war message in the original script for *Kelly's Heroes* (1970) was lost in the final edit.

In *Flags*, the first part of his Iwo Jima diptych, Eastwood makes amends, presenting a thoughtful meditation on the impact of war. The soldiers are not portrayed as fabled heroes, but merely ordinary men carrying out their duty. The Battle of Iwo Jima was a brutal conflict that saw the combined dead

on both sides reach an estimated 25,000. To this end, the film strives to represent the true ferocity and trauma of the battle.

The muted colour palette wielded by cinematographer Tom Stern supports this approach. Eastwood compares his images to sketches, luring the audience into the frame to complete the picture. At times the colours are so drained that the sequences appear almost monochrome. But rather than black and white, the film employs subtle shades of grey. It is a colour scheme that characterizes the confused and chaotic nature of war – this is not a tale of good versus evil but rather the story of a group of individuals simply fighting to survive.

The screenwriters acknowledge the challenge of telling a story with such a large number of characters. As is common in the war genre, with the cast clad in similar military fatigues it is occasionally difficult to follow the action. Admittedly, the fractured narrative – jumping between the battle, the bond drive and James Bradley's investigation – further complicates matters. However, this is not necessarily a shortcoming. Just as Eastwood's visual style encourages an active contribution, the splintered narrative requires a little work on the part of the audience.

To assist the audience's engagement, the film-makers make every effort to achieve a sense of authenticity. Photographs of the era were studied for reference and military advisors were brought in to train the actors. Even the black sand at the Icelandic location was carefully sieved and sculpted to match Iwo Jima.

With this extensive attention to period detail and a budget reported to be in excess of $50 million, the production is of a grander scale than is typical of Eastwood. Yet the primary focus remains on the three survivors, creating what Stern describes as a 'personal epic'. This is evident in the use of objective camera angles to present events through the eyes of the protagonists. Ultimately, the film succeeds in its attempt to honour the memory of the troops as ordinary men, while inspiring the audience to remember the extraordinary contribution that they made to history.

John Caro

Glory

Studio/Distributor:
TriStar Pictures

Director:
Edward Zwick

Synopsis

The young Union Army Captain, Robert Gould Shaw, returns home to Massachusetts after his company is slaughtered at Antietam. Here his family connections secure him a post as Colonel of the first 'coloured' regiment in the Union Army. In the face of the scepticism and outright obstruction of much of the rest of the army, the men are laboriously made ready for battle and the officers gain the trust of their soldiers. When they reach the frontline, the men of the 54th face both

Producers:
Freddie Fields
Pieter Jan Brugge

Screenwriter:
Kevin Jarre
From the diary of Robert Gould Shaw

Cinematographer:
Freddie Francis

Art Directors:
Keith Pain
Dan Webster

Composer:
James Horner

Editor:
Steven Rosenblum

Duration:
122 minutes

the boredom of camp life and the horror of a war that pits them against innocent civilians. However, once they have the chance to distinguish themselves in battle they gain the respect of the rest of Union Army and volunteer to lead the charge on an impregnable Confederate fortress outside of Charleston.

Critique

Edward Zwick's Civil War drama was the first of a wave of film and television projects commemorating the 125th anniversary of the conflict, and made the director one of Hollywood's go-to men for historical epics (*Legends of the Fall* [1994], *The Last Samurai* [2003], *Defiance* [2008]). However, it is best remembered for being the first major screen treatment of the role of African-American soldiers in the Civil War. Based on the true story of the 54th Massachusetts (Coloured) Infantry regiment, *Glory* garnered widespread critical acclaim, including three Oscars, and was praised for its unprecedented historical accuracy. Much of this is due to the film's extensive reliance upon the diary extracts and letters of the real-life commander of the 54th,

Glory, 1989, Tri Star.

Cast:

Matthew Broderick
Denzel Washington
Morgan Freeman
Cary Elwes

Year:

1989

Colonel Robert Gould Shaw (Matthew Broderick). (Indeed, Shaw is credited as one of the film's screenwriters, an attribution best understood as a paratextual bid for authenticity.) Delivered as a voiceover, the formal tone and relentless idealism of these extracts counterpoints the often vicious and unforgiving conditions under which Shaw's men must survive, as well as the hardness with which Shaw conditions his raw recruits. However, while the racially-tolerant Shaw is the familiar figure through which a contemporary audience initially gain access to the remote battlefields of the Civil War, the story soon shifts its focus to the men under his command. Here, *Glory*, flaunts its research, paying particular attention to the techniques of quickly loading and firing muskets, and fighting with bayonets, even as it dramatizes the recruits' development from a disparate band of runaways and freedmen to an effective military unit.

At its heart, however, *Glory* is a platoon drama and, like all platoon dramas, it functions synecdochally. Thus we follow a central quartet of black characters, each an archetype of one of the kinds of men who volunteered for service in the 54th: Rawlins (Morgan Freeman), a wise, old survivor; Trip (Denzel Washington), a rebellious runaway Southern slave; Sharts (Jihmi Kennedy), an ignorant former field-slave; and Thomas (Andre Braugher), an educated Northern black used to freedom and privilege. Through the private exchanges in the tent they share and their moments of mutual support on the battlefield we read the growing trust and understanding between these men as a symbol of the development of an encompassing black identity out of the disparate experiences of the men of the regiment. Yet the pride they take in this identity is called into question, not only by the resistance of the rest of the Union Army to offering the 54th an equal role in combat, but by an encounter with another black Union regiment, this time composed of poorly-trained, recently-freed slaves. These soldiers, encouraged into animalistic behaviour by their commanding officer, impress upon the 54th the way they are viewed by the rest of the nation for which they are notionally fighting. When they are ordered to take part in the atrocities committed by this other unit by torching the houses of Confederate civilians, *Glory* provides a moment of pure abjection in a narrative of liberation and integration.

Ultimately, it is the film's use of these moments that foreground the distance between the white officers of the 54th and the black soldiers in their charge, which prevents it from oversimplifying its subject. Though it makes use of a melodramatic orchestral score and ends in a pat moment of symbolic unity, as the distance between white and black is erased in the mud of a mass grave, *Glory* also allows itself a freedom of dissent from its own narrative that no amount of uplifting music can conceal.

Martin Zeller-Jacques

Guadalcanal Diary

Studio/Distributor:
20th Century Fox

Director:
Lewis Seiler

Producer:
Bryan Foy

Screenwriters:
Lamar Trotti
Jerry Cady
From a novel by Richard
Tregaskis

Cinematographer:
Charles Clarke

Editor:
Fred Allen

Art Directors:
James Basevi
Leland Fuller

Duration:
90 Minutes

Cast:
Anthony Quinn
Richard Conte
Richard Bendix
Preston Foster
Lloyd Nolan

Year:
1943

Synopsis

Guadalcanal Diary is an account of the US Marine Corps' invasion of the Japanese stronghold of Guadalcanal in the Pacific Solomon islands between 7 August and 10 December 1942. Following a time of jovial good humour and enthusiasm aboard ship, the Marines find themselves thrown into battle almost as soon as they make their way inland. Amid increasing hostilities and against overwhelming odds, the company battles to defeat the entrenched Japanese forces and in securing a landing strip that will prove important to subsequent success in the war.

Critique

Although Guadalcanal Diary was not the first World War II combat film to be made in America, it has proved to be one of the most significant and enduring. In its essentially episodic account of a group of marines engaging the entrenched Japanese forces on Guadalcanal Island, as seen and reported by a war correspondent who narrates in stages the men's physical and psychological progression, it helped to establish and popularize a narrative model that would remain broadly intact through successive decades of the WWII combat film: from *The Story of GI Joe* (1945) through to *Windtalkers* (2002).

The Pacific Battle of Guadalcanal was the first land battle to be fought in the Second World War, and provided its own inherent, microcosmic story arc of enthusiastic preparation for battle followed by sobering reality and ultimate triumph. It thus offered what was to be a brief window of positive, optimistic representation and reflection before subsequent conflicts began to sour the national mood and awaken those back home to the enormity and potential futility of the war. By the time of *Bataan* (1943) later the same year, there was already a questioning of America's role in the war, as well as a tacit acknowledgement that it was likely to prove a protracted and bitter struggle that may not prove ultimately successful.

There is an obvious sense in which Guadalcanal Diary, like Bataan, had to contend with events very fresh in the national consciousness and, thus, had the primary task of engendering support for the fighting troops on foreign soil. As a result, there is at the heart of the film a collection of figures who (unlike in, say, The Sands of Iwo Jima [1949]) are not defined as soldiers but, rather, as ordinary citizens in the process of becoming soldiers for the greater good, including a jovial and pragmatic priest. To complement this there is also a discourse on morally-correct ways to engage in battle, a clear demarcation between the up-front, direct engagement of the Marines and the perceived underhand tactics of the numerically-superior Japanese (who kill remorselessly, even pretending

to surrender in order to do so). Indeed, *Guadalcanal Diary* shares with *Bataan* a portrayal of the Japanese as literally sub-human. The protagonists constantly refer to their enemy as monkeys or rats, and as if to reinforce this definition they are most often seen hiding in trees or scurrying through caves, an undifferentiated, animalistic mass as opposed to the carefully-individuated marines, with their lives back home clearly mapped out and elucidated. They are, in fact, stereotypes rather than characters, decked out as a checklist of contrastive personalities harmoniously blending together as a unit: from a tentative rookie nicknamed chicken (played by Richard Jaeckel, later a veteran of WWII films such as *Attack* [1956], *The Naked and the Dead* [1958] and *The Dirty Dozen* [1967]) to an experienced, fatherly older soldier, a baseball-mad New Yorker and a womanizing but brave Hispanic.

It is this characterization of the enemy that then serves to transpose the generic iconography of *Guadalcanal Diary*: from the denotative climes of the war film to the connotative face of the Western. In particular, the film comes to resemble nothing so much as *Stagecoach* (1939), as the marines cautiously pick their way through a valley overlooked by steep cliffs, the caves in which are full of Japanese lying in wait. The camera pans between the two groups in an almost exact replica of Ford's film, with the enemy combatants standing in for the Indians and the diagrammatic cross-section of frontier society replaced by a catch-all representation of American manhood and dignified masculinity.

Such a direct appropriation of the Western, something John Woo would echo almost sixty years later by framing *Windtalkers* within the symbolic visage of Monument Valley, alludes to the ideological imperatives of *Guadalcanal Diary*, to its vision of necessary hardship for the common good. The fact that it accomplishes this feat without any overbearing sentimentality or recourse to overt platitudes is as much as one could reasonably expect from such a film at this historical juncture, made only months after the actual battle it depicts. It is also a tribute to the artful artlessness of Lewis Seiler, a veteran of programme pictures at Warner Bros, who had already directed a WWII short with Ronald Reagan entitled *Beyond the Line of Duty*. His no-frills direction and B-movie sensibility, which includes liberal use of stock battle footage, ensures that however much it has dated as a propagandistic flag-waver, *Guadalcanal Diary* remains of note for the extent to which it defines a brief, all-but-forgotten time.

Adam Bingham

Jarhead

Studio/Distributor:
Universal Pictures

Director:
Sam Mendes

Producers:
Lucy Fisher
Douglas Wick

Screenwriter:
William Broyles Jr
Based on a book by Anthony
Swofford

Cinematographer:
Roger Deakins

Art Directors:
Stefan Dechant
Marco Niro
Christina Ann Wilson

Editor:
Walter Murch

Duration:
125 minutes

Cast:
Jake Gyllenhaal
Peter Sarsgaard
Chris Cooper
Jamie Foxx

Year:
2005

Synopsis

It is 1989 and young Swoff is feeling a tad apprehensive about starting basic training at US Marine Corps Camp Pendleton. Attempting to get out of boot camp, he fakes illness but instead gets picked to join an elite unit of eight scout/snipers under the command of Staff Sergeant Sykes. By age 20, Swoff is a trained killing machine with a state-of-the-art rifle and best friend Troy as his spotter. When Iraq invades Kuwait, Swoff's unit flies to the Saudi Arabian desert to protect the Saudi oil fields. Swoff waits anxiously for the war to begin, struggling to keep from losing his mind out of sheer boredom and carnal fear. After an interminable wait, war finally breaks out. The eight Marine scout/snipers and Sykes join Operation Desert Storm at the Kuwaiti border, where they come face to face with 'friendly fire', civilian casualties, and the reality that this war will not be won by the soldiers on the ground.

Critique

Although Hollywood has not been forthcoming with films depicting the first Gulf War; it has given us Jarhead, the exceptional third feature by Sam Mendes (American Beauty [1999]). As in Anthony Swofford's 2003 best-seller on which the film is based, the Vietnam War is a recurring theme throughout. Before deploying, Swoff and his fellow Marines watch the film Apocalypse Now (1979) to get fired up for battle. This scene expresses how Swoff's generation of Marines, whose fathers fought in Vietnam, hunger for a war they can call their own. Yet Mendes forgoes the heavy action sequences and spectacular heroics typical of war films and in contemporaries, Black Hawk Down (2001) and Enemy at the Gates (2001). 'Every war is different, every war is the same', Swoff reflects. One could say the same thing about every war film. Jarhead is as much a film about what it is like to be a young Marine going to fight in a modern technological war as it is a film about the difficulties in surviving a long tour in the desert.

The Marines are rigged out to handle anything the enemy might throw at them, even Saddam's chemical weapons, but nothing could prepare the men for the long period of waiting that lies ahead. Director of Photography Roger Deakins, known for his work with the Coen brothers, uses time-lapse photography superbly to capture the exasperating boredom of killing time in the desert. Images of sand evoke the passing of time, like grains of sand flowing through an hourglass. When the sands of time run out, what materializes is, in fact, not a month of Sundays spent tarrying in the desert but a brief moment in human history, and one that will never leave

Swoff as long as he lives. The third act is a fluid blend of cinematography with visual effects. Deakins's remarkably-steady handheld camera keeps all attention on the characters, and not on special effects. The infinite beige landscape becomes stained with black as oil engulfs the frame. Oil well fires shoot up vertically against the horizon. Clouds of vapourized oil cast a black shadow over the sky, recalling Herzog's *Lessons of Darkness* (1992). References are made to *Giant* (1956) and 'big oil', but *Jarhead* deftly avoids any political point of view. When a debate sparks up amongst the scout/snipers, Troy promptly extinguishes it, saying, 'Fuck politics, all right. We're here. All the rest is bullshit.' With his well-wrought adaptation of Swofford's memoir, screenwriter, William Broyles Jr articulates both the universality as well as the surrealism of what it is like to go to war.

In the new cycle of Hollywood Iraq-Afghanistan-war-themed films, Oscar-winner *The Hurt Locker* (2009), like *Jarhead*, manages to avoid taking a political position, whereas *Green Zone* (2010) states its message about power and politics most conspicuously. *Green Zone* is the antithesis of *Jarhead* in its willingness to take a political stance, following the formula of a conspiracy thriller to suit its *Bourne Trilogy* audience. Others such as *In the Valley of Elah* (2007) and *Stop Loss* (2008) are stories that follow soldier's post-combat lives – as *Jarhead* did in covering how Swoff and Fergus cope with Troy's post-war tragedy. It will be interesting to witness *Jarhead*'s impact on the next generation of war films. Will tomorrow's war films be about characters that grew up watching *Jarhead*, as *Jarhead* is a film about soldiers who grew up watching *Platoon* (1986)? In *Platoon*, Stone brings the Vietnam War into question, but the film is often appropriated as a glorifier of war rather than one that raises issues for further discussion. *Jarhead* is a definite question-raiser, and the broader question being: Will there continue to be a place for this discussion in Hollywood?

Carrie Giunta

Letters from Iwo Jima

Studio/Distributor:

Amblin Entertainment
DreamWorks SKG
Malpaso Productions
Warner Bros
Paramount Pictures

Synopsis

In 1945 the Imperial Japanese Army prepares fortifications for the impending US assault on Iwo Jima. For Private Saigo and his fellow conscripts the task of digging trenches and tunnels is seemingly endless. It is close-run as to whether they will die from dysentery or the US bombardment. When General Kuribayashi takes command of the island's defences, both supplies and morale are already running low. Many of the senior officers question Kuribayashi's tactics, doubting his loyalty because of the time he served as a military attaché in North America. Yet Kuribayashi finds an ally in former Olympic show jumper Lieutenant Colonel Baron Nishi and together

Director:

Clint Eastwood

Producers:

Clint Eastwood
Robert Lorenz
Steven Spielberg

Screenwriters:

Iris Yamashita
Paul Haggis

Cinematographer:

Tom Stern

Production Designers:

Henry Bumstead
James J Murakami

Editors:

Joel Cox
Gary D Roach

Duration:

135 minutes

Cast:

Ken Watanabe
Kazunari Ninomiya
Tsuyoshi Ihara
Ryo Kase

Year:

2006

the two men fight to protect the island, while struggling to uphold their honourable principles. When the defences on Mount Suribachi crumble, the beset Saigo questions the worth of continuing to fight for what is clearly a lost cause. Led by Kuribayashi, and out of ammunition, the remaining Japanese forces regroup for one final desperate attack. Saigo is ordered to stay behind to destroy secret military documents and personal correspondence. Instead, he buries the letters and years later they are discovered by Japanese archaeologists. Finally, the soldiers' personal stories will be heard.

Critique

Part of Clint Eastwood's Pacific War diptych, *Letters from Iwo Jima* is best watched in conjunction with *Flags of our Fathers* (2006). Co-producer Robert Lorenz recounts that, while scouting the island, Eastwood was inspired to tell the story from the Japanese soldiers' perspective. As with *Flags*, events are related through the eyes of a small group of men. Reflecting the lower budget, it is a more intimate film, creating a claustrophobic mood through the low-key lighting and oppressive locations. However, eschewing the complex fractured narrative of *Flags*, it principally concentrates on the battle, although the back-stories of the protagonists are revealed over the course of several flashbacks.

In common with *Flags*, the primary objective is to honour the memory of the soldiers. Actor Ken Watanabe states that the battle is 'a piece of our history that we should never forget'. The film's promotional materials suggest that World War II is a topic largely avoided in Japan. As Eastwood acknowledges, it may appear odd that an American director would attempt to portray a Japanese viewpoint but, with memories still raw, perhaps an outsider was required to broach the subject.

At the Tokyo premiere Eastwood playfully referred to himself as a Japanese director, but he has demonstrated respect for the country's culture. He sought guidance from the Japanese Iwo Jima Veterans Association and the script is based on Japanese source material, co-adapted by Iris Yamashita, a *Nisei* (second generation) Japanese-American. Elements of the characterization and visual style even recall the work of Akira Kurosawa, one of Eastwood's early influences.

However, for an American director to take on a Japanese perspective remains problematic and potentially controversial. *Letters* has been criticized by members of the Association for the Advancement of Unbiased View of History for inaccuracies, including the use of westernized, *gairaigo* dialogue. With its depiction of kimono costumes and sliding *sh ji* front doors during the flashbacks, the film has also been accused of Orientalism. However, this can be countered by the defence that *Letters* at least features Japanese actors speaking their native language and makes a direct attempt to elicit an empathetic response from audiences.

Nevertheless, Eastwood walks a fine line. On one hand his portrayal of the Japanese military has been criticized for being too deferential, focusing on US war atrocities. Yet others claim that Eastwood's apparent sensitivity is superficial. The only sympathetic Japanese officers are revealed to have once lived in the United States, implying that their values have been tempered by their exposure to American culture. But such charges rather miss the point. Besides the fact that in reality Kuribayashi and Nishi did visit North America, the result of their experience is that they understand their enemies are ordinary men, missing their loved ones and wanting only to return home. The theme is emphasized after Nishi's unit comforts a dying US Marine. Reading a letter from his mother, the assembled Japanese soldiers silently acknowledge that their opponent is not so different from themselves.

Although it would be easy to be cynical about this simple premise, it is commendable that a film from a major Hollywood studio and an 'All-American' movie icon strives to remind audiences that war is to be lamented and that the resulting loss of life is traumatic for both sides. It may not be an original or sophisticated message but *Letters* provides a sadly all-too-relevant reminder of the personal cost of war, suggesting that lessons have yet to be learned. As actor Tsuyoshi Ihara has observed, the film offers an opportunity to reflect upon 'wars fought in the past as well as battles we'll fight in the future'.

John Caro

Platoon

Studio/Distributor:
Hemdale Film Corporation
Orion Pictures
MGM

Director:
Oliver Stone

Producer:
Arnold Kopelson

Screenwriter:
Oliver Stone

Cinematographer:
Robert Richardson

Art Directors:
Rodell Cruse
Doris Sherman Williams

Synopsis

Beginning his tour of duty in late 1967, young volunteer Chris Taylor arrives in Vietnam and is stationed near the Cambodian Border. Prompted to enlist for the war by a sense of national and familial duty, Chris soon begins to question the rationale behind his decision. Struggling under the weight of exhaustion and the ever-present threat of death, Chris finds himself within the crossfire of political tensions that are enveloping his platoon. Following an ambush in which he is superficially wounded, Chris is accepted by a group of soldiers under the leadership of Sergeant Elias. However, as the events of the war begin to spiral out of control, and Elias' conflict with Sergeant Barnes threatens to divide the loyalties of the platoon, Chris discovers that the real enemies in the Vietnam War may be fighting on the same side.

Critique

From the opening title card ('Rejoice o' young man in thy youth') *Platoon* establishes its venture into the Vietnam War

Editor:

Claire Simpson

Duration:

120 minutes

Cast:

Charlie Sheen
Willem Dafoe
Tom Berenger
Keith David
John C McGinley
Forest Whitaker
Johnny Depp

Year:

1986

within the dramatic context of a coming-of-age narrative. For director Oliver Stone, who served in the war, Vietnam signified a defining moment both in terms of his life and that of the American cultural psyche. Conflating the national and the personal through the character of Chris Taylor (Charlie Sheen), *Platoon* explores the war as an event in which the United States was forced to confront the morality of its involvement in world affairs.

Utilizing the platoon dynamic as a microcosm of the various political conflicts that characterized the Vietnam experience, Stone focuses on the relationships between the men as the war takes its toll and the group self-destructs. Dubbed 'new meat', Taylor's introduction to the platoon provides an outsider perspective (expressed through a series of voice-overs) through which to comment upon this fragmentation of fraternal bonds. Initially viewing his fellow 'grunts' with an air of deference ('They're the best I've ever seen … the heart and soul'), Taylor increasingly comes to admonish the dissolution of morality amongst the men ('I don't know what's right and what's wrong anymore').

In charting the loss of Taylor's *qua* American innocence, Stone structures the film through a series of stylistic and thematic dualisms that gesture to the contrasting nature of war. Prolonged periods of stillness and silence are ruptured by brief and brutal sequences of violence (indiscriminate killing, rape, fragging); stylistic realism gives way to grandiose moments of slow motion; while the allegorical conflict between Sergeant Barnes (Tom Berenger) and Sergeant Elias (Willem Dafoe) approaches a level of biblical importance. Beyond the war itself, Stone seems intent on dramatizing Vietnam as an exploration of the human condition, a conflict of the soul that is exteriorized in the battleground of the Vietnamese jungles.

Ultimately, though, Stone appears determined to shine a way forward from the ambivalence that characterized the public's response to Vietnam. Rather than coming down on the side of the political doves or hawks, *Platoon* attempts to merge both viewpoints through Taylor. If at times the character appears condemnatory of the US presence in Vietnam, at others he laments the lack of a bipartisan front ('I can't believe we're fighting each other, when we should be fighting them'). Indeed, Taylor's final confession that he is a 'child born of those two fathers' (the liberal dove Elias and conservative hawk Barnes) bespeaks an attempt to appeal to both sides of the Vietnam conflict simultaneously.

As a consequence, *Platoon* represents a significant milestone in American cinema's depiction, and parallel cultural acceptance, of the war in Vietnam. Where earlier depictions of the conflict had approached Vietnam from ultra-nationalistic (*The Green Berets* [1968]), pseudo-mythical (*The Deer Hunter* [1978], *Apocalypse Now* [1979]), or super-heroic (*Missing in Action* [1984], *Rambo: First Blood, Part II* [1985]),

standpoints, the vivid moments of realism that Stone captures reiterate a willingness to finally confront certain 'realities' of the conflict. In doing so, *Platoon* clearly struck a chord with the audience of the day who empathized with the film's final-scene plea for national reconciliation and regeneration. Oliver Stone continued his exploration of the Vietnam War in two subsequent films: *Born on the Fourth of July* (1989) and *Heaven and Earth* (1993).

Josh Nelson

Saving Private Ryan

Studio/Distributor:
DreamWorks
Paramount Pictures
Amblin Entertainment

Director:
Steven Spielberg

Producers:
Steven Spielberg
Ian Bruce
Mark Gordon
Gary Levinsohn

Screenwriter:
Robert Rodat

Cinematographer:
Janusz Kaminski

Art Director:
Tom Sanders

Composer:
John Williams

Editor:
Michael Kahn

Duration:
169 minutes

Cast:
Tom Hanks
Matt Damon
Tom Sizemore

Year:
1998

Synopsis

Captain John Miller, a survivor of the landing at Omaha Beach, leads a mission to find the missing Private James Ryan and bring him home. Miller has chosen seven men for this treacherous task. Their journey brings them into the heart of a devastated France and, in the end, they find Ryan but the soldier refuses to abandon his comrades because of an impending German attack. So Captain Miller and his squad choose to stay with Ryan; the mission to bring him home coming at great cost to all those involved.

Critique

The opening of *Saving Private Ryan* is a terrible journey inside the representation of the event of war itself. Erasing the experiential memory of many of the previous war movies dedicated to World War II, Steven Spielberg chooses to nail the viewer to his/her chair and to immerse their perception in a realm that is inescapable. The violence contained in the landing sequence is a sort of prologue to the actual narrative.

Saving Private Ryan begins with a touching visit paid by an old man and his family to the grave of one of the American soldiers buried in the war cemetery in Normandy. With the solemnity that is typical of many Spielberg movies, the director makes us participate in a suffering that the rhetoric of cinema transforms into the focus of the entire movie. Spielberg focuses on the visible pain that covers the face of this old man, slowly drawing us into a touching proximity with his blue eyes while we begin to hear the sounds of the sea. The ensuing flashback seems to find the same pair of blue eyes, inside a military boat approaching Omaha Beach many years before. These eyes belong to a trembling man, sitting among other trembling men ready for the landing – pair of blue eyes surrounded by a frightened body. Our hero is Captain Miller, who miraculously survives the slaughter of Omaha Beach and is then asked to lead a suicide mission.

But in Spielberg's perspective, finding James Ryan is not the final goal of Miller's mission: the soldiers need to save

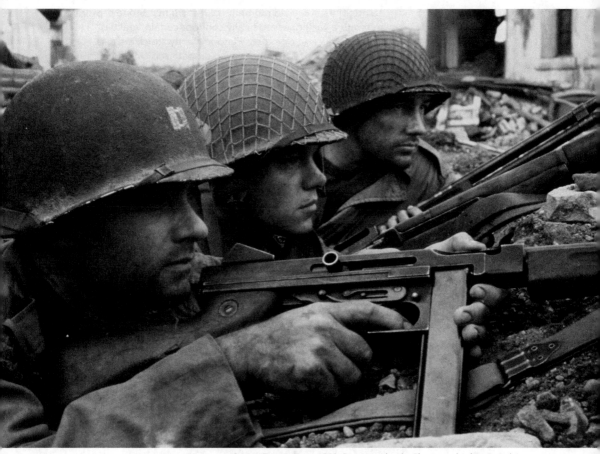

Saving Private Ryan, 1998, Dreamworks Llc. Photographed By David James.

their own lives and gain new meaning for their existences after their passage through the gates of desperation.

During their journey in the deserted lands of France, the soldiers continuously think about their lives before the war and discuss their views about life after the abominable survival they almost feel guilty about. The expedition they are asked to pursue – to save a single soldier, putting the lives of eight in extreme danger – appears meaningless but Spielberg literally *plays* with the weapons of symbolism throughout the entire movie: the passage through the bottleneck of Omaha Beach means, for the soldiers, the loss of their own individuality, because death and destruction are represented in their absoluteness, in a fragmented and exploded reality in which the only existing things are death and survival. The soldiers sent to rescue a (probably) dead comrade are charged with a highly-symbolic task: they have to bring back at least one (live) son to a mother who has lost her other three sons because of the war. Captain Miller and his squad are forced

to give the US a reason to hold on, a valid explanation for an apparently suicidal participation in the European conflict, and are asked to find a logic in a totally illogical reality.

The strictly-symbolical approach adopted by Spielberg is vividly exemplified by the French and German characters met by the soldiers during their journey: a French family whose father wants to save his daughter by consigning her to the American soldiers (the girl and her mother, humiliated, refuse), and the German soldier who betrays the deal made with Miller, represent the wholeness of France and Germany in relation to the conflict. Similarly, we might see the long landing sequence confirming this wholeness, as Spielberg does not permit us to recognize a single distinguishable person in the indistinct slaughter. At the end of the movie, Spielberg deliberately chose to play with the audience's attention and to betray the trust that insists on the logic of flashback. The flashback of the old man that opened the movie is actually an impossible one, because right before the end we see Miller die. The old man remembering is actually Private Ryan, who was dropped from an aeroplane inside France and never participated in the Omaha Beach landing. Saved by the heroism of a few soldiers, he ceased to be *just* James Francis Ryan and became something more and some-thing less: a man who had to earn the sacrifice made for him by other men, a man who can mirror himself in a discoloured flag that continues to wave.

Franco Marineo

Defining Hollywood drama in generic terms is a difficult task. Where, for example, do we find the common generic ground between *On the Waterfront* (1954), *Thelma and Louise* (1991) and *Philadelphia* (1993)? Drama functions more as a labelling term for those films leftover from the more easily-distinguishable genres such as action, crime, the Western or romance/the romantic comedy. Although many films are easily classified or referred to as 'dramas', the category is too vast. Indeed in contemporary terms the phrase 'drama' is used rather too easily to refer to films that do not have the fast pace of an action film, the spectacle of an epic, the historical content of a bio-pic, the humour of a comedy or the conventions/setting of a Western. Neither Steve Neale (2000) nor Barry Langford (2005), in their accounts of Hollywood genres, recognize drama as a category – no doubt because it is too broad. Drama, then, becomes an umbrella term that describes a range of genres, or film types, that could be grouped together as 'dramatic genres', for example social problem films, melodramas or courtroom dramas.

It seems necessary to mark out the difference between drama and melodrama, a genre that fits into this wider group. Although drama is not dealt with by the majority of genre critics, Neale does briefly touch upon the ways in which melodrama and drama differ. He quotes Epes Winthrop Sargent who wrote: 'simple drama occupies a place between melodrama and tragedy in that it lacks the violence of the one and the loftiness of the other' (cited in Neale 2000: 193). Both Langford and Neale spend some time discussing the complexities of melodrama. As Neale writes: 'drama, whose provenance may lie in the theatrical genre of *drame* … was certainly distinguished from melodrama in the [film] industry's press' (2000:193). He notes the different uses of the term in industry press and academic scholarship. Melodrama within academic scholarship has begun to refer to 'women's films': family melodramas typified by the work of directors such as Sirk, Ray or Minnelli. Although family melodramas still exist in Hollywood, for example *Far From Heaven* (2002) or *Moonlight Mile* (2002), the term is most readily associated with Classical, studio films. It has also come to denote a set of films that display their tensions through *mise-en-scène*. Outside of scholarly writing, the term melodrama had a very different usage: '"Melodrama" seems generally … to have denoted blood-and-thunder dramas of passion, crime, injustice and retribution' (Langford 2005: 30). Neale cites as an example of this a reviewer who believed melodrama aimed 'to give a thrill rather than an edifying emotion' (2000: 193).

If Hollywood drama does have its roots in the French theatrical genre of 'drame', situated between comedy and tragedy and paying particular attention to (middle-class) social issues, then it seems necessary to include 'social problem' films under the umbrella of dramatic genres. An interest in social issues permeates the Hollywood genre of the 'social problem' film, which fits under the wider umbrella of dramatic narratives. These films combine

> social analysis and dramatic conflict within a coherent narrative structure. Social content is transformed into dramatic events and movie narrative adapted to accommodate social issues as story material. (Roffman & Purdy cited in Neale 2000: 113)

Left: *Thelma And Louise*, 1991, MGM/Pathe.

The social problem film often tells the story of the disenfranchised or the smaller man against an institution, such as government or big business. This is typified by Frank Capra's *Mr Deeds Goes to Town* (1936). The social problem film, in this instance, crosses over into the courtroom drama, another dramatic genre in which social issues and power struggles are often played out. Although the social problem film was prominent in the studio era, in contemporary Hollywood the same crossover is evident in a film such as *Philadelphia*, in which homophobia and its resulting tensions are played out within a courtroom setting. The social problem film draws upon audience experience and emotion in order to create an empathetic response. That said, social issues are increasingly widespread in Hollywood narratives. Although social problem dramas elicit a more serious response, the troubles of the nuclear family become a social issue that permeates a number of action and adventure blockbusters, for example *True Lies* (1994), *Deep Impact* (1998) or *The Day After Tomorrow* (2004).

Langford notes the generic crossover in such films, suggesting that contemporary 'family' action films function as a re-working of melodrama, drawing both on the scholarly and industry interpretations of the term. On the one hand, the excessive action links to the idea of melodrama perpetuated by film industry critics, on the other, the dramatic family narrative and the playing out of tensions through the *mise-en-scène* (in these films typified by special effects) links to the academic appropriation of the term.

This allows melodrama to be separated from 'women's film', a phrase with which it has been traditionally linked. Of course, these films are more readily categorized as action-adventure films. This reiterates the crossover between genres, and the difficulty in grouping films by clear-cut genre definitions. It also begs the question of what the defining characteristics of a genre are.

Although drama does not stand alone as a genre, it has come to be a term that refers to plot- or character-driven films, and to tensions in the narrative rather than visuals and action. It is complex characters, social issues and a strong narrative that links films such as *On the Waterfront*, *Thelma and Louise* and *Philadelphia*. Drama films often deal with 'real' situations and elicit an emotional response. This undoubtedly has affected the perception of many dramas as weepies or women's films – one thinks of *Terms of Endearment* (1983), for example. However, dramas are not explicitly aimed at women. The films directed by Clint Eastwood, such as *A Perfect World* (1993), *Million Dollar Baby* (2004) or *Gran Torino* (2008), show the same attention to plot, character and 'real' issues as the more 'emotional' women's films but have at their centre male characters, and more 'masculine' concerns. The importance of drama in these films is the tone; the seriousness. Hollywood dramas, then, provide strong narratives, engaging characters and represent the world in a realistic, considered way.

Claire Jenkins

References

Langford, B (2005) *Film Genre: Hollywood and Beyond*, Edinburgh: Edinburgh University Press.

Neale, S (2000) *Genre and Hollywood*, London: Routledge.

Falling Down

Studio/Distributor:

Alcor Films
Canal+
Regency Enterprises
Warner Bros

Director:

Joel Schumacher

Producers:

Timothy Harris
Arnold Kopelson
Herschel Weingrod
Arnold Milchan

Screenwriter:

Ebbe Roe Smith

Cinematographer:

Andrzej Bartkowiak

Art Director:

Larry Fulton

Editor:

Paul Hirsch

Duration:

113 minutes

Cast:

Michael Douglas
Robert Duvall
Barbara Hershey
Tuesday Weld
Rachel Ticotin

Year:

1993

Synopsis

In early 1990s' Los Angeles, an unnamed, disturbed former defence employee begins a journey across town to his ex-wife's home to see his estranged daughter on her birthday. After traffic holds him up on the freeway, he travels by foot through various disadvantaged areas of the city, encountering immigrant shop keepers, gang members, and other denizens of the city, getting more and more frustrated with the status-quo and lack of respect. Meanwhile, Detective Prendergast, a timid former street cop, is about to retire and move to Arizona. On his last day at the job he becomes intrigued by an evolving case of a seemingly-violent individual causing chaos in different communities, and he begins to piece together the man's path across the city.

Critique

'I did everything they told me to', a disturbed former defence employee states near the conclusion of *Falling Down*, a powerful and multi-layered depiction of the unstable nature of families, communities, and professional relationships in early 1990s' Los Angeles. The film represents some of the best and most thought-provoking work director Joel Schumacher and actor Michael Douglas have ever committed to film, and while it is very much 'of its time', it also still feels all too relevant to real-life events and issues today: communities in the US and the rest of the industrialized world continue to be traumatized by disgruntled citizens who go on shooting rampages (though the film's main character does not willingly shoot innocent bystanders, his attitude towards everyone he encounters makes them believe he will). *Falling Down* is a brave portrait of a disturbed and unstable man, affecting and meaningful in both its moral and cultural dilemmas, and its vocalization of legitimate grievances within contemporary industrialized American society. Douglas' character is named 'D-FENS' in the film's end credits, reflecting the character's licence plate on the car that he abandons at the beginning of the film. Douglas' portrayal concentrates on the psychology underneath the surface, and even though the character's encounters with gang members, fast food restaurants, and neo-Nazi shop owners function as action centrepieces of the film, the most unsettling scenes are often the in-between moments, as D-FENS makes phone calls to his ex-wife (Barbara Hershey), letting her know that he is on his way home. In one call, he compares himself to NASA's Apollo missions: 'I'm on the other side of the moon now, out of contact, and everybody's just going to have to wait until I pop out.'

There are no easy answers in *Falling Down* for either D-FENS or the retiring Detective Prendergast (Robert Duvall), who is dealing with his own stressful phone calls from his unstable wife and an increasing unwillingness to say goodbye to his job. A major thread throughout questions the traditional ideas of masculinity –in both Douglas' and Duvall's characters. Schumacher alternates between birds-eye view shots of LA's diverse street corners and

Falling Down, 1993, Warner Bros.

close-ups of Douglas' weary and heat-stricken face, blurring the instability of the city's subcultures with the psychological dilemmas inherent in the mind of D-FENS. Proof that the film reflected its contemporary surroundings was provided during production when the 1992 LA Riots, sparked off mainly by the videotaped police beating of Rodney King, created upheaval in the city and gained national attention. *Falling Down* also includes a reference to its own location-shooting style – as D-FENS is preparing to shoot a bazooka at a construction site, he is mistaken for an actor filming an action movie. When a kid asks him what the film is called, he nervously mutters an appropriate 'high concept' title: *Under Construction*. As *Falling Down* reaches its denouement, D-FENS begins to realize that his increasingly-radical choices have consequences within a 'civil' society: 'I'm the bad guy?' he asks, genuinely. The film's mixed reception at the time of release indicates that we as an audience were experiencing similar confusion, perhaps not only about the film and its moralities, but how they related to our everyday lives.

Michael S Duffy

Good Will Hunting

Studio/Distributor:
Miramax Films

Director:
Gus Van Sant

Producers:
Lawrence Bender
Kevin Smith

Screenwriters:
Matt Damon
Ben Affleck

Cinematographer:
Jean Yves Escoffer

Art Director:
James McAteer

Composer:
Danny Elfman

Editor:
Pietro Scalia

Duration:
126 minutes

Cast:
Matt Damon
Robin Williams
Ben Affleck
Stellan Skarsgård
Minnie Driver

Year:
1997

Synopsis

Gerald Lambeau, a perpetually-bescarfed professor of algebraic graph theory, poses a perfunctory brain teaser to his class of MIT students. When it is solved by an anonymous intellect, Lambeau posits another, much harder, equation. Noticing a mere janitor seemingly defacing the white-board problem, the professor chases him away, only to discover the correct deduction scribbled down. The janitor is Will Hunting, a local youth with genius-level intelligence. Will is involved in a street fight with his old kindergarten bully and, as a result, is prosecuted. Coming to the boy's defence, Lambeau offers his guidance, and supervised therapy. Will's reluctance to psychoanalysis leads to a number of unhappy encounters before a partial meeting of minds with Lambeau's old college friend Sean Maguire, a community college psychology instructor. Eventually, Will must choose between a high-powered career, his blue-collar friends, and his burgeoning relationship with Skyler, a British Harvard student.

Critique

On its release in 1997, *Good Will Hunting* appeared to be something of a departure for Portland-based maverick Gus Van Sant. Formerly best known for his modish studies of junkies and rent boys, Van Sant's sidestep into the world of blue-collar friendship, emotional hang-ups and heterosexual desire was taken by many as an unfortunate pitch towards the mainstream. Granted his fresh, relaxed direction provided a vaguely counter-cultural edge, effortlessly eliciting star-making performances from the then little-known acting/writing pair Ben Affleck and Matt Damon; but the sheer weight of unearned sentiment and lightweight philosophizing made the case for an auteur sell-out.

The benefit of hindsight may well have forced some of the sneerers (this writer included) into reconsidering their position. In the dozen or so years following *Hunting*, Van Sant has proved to be a director with a rare sensibility for combining the radical with the conventional, gracefully flitting between the personal and the popular, and continually refining his knack for blurring the two. Here, inclined viewers do not have to work overly hard to find queer-tinged elements in such an ostensibly hetero-narrative. Putting aside the female love interest, Skyler (Minnie Driver and her mannish laugh), *Good Will Hunting* is, at heart, a drama about two early-middle-aged men, taking it upon themselves to offer a helping hand to a gifted, and rather good-looking, youngster. Whilst Will is quick to note any hint of feyness in his more mature mentors, his bad-boy posturing can be happily viewed as knowing provocation. Such a deflected 'grooming' narrative can be seen, with varying degrees of abstraction, in many of Van

Sant's works: from his debut, *Mala Noche* (1985), through to *Finding Forrester* (2000) and *Paranoid Park* (2007). That said, *Good Will Hunting* is not a gay film in any clear sense of the term, and can be easily enjoyed as an orthodox hymn to straight male bonding.

Interestingly, the May-December mentoring narrative was mirrored somewhat in the films gestation, with seasoned pros Rob Reiner and Kevin Smith taking the fledgling screenwriters under their wing. Buddy-movie script specialist William Golding was consulted, but rumours of a full re-write were flatly denied. Indeed the theme of transgenerational affection can be taken a step further if one chooses to scrutinize the somewhat unlikely dedication to beat generation heroes William Burroughs and Allen Ginsberg. Whether they would have chosen to accept the film's overt extolling of touchy-feely psychoanalysis or preferred to take more pleasingly perverse readings will, sadly, never be known.

The real discovery of the film, however, is John Mighton – effortlessly stealing every scene he appears in as Lambeau's simultaneously resentful and kind-hearted assistant. Mighton, a mathematician originally brought in only as a technical advisor, shows remarkable nuance and understatement for a debut screen performance (his other career as a playwright would have helped). After the film, Mighton went on to set up a charitable foundation named Junior Undiscovered Math Prodigies (JUMP). In an even smaller role, a frazzled-looking Harmony Korine walks by, uncredited.

Rob Dennis

Gran Torino

Studio/Distributor:
Malpaso Productions
Warner Bros

Director:
Clint Eastwood

Producers:
Clint Eastwood
Bill Gerber
Robert Lorenz

Screenwriters:
Nick Schenk
Dave Johannson

Cinematographer:
Tom Stern

Synopsis

Following the death of his wife, Korean War veteran and retired auto-worker Walt Kowalski becomes increasingly withdrawn. One of the few remaining white Americans in his Michigan neighbourhood, he rejects overtures of support from the local Catholic priest and dismisses his sons and grandchildren as idle and selfish. Still haunted by his wartime memories, the only genuine affection he expresses is for his dog and his 1972 Gran Torino – a vehicle that he personally helped to assemble on the production line. However, after a failed attempt to steal the cherished car, Walt is compelled to confront the prejudices he feels for the Hmong family living next door. Reluctantly at first, he finds himself increasingly involved in the affairs of his neighbours, befriending young Sue Lor and becoming a role model for Thao, her introverted brother. Walt intervenes in several unpleasant confrontations with local gangs in an attempt to protect Thao's family. Nevertheless, the situation continues to escalate, culminating in a brutal assault on Sue. Despite Walt's best efforts,

Art Director:

John Warnke

Editors:

Joel Cox

Gary D Roach

Duration:

112 minutes

Cast:

Clint Eastwood

Christopher Carley

Bee Vang

Ahney Her

Year:

2008

it appears that young Thao is destined for a life of gang violence and crime. But Walt has one final courageous plan to find peace and salvation for Thao and himself.

Critique

Despite a campaign that appeared to market *Gran Torino* almost as a continuation of the *Dirty Harry* series (the movie's one-sheet poster depicts a typically grim-faced Eastwood, rifle in hand), with its themes of regret and redemption it would be more appropriate to view the film as a companion piece to Eastwood's *Million Dollar Baby* (2004). 'A man's got to know his limitations', Harry Callahan mused in *Magnum Force* (1972). In *Gran Torino* Eastwood and his character, Walt Kowalski, take this advice to heart. It would have been all too easy to have followed a crowd-pleasing 'senior citizen vigilante' route but, instead, Eastwood elects to pursue a more nuanced and reflective approach, returning to the ideas he explored in *Unforgiven* (1992) and *Mystic River* (2003), where violence has disturbing and lasting consequences.

The symbolism of the eponymous car is clear. As Eastwood comments in the DVD's bonus features, 'Walt sort of is the Gran Torino. He's worked on them in the factory and he's as antique as they are'. The car, popularized by the 1970s' cop show *Starsky and Hutch* (1975–1979) provides a metaphor for the former and faded glory of American machismo.

Gran Torino acknowledges that times have changed. Dirty Harry's above-the-law tactics no longer apply. As previously seen in films such as *Bronco Billy* (1980), Eastwood satirizes his tough-guy persona. The one occasion Walt fires his rifle it is in error, the shot harmlessly ricocheting off his garage walls. Making as if to draw a pistol on troublesome gang members, absurdly he only produces his pointing index finger – a gesture the youths greet with bewilderment. Most tellingly, when Walt finally resorts to violence, viciously beating a member of the gang that is persecuting Thao, he only serves to escalate the bloodshed.

Much has been made of the racist language used by Walt, but it serves as a signifier of an out-of-date masculinity. The slurs doled out to various ethnicities are distinctly squirm-inducing, yet they are emblematic of a character who, as his son observes, 'still lives in the fifties'. For Walt, trading personal insults is often a displacement for unspoken affection, a coarse social interaction learned in the military and on the factory floor. It even becomes part of a rite of passage as Walt educates Thao in 'correct usage'.

Eastwood enjoys confounding audience expectations. There is something unsettling and strangely moving watching this symbol of stoic masculinity play the role of a retiree: mowing his lawn, struggling to make small talk with a group of teenagers at a party, or, most disturbingly, being presented with retirement-home brochures by his insensitive family. In

film, seniors are usually peripheral characters – figures of fun or wise sages contributing advice from the sidelines. Offering a refreshing variation, here is a sympathetic portrayal of a senior citizen as a fully-realized protagonist.

But if Walt's character is well-drawn, the depiction of his family is rather one-dimensional. It is difficult to believe that even the most self-centred family would behave so inappropriately at a funeral. However, in an attempt to provide a little depth, Walt does express regret that he was not closer to his sons. There are hints that they have reached out to their father, only to have their offers rejected. Ultimately, like John Wayne's Ethan Edwards in *The Searchers* (1956) and Alan Ladd's protagonist in *Shane* (1953), the film acknowledges that that the saviour of the civilized community must move on. Perhaps the ways of the Old West may no longer apply, yet the tropes of the Western genre continue to persevere.

John Caro

Kramer vs Kramer

Studio/Distributor:
Columbia Pictures

Director:
Robert Benton

Producer:
Stanley R Jaffe

Screenwriter:
Robert Benton

Cinematographer:
Nestor Almendros
Production Designer:
Paul Sylbert

Editor:
Jerry Greenberg

Duration:
105 minutes

Cast:
Dustin Hoffman
Meryl Streep

Year:
1979

Synopsis

Joanna Kramer is an unhappy housewife and mother. Her workaholic husband Ted has little time for her or their son. Joanna decides to leave her family in order to find herself, forcing Ted to adapt to life as a single, working father. Initially Ted struggles with his new responsibility. The experience, however, transforms him. He has to take a lower-paid job with fewer hours but his relationship with his son improves. Joanna then resurfaces wanting custody of her son. A court battle ensues in which Joanna is awarded custody but she eventually relents and allows Ted to remain with his son.

Critique

Kramer vs Kramer undoubtedly helped launch Streep's stellar career. Although she was already a recognizable face in Hollywood, the film propelled her to a new level of success, awarding her a best supporting actress Oscar for just ten minutes screen time. The impassioned speech Joanna Kramer gives in the courtroom was actually re-written by Streep. This role cemented her as an actress with talent, sensitivity and a clear idea of women's rights. It is both the film's effect on Streep's career, and the way in which it dealt with gender politics within a changing family that has made *Kramer vs Kramer* so important.

The relationship on set between Streep and Hoffman was notoriously turbulent. The scene in which Ted Kramer throws a glass at the wall, frustrated by Joanna's reappearance and her claim for custody of her son, was, allegedly, Hoffman's own reaction to Streep out-performing him. The tension

between Streep and Hoffman is echoed in the gender politics of the film. Following on from a decade of weak leading men on the Hollywood, and political, stage, the film attempted to reconcile the 'new man' of 1979 with the authoritative father. The 'new man' was a direct response to second-wave feminism. Ted Kramer learns to make the sacrifices many women face in order to be a mother. He must change his job, work shorter hours and his personal life is also affected. However, through all of these changes he learns to become a more selfless and nurturing man. The celebration of the improved father, however, comes at the expense of the mother. Joanna Kramer has come to represent the archetypal 'bad' feminist mother whose personal desire to find herself comes at the expense of her family and child. The film fails to fully explore the role of the dissatisfied mother by simply pushing her out of the majority of the narrative instead of trying to unpick Joanna's motivation for leaving her family. The film also fails to recognize or acknowledge how a woman might be able to juggle work and her own interests with family life.

The conclusion of the film, in which Joanna is awarded custody of her son but then forfeits this in favour of the father, provides a problematic resolution to the gender politics explored within the film as a whole. By awarding custody to the mother the film highlights a bias towards maternal care as necessarily the best. That said, Joanna does have a right to be a parent and indulge in her own interests. Joanna's decision to give up custody of her child allows the film to eventually side with the father and celebrate his right to be the central parent. On the one hand this makes the film quite radical in its exploration of family, gender and fatherhood, on the other it punishes the mother for pursuing interests away from the family.

Regardless of one's feelings about the narrative or its conclusion, *Kramer vs Kramer* has a long-lasting legacy of father-son films that dominated the 1980s. A film such as *Ordinary People* (1980) owes a debt to *Kramer vs Kramer*, as it, too, explores the emotional and nurturing bond between father and son. The legacy of *Kramer vs Kramer*, however, is also seen in the absence of mothers in father-son narratives throughout the 1980s and in the demonization of the professional woman – a more frequent image in 1980s' Hollywood, evidenced in a film such as *Fatal Attraction* (1987). The film, though, remains significant in its representation of a specific cultural shift, in its measured representation of gender and family issues, and by providing a thoughtful and provoking narrative.

Claire Jenkins

On the Waterfront

Studio/Distributor:
Columbia Pictures

Director:
Elia Kazan

Producer:
Sam Spiegel

Screenwriter:
Budd Schulberg

Cinematographer:
Boris Kaufman

Editor:
Gene Milford

Composer:
Leonard Bernstein

Duration:
108 minutes

Cast:
Marlon Brando
Lee J Cobb
Karl Malden
Rod Steiger
Eva Marie Saint

Year:
1954

Synopsis

The mob-controlled unions have been running the docks through intimidation and violence for years. As the long-shoremen have been forced into poverty, the union boss Johnny Friendly has grown wealthier and more powerful. The Waterfront Crime Commission is investigating but the dock workers have learned to play deaf and dumb for their own safety. When Friendly orders the murder of Joey, a well-liked member of the community who was cooperating with the police, he uses Terry to coax Joey into an ambush. Terry, a simpleminded ex-boxer, is troubled by his role in the murder and begins to question his relationship with Friendly. Terry's brother Charlie is Friendly's right-hand man and tries to convince Terry to remember who his friends are and not cooperate with the police. Meanwhile, Terry has become enamoured with Edie, Joey's sister, who along with Father Barry, is trying to convince Terry to testify against the union.

Critique

This film is best remembered for the Marlon Brando star persona and Hollywood's recognition of the actors' studio and Stanislavski method. Without any romanticism, Brando presents a simple guy struggling to make meaning out of the events around him and to understand his responsibility in the situation while everyone around him seems so certain of what he must do. Terry behaves as a selfish, aloof loafer who has lost all faith in himself. The performance gains so much attention because of the quality of the portrayal but also because Brando, a star and celebrity, depicts a character that is so quickly understood and easily dismissed but gives the character a sincere human quality. By far the most referenced scene from the film is between Terry and his brother Charlie. Terry faces the reality of what he has become and what Charlie has done to him as he pours out the tragedy that they have both created. Brando used the method acting technique taught at the Actors' Studio, a style aimed at creating psychological realism through personal identification with the character and the careful consideration of the character's psychological motives.

Other celebrated Brando films, *The Godfather* (1972), *Ultimo Tango a Parigi/Last Tango in Paris* (1973) *Apocalypse Now* (1979) often cast him as an older man. This film enables people to see him as a younger man, when he was a sex symbol. Marlon Brando along with James Dean best epitomized a new generation of film actors which coincided with a disaffected post-war youth culture that was not yet understood. Brando's last film before *On the Waterfront* was *The Wild One* (1953), a star vehicle identifying him with tough rebellious youth. *On the Waterfront* was a move away from

becoming a typecast rebel and established depth and tenderness to the persona. The empathy in his performance was associated with the beatnik generation that acted as a precursor to the hippie movement.

The interpretation of this film and the reasons why it is remembered have significantly changed since it was first released. Today, the film is most commonly referenced because of Brando, though originally the film was seen in the light of Elia Kazan's testimony at the House of Un-American Activities Committee two years earlier. Kazan was criticized for cooperating with HUAAC and naming associates from his time as a member of the Communist Party of the United States of America. Kazan was quite determined to make a film about the Hoboken docks and, while people accused him of using it to justify informing, he would later claim that it was to show everyone that he had not backed away from his convictions. What is certain is that Kazan's informing was not forgotten and he was never fully accepted in Hollywood after his testimony.

Michael Honig

Philadelphia

Studio/Distributor:
TriStar Pictures

Director:
Jonathan Demme

Producers:
Edward Sayon
Jonathan Demme

Screenwriter:
Ron Nyswaner

Cinematographer:
Tak Fujimoto

Art Director:
Tim Galvin

Editor:
Craig McKay

Duration:
125 minutes

Cast:
Tom Hanks
Denzel Washington

Synopsis

Having excelled in his position at a prominent law firm in Philadelphia, attorney Andrew Beckett celebrates his recent promotion to senior associate. Yet, as friendly as he is with the firm's partners, he conceals both his homosexuality and his contraction of AIDS for fear of bias in the workplace. However, while celebrating the new promotion with his colleagues, and the subsequent honour bestowed upon him to represent one of the firm's most prestigious clients, one of the partners questions the lesion-like mark on Andrew's head. Soon after, having successfully completed his duties for the case, a file is mysteriously missing and, subsequently, Andrew is fired for incompetence. Believing firmly that this was sabotage, solely due to the discovery of his sickness, he seeks the help of attorney Joe Miller in bringing a case against the firm for wrongful dismissal. Joe initially struggles with his own prejudices against homosexuality and his fear of AIDS, before submitting himself to what will be a historical legal case and a deep, life-changing friendship.

Critique

At the time of its release in late 1993, *Philadelphia* was one of merely a handful of mainstream American films to deal with the then controversial topic of AIDS. It followed, most notably, John Erman's television movie *An Early Frost* from 1985; and Roger Spottiswoode's television movie adaptation

Antonio Banderas
Jason Robards
Joanne Woodward

Year:
1993

Philadelphia, 1993, Columbia. Photographed by Ken Regan.

of Randy Shilts' non-fiction book, *And the Band Played On*, which first aired in September 1993. However, given Jonathan Demme's status after the success of *The Silence of the Lambs* (1991), along with his casting of such esteemed actors as Washington and Hanks, *Philadelphia* benefitted from world-wide release and subsequent box-office success. As much as the film's narrative should be commended for bringing to light the repercussions of AIDS in a heartfelt and humane manner, Demme's approach both cinematically and in terms of his deployment of music merits closer inspection in the same regard.

The opening sequence of *Philadelphia* is remarkably mem-orable. Bruce Springsteen's eminent voice – accompanied by an urban resonance of dusky drumbeats – envelops a fast-paced melange of sweeping aerial shots and *terra firma* dol-lies of the streets of Philadelphia. The establishing sequence,

along with Springsteen's lyrics, recounts the bittersweet realities of a contemporary metropolis: the simultaneous existence of wealth and poverty, belonging and alienation, architectural beauty and dereliction. Demme's utilization of the city continues throughout: aesthetically, the fragmentation and the paradoxes of urban space symbolize the deterioration of Andrew's health and the divide in social opinion on issues of gay rights and the recognition of AIDS. Similarly, he uses the city's greyness as a concrete jungle, intimating the ethical corruption of large-scale firms while continuously juxtaposing such power with the human emphasis in its narrative. Here, Demme uses the technique of close-shot camera work to its full advantage: point-of-view shots are offered in the form of faces gazing into the camera on a number of occasions, and the outcome thus complements the film's humanistic and anti-prejudice stance to an admirable extent.

Equally, the film's closing sequence is effective through its application of audio-visual technique. Neil Young's 'Philadelphia' – Oscar nominated along with Springsteen's winning song – imbues a complex conclusion. Young's soft, melancholic piano escorts such lyrics as 'City of brotherly love, place I call home, don't turn your back on me', making direct reference to not only the city in which Andrew fights for both his life and his human rights, but the city in which we all reside. Demme's film documents the story of a million voices, struggling for social compassion in the wake of their contraction of this tragic illness. In this final sequence, the camera embraces the love by which Andrew was surrounded through family and friends, regardless of the cold attitudes that awaited his presence in the city, before visually succumbing to the home-movie footage that plays on a TV screen in the background. The frame is then filled with the grainy aesthetic of amateur video, and scenes of Andrew's healthy and happy childhood.

Given its widespread commercial success, *Philadelphia* exposed the realities of an issue infrequently tackled by mainstream media. Its narrative triumphs in the themes it induces, rather than through any deep portrayal of character psyche – which it lacks on several occasions. Yet, more praiseworthy is Demme's endeavour to transcend specific social groups by consistently reverting to the streets, the 'everyday' people of America, and through his employment of music from two of his generation's most renowned male artists. These aspects contributed in immeasurable ways to the film's grounding as a socially-significant milestone in the history of Hollywood cinema.

Abigail Keating

Thelma & Louise

Studio/Distributor:
MGM

Director:
Ridley Scott

Producers:
Mimi Polk
Callie Khouri
Dean O'Brien
Ridley Scott

Screenwriter:
Callie Khouri

Cinematographer:
Adrian Biddle

Art Director:
Lisa Dean

Editor:
Thom Noble

Duration:
130 minutes

Cast:
Geena Davis
Susan Sarandon
Harvey Keitel
Michael Madsen
Christopher McDonald
Brad Pitt

Year:
1991

Synopsis

Best friends Thelma and Louise, a housewife and a waitress respectively, seek temporary respite from their unfulfilling lives by taking a road-trip. Their initially light-hearted getaway takes a disturbing turn after a man they meet in a bar attempts to rape Thelma. Using her gun initially to deter him, Louise becomes so incensed by his unrepentant attitude that she shoots and kills him. Suddenly the women find themselves on the run rather than simply on the road. Wanted for murder, they determine to reach Mexico and safety – a goal frustrated by Louise's mysterious insistence that they avoid Texas. Their journey is fraught with adversity. Having received some money from Louise's on/off boyfriend Jimmy, the women encounter a handsome and charming armed robber-cum-confidence man who steals their money yet leaves Thelma with the savvy to hold up a rural gas station and replace their lost cash. Detective Hal Slocumb, who has sympathetically pursued the women since the murder was discovered, finally tracks them down as they traverse the iconic Monument Valley. Unwilling to relinquish their newfound freedom – and lacking confidence that the legal system will support them in their plight – the women agree to continue the journey rather than surrender.

Critique

Contentious at the time of its original release, *Thelma & Louise* is a film that continues to generate critical debate. Its controversy is due in part to its genre hybridity as well as to its treatment of gender. The comedic tone of the early part of the film, which underscores the pleasure the women find in their friendship, emerges time and again, even when disaster strikes them later on. Yet the influence of other Hollywood genres is also very much in evidence. Drawing on the iconography of classic John Ford films, including guns, Stetsons and epic scenery, *Thelma & Louise* also shares a number of thematic and narrative preoccupations with Westerns. The clearest example of these is perhaps the women's frustration with the confines of domesticity and routine and the autonomy they gain once they are compelled to journey away from these constraints. There is also a clear affinity with the generic tropes of the road-movie genre which arguably sprang from the Western. Cast early on as wrongdoers – legally if not morally – the eponymous Thelma and Louise share their uneasy status with their road-movie predecessors including *Bonnie and Clyde* (1967) and *Butch Cassidy and the Sundance Kid* (1969). All these characters find freedom on the road, although this promise is short-lived and the outcome of the journey often proves tragic. It is important to note that this generic ancestry is seen largely as a masculine one and this is

what sets *Thelma & Louise* apart from its forebears. With two strong female leads and a female scriptwriter, this is undeniably a project shaped by women and its masculine cinematic roots might seem surprising. These genre choices raise questions. What place do women have in these traditionally-masculine spheres? And why should two seemingly-ordinary women be portrayed as outcasts from society in the early 1990s?

Both of these questions have provoked intense critical, popular and academic debate; much of this centres on whether or not the film can be described as feminist (Sturken 2000: 9). The character traits and actions associated with Westerns and road movies might be construed as intrinsically 'anti feminist'. For some critics, then, with regard to the first question, the turn to guns and violence means these female protagonists are simply appropriating the worst features of aggressive masculinity. The second question complicates the matter, however. For other critics, *Thelma & Louise* represents a clear critique of late-twentieth-century American society. This was a time when Second Wave feminism had the quest for female equality firmly on the public agenda whilst also experiencing what journalist Susan Faludi termed a 'backlash' – a denouncement of so-called 'militant feminism' at the very time the Second Wave was gaining ground as a movement (1991: 12). With this context in mind, some argue that Louise and Thelma might be angry, even aggressive, but what choice does such a society leave them? The attempted rape, the catalyst for the shift in tone, is clearly an act of male aggression – one arguably embedded in a patriarchal culture which suppresses and stifles – yet Louise's act of retribution means the women will be the only ones held accountable. The revelation that Louise is determined to circumvent Texas because she was raped there in the past reinforces the notion that society has failed these women and is likely to do so again. Outlawed from patriarchal society, it is through those genres closely associated with self-reliance and with liberty that they are offered temporary reprieve whilst the impossible nature of their predicament is laid bare. The interplay between genre and gender thus renders this a thought-provoking film.

Rebecca Janicker

References

Faludi, S (1991) *Backlash: The Undeclared War Against American Women*, London: Vintage.
Sturken, M (2000) *Thelma & Louise*, London: BFI Publishing.

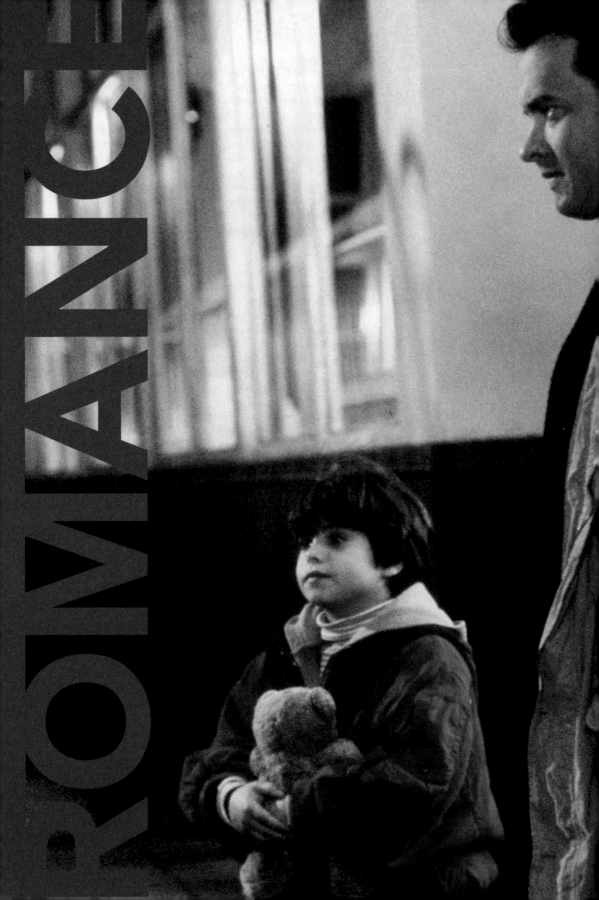

Romance has always been popular in Hollywood, not only as a genre but also as a key ingredient of most productions. Love, adventure and mystery are essential components of romantic dramas and romantic comedies, but they also form the emotional backbone of many Westerns (*Duel in the Sun* [1946], *North to Alaska* [1960], *Brokeback Mountain* [2005]), crime films, and especially films noirs (*Laura* [1944], *The Big Sleep* [1946], *The Lady from Shanghai* [1946]), musicals (*The Love Parade* [1929], *Singin' in the Rain* [1952], *Grease* [1978]), thrillers and fantasies (*The Ghost and Mrs Muir* [1947], *Wild at Heart* [1990], *Twilight* [2008]), science fiction films (*The Terminator* [1984], *Eternal Sunshine of the Spotless Mind* [2004]) or adventure films (*King Kong* [1933], *Raiders of the Lost Ark* [1984]). In short, romance permeates a range of established genres.

Romances are often set in distant times or places where events are happier, or grander, or more exciting than those in real life. As in fairytales, they do not dwell upon life after marriage.[1] They tend to present Manichean worlds peopled, as Lesley Brill remarked,

> with extreme and relatively pure human traits. Heroes are brave, handsome, and unentangled by previous commitments; they seek and serve women who are lovely and pure of heart despite dreadfully compromising circumstances; and they oppose villains who reek of carrion and the smoky fires of hell. (Brill 1988: 6)

Many movies centre on the choice of the right partner, which often comes with the heroes' search for identity: two perspectives of a single goal. There are difficulties for the couple to overcome in order that they be together: they are mismatched, the tough guy then discovers love entails complex mating patterns from the initial verbal sparring or power struggle to the emergence of mutual attraction, which builds up to (non) consummation, and either to a final catastrophe or to a happy ending, with the mundane miracle of love resolving the problems of both partners. Such is the formula of a classic romance that contributed largely to making Hollywood the 'Dream Factory' that Hortense Powdermaker had criticized in her 1950 book.[2]

The inclination for romance was already patent in the silent era. Emotions, passion, and love conflicts were common plot material. It can be traced back to the 'song films'. These four-shot, three-and-a-half to five-minute films illustrated sentimental and patriotic ballads in motion pictures. *Everyday is Sunshine When the Heart Beats True* (1903), for example, tells the story of a man who has lost his beloved wife and recalls their happiness together (Musser 1990: 363). The romantic cycle also relied heavily upon popular literary and dramatic works: *Madame X* (1916 and 1920), *The Garden of Allah* (1927), *Camille* (1917), *Romeo and Juliet* (1916). The success of romantic movies was also largely due to the presence of great female stars: Mary Pickford in *A Romance of the Redwoods* (1917), Lillian Gish in *Broken Blossoms* (1919), Janet Gaynor in *Sunrise* (1927), and Greta Garbo in *Torrent* (1926).

In the 1930s, poor social environments became one of the favourite settings for romances, especially during the Great Depression. The films of that period teemed with destitute heroes and heroines whose

Left: *Sleepless In Seattle*, 1993, Tri-Star.
Photographed By Bruce Mcbroom.

fates took new turns, thanks to love: *Lucky Star* (1929), *City Lights* (1931), *One Way Passage* (1932). Equally popular were the films staging fallen women and golddiggers: *Stella Dallas* (1925), *Street Angel* (1928), *Only Yesterday* (1933). The Hays Code also contributed to the evolution of romance. The Production code that was adopted in 1930 by the Motion Pictures Producers and Distributors Association spelled out what was acceptable and what was unacceptable content for films produced for a public audience in the United States. The general principle of the Code aimed to protect the moral standards of the audience. It had repercussions for romance, since it stipulated that '[s]cenes of passion are not to be introduced when not essential to the plot. Excessive and lustful kissing is to be avoided, along with any other treatment that might stimulate the lower and baser element.' In other words, screenwriters and directors had to develop strategies to convey emotional intensity without lowering the moral standards. Ironically, this constraint stimulated their creative imagination, and sometimes even endowed some films with erotic undertones. Moreover, screenwriters managed to get away with licentious content by adapting great literary works for the screen and by resorting to history. It was shrewd of them to adapt *Romeo and Juliet*, *Camille* (1936), *Anna Karenina* (1935), or to screen *Queen Christina* (1933) and *The Private Lives of Elizabeth and Essex* (1939). History and canonical literature garnered seals of approval under which such controversial topics as suicide, out-of-wedlock sex or birth became perfectly acceptable.

With the outbreak of World War II and Hollywood's participation in the war effort, romance faded into the background. However, it still provided a rich emotional knot with which to help get the patriotic message of Roosevelt's propaganda across; as Thomas Schatz explains, 'within days of Pearl Harbor, President Franklin Roosevelt commissioned Hollywood to "emotionalize" the conflict and to mobilize public awareness and support' (Schatz 1999: 131). Love stories were recast in terms of wartime separation and duty, the most famous result, of course, being *Casablanca* (1942). The last years of the war and the postwar period witnessed the emergence of film noir. Although the genre is mainly renowned for its incipient darkness, most films display great romantic love stories as well. Howard Hawks capitalized on the Humphrey Bogart-Lauren Bacall real life relationship in *To Have and Have Not* (1944), a romantic comedy with a war-related backdrop, and in *The Big Sleep*. Similarly, Otto Preminger's *Laura* stars Gene Tierney and Dana Andrews in a story that blends love and crime. Alfred Hitchcock also artfully combined crime and romance in his most famous films.

The 1950s were marked by the release of beautiful and breathtaking romantic dramas such as *Pandora and the Flying Dutchman* (1951) or *An Affair to Remember* (1957). However, some of them expressed a very critical, even cynical, view of American society: *Magnificent Obsession* (1954), *All that Heavens Allows* (1955), *In a Lonely Place* (1950), *The Barefoot Contessa* (1954), and *Some Came Running* (1958). This evolution foreshadowed the upcoming metamorphosis. The focus of attention began to shift from the formation of the couple to the exploration of the dark sides of relationships: domestic crises, repression of homosexuality and ensuing frustration in *Cat on a Hot Tin Roof* (1958), unhealthy desires of mature men for sensuous, provocative, young girls with strong paedophilic implications in *Baby Doll* (1956) or *Lolita* (1962), domestic violence and sexual abuse in *Peyton Place* (1957), or male prostitution in *Breakfast at Tiffany's* (1961). Without yet violating the provisions of the Hays Code, romances were beginning to adopt a more ironic and bitter tone. Classical romance seems to be intrinsically linked to the enforcement of the Code. It fell into disuse as more and

more studios chose to ignore it by the early 1960s, and in 1966 it was replaced by the MPAA's rating system. With the end of taboos, romance had to find new channels.

The end of the 1960s and the 1970s were not great decades for romance. Films such as *Bob and Carol and Ted and Alice* (1970) or *Shampoo* (1975) depict sexual freedom and attempted to discuss emotional feelings. *Carnal Knowledge* (1971) reveals concerns about the Vietnam War as well as sexual and emotional confusion. A feeling of disenchantment pervades *The Way We Were* (1973) and in *The Great Gatsby* (1974) a couple is driven apart by their diverging political views. Mike Nichols' *Who's Afraid of Virginia Woolf?* (1966) and *The Graduate* (1967) also stage acute conjugal crises.

The genre was progressively revived in its classical form in the 1980s. If some films were still provocative, just as many were marked by the return to moral order. In the same decade, films as distinct as *American Gigolo* (1980), *Victor Victoria* (1982), *Out of Africa* (1985), *9 1/2 Weeks* (1986), and *Fatal Attraction* (1987) were released. The 1990s confirmed that the classical Hollywood tradition of romantic comedies and romantic dramas was very much alive with titles such as *Pretty Woman* (1990), *Titanic* (1997), *The Bridges of Madison County* (1995), *Notting Hill* (1999), *Love Actually* (2003), and *Leap Year* (2009).

Cristelle Maury

Notes

1. To quote David Hume, 'whoever dreams of raptures and ecstasies beyond the honeymoon is a fool. Even romances themselves, with all their liberty of fiction, are obliged to drop their lovers the very day of their marriage' (Hume 1753: 215).
2. As Caryn James summed up, Powdermaker's *Hollywood, the Dream Factory* 'presented the unromantic picture of an industry churning out mass-produced dreams with all the cold efficiency of a Detroit auto plant' (James 1989).

References

Brill, L (1988) *The Hitchcock Romance: Love and Irony in Hitchcock's Films*, Princeton, NJ: Princeton University Press.

Hume D (1753) Essay XIX 'Of Polygamy and Divorces', *The Philosophical Works of David Hume: Essays and Treatises on Several Subjects*, vol.3, *Essays, Moral and Political*, London: A Millar.

James, C (1989) 'Critic's Notebook : Romanticizing Hollywood's Dream Factory', *The New York Times*, 7 November.

Musser, C (1990) *The Emergence of Cinema: the American Screen to 1907*, New York: Macmillan.

Powdermaker, H (1950) *Hollywood, the Dream Factory: An Anthropologist Looks at the Movie-Makers*, New York: Arno Press.

Schatz, T (1999) *Boom and Bust: American Cinema in the 1940s*, Berkeley, CA: University of California Press.

American Beauty

Studio/Distributor:
DreamWorks SKG

Director:
Sam Mendes

Producers:
Bruce Cohen
Dan Jinks

Screenwriter:
Alan Ball

Cinematographer:
Conrad Hall

Production Designer:
Naomi Shohan

Editors:
Tariq Anwar
Christopher Greenbury

Duration:
121 minutes

Cast:
Kevin Spacey
Annette Bening
Mena Suvari
Thora Burch
Wes Bentley

Year:
1999

Synopsis

Lester Burnham is 41 years old. He has everything but has nothing. He lives a comfortable life in the suburbs, but he hates his job, his marriage is passionless and he cannot connect with his teenage daughter Jane. Lester is reawakened when he becomes infatuated with Angela, the 15-year-old friend of his daughter. He sets about transforming his life, quitting his job, working out and revisiting the passions of his youth. Meanwhile, his wife has an affair and Jane becomes involved with Ricky, the strange boy-next-door who records everyday events on his video cam. The repressed tensions behind the doors of Robin Hood Trail are finally released and a murder is committed – but Lester finds redemption.

Critique

This film begins with a man masturbating in a shower. Subsequently, it dwells on that same man's attempts to woo a 15-year-old nymphet. Nonetheless, *American Beauty* is one of the most romantic films ever made.

American Beauty is 'romantic' in both senses of the word. Its dominating visual motif is the red rose (the title refers partly to a variety of the flower) and it is never used sardonically. The film is also broadly positive about the thought, conventional though it is, of finding fulfilment via romantic love. But *American Beauty* is also imbued with the Romantic spirit of Edmund Burke and William Blake. In the film, Ricky is an 'old soul', a teenager who feels and knows the truth that is hidden from others. His all-encompassing notion of 'beauty' recalls Burke's 'terror of the sublime' or Blake's cleansed 'doors of perception'. Ricky bursts with joy as he sees a plastic bag dance in the breeze because, like Burke, he is overwhelmed by 'this entire life behind things'.

In essence, *American Beauty* is a film that could have been made – all historical things being equal – by Henry David Thoreau. Lester characterizes Thoreau's famous maxim that 'the mass of men lead lives of quiet desperation'. In his own words, he is 'sedated' and this thought is carried into every element of the film. Spacey is superb in the lead role: a righteous bundle of anger, self-satisfaction and passion. The *mise-en-scène* is also highly crafted, fearfully symmetrical for the most part but becoming more fluid as the characters begin to free themselves from their physical and psychological trappings. Further plaudits should go also to the composer Thomas Newman. The score to *American Beauty* is part scored/part found and Newman's spacious piano theme implies both the melancholy that pervades the lives of the residents of Robin Hood Trail and the ultimate promise of salvation.

Of course, the film is finally, and properly, attributed to Sam Mendes and Alan Ball. It signalled Mendes' interest in themes of identity and disparities between public and private persona. *American Beauty* also demonstrated Ball's zeal for exploring the murky unconscious of suburbia (he would carry this idea through to his subsequent scripts for HBO's *Six Feet Under* [2001-05]).

Pauline Kael saw the film as 'a con', an airy piece of fluff aimed at the 'educated liberals' who had formerly patronized the art houses. But *American Beauty* was unquestionably a thoughtful and challenging moment of cinema, which scarcely felt like a DreamWorks production. The story darted around, Angela disappeared entirely for large sections, the introduction was reprised at 82 minutes and the film defied sure fixing by genre.

In many respects, *American Beauty* felt like a film of the moment. There is nothing like the turning of a century to inspire self-reflection on the things that really matter in life, such as the shallowness of our material dreams and our psycho-sexual relationships with ourselves and others. But *American Beauty* also dealt with some eternal themes. The ending was, perhaps, conservative in its suggestion that true happiness resides in family life, but it is the film's general sense of yearning that endures in the memory. In their individual ways, Lester, Angela, Colonel Fitts and the other characters are all caught in a desperate quest to find themselves.

This is the stuff of life.

Laurie N Ede

Annie Hall

Studio/Distributor:
Rollins-Joffe Productions
United Artists

Director:
Woody Allen

Producers:
Charles H Joffe
Jack Rollins

Screenwriters:
Woody Allen
Marshall Brickman

Cinematographer:
Gordon Willis

Art Director:
Mel Bourne

Editors:
Wendy Greene Bricmont
Ralph Rosenblum

Duration:
89 minutes

Synopsis

Related through a fractured narrative of flashbacks, fantasy sequences and asides to camera, lovelorn New Yorker Alvy Singer reflects on the trials and tribulations of his entangled romantic history. Although a successful comic and writer, his personal life is littered with a trail of divorces and failed relationships. But when Alvy meets Annie Hall, there is a brief glimmer of hope that he may have finally met his true love. He encourages her self-education and singing hobbies, even introducing her to the dubious pleasures of psychoanalysis. However, Annie gradually outgrows the increasingly-insecure and jealous Alvy. Resisting his influence, she begins to develop her own ambitions and interests. When she eventually relocates to Los Angles to pursue a singing career, a desperate Alvy follows her, making one final grand gesture in an attempt to win her back.

Critique

Woody Allen's seventh feature film as director, it is reported that *Annie Hall* was originally conceived as comedy murder-mystery. The screenplay was initially entitled 'Anhedonia', a condition described as the inability to feel joy. Yet when Allen found himself in the editing room, he decided that the romantic sub-plot following the two protagonists was the more engaging aspect of the story. He subsequently re-cut most of the film, focusing on the relationship between Alvy and Annie. Allen later recycled his first idea, directing and co-writing *Manhattan Murder Mystery* in 1993, again co-starring Diane Keaton.

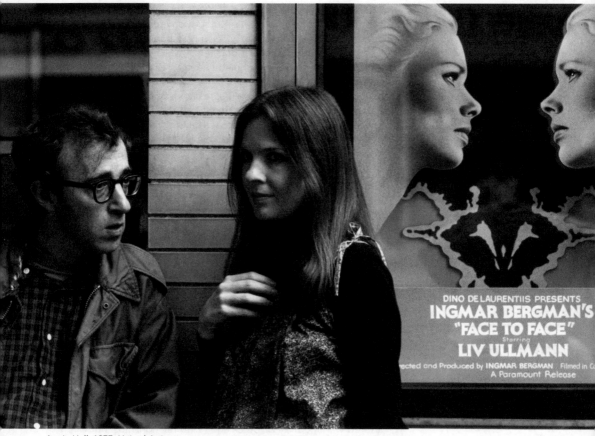

Annie Hall, 1977, United Artists.

Cast:
Woody Allen
Diane Keaton
Carol Kane
Paul Simon

Year:
1977

Receiving wide critical adulation, *Annie Hall* proved to be a turning point in Allen's career. In the same year as *Star Wars* (1977), the film won Academy Awards for best director, screenplay and picture, although Allen shunned the ceremony because it clashed with his regular stint playing clarinet with his band. Up until this time, he was better known for his Marx Brothers- and Chaplin-inspired comedies. As critic Neil Sinyard observes, *Annie Hall* marks a shift from 'cine-pastiche to self-revelation'.

Although Allen opined that the film was, 'hardly my 8½ (1963), more like my 2½", it sees him move to a distinctly middle-class, intellectual perspective. The references to Groucho Marx are still present but Allen reveals a broader interest in cinema and literature beyond comedy, including nods to Federico Fellini and Marcel Ophüls. *Annie Hall* has been compared to *Scenes from a Marriage* (1973), directed by Allen's cinematic inspiration, Ingmar Bergman. Revealing Allen's scholarly and creative leanings, Marshall McLuhan and Truman Capote also make humorous cameo appearances. In one fantasy sequence, Allen uses animation to reference *Snow White and the Seven*

Dwarfs (1937), amusingly juxtaposing Disney-like characters with more adult themes. As well as being indicative of a 1960s' underground comix influence, the scene also anticipates the current crop of television animated comedies.

Although Allen has subsequently denied it, at the time of its release *Annie Hall* was his most autobiographical work to date. He was once romantically involved with Diane Keaton, whose actual surname is Hall. Like Alvy, Allen started out as a comedian and writer, and much of Alvy's material makes use of gags from Allen's stand-up act. And like Alvy, Allen had previously been divorced twice. The intertextuality and autobiographical content effectively coalesce during one sequence where an irritated Alvy waits for Annie outside a cinema. Hassled for his autograph by two Italian-American passers-by, Alvy sarcastically quips that he is 'standing with the cast of *The Godfather*'. Diane Keaton had previously starred in *The Godfather* (1972), and was in a relationship with her co-star, Al Pacino. The two films even share the same cinematographer, Gordon Willis.

Annie Hall's success proved to be influential in Hollywood, encouraging several further romantic comedies, such as *When Harry Met Sally* (1989), *LA Story* (1991) and *Meet the Parents* (2000). Annie's androgynous fashion taste, apparently Keaton's own, also become very popular in the late 1970s. In addition, the film is notable for early screen appearances from Sigourney Weaver, Jeff Goldblum and Christopher Walken. Yet, unlike those later entries, *Annie Hall* is not a typical romantic comedy. Tellingly, Alvy never tells Annie that he loves her, instead stealthily and comically avoiding the subject. The film successfully deconstructs the genre, revealing the artifice behind its glib sentimentality. *Annie Hall* constantly reminds the audience that outside of the movies 'love fades'. Writing a play based on his relationship with Annie, Alvy constructs a happy ending. As he comments to camera during an earlier scene, 'Boy, if only life were like this'.

John Caro

Beauty and the Beast

Studio/Distributor:
Walt Disney Pictures
Silver Screen Partners IV

Directors:
Gary Trousdale
Kirk Wise

Synopsis

Belle lives a quiet, bookish existence in a small French town, but dreams of a more exciting life elsewhere. Belle continually rejects the romantic overtures of Gaston, an arrogant local hunter. One evening, Belle's frail father Maurice, an inventor, travels through a nearby forest on the way to a fair and seeks shelter in a castle during a storm. The castle is occupied by the Beast, who takes Maurice prisoner for trespassing. When Belle eventually locates her father, the Beast agrees to let him go in exchange for keeping Belle instead. Belle soon discovers that the castle is enchanted, and though she initially sees only anger in the Beast, she gradually discovers that there is

Producers:

Don Hahn

Sarah McArthur

Howard Ashman

Screenwriters:

Linda Woolverton (animation screenplay)

Roger Allers (story supervisor)

Art Director:

Brian McEntree

Editor:

John Carnochan

Duration:

84 minutes (theatrical)

91 minutes (2002 IMAX theatrical release and home video)

Cast:

Paige O'Hara

Robby Benson

Richard White

Jerry Orbach

Angela Lansbury

David Ogden Stiers

Year:

1991

more to the creature than meets the eye. Soon, Gaston and other villagers begin a journey towards the castle in an effort to both release Belle and kill the Beast.

Critique

Beauty and the Beast was the central peg in what is commonly known as the 'Disney Renaissance': a creative return to form for the animation company which is roughly considered to have lasted from 1989's *The Little Mermaid* through to 1999's *Tarzan* (though *Waking Sleeping Beauty*, a 2010 documentary by *Beauty*'s producer Don Hahn, argues that Disney's true renaissance was from 1984 to 1994, when Michael Eisner, Frank Wells and Jeffrey Katzenberg were heading the company). Walt Disney himself had twice attempted to adapt *Beauty and the Beast* into a feature in the 1930s and the 1950s, but could never find the right approach. The story is based on the original fairytale by Jeanne-Marie Le Prince de Beaumont, who was uncredited in the English versions of the released film (but credited in the French print), and the film is also heavily influenced by *La Belle et La Bête*, the 1946 Jean Cocteau-directed live-action feature. Disney's character of Gaston is another version of Avenant, a character that was created for the Cocteau film. *Beauty and the Beast* was the first Disney-animated film to be developed from a written script instead of storyboards; it was also the first to incorporate fully-rendered and textured computer-generated imagery and 3D moving backgrounds with the traditional cel animation. *Beauty and the Beast* is also notable for its incorporation of the Pixar-developed CAPS (Computer Animation Production System) system, a digital scanning, ink, paint, animation and compositing process (most recognizable in the film's ballroom dance sequence); Disney had introduced the process into production in 1990's *The Rescuers Down Under*.

Beauty's opening prologue (narrated by David Ogden Stiers) reveals the origins of the Beast and the enchanted castle through stained-glass mirrors, telling an extraordinary story in itself, and setting up the 'tale as old as time'. Every element of *Beauty and the Beast* is impeccably conceived and delivered, even John Alvin's theatrical poster, a beautiful, sparse image of Belle and the Beast dancing in candlelight and shadow. 'Isn't it amazing' Belle sings in her opening song, evoking the feeling she receives from the fairytales she loves reading about in books; the film's expert visual aesthetic and dramatization evoke a similar feeling throughout. There are conscious references to Judy Garland's Dorothy from *The Wizard of Oz* (1939) and Julie Andrews' Maria from *The Sound of Music* (1965) in Belle's characterization and appearance, and the performances, particularly Paige O'Hara's Belle and Robby Benson's Beast, are as affecting and meaningful as any live-action award-winning performances you might see from an old-fashioned Hollywood romance. Benson is

both terrifying and sensitive when the script calls for it, and Jerry Orbach is also memorable, adopting a French accent for Lumière, an enchanted candle. There is a genuine feeling of intelligent strength surrounding Belle, in contrast to many previous Disney heroines.

Alan Menken and Howard Ashman wrote the music and songs for the production, and the film is dedicated to Ashman, who passed away eight months prior to the theatrical release. Charles Aznavour recorded a version of the theme song (originally sung by Celine Dion and Peabo Bryson) for the French release of the film, and martial-arts star Jackie Chan provided both the speaking and singing voices for the Beast for the original Chinese theatrical release. A stage version of the film opened on Broadway in New York in 1994, and had over five thousand performances before it closed in 2007. The film was restored and re-released in 2002 for IMAX and home video (it included an initially-abandoned five-minute musical sequence), and a 3D re-release is set for 2011. *Beauty and the Beast* was the only animated film ever to be nominated for the Academy Award for Best Picture, until Pixar's *Up* (2009).

Michael S Duffy

Broken Blossoms

Studio/Distributor:
DW Griffith Productions
Paramount Pictures
United Artists

Director:
DW Griffith

Producer:
DW Griffith

Screenwriter:
DW Griffith

Cinematographer:
GW Bitzer

Art Director:
Charles Baker (uncredited)

Editor:
James Smith (uncredited)

Synopsis

Cheng Huan is an idealistic Chinese missionary eager to spread Buddha's 'gentle message' abroad, but he soon becomes disillusioned and worn down by the grim realities of London's Limehouse slum district, becoming an opium user and settling for the life of a shopkeeper. However, his better nature is reinvigorated by a teenage girl whom he admires from afar: Lucy, the downtrodden daughter of an alcoholic and abusive prize-fighter known as Battling Burrows. When she collapses one day outside the store after a particularly severe beating, Cheng takes in Lucy so that she can recover. However, word gets back to the boxer about her whereabouts and, enraged that his daughter is associating with someone of another race and religion, Burrows forcibly retrieves Lucy while Cheng is out buying flowers for her. Back at the Burrows residence, Lucy is brutally beaten by her father. Cheng rushes to their home, only to find that Lucy has died from her injuries. After shooting Battling Burrows dead in revenge, Cheng takes Lucy's body back to his store where, after performing a Buddhist ceremony, he commits suicide.

Critique

Despite reputedly being Griffith's personal favourite of his own films (Allen 1999: 168), *Broken Blossoms* in many

Duration:

90 minutes

Cast:

Lillian Gish
Richard Barthelmess
Donald Crisp
Arthur Howard
Edward Peil Sr
George Beranger
Norman Selby

Year:

1919

respects seems quite a significant departure from the director's typical style. The film lacks the action and fast parallel editing of much of Griffith's work and, indeed, can be accurately characterized as a 'mood' piece, yet it also exemplifies some of his deepest preoccupations, for example nostalgia for a fading and even bygone age. Simmon has suggested that Griffith never really made the 'leap into the post-1918 world, of either art or a wider culture' (1993: 24) and *Broken Blossoms* certainly testifies to such a backward-looking sensibility. On the other hand, however, Schickel describes the work as 'the first memorable European film made by an American', arguing quite persuasively that 'more than any other Griffith film, its force derives from its visual rather than its dramatic qualities', dominated by a sense of place rather than pace (1984: 389–95).

The film's success may indeed be attributed to this often-unlikely combination of qualities. It marks the return of certain motifs from the Biograph shorts, often transformed into a self-conscious nostalgia which would also feature prominently in Griffith's subsequent rural-life cycle of films (Simmon 1993: 24–5). Here, however, the atavistic subject-matter of the waif in peril is wedded to a very different visual style. Griffith found inspiration in George Baker's watercolour paintings of Limehouse, but the dreamlike atmospheric ambience (as in the foggy exteriors and the smoky opium den) owes much to the continental-European style provided by the assistant camerman Hendrik Sartov, who specialized in soft-focus lighting and photography (Cook 1981: 101). The effect is enhanced by the use of soft pastel tints, which serve a more interesting purpose than those employed in *Intolerance* (1916), to distinguish the four storylines, suggesting among other things Lucy's claustrophobic domestic prison and the social separation of people from different walks of life. This overall visual style would, in turn, influence a number of European directors, most notably Louis Delluc in France (Barry 1940: 29) as well as the German film-makers associated with *Kammerspielfilm* (Cook 1981: 101).

As a tragic love story, the film is replete with Griffith's personal predilections and nostalgic Victorian sensibilities. In one of the most obvious changes from the source material, a short story from Thomas Burke's *Limehouse Nights* (1916), the director de-emphasized the original undertones of sexuality from the relationship between Lucy Burrows and Cheng Huan, excising entirely a kiss for example. In concert with Gish, he also added the hyperbolic sentimental motif of Lucy's contrived smile (using two fingers to upturn her mouth), an attempt to appease her abusive father. At the same time, these touches are counterpointed in many places by an uncompromising starkness, as in the almost documentary-like realism of scenes involving Battling Burrows and the pessimism of an ending during which all three of the main characters meet violent deaths.

Perhaps still stung by the controversy over racism in *The Birth of a Nation* (1915), Griffith made further changes to the original story's portrayal of Cheng Huan, all designed to make him a more sympathetic and less stereotypical figure. These included giving the character the back story as an idealistic Buddhist missionary as well as both softening and 'American-izing' the nature of his revenge so that Burrows is killed by gunshot in a direct confrontation rather than the more cold-blooded and premeditated planting of a snake in his bed. Such a depiction, although not without its own problems, may suggest the extent to which the racism of *Birth* derived from the blind spot of Griffith's Southern background and his father's role in the Civil War.

David Garland

References

Allen, M (1999) '*Broken Blossoms*', in P Cook & M Bernink (eds) *The Cinema Book* (2nd edition), London: BFI Publishing, pp. 167–68.

Barry, I (1940) *DW Griffith: American Film Master*, New York: The Museum of Modern Art.

Cook, DA (1981) *A History of Narrative Film*, New York: WW Norton & Company.

Schickel, R (1984) *DW Griffith: An American Life*, New York: Simon and Schuster.

Simmon, S (1993) *The Films of DW Griffith*, Cambridge: Cambridge University Press.

Love Story

Studio/Distributor:
Paramount Pictures

Director:
Arthur Hiller

Producers:
David Golden
Howard G Minsky

Screenwriter:
Erich Segal

Cinematographer:
Richard C Kratina

Art Director:
Robert Gundlach

Synopsis

Set in the late 1960s and partly amid the walkways of Harvard University's scenic campus – a time and place typified by opportunity and the exuberance of youth – *Love Story* recounts a tale of kindred spirits, soul mates, and the devasta-tion of loss. Instigated in flashback form, it traces the story of Oliver Barrett IV and seemingly-opposite Jennifer Cavalleri as they meet and begin a quarrelsome friendship while simultaneously falling deeply and irrevocably in love. It does not take long for Oliver – a 'preppy' soon-to-be lawyer from a prestigious Massachusetts family – and Jennifer – a music scholar of modest, Catholic lineage – to submit themselves to their hearts' true desire, and embark on the journey of life together. Yet, they soon come to realize the sacrifices they must make in order to be as one in a paradoxical world of erstwhile rules, social status, and the liberalism of this defin-ing decade. Persevering through countless familial, financial and emotional struggles, they finally attain the life of which they had always dreamed. However, the cruel hand of fate

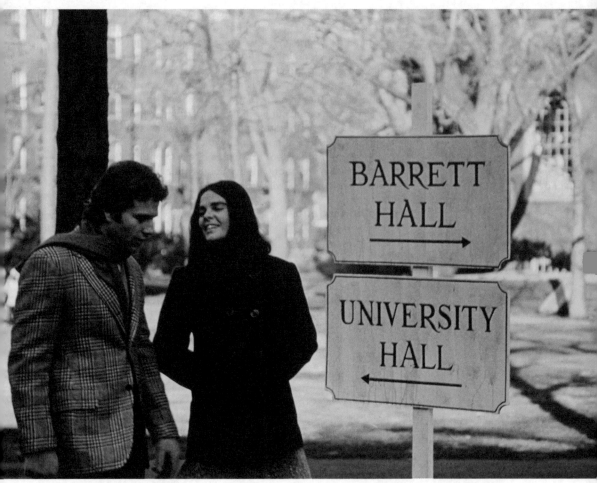

Love Story, 1970, Paramount.

Music:

Francis Lai

Editor:

Robert C Jones

Duration:

99 minutes

Cast:

Ali MacGraw
Ryan O' Neal
John Marley
Ray Milland

Year:

1970

puts their relationship to its ultimate test and, in turn, grounds this union of souls in the greatest love that life can offer.

Critique

In its simplest guise, *Love Story* portrays the universal boy-meets-girl narrative: a classical Hollywood attempt at infusing an entertaining story with its trademark level of 'tragi-drama' and lachrymal sentimentality. Indeed, a tragic love story it is. Yet, upon inspection, one realizes that *Love Story*'s delicacy – its conveyance of an age-old tale with filmic grace and aesthetic subtlety – has been somewhat overlooked in the analytical discussion of the romance genre. In some ways, it has been cinematically recognized as a defining moment in the history of the romantic tragedy: its most famous utterance – 'love means never having to say

you're sorry' – has been quoted, manipulated, and parodied the world over. Yet, the scant amount of scholarly reading or critical insight into the film seem to suggest that it has been shackled solely under the rubric of narrative-based Hollywood 'chick flick'. As impressive as Hiller and Segal's ability to instil the audience with a deep sense of character affiliation is, the film triumphs when viewed beyond the surface: what awaits is a rich amalgamation of photographic splendour, careful deployment of camera movement, and an intricate application of sound.

Arthur Hiller has gained a reputation as the Hollywood 'nice guy'. Although this is largely due to his standing as a fair and empathetic director while on set, it is also indicative of Hiller's attitudes towards both the film-making process and the end result. Never has his belief that film is a 'team effort' been more apparent than it is in *Love Story*. Although Segal's screenplay depicts the couple's love and life in a heart-rending manner, the narrative abstains from drowning itself in the exaggerated, and often meaningless, sentimentality that is so rife in the classical American love movie. However, while this is to be commended, it is the film's accumulation and simultaneous utilization of *several* aspects of film-making that ensure its ability to tell a love story, while retaining an admirable, and at times enthralling, level of filmic artistry.

Perhaps most famously, composer Francis Lai shadows the film with a sensitive and ageless score; the film's theme tune serving as a warm leitmotif throughout. The sound-image arrangement is particularly striking when Lai's reorchestrated tune experiments with diegetic street sounds, and thus encapsulates the sequence's events impeccably. Although the score embalms certain moments of the film, it is usually divulged in snippets, and therefore stands as a perfect example of the meticulousness of both the film's direction and editing. Macgraw and O'Neal share an undeniable chemistry, and interestingly, it is both when the couple are physically off-screen – but present due to the deployment of asynchronous sound – and during the film's quietest moments that this excels. As minimalist as Segal's dialogue is at certain times, it is repeatedly complemented by Hiller refraining from smothering their intimacy with an over-indulgent camera. Instead, Hiller conveys an enduring respect for his characters: the camera stays gently immobile or distant at tender moments, skilfully handheld at times of debate, and appears quick and lightweight on more playful occasions. This approach is further flattered by Robert C Jones's tact in cutting scenes at precisely the right moment.

And it is just that – timing – which is at the core of every aspect of *Love Story*. Utilizing every season to the film's aesthetic advantage, and concurrently depicting the beauty of the couple's years and journey together, Hiller's film is both perfectly timed *and* timeless. The genre in its contemporary

state would not look so dismal if *Love Story* came to stand as *the* benchmark for the Hollywood romance, and was subsequently granted the scholarly and investigative respect it deserves.

Abigail Keating

Manhattan

Studio/Distributor:
United Artists

Director:
Woody Allen

Producers:
Charles H Joffe
Jack Rollins

Screenwriters:
Woody Allen
Marshall Brickman

Cinematographer:
Gordon Willis

Production Designer:
Mel Bourne

Editor:
Susan E Morse

Duration:
96 minutes

Cast:
Woody Allen
Diane Keaton
Michael Murphy
Mariel Hemmingway
Meryl Streep

Year:
1979

Synopsis

Issac Davis is a 42-year-old TV scriptwriter who lives in Manhattan. He is in the grip of an early mid-life crisis. His marriage ended acrimoniously and he is now dating a 17-year-old girl, Tracy. Ike quits his job, which he hates, in order to write a book. His former wife has also written a volume, a scandalous account of her marriage to Ike. Shortly, Ike embarks on a relationship with Mary, a neurotic journalist who has been dating his married friend, and serial philanderer, Yale. Ike ends his relationship with Tracy, but Mary returns to Yale. Ike attempts to win Tracy back.

Critique

Towards the end of *Manhattan*, Ike (Woody Allen) reflects that his book-in-progress should be about 'people who create neurotic problems for themselves as a means of avoiding real issues'. On the face of it, this quiet comedy indulges the petty hang-ups of a group of people who have nothing to worry about. But the lives of the privileged New Yorkers end up shining light on universal themes of faith, self-knowledge and mortality. *Manhattan* is ultimately a film about trust and the things that we *can* trust to endure within an unstable world.

The intellectual terrain of the film is established in a four-minute prologue, wherein Ike struggles to write the introduction for his book. His mental trials are presented as a voiceover, set against a montage of images of New York. Ike's monologue provides four different views of the city and his relationship with it, ranging from the romantic to the sociological to the purely narcissistic. The truth, insofar as it can be ascertained, turns out to be a combination of the four accounts, but it is the monochromatic city imagery that stays in the viewer's mind for the rest of the film. *Manhattan* was shot entirely in respectful black and white.

The shots of the swanky hotels, boutiques and galleries (and a few street scenes) serve as a counterpoint to the fragile characters and their vainly-solipsistic search for certainty. *Manhattan* dwells in particular on the futility of culture and knowledge as sources of meaning. The characters all lead cultured lives (as viewers, we yearn for *Elaine's* restaurant and the wonderful book shops), but they find

no succour in them. Allen portrays culture as a political terrain, a resource which intellectuals use to exert power over others and thus feel, fleetingly, better about themselves. This tendency is exemplified by Yale and Mary's 'Academy of the Over-Rated': a nauseating mental game whereby stellar artists and intellectuals (including Mahler, Jung and Bergman) are ridiculed, to the affected delight of the pretentious lovers. The film's view of high culture is also demonstrated by the delightful Gallery scene, in which Mary expresses her rarefied admiration for a piece of modern sculpture: a plain metal cube which she deems to have 'marvellous negative capability'.

Manhattan is also concerned with the limitations of knowledge. Ike is clearly right when he asserts that 'nothing worth knowing can be understood by the mind'. The film extols the realm of the imagination but it also stresses the need for self-knowledge. Psychotherapy may be of use here, providing the practitioner is competent and the patient is ready to accept responsibility (in any event, one cannot say much for Mary's therapist, who pesters her for dates and overdoses on drugs). *Manhattan* suggests that traditional bookish knowledge is a non-starter for the modern seeker of the truth. Damningly, the college professor Yale is a deluded charmer who is unable to resist the compensatory pleasures of women and a second-hand Porsche.

In the end, *Manhattan* seems to perceive two true paths to enlightenment. Innocence, as embodied in the precocious – and veracious – figure of Tracy, is to be treasured. Moreover, the film asserts the need for us to reconnect with the built world. The buildings of the Upper East Side may be the playgrounds of the rich, but they also embody dreams and shared memories. By some glorious fluke, they continue to resound to the tunes of George Gershwin. Ike becomes the voice of the film as he entreats us to hear *Rhapsody in Blue* playing on the breeze.

Laurie N Ede

Sleepless in Seattle

Studio/Distributor:
Tristar Pictures

Director:
Nora Ephron

Synopsis

Sam is a recently-widowed father. His son Jonah, worried about his father, calls into a radio-phone in and persuades his father to speak on air about how much he misses his wife. This leads to thousands of women writing love letters to Sam. One such woman is Annie. Although Annie is engaged she falls for Sam's sensitivity. When Jonah reads her letter he decides she is the perfect partner for his father. He orchestrates a meeting between the two at the top of the Empire State Building on Valentine's Day. Annie travels to New York,

Producer:
Gary Foster

Screenwriters:
Nora Ephron
David S Ward
Jeff Arch

Cinematographer:
Sven Nykvist

Art Director:
Charley Beal

Editor:
Robert Reitano

Duration:
105 minutes

Cast:
Tom Hanks
Meg Ryan
Rita Wilson
Bill Pullman

Year:
1993

having broken off her engagement, but Sam refuses to go. Jonah then decides to travel alone, forcing Sam to follow after him. As a result, Sam and Annie meet and the film concludes in the inevitable Hollywood fashion.

Critique

The worldwide success of *Sleepless in Seattle*, grossing $227 million at the international box office, demonstrated there was money to be made from 'chick flicks'. Not only was the film hugely successful but it also cemented its stars, Meg Ryan and Tom Hanks, as box-office leaders. Despite a predictable, ordinary, and at times insipid plot, the film evidently provided women audiences with what they wanted.

Nora Ephron has written and directed a number of successful films for, or about women. However *Sleepless in Seattle* differs from films directed or written by Ephron such as *Silkwood* (1983), *When Harry Met Sally* (1989) or, more recently, *Julie and Julia* (2009). These examples display well-rounded, interesting women. Even Ephron's 'follow-up' to *Sleepless in Seattle*, *You've Got Mail* (1998), placed Meg Ryan in the role of a determined and headstrong bookstore owner. *Sleepless in Seattle*, however, provides a rather embarrassing portrait of womanhood. Annie is so consumed by romantic fantasy that she is prepared, at the drop of a hat, to chase after a man she has heard on the radio, forsaking her reliable, if dull, fiancé in the process. What is worse, Annie's behaviour is portrayed by the film as romantic and kooky rather than just plain crazy.

The sense of grand romance is played out through references to *An Affair to Remember* (1957). Annie watches the film with a friend and her decision to meet Sam at the top of the Empire State Building echoes the plot. Annie's relationship to the film and its romanticism is used as a device to forgive her behaviour. Unfortunately *Sleepless in Seattle* lacks the grandeur and class of *An Affair to Remember*. Annie seems to have very little substance or personality and rather than providing an affecting romance, the film functions as a vehicle to make women audiences fall for the sensitive single father.

The role of the single father within the film is crucial. The plot device in which Jonah effectively chooses his father's new suitor references a Hollywood convention that is demonstrated in films such as *The Courtship of Eddie's Father* (1963) or *The Sound of Music* (1965). The romantic relationship between Sam and Annie is somewhat of a nonentity. The film concludes with them having spoken barely a few words to each other and never having shared a kiss; instead, they walk off hand-in-hand grinning at each other. Romance, in this respect, is linked to the chaste reconciliation of a pseudo-nuclear family. Sam becomes attractive to Annie because he is a sensitive and nurturing dad who is in touch with his

emotions. The eventual romantic union allows the previously-broken nuclear family to be restored. The hand-holding conclusion separates parental romance from sex and allows Annie and Sam to remain 'innocent' characters. The way in which Annie and Sam seem to fall in love without knowing each other allows this film to promote a fantasized, idealized romance of destiny, as well as an all-too-easy reconciliation of the damaged family. This film for women audiences denies any likeable female characters with which to identify and promises that romance, and a family, are easy to come by and destined to happen.

Claire Jenkins

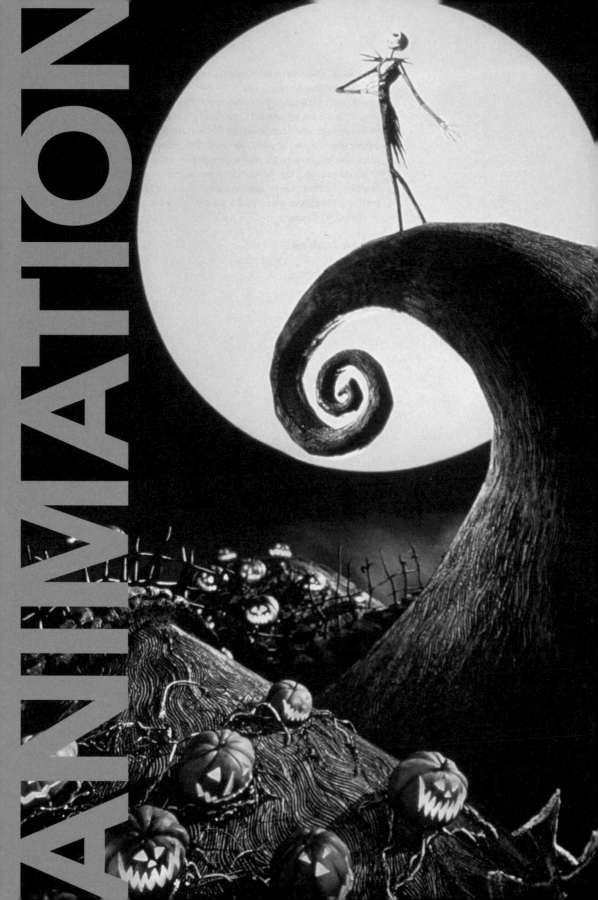

The arrival of the first computer-animated feature film in John Lasseter's *Toy Story* (1995) was not only the culmination of two decades of experimentation in the CGI field but it also embodied all that critics commonly understood American narrative-driven animation to be. That through its intense relationship with organized commerce, (more than in *any* European or Third World context) Hollywood animators have refined formal techniques that foreground rationalization, accessibility, consistency, anthropomorphism (ascribing human characteristics to either animals or inanimate objects) and an ongoing love affair with spectacle. Yet, curiously, US animation has displayed both nostalgic *and* progressive elements due to its reflexive nature. It has constantly reaffirmed and assessed itself as a medium both formally and thematically since the days of Otto Messmer's *Felix the Cat* series (1919–1928) and through to television examples such as *The Simpsons* (1989–Present), consistently highlighting animation's own distance from 'live action' as well as its ties to an historical lineage.

Progression is permeable through Hollywood's adherence to an ethos of technical progress. This is no more apparent than the culture of advancement propagated by the Walt Disney studios which has informed some of the most notable breakthroughs commonly associated with the medium. Via Disney's incredibly efficient Fordist model of production, 'sound' (1929's *Steamboat Willie*), 'colour' (1932's *Flowers and Trees*), 'depth', (1936's *The Old Mill*), 'personality animation' (1933's *The Three Little Pigs*) and 'feature-length' films (1937's *Snow White and the Seven Dwarfs*) all emerged as landmarks. But they were, in truth, cost-efficient extensions of earlier, abandoned progressions made by European artists working inside *and* outside the American system, such as The Fleischer Brothers and Lotte Reiniger, and, here, willed into being by overseer Disney. Thus, by the 1930s, Disney had become an animation standard within the industry. Albeit a standard enforced by one of the most ruthlessly-adaptable multi-media business models that has seen the company now embedded within popular American culture. For many people, US animation simply *is* Disney and the values of patriarchal, white, middle-class America that are permeable as subtext throughout his oeuvre are just as indelible.

However, to assume that American animation is simply *all* about hyperrealist form derived from Romantic/Classical painting styles is an error. Indeed, Disney's willingness to challenge his own methods in experiments with 'limited' (as opposed to 'full') animation (1941's *The Reluctant Dragon*), dalliances with high art sensibilities in *Fantasia* (1940) and *Destino* (1945) illuminate an historical narrative that needs to be continually nuanced and assessed. Indeed, up to the successes of the 1930's *Silly Symphonies* the cartoons of *all* the various satellite animation studios attached to parent cinema production companies, from Van Buren to Walter Lantz, sought greater articulacy alongside a creative free-form embrace of absurdism *and* surrealism. And this impulse extended as an ongoing narrative into the currency of the seven-minute cinema bill-fillers which allowed directors like Frank Tashlin (see *Porky Pig's Feat* for Warner Brothers in 1939 and 1940's *Fox and Crow* series for Columbia) and Chuck Jones (*The Dover Boys* in 1943 and *Duck Amuck*, again for Warners in 1953) to offer retorts to the restrictions undeniably imposed by Disney's dominance.

Left: *The Nightmare Before Christmas*, 1993, Touchstone/Burton/Di Novi.

Yet understandably within commercial settings Hollywood's relationship with experimentation has always been fractured. As the 1940s turned into the 1950s, and under the creative guidance of ex-Disney animator John Hubley, a fusion of contemporary graphic design, European art traditions and limited animation arrived with the inception of 'United Productions of America'. In today's climate, UPA now appears all but forgotten, yet the studio utilized restricted movement, jettisoned design uniformity, abandoned chase narratives and (initially) denied the trope of recurring characters. Based at Columbia, the studio redefined mainstream animation itself and pointed the way towards today's forms through shorts like Bob Cannon's *Gerald McBoing-Boing* (1951) and Hubley's *Rooty-Toot-Toot* (1952). After several prolific years they succumbed to the pressures of expediency by embracing advertising, championing the recurring character of *Mr. Magoo* (first introduced in 1949), and acquiescing to the demands of television. UPA's flat, sparse style became incorporated all too quickly and can be seen today as an omnipresent aesthetic, evident within the postmodern quotations of John Kricfalusi's *The Ren and Stimpy Show* (MTV, 1991–1992) and the CGI cinema approximations of *Madagascar* (2005). It appears that the lasting formal impression of contemporary US animation may not in fact reside with the painterly Disney but more with UPA.

'Somewhere between here and there': Summating Hollywood animation

Hollywood animation has suffered from a perennial lack of self-esteem as the 'lowly sibling' with its origins located in the arena of vaudeville and newspaper strip forms, especially when compared to cinema's perceived loftier status as extended from a theatrical/literary pedigree. Indeed Hollywood's self-esteem has been retrieved in recent years, after the misconceptions enforced by the sale of cinema cartoons to children's schedulers on US television in the 1950s and compounded by the weight of recycled, industrial animation exemplified by TV producers like Hanna and Barbera. This is in part due to the virtuosity of Robert Zemeckis' *Who Framed Roger Rabbit* (1988), which not only revitalized a moribund Disney corporation in the late 1980s but also, through a reframing of established (brand) characters for later films like *Space Jam* (1996), centralized history through nostalgia and corporate ownership. Animation received justification once more but, in one swoop, contemporarized, innovative voices like Hubley, Ralph Bakshi, Messmer, The Fleischers, were reduced to being marginal historical players.

Today progression and nostalgia prevail. Pixar's successes have prompted a market response that has inadvertently shaped a return to Classical studio practice, with Paramount, Fox, Warner Bros, MGM and Sony now *all* involved in producing feature-length animations of varying quality. And it is readily apparent that it is the adaptive capabilities of capitalism that will facilitate survival in a hyper-fragmented future landscape of multi-media web animations, computer games and virals. So despite occasional rare, oppositional works like *Snow White* (1933), *Heavy Traffic* (1973), *Little Rural Riding Hood* (1949) and *The Iron Giant* (1999), today it appears that mainstream animation is governed by an innate conservatism. As recent efforts such as *Monsters vs Aliens* (2009) and *The Princess and the Frog* (2010) confirm that, despite the window dressing of opulence, race and gender twists, form remains a primary concern and American animation still, ultimately, tells predominantly white (male) stories.

Van Norris

Fantasia

Studio/Distributor:
Disney
RKO

Director:
Ben Sharpsteen

Producer:
Walt Disney

Story Direction:
Joe Grant
Dick Huemer

Cinematographer:
James Wong Howe

Editor:
John L Carnochan

Duration:
125 minutes

Genre:
Musical/Fantasy

Cast:
Leopold Stokowski
Deems Taylor

Year:
1940

Synopsis

Fantasia is made up of eight separate, self-contained narratives that are linked together by tinted, silhouetted 'live action' footage of the composer Leopold Stokowski conducting an orchestra. Each narrative presents a series of animated literalizations of classical music, mimetically organized by Walt Disney and his team. Each story is tied to a specific piece and relates accordingly in terms of pace, tone and rhythm. Attached to Bach's *Toccata and Fugue in D Minor* is an abstract, non-figurative procession of images suggesting a journey between Heaven and Earth and glimpses of the unknowable 'Infinite'. *Nutcracker Suite* offers a lighter, humorous segment set within a forest. *The Rite of Spring*, in sombre fashion, condenses the beginnings of the Earth and the collapse of the dinosaur age. *Intermission/Meet the Soundtrack* offers a formal, abstract play with sound and image correlation overseen by Stokowski. *The Pastoral Symphony* presents an uneasy balance between sensuality and Disney's more chaste sensibilities, set within a bacchanalian narrative. *Dance of the Hours* offers traditional personality animation of a performance by animals located within an abstract performative space. And the last story, *Night on Bald Mountain/Ave Maria*, details a polarization of good and evil played out over one night overshadowing a small town.

Critique

Retrospectively it is easy to see why Walt Disney's portmanteau feature-length animation *Fantasia* is one of the key films within American animation history. It is a high-water mark in terms of artistic ambition within the studio. One that is even more remarkable when only a few scant years earlier, previous to the release of *Snow White and the Seven Dwarfs* (1937), Disney himself was unsure whether the animated feature film was an artefact that could be accepted by mainstream audiences. *Fantasia* is exploratory, conciliatory, and may well be an indicator of the hubris of its creator but it is, in many ways, all about 'potential'.

Since the original 1940 release it has been reviled *and* revered. *Fantasia* signposts the end of Disney's honeymoon period in terms of public relations, as the release of the film coincided with bitter strike action from his staff that altered public perceptions of the man (and his studio) for good. It also heralded a period of creative anomie (prolonged by World War II) before the re-submersion into formula. Arguably, the studio's most expressive work can be located in the highly-compromised 'package films' commencing with *Saludos Amigos* (1942) and concluding with *The Adventures of Ichabod and Mr Toad* (1949) that defined the period's output before the fairytale familiarity of *Cinderella* (1950). *Fantasia* was a subject consistently deemed worthy of lampoon by irreverent animated film-makers such as the Warner Bros satirists, who consistently mined the film for its perceived pretensions in any number of classical/low-brow swipes, from Bob Clampett's *A Corny*

Concerto (1943) to Chuck Jones' *What's Opera Doc* (1956).

It has also been seen as an emblem of capitulation. The sublimation of German abstractionist Oskar Fischinger's non-figurative, non-immersive designs in the *Bach Toccata* segment by more rationalist voices within the studio have since cast the film as possibly where the formal traditions of European and American animation divide. *Fantasia* points to a well-intentioned Disney's unwillingness to step beyond the boundaries of his own tastes and truly embrace the avant-garde. And indeed the misappropriation of 'Mickey Mouse' as the film's signature image (via the *Sorceror's Apprentice* section) exemplifies the concessionary impulses that capsize this curate's egg. *Fantasia* appears today as a contradictory but still ultimately monumental piece of work that hints towards unrealized promise in freeing up commercial animation from simple storytelling.

Although initially a box-office disappointment, *Fantasia* has been critically reappraised as Disney's original intent for it to be a regularly-updated indicator of creative/industrial progress at the studio, its chequered reputation aided by subsequent historical revisionism. Its reclamation through radical countercultural sources and academic critics/historians rests on its status as one of the few films supported in a commercial setting that celebrates animation for its own sake. Indeed, as a compendium of animation techniques, *Fantasia* remains breathtaking. The free-form approach inspired and supported by Disney himself drew the very best from artists like Bill Tytla, Art Babbitt, James Algar, Ben Sharpsteen and Samuel Armstrong. And certainly there is a predictive flavour in *Night on Bald Mountain*, for example, through the deployment of impressionistic figurative work that would soon dominate the 1950s' mainstream. The flirtations and refutations of narrative linearity and the sheer abandon located within the differing registers of style, tone and humour reveals ingenuity at work that challenges the boundaries of an entire medium. *Fantasia* is a moment that can never be replicated. It exists as the very embodiment of Disney's own conflicted nature: the 'artist' ever compromised by the 'capitalist'. One can only surmise at what creative directions Disney, and indeed the American animated form itself, would have taken as a result of *Fantasia* succeeding on its own terms in 1940.

Van Norris

The Nightmare Before Christmas

Studio/Distributor:

Touchstone Pictures/Buena Vista Pictures
Skellington Productions

Director:

Henry Selick

Producers:

Tim Burton
Denise Di Novi
Danny Elfman
Kathleen Gavin
Don Hahn (2006 3D version)

Screenwriters:

Tim Burton
Michael McDowell
Caroline Thompson

Cinematographer:

Pete Kozachik

Art Director:

Deane Taylor

Editor:

Stan Webb

Duration:

76 minutes

Genre:

Musical/Horror

Cast:

Danny Elfman
Chris Sarandon
Catherine O'Hara
William Hickey
Glenn Shadix
Paul Reubens

Year:

1993

Synopsis

In the fictional land of Halloween Town, Jack Skellington becomes tired of the 'holiday' season and scaring people, and begins to seek further inspiration with his ghost dog Zero. He comes across a set of doorways which lead to different holiday towns, and Jack chooses the door that leads to Christmas Town. Though he does not quite understand everything he witnesses, he becomes fascinated with giving Christmas a new Halloween-style spin, and convinces the rest of Halloween Town to join his endeavours. Other characters such as rag doll Sally (who secretly loves Jack), Dr Finklestein (her 'creator') and the Mayor of Halloween Town (whose face spins between happy and sad) all get involved in the task to re-format Christmas. Jack begins to deliver Halloween-themed presents around the world, but local gambler/gangster Oogie Boogie has other ideas...

Critique

The Nightmare Before Christmas is a wonderful stop-motion animated feature which manages to be witty, engaging, innovative, touching, and wonderfully perverse all at the same time. The basic characters and ideas were conceived by director Tim Burton when he was working as a Disney animator during the early 1980s, and the success of Burton's 1982 stop-motion short *Vincent* (featuring famous legendary horror actor Vincent Price) made Disney consider *Nightmare* as a short or a television special, but the film did not get the full go-ahead until 1991. Burton and Henry Selick (who also worked at Disney early on) settled on a musical approach, and recruited long-time Burton collaborator Danny Elfman to compose songs and music for the feature. Selick then took over directing duties because Burton was too busy with blockbuster sequel *Batman Returns* (Disney's labelling of *Nightmare* as 'Tim Burton's ...' was a branding tool to help sell the movie). Despite not having a direct hand in the production itself, *Nightmare* contains many recognizable Burtonisms, including the noticeable influence of the German Expressionist style (particularly the abstract, curvy set design of 1920's *The Cabinet of Dr. Caligari*). The charming story of Jack Skellington's quest to liven up Christmas by giving it his Halloween Town spin, *Nightmare* is that rarest of features that succeeds in being equally enjoyable and engaging for adults as well as children.

The songs are creative and emotional, and the unique characters (and characterizations) are constantly engaging. Chris Sarandon provided the voice of Jack for speaking scenes, but Elfman provided the character's singing voice (as well as contributing to few others). 'This is Halloween' and 'What's This?' are just two of the standout tracks that feature amongst

an entire film's worth of meaningful musical storytelling. Burton's idol Vincent Price was originally cast as Santa Claus, but his health was too frail and his recordings were unusable (but Burton did manage to capture one of Price's last screen performances in his acclaimed 1990 fantasy *Edward Scissorhands*). Around 400 heads were made to enunciate the myriad of expressions Jack would have to express throughout *Nightmare*, and over one hundred crew members worked on bringing the film to life. The troublemaker character of Oogie Boogie was inspired by famous jazz performer Cab Calloway, and voiced by African-American actor Ken Page for the film, but endured some controversy regarding its alleged racial undercurrents. Patrick Stewart recorded an introduction for the movie, but it was not used, and can only be heard on the film's soundtrack.

Disney released *Nightmare* under their Touchstone banner because they thought much of the content of the film was too intimidating for young children. Interestingly, though, an early 1992 teaser trailer carrying the Walt Disney banner placed *Nightmare* in the tradition of the studio's legacy, and featured clips of Walt Disney himself, *Fantasia* (1940), *Snow White and the Seven Dwarfs* (1937), *101 Dalmatians* (1961), *Who Framed Roger Rabbit?* (1988), and *Beauty and the Beast* (1991). Disney seems to have 'reclaimed' *Nightmare* in every release of the film since (no doubt its critical accolades and significant financial returns had something to do with the company's decision). The film sprouted a merchandising bonanza in spin-off products (particularly toys and collectibles), which continue to move units to this day. In 2006 and numerous times since, Disney has theatrically re-issued the *Nightmare* in 3D; Industrial Light & Magic digitally transferred the film, but kept the stop-motion imperfections intact, at Burton's request. Disney logically asked Burton for a sequel (which they considered rendering with computer-generated animation), but he did not seem interested. Burton would go on to direct a similarly-styled stop-motion project called *Corpse Bride* (2005), featuring the voices of Johnny Depp and Helena Bonham Carter, and Selick directed the critically-acclaimed stop-motion features *James and The Giant Peach* (1996) and *Coraline* (2009).

Michael S Duffy

Shrek

Studio/Distributor:
DreamWorks Animation

Directors:
Andrew Adamson
Vicky Jensen

Producers:
Jeffrey Katzenberg
Aron Warner
John H Williams

Screenwriters:
Ted Elliot
Terry Rossio
Joe Stillman
Roger SH Schulman

Art Directors:
Guillaume Aretos
Douglas Rogers

Editor:
Sim Evan-Jones

Duration:
90 minutes

Genre:
Fantasy/Family film

Cast:
Mike Myers
Eddie Murphy
Cameron Diaz
John Lithgow
Vincent Cassell

Year:
2001

Synopsis

Shrek, a large, green, solitude-loving ogre is dismayed when his swamp is invaded by a band of fairytale creatures, who have been evicted from their kingdom by the order of evil Lord Farquaad. Accompanied by a loud-mouthed Donkey, Shrek travels to the country in order to challenge Farquaad and regain control of his home. Meanwhile, Farquaad consults a Magic Mirror, which instructs him that he must marry a princess in order to rule over the fairytale kingdom. Shrek and Donkey, having won a duel deeming them worthy, are sent by Farquaad to rescue the beautiful Princess Fiona from a castle guarded by a fire-breathing Dragon, assured that in exchange the Lord will remove the fairytale creatures from the swamp. Shrek and Donkey rescue Fiona, but on their return journey the ogre and the princess, who herself harbours a dark secret, begin to fall in love.

Critique

Shrek established DreamWorks as a serious player in the field of family-friendly animation by combining the old-fashioned storytelling and vibrant, visual charm of the screen fairytale with a firmly-postmodern tone of irreverence and pop-cultural parody. The film garnered huge commercial success and critical acclaim, becoming the first to win the newly-created Academy Award for 'Best Animated Feature' and represented a significant challenge to the dominance of Disney and Pixar in the domain of Hollywood's most lucrative genre, the family film.

DreamWork's self-proclaimed 'Greatest Fairytale Never Told' is a near-perfect example of a film for all ages. *Shrek* is well versed in the generic tropes of the fairytale film, a focus of nostalgia for adults and a favourite of their children, and the success of its comedy lies in its relentless yet affectionate parody of its stock characters and narrative conventions that are such a part of its audience's popular consciousness. The film begins, in Disney style, with the turning pages of a storybook that tells the story of a cursed princess waiting for her true love, before the large green hand of Shrek tears a page from the book and uses it as toilet paper, proclaiming 'That would never happen!' and from that point on the genre parody is impressively consistent. What follows bears the hallmarks of a buddy-movie, with the curmudgeonly Shrek gradually warming to the annoying Donkey, who represents Eddie Murphy's funniest performance in years. The comedy is heavily character-based. The film's major laughs stem from the incompatibility of the ogre and the wise-talking Donkey in their relationship with each other and lie in the fairytale role of the noble hero and the counterpoint of the ineptitude of the various fairytale characters when they are forced

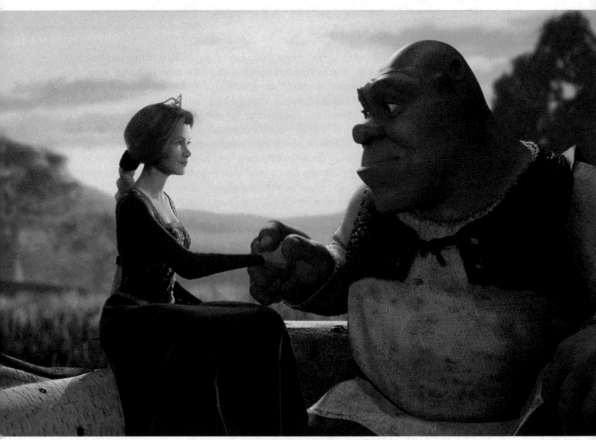

Shrek, 2001, Dreamworks Llc.

outside of the fairytale land – the three blind mice being a perfect example. Added to this are supporting gags aimed at young tastes, the general silliness of 'Monsieur Hood' and his friends re-enacting Riverdance and the gross-out comedy of the opening sequence; for more mature viewers, Katzenberg's satire of his former employers Disney, and Donkey's misguided attempts to provide relationship counselling for Shrek and Fiona. The film succeeds in the rare triumph of thoroughly entertaining viewers of all ages.

As has become the norm for the popular family film, *Shrek* has established itself as a popular screen franchise, spawning three successful sequels. *Shrek 2* (2004) features the newly-married couple travelling to the Kingdom of 'Far Far Away', an extended parody of Los Angeles and its entertainment industry, to meet Fiona's parents, who are less than pleased to discover that their daughter has married an ogre. While the characterization lacks the depth of the first, and DreamWorks' satire of Disney was considerably sharper than its relatively innocuous digs at Hollywood, *Shrek 2* was still consistently

funny and the addition of Antonio Banderas-voiced Zorro parody 'Puss in Boots' breathed new life into the proceedings. Sadly, by *Shrek the Third* (2007) the franchise seemed to be running out of ideas, with the fourth film, *Shrek the Fourth* (2010) attempting to cash in on the craze for 3D film.

Victoria Kearley

The Simpsons Movie

Studio/Distributor:
20th Century Fox

Director:
David Silverman

Producers:
James L Brooks
Matt Groening
Al Jean
Richard Sakai
Mike Scully

Screenwriters:
James L Brooks
Matt Groening
Al Jean

Art Director:
Dima Malanitchev

Editor:
John Carnochan

Duration:
87 minutes

Genre:
Comedy

Cast:
Nancy Cartwright
Dan Castellaneta
Julie Kavner
Harry Shearer
Yeardley Smith

Year:
2007

Synopsis

Having witnessed the rather supernatural verbal convulsions of Grandpa Simpson's armageddon-like premonition at Sunday congregation, Marge becomes acutely concerned that such an occurrence was more than the après-deemed 'senior moment'. Furthermore, the string of unusual incidents that begins to transpire at home suggests that there was grave substance in her (now blasé) father-in-law's mysterious gibberish. Meanwhile, Lisa campaigns effectively for Springfield to acknowledge the appalling condition of its lake by giving the presentation 'An Irritating Truth' to its populace. Yet, in spite of his daughter's protestations, Homer contributes to the town's *past* environmental unfriendliness by utilizing the lake as dumping ground for the ejecta of his new ungulate companion. Consequently, Grandpa's mumblings are realized, and catastrophe begins. With President Schwarzenegger's futility in the role of decision-maker during this (national) crisis, and the town's cartographical irrelevance to the rest of the country, Springfield's fate suddenly lies in the hands of an evil corporation. However, after a chance encounter with an unknown 'boob lady', and the subsequent epiphanic state her wisdom induces, Homer, the culprit, devises a heroic plan that may save the town, and his own familial life, from seemingly-inevitable annihilation.

Critique

At the beginning of a teaser trailer, which circulated extensively before the film's release, a voice-over speaks of the 'unsurpassed beauty' of contemporary computer animation while, onscreen, a three-dimensional rabbit cavorts gleefully round a flower-dancing meadow. The idyllic sight of CGI anthropomorphism is accompanied by the all-too-familiar sound of Tchaikovsky's 'Dance of the Sugar Plum Fairy', and serenely recalls the instantly-identifiable aesthetic of a number of recent animated features. However, such a spectacle is short-lived, as it is not long before a 2-D frame, which proudly announces the arrival of *The Simpsons Movie*, plunges violently onto the screen, and accidentally crushes the bunny to death. Such a typically 'Simpsons' juxtaposition of past and contemporary art, and cultural commentary

The Simpsons Movie, 2007, 20th Century Fox. By Matt Groening.

– cleverly done so in mere seconds – immediately and excitingly evoke the show's glorious heyday: the era which hardcore fans now lament, when its genius writers – inarguably some of the greatest to ever grace American, or world, television – produced moment after moment of shocking absurdity and classic, multi-layered hilarity.

While, for this viewer, the show has undoubtedly lapsed since the mid-to-late 1990s (1997 standing as an unmatchable year in many regards) the much-awaited feature proved welcomingly reassuring. Long-running TV shows, especially within the comedy genre, are vulnerable to becoming exhausted. As much, and as impressively, as *The Simpsons* (1989–Present) gave the world over a decade of comically-ageless entertainment, such a fate was inevitable. Too often, the show – in recent times – produces episodes that descend markedly into excessively plotted, over-consciously postmodern narratives, while several of the show's most cleverly-crafted characters have simply become parodies of themselves: the latter, an exceptionally-rife ailment among elderly sitcoms.

Yet, eighteen years after the show first aired, *The Simpsons Movie* somehow steers clear of both the aforementioned grievances and the archetypal small-to-big-screen failure. Frequently reminiscent of the 1997 glory days, the film reverts to the beauty of subtlety, cementing an awe-inspiring technique of jam-packing the *mise-en-scène* with magnificently-bizarre objects (note Grandpa Simpson's reading of 'Oatmeal Enthusiast' in the background of one scene), with a cavalcade of multiple-meaning utterances throughout. Owing to this, as with landmark episodes, the film is commendably re-watchable. However, as classic as the comedy is, *The Simpsons Movie* is remarkably of its time. Interestingly, the usual Left-leaning commentary – through pop-culture references and the accentuation of national stereotypes – here transcends into another realm of political critique. As the film is fuelled by a narrative concerning environmental cataclysm, includes special guests like the

famously outspoken rock band Green Day, and comprises a multitude of references to the tense political climate during which it takes place, the creators audaciously surpass their customary jab at the 'American idiot'. On top of this, representations of contemporary American Republicanism are offered mockingly – albeit convincingly – as President Arnie declares a number of 'Bushisms' – 'I was elected to lead, not to read' – when presented with crucial State information.

A majestic exhibition of the sharp intellect for which they are so deservedly renowned, and a profusion of side-splitting one-liners later, it seems *The Simpsons*' creators are not yet ready to hang up their cels. As long as one's childlike sensibility will allow it, the brilliance of CGI animation will inevitably continue to astound. Admittedly, the wide-eyed 7-year-old within this viewer is partial to an anthropomorphic, three-dimensional bunny on occasion. Yet, *The Simpsons* – at its best – is incomparable. Indeed the method of animation has earned it an aesthetic recognizable the world over; yet it also substantiates the show's and film's attitude on the imperfections of mainstream culture – of which it repeatedly and magnificently acknowledges it is a part.

Abigail Keating

Snow White and the Seven Dwarfs

Studio/Distributor:
Walt Disney Productions
RKO

Supervising Director:
David Hand

Producer:
Walt Disney

Screenwriters:
Ted Sears
Otto Englander
Earl Hurd
Dorothy Ann Blank
Richard Creedon
Dick Rickard
Merrill De Maris
Webb Smith

Synopsis

The young princess Snow White is kept in servitude as a scullery maid by her stepmother, the wicked Queen. Jealous of her beauty and the attentions of a handsome Prince, the Queen orders the Huntsman to kill Snow White. After the huntsman is unable to fulfil his task, Snow White flees into the ominous-looking forest and, aided by friendly woodland animals, comes across the cottage of the Seven Dwarfs. Here, Snow White finds safe harbour after wooing the fearful Dwarfs with her beauty, charm and domestic talents. The wicked Queen disguises herself as an old hag and persuades Snow White to eat a poisoned apple, which sends her into a death-like sleep. Desperate with grief, the Dwarfs are unable to bury the beautiful princess but, instead, place her in a glass and gold coffin. Snow White's slumber is broken by a kiss from the handsome Prince, with whom she rides off into the sunset to 'live happily ever after'.

Critique

Known during production as 'Disney's folly', *Snow White* was the first animated feature-length film produced by the Disney studios. The film expands on many of the attributes of the Disney short cartoons, which would have already been familiar to 1930s' cinema audiences. The images are meticulously hand-drawn and animated in vibrant Technicolor, with realistic movement, anthropomorphized animals and a rural, bucolic

Supervising Animators:

Hamilton Luske
Fred Moore
Vladimir Tytla
Norman Ferguson

Duration:

80 minutes

Genre:

Musical/Fantasy

Cast (uncredited):

Adriana Caselotti
Harry Stockwell
Lucille LaVerne
Roy Atwell

Year:

1937

setting. Technically, the film was a feat of creativity, talent and patience and the artisanal quality of the images prevails in the face of far more advanced animation techniques and technologies. Just as music played an important role in Disney's shorts so, too, this film features several songs, of which many became hits and remain known to this day. The catchy tunes of 'Whistle While You Work' and 'Heigh-Ho', in particular, have permeated the fabric of contemporary popular culture. The film went extremely over-budget and schedule (hence the nickname), but Disney's insistence on the viability of a feature-length cartoon turned out to be well judged and *Snow White* was a success with the public, making a large profit for the studio.

An adaptation of one of the classic Grimms' fairytales, the film reinforces traditional values and can be seen as articulating Disney's own conservative world view. A strong work ethic is painted as a virtue. The Dwarfs are happiest at work in their diamond mine and Snow White works uncomplainingly at her domestic duties and takes pleasure in looking after the Dwarfs. In particular, the film demonstrates work for its own sake, rather than for reward. The Dwarfs seem unconcerned with financial remuneration for their toils and Snow White never seeks praise or thanks. Cleanliness is also valorized. When Snow White first arrives at the cottage she assumes it to be occupied by 'seven untidy little children' and immediately sets about cleaning up, guiding her woodland animal helpers in the correct way to wash dishes and sweep floors (and at the same time teaching the audience). She also instills a new sense of personal hygiene in the Dwarfs and a lengthy and funny hand-washing sequence results. The representation of women in *Snow White* lends itself to a feminist critique. Women, it suggests, belong in the domestic sphere and should be wholesome, demure and valued for their looks. Any transgression from this 'norm' (as embodied by the evil Queen) leads to an unhappy end (a fall from a great height in the case of our villainess). Adhering to these feminine qualities will, on the other hand, lead to great personal reward in the form of a dashing man whisking you off into the sunset. As befits a fairytale, the film's theme of good triumphing over evil may seem excessively simplistic, but the naivety of the story and the characters is also what lends this film its charm. There is, undeniably, pleasure to be had in a world where humans and animals live in harmony, people work for fulfilment rather than money and problems can be solved with a single kiss.

Despite, or perhaps because of, the reinforcement of traditional values and gender roles, *Snow White* has remained a perennial favourite. The film also laid the groundwork, both stylistically and practically, for subsequent animated features produced by the Disney studio, ranging from *Pinocchio* (1940) to *The Princess and the Frog* (2010). The film's legacy extends beyond the Disney oeuvre and can be seen as one of the foundations on which the canon of contemporary animated feature films is built.

Bella Honess Roe

South Park: Bigger, Longer, and Uncut

Studio/Distributor:
Comedy Central Pictures
Paramount Pictures
Warner Bros (international)

Director:
Trey Parker

Producers:
Trey Parker
Matt Stone
Scott Rudin
Frank C Agnone II (animation producer)

Screenwriters:
Trey Parker
Matt Stone
Pam Brady

Art Director:
JC Wegman

Editor:
John Venzon

Duration:
81 minutes

Genre:
Comedy/Musical

Cast:
Trey Parker
Matt Stone
Mary Kay Bergman
Isaac Hayes

Year:
1999

Synopsis

South Park kids Stan, Kenny, Kyle, and Cartman go to see the new movie from controversial Canadian comedy duo Terrance and Phillip, and spread its profanities all around school, influencing other children to see the movie. When Kyle's mother finds out about the film, she attempts to get it banned, and forms a fringe group to capture Terrance and Phillip, who are promoting the movie in America. When the US refuses to release them, Canada retaliates with a bomb, and the US declares war on Canada. Meanwhile, Kenny, having died from a botched heart transplant, is in Hell, and discovers that Satan and Saddam Hussein will return to Earth to rule the world if Terrance and Phillip are killed. The kids of South Park must not only figure out how to stop the US/Canada war, but also prevent global annihilation.

Critique

Political, cultural, and social satire meet contemporary animated musicals in *South Park: Bigger, Longer and Uncut*. The inferences and double entendres begin with the title itself, and continue in multiple subtexts throughout the film. Trey Parker and Matt Stone, the creators of *South Park* (1997–Present), the long running, controversial animated television programme which runs on the Paramount-owned Comedy Central cable network, were commissioned to make this film version of the show less than two years into its run. Though the show regularly (and rapidly) hits on topical issues in the media and elsewhere, Parker and Stone very cleverly designed the feature-length movie's surface plot around the very issues which would likely gain the film additional attention: the discrepancy in the US motion picture ratings system between violent content, profanity and sexuality, and the political and media attention that often comes with controversial films. The *South Park* movie is brilliant in its scathing critique of nearly every cultural and political touchstone of the era, especially its storyline featuring a fictitious US invasion of Canada and a spiritual/cultural uprising (and troubled love story!) facilitated by former Iraqi dictator Saddam Hussein and the ruler of Hell, Satan. Within this already-complex creative agenda, the film also manages to satirize and interrogate public and media attitudes towards recent military conflicts, and America's confusing feelings about its own allies. All of the central characters from the show have prominent roles here. In fact, the traditionally cheap-looking animation style and cut-out aesthetic match the television show's style so succinctly that one would not be remiss in mistaking any portion of the film for a regular episode. Therein lies the film's charm – Parker and Stone both embrace and critique the 'bigness' and audience expectations that are often associated with,

or expected of, a feature film spin-off of a television series. Though the film does feature several 'big' sequences, the original aesthetic style and feeling of the show and characters is never lost on screen.

The real genius revealed in the film, however, is that it is actually a musical – and quite a good one. Trey Parker and Marc Shaiman write twelve original songs for the production (Matt Stone contributed additional lyrics); James Hetfield of heavy metal band Metallica also contributed music and vocals to the song 'Hell is Not Good'. The writers manage to not only narratively integrate every song in intricate ways but also to satirize innumerable well-known musicals and films within each song, including (but not limited to) Disney's *Beauty and the Beast* (1991), *Les Miserables*, and *Oklahoma!* 'Blame Canada' is the standout performance here, and it was deservedly nominated for an Academy Award for Best Original Song (Comedian Robin Williams performed the song live with a full chorus line during the 2000 Academy Awards). In fact, the film was the recipient of many awards from respected critics groups, including Best Original Score/Music awards from the Los Angeles Film Critics Association, Chicago Film Critics Association, and Online Film Critics Society, and an MTV Movie Award for Best Musical Performance; it was also awarded the Best Animated Feature award from New York Film Critics Circle that year. Additionally, the film has the distinction of making it into the 2001 Guinness Book of World Records for 'Most Swearing in an Animated Film' (for 399 profane words during its running time). Parker and Stone claim that the potential film title *South Park: All Hell Breaks Loose* was rejected by the Motion Picture Association of America Ratings Board; the MPAA denies that they ever received the submission.

Michael S Duffy

Toy Story

Studio/Distributor:
Pixar
Disney

Director:
John Lasseter

Producers:
Bonnie Arnold
Ralph Guggenheim

Synopsis

On Andy's tenth birthday, his toys find themselves with a new addition to their ranks. The newest must-have toy, Buzz Lightyear, impresses Andy's toys with his endless enthusiasm, his apparent ability to fly, and his eccentric character; however, not everyone is happy with his arrival. Woody, a pull-string-activated cowboy, believed he would be Andy's favourite toy forever, only to find that he is now cast aside as Andy's room is transformed from an old-west themed corral to new hi-tech space-themed room with the arrival of Buzz. Jealous of Buzz's new found popularity, Woody tries to restore his importance amongst the other toys; however, one incident backfires and Buzz is knocked out of Andy's room window, prompting the other toys to turn against and ostracise Woody

Screenwriters:

Joss Whedon
Andrew Stanton
Joel Cohen
Alec Sokolow

Art Director:

Ralph Eggleston

Editors:

Robert Gordon
Lee Unkrich

Duration:

81 minutes

Genre:

Comedy/Family film

Cast:

Tom Hanks
Tim Allen
Don Rickles
Wallace Shawn
Jim Varney
John Ratzenberger

Year:

1995

for the selfish act that led to the loss of their new hero. Woody sets out to 'rescue' Buzz and bring him back to Andy's room to regain respect from the other toys. On the way, Woody's selfishness and Buzz's naivety are transformed as the characters grow, and a friendship is formed that will change the dynamic of Andy's toys forever.

Critique

With the coast clear of any other film of its class, on its release in 1995, *Toy Story* made its mark in cinema history by becoming the first feature-length, 3D animated film to go on general release, and became one of the highest-grossing films of the year. A culmination of almost ten years work by the Pixar studio, *Toy Story* was inspired by their 1988 short film *Tin Toy* – the first 3D animated short to win an academy award. The influence of *Tin Toy* is evident through the theme of toys as well as the shot where the eponymous Tin Toy escapes under a sofa to find a host of terrified toys hiding from the drooling baby that it also was running from. A similar scene is found again in *Toy Story* where Woody and Buzz find themselves looking for a way to escape from Sid, Andy's toy-torturing next-door neighbour, and come across some hiding toys.

In essence, *Toy Story* is a buddy movie told through the eyes of toys. The simple yet delightful storyline written by director John Lasseter, the award-winning score by Randy Newman, and the obvious attention to detail, despite the simple rendering techniques available at the time, no doubt influence its success. The *mise-en-scène* skilfully makes reference to the history of Pixar with, for example, the books in Andy's room depicting the titles of previous Pixar short films and fairytale classics, and the attention to detail demonstrated by the variety of toy soldiers and the virtual dust add to the verisimilitude of the images. The pizza delivery van has become a motif found in every Pixar feature animation to date.

The limitations of the technology at the time confined the rendering to smooth surfaces and simple shapes which resulted in a *Toy Story* told from the point of view of the toys enhancing the believability of the aesthetics. The 3D space was now closer to live action films as it was now able to be penetrated by the virtual camera, as with the famous ballroom scene in *Beauty and the Beast* (1991) where 3D animation was used in combination with traditional techniques in order to highlight the significance of the scene (through the significance and spectacle of the graphics). Fundamentally, *Toy Story* hailed a new aesthetic style whilst sticking to the aims of the western animation tradition, particularly of Disney, to create believable characters with lifelike movements, this time using digital motion-capture technology rather than life models as used in *Snow White* (1937). Its obvious aesthetic difference subsequently became the mainstay of Hollywood animation, until 2010 when Disney animation, now headed by

John Lasseter, made a return to traditional aesthetics on the release of *The Princess and the Frog* (2010).

Toy Story demonstrates how far digital technology in animation had progressed since the motion blur achievement of *Andre and Wally B* in 1984 and the 50 visual effects shots in *Jurassic Park* (1993) just two years before its release. With this, and the subsequent re-releases – one commercially-successful sequel (also re-released for 3D exhibition), and a third in the series, *Toy Story 3*, released in the summer of 2010 fourteen years after its original release – the legacy of *Toy Story* is still flying with style to infinity and beyond.

Simone Gristwood

Up

Studio/Distributors:
Pixar
Disney

Directors:
Pete Docter
Bob Peterson

Producer:
Sonoko Ishioko

Screenwriters:
Pete Docter
Bob Petersen
Ronnie Del Carmen
Tom McCarthy

Director of Photography:
Patrick Lin

Art Directors:
Don Shank
Nathaniel MacLaughlin

Editors:
Kevin Nolting
Karen Ringgold

Duration:
89 minutes

Genre:
Adventure

Synopsis

Widower Carl Fredricksen decides that he will attach balloons to his home and float it to the location of Paradise Falls. This is a site that has taken on mythic importance, as it was to be where he and his late wife, Ellie, were to spend their twilight years. On the journey out Carl accidentally picks up Russell, an awkward and obviously emotionally-neglected young boy. They subsequently land in a ravine and end up pulling the still-suspended house around with them whilst searching for Carl's desired location. In turn, they encounter a flightless bird (named 'Kevin' by the boy) and a dog (called 'Dug') , sent to investigate them by Carl's boyhood hero Charles F Muntz. Muntz has been in hiding since a spectacular fall from grace and has spent his time obsessively-hunting Kevin's breed to extinction. When Muntz's mania is revealed, Carl frees the bird from captivity and brings about the demise of his hero, in the process becoming a surrogate parent to Russell. As the films ends we see the house finally drift of its own accord to find its final, appropriate resting place at Paradise Falls.

Critique

Sylvain Chomet, the independent French animation auteur behind *Les triplettes des Belleville* (2003), surely must have been curious to observe the resemblances between his film and Pete Docter's beautifully-rendered and meticulously-constructed *Up*. For it could be argued that Pixar have inadvertently remade Chomet's European feature in an American idiom, for many similarities abound. *Up* is another in Pixar's run of films from *Toy Story* (1995) onward that cements their reputation as the dominant generator of mainstream animation today. It is a continuation of Pixar's explorations of interpersonal relationships set against fantastical environments and their ongoing fascination with variations on the parent-child dynamic. Son-father/daughter-father bonds are central

Cast:

Ed Asner
Jordan Nagai
Christopher Plummer
John Ratzenberger
Delroy Lindo

Year:

2009

to *Finding Nemo* (2003), *The Incredibles* (2004), *Monsters Inc* (2001), among others, and broader familial dynamics are essayed within *Cars* and *Wall-E* (2008), all of which serve the industrial role of immersion that conforms to the mainstream American animation project. Pixar's films explore how men/parents can redeem themselves through roles of responsibility. *Up* maintains this obsession around the functions of masculinity and how aspects of damaged or isolated maleness can be retrieved to allow re-entry back into a social group and to benefit a wider community. As throughout *Up*, Carl mends eroded family ties and reasserts himself through his own rediscovered courage.

The central protagonists in both Chomet and Docter's films are elderly. They traverse great distances in unusual modes of transport; they are fixated on obsessive missions; they engage in a relationship with an interiorized male who lacks socialization. Both *Belleville* and *Up* also play games with anthropomorphism by centralizing cartoon dogs that seek to locate the embodiment of canine behaviour in animated constructs, (see 'Bruno' and 'Dug' respectively). Also notably, both *Belleville* and *Up* fetishize the past and unashamedly revel in nostalgia. For Chomet this serves as an affirmation of European/American exchange, individuality and transgression; for Docter this comes through a genuine attempt to reconnect contemporary audiences to more earnest modes of adventure in his resetting of twentieth-century adventurer myths of Conan Doyle, Rice Burroughs, Howard Hughes (complete with airship and a lost plateau). Docter eulogizes over the connotations of innocence, unity and linearity surrounding the newsreel exploits of explorer Charles F Muntz, mirroring Chomet by positing the journey as a dissertation on the resonance of memory and crossing through literal and figurative boundaries of grief.

This discernible lack of radicalism is ultimately what the studio has chosen to embody, strengthened through their connections with Disney, reinforced with a fixation on verisimilitude and through the desire to place Pixar within a lineage of US animation history. The wall paintings of Earl's house not only suggest the postwar American graphic approach of Rand and Lustig but, more pertinently, it echoes the in-house style of 1950s'/60s' UPA/DePatie-Freleng. As *Wall-E* prioritized the outcome of a chaste, heterosexual union (between two models of automaton), that *The Incredibles* told us (using the voice of Ayn Rand) that brilliant people should not be hampered by the 'less than brilliant', and that *Cars* reminded America not to reject isolationism during the troubled Bush years but to look inward to the heartland, we can applaud any conciliatory gestures towards expansion and inclusion, (see also 2007's *Ratatouille*), as welcome counterpoints to reassure us that Pixar has not completely shut up shop around more progressive impulses.

Up may offer up revisionism through the recasting of Muntz's heroism but ultimately it yearns for a simpler life. This

is readily apparent in its painstakingly sentimental prologue suggesting that 'old times' really were better than the 'now times'. And both seemingly disparate films tell us much about our very global, relationship with animation, memory and existence.

Van Norris

WALL-E

Studio/Distributor:
Pixar
Disney

Director:
Andrew Stanton

Producer:
Jim Morris
John Lasseter

Screenwriters:
Andrew Stanton
Jim Reardon

Art Director:
Ralph Eggleston

Editor:
Stephen Schaffer

Duration:
98 minutes

Genre:
Science Fiction

Cast:
Ben Burtt
Elissa Knight
Jeff Garlin
Fred Willard
John Ratzenberger
Kathy Najimy
Sigourney Weaver

Year:
2008

Synopsis

WALL-E is the last remaining robot left cleaning up the rubbish on a desolate and deserted planet Earth in 2805. Each day WALL-E goes about his duty, as he has for years, creating skyscraping mounds of compacted trash and collecting trinkets as he goes, including nodding dogs, Rubik's cubes, lighters and, significantly, a plant. One day, as WALL-E goes about his solitary existence, a hi-tech spaceship lands on Earth and deposits another robot: EVE. With this new arrival, the entire nature of WALL-E's existence is about to change. WALL-E develops a friendship with EVE who, on inspection of the plant, shuts down unexpectedly. Not knowing what else to do, and with a developing affection for her, WALL-E continues to look after EVE until, one day, the hi-tech spaceship returns to collect her. As he flies into space hot on the heels of his new robot friend, little does he know how his simple motive will, in fact, hold the key to the return of the human race to Earth.

Critique

Reminiscent of the appearance of Johnny Five of *Short Circuit* (1988) fame, the delightfully endearing character of WALL-E (Waste Allocation Load Lifter – Earth Class) becomes the unlikely hero of epic proportions, in essence saving the human race from the fate of becoming oversized space-inhabitants for eternity. The beginning of this adventure is set when WALL-E develops affection for EVE (Extraterrestrial Vegetation Evaluator). This sleek hi-tech robot sent back to Earth to search for signs of life instigates the events that send WALL-E into space, sacrificing his septuacentennial of solitude and leaving his only friend, a pet cockroach with personality, behind.

WALL-E was released at a time when the only animation in Hollywood, aside from stop motion, was digital 3D. However, the plethora of releases did not affect its general success and it has managed to maintain its position in the top-ten computer animations for box-office returns. In fact, Pixar have maintained a stronghold on the top ten, only to be challenged with the *Shrek* franchise from DreamWorks SKG. With one technical achievement after another demonstrated through each of

their pictures, the Pixar team outdo themselves with their ninth commercially-successful film directed by Andrew Stanton, of *Finding Nemo* (2003) fame. Despite this, *WALL-E* is in fact, one of Pixar's least successful films, yet it is also one of the most interesting, raising not least questions about gender, philosophy, and technology whilst at the same time demonstrating technically-sophisticated rendering of the 3D space.

The opening 30 minutes are particularly impressive graphically, and it only takes a moment for them to stand out as the digital animation studio's most photorealistic rendering to date. Far removed from the simple shapes and textures of *Toy Story* (1995), the audacious absence of dialogue, and leisurely pace, highlights the accomplished cinematography that can easily be mistaken for real cameras. Particularly impressive are scenes depicting intricate textures of the Earth, the focus of the lens on the plant, close-ups and tracking shots, and the shadows falling on trash resembling deserted buildings as the camera moves authentically around these virtual objects. The accomplished cinematography works with the *mise-en-scène* to create a highly-photorealistic world; the echoes of the diegetic music played through WALL-E's recorder, and the variety of settings such as the inside of a supermarket where the sound of crashing shopping trolleys, combined with the sophisticated graphics, give the impression of true existence. At the same time, these scenes establish the decidedly-authentic main characters and their burgeoning romance.

The graphics are additionally interesting, with the use of live action in the form of recorded footage of humans on Earth and references to older media, such as a video-tape recording of *Hello Dolly* (1969). Combined with animation, this does little to disrupt or distract from the story, yet it also emphasizes the complexity and depth of the rendered graphics. Furthermore, the contrast between the initial sequences on Earth, with the crisp, clean graphics set in space on board the Axiom, where WALL-E and EVE become rogue robots, serves to highlight this technical achievement further, since the rendering of the human characters are decidedly more (potentially deliberately) cartoon-like than the rest of the film.

Appealing characters, and the many, often subtle, details including references to popular culture (such as the ipod-related design of EVE and the Windows start-up sound effect when WALL-E becomes fully charged) again demonstrate that Pixar are not only pioneers of sophisticated graphics in 3D animation but, additionally, masters of detail and the art of story-telling. *WALL-E* may not be Pixar's most successful film at the box office, but they have demonstrated that it is possible to make hyper-jumps into pioneering rendering of photorealistic digital imagery and cinematography, which will no doubt make an impact on the potential for these kinds of graphics to filter down to earth.

Simone Gristwood

Within the film industry, 'blockbuster' has traditionally been a term applied to motion pictures that are extremely successful during their initial theatrical release, although in recent years it has been used by Hollywood to define in-production films of a massive size and scope and a 'high concept' mentality. Though the term can describe successes in theatre and, more recently, successful novels, it has been a central descriptive component of the Hollywood industry since the summer release of *Jaws* in 1975. The massive commercial success and cultural impact of Steven Spielberg's shark-themed thriller instituted a new sensibility in Hollywood film-making. *Jaws* was the first motion picture to achieve $100 million at the US box office (eventually grossing much more), a benchmark which still holds significance in the industry, even though contemporary blockbusters can often soar to $500 million or more in worldwide sales. The time of release and marketing methodology surrounding *Jaws'* release also influenced a 'summer tentpole' mentality in Hollywood; in the future, films and/or franchises would often be designed as 'events' that studios could parlay into a number of different revenue streams. The release of George Lucas' *Star Wars* in 1977 further accelerated this strategy. Lucas built his career by anticipating the blockbuster possibilities of his own story: his initial contract with 20th Century Fox included not only sequel rights but all of the merchandising rights to the franchise, shutting the studio – who did not think the movie would be that successful – out of untold amounts of future profits. Lucas and Spielberg are just two of the many directors and producers who helped expand the blockbuster philosophy by producing or directing projects that continually appealed to wider demographics and multiple age groups, while further integrating merchandising tie-ins and ancillary marketing. On the flipside, the disastrous failure of Michael Cimino's *Heaven's Gate* in 1980 and subsequent collapse of United Artists were also significant factors in Hollywood's move towards a studio-controlled blockbuster mentality.

Interestingly, many of the films and franchises which contributed to the expansion of Hollywood's blockbuster approach during the 1970s and 1980s were conceived or produced independently of the major studios, including the *Star Wars* franchise (which relied on Fox for distribution) and the 1978–1987 *Superman* film franchise (distributed by Warner Bros in most territories). Talented and forthright directors have also significantly contributed to the creation of blockbusters which help move the industry forward in other areas, such as film-making technologies. James Cameron's *The Terminator* (1984) was a substantial success, considering its small budget, but sequel *Terminator 2: Judgment Day* (1991) not only eclipsed its predecessor in profit (the sale of worldwide distribution, home video and television rights prior to the film's release recovered its $90 million budget) but advanced the art of special/visual effects as well. Cameron continued to deliver effects-heavy blockbusters throughout the 1990s with *True Lies* (1994) and *Titanic* (1997), and enjoyed enormous success a decade later (commercially, if not critically) with science-fiction epic *Avatar* (2009). Contemporary potential blockbusters often require additional investment from outside the major studios in order to defer their ambitious production- and marketing costs: Warner Bros has a long-term

contract with Legendary Pictures, a group of private equity and hedge-fund investors who typically contribute 50 per cent of costs to any production they partner with the studio. *Batman Begins*, director Christopher Nolan's revival of the Batman film franchise in 2005, was the first of many films completed under this agreement, which is increasingly becoming a central component of the Hollywood majors' studio production.

Though international co-production has long been a part of Hollywood production, various political, economic, and cultural shifts since the mid-1990s have influenced an increasing movement towards global investment in Hollywood feature films, particularly in the design of culturally-diverse blockbusters with international appeal. China's deeper interest in partnering with Hollywood studios on a variety of potential blockbusters (such as 2000's *Crouching Tiger, Hidden Dragon*, a Chinese-Hong Kong-Taiwan-US co-production which became a blockbuster success in the US) indicates an attempt to both preserve and expand cultural appeal and influence in both the East and the West. European regions have also developed their own blockbuster approaches, which frequently involve multiple genres: France's internationally-successful 2001 film *Brotherhood of the Wolf* has elements of mystery, horror, fantasy and martial arts, and Sweden's 2009 *Millennium* trilogy achieved a domestic and global success equal to its source novels (in turn, Hollywood has been ever quicker to adapt and remake blockbusters from other regions – Sony Pictures acquired the rights for an American film adaptation of the *Millennium* books in 2010, with plans to release the first film in 2011).

One of the most successful partnerships of media, capital, and source material to create a hugely profitable franchise in the 2000s has been *The Lord of the Rings* trilogy (2001–2003). Produced by New Line Cinema and filmed in New Zealand, the trilogy was an unprecedented risk monetarily (New Line maximized the value of its estimated $300 million production through German tax shelters and New Zealand rebates) and cinematically (director/co-writer Peter Jackson had not commanded a budget higher than $30 million). Despite liberal changes to the widely-revered original novels by JRR Tolkien, the film trilogy was an enormous success creatively and financially, and the series spawned numerous imitators, both large and small, in the international marketplace. Equally successful during the first decade of the 2000s were big-budget Hollywood comic book superhero adaptations. Sparked originally by the theatrical, home video and merchandising success of 1989's *Batman* and reinvigorated by 2002's *Spider-Man*, Hollywood latched onto superheroes as its next 'hot' genre, producing an innumerable successful and not-so-successful adaptations over the course of the decade. Warner Bros' *The Dark Knight* (2008) eclipsed all others in the genre, grossing over $1 billion worldwide in theatres. While studios allowed substantial freedom to film-makers approaching the material, potential franchise-starters which did not consistently break opening weekend records or unanimously please critics, fans and audiences (Ang Lee's psychologically-dense 2003 take on *Hulk*; Bryan Singer's 2006 self-described 'vague sequel' *Superman Returns*) were deemed creative misfires and contributed to the convolution of the genre. Throughout the decade, Hollywood found that manufacturing blockbusters from such ready-made mythological material was often just as difficult as creating an original franchise of their own.

Failed blockbusters can backfire on stars' careers – Arnold Schwarzenegger never quite recovered from the disappointment of 1993's self-referential *Last Action Hero* (which the star claims would have performed better had it not been released one week after Spielberg's monumental success, *Jurassic Park*).

Kevin Costner's public reputation was significantly damaged after the release of *Waterworld*, an under-performing 1995 post-apocalyptic adventure which takes place mostly on water (though the troubled $200 million-budgeted production is commonly noted as a 'flop' in the US, overseas grosses eventually made the film profitable). Sometimes gambling on few or no stars is a lucrative enterprise; when it works, no one quite expects it – 2009's $35 million-budgeted *The Hangover* became the highest grossing R-rated comedy to date, grossing over $460 million worldwide. Recent attempts by certain portions of the industry to consider 'film futures' within the design and investment of major motion pictures (and, presumably, potential blockbusters) may have even more unsettling effects on what remains of the 'star system' and the production and promotion of block-busters. Though tied to the industrial movements of Hollywood since the 1970s, the 'blockbuster sensibility' continues to directly or indirectly impact and influ-ence film production, government quotas, cultural and economic exchanges, and audiences' ability to process contemporary film and media worldwide.

Michael S Duffy

Batman

Studio/Distributor:
Warner Bros
Guber-Peters Company
PolyGram Pictures

Director:
Tim Burton

Producers:
Peter Guber
Jon Peters
Benjamin Melniker
Michael E Uslan

Screenwriters:
Bob Kane
Sam Hamm
Warren Skaaren

Cinematographer:
Roger Pratt

Art Directors:
Leslie Tomkins
Terry Ackland-Snow
Nigel Phelps

Editor:
Ray Lovejoy

Duration:
126 minutes

Genre:
Action/Superhero

Cast:
Michael Keaton
Jack Nicholson
Kim Basinger
Michael Gough
Pat Hingle
Billy Dee Williams

Year:
1989

Synopsis

Mysterious millionaire and bachelor Bruce Wayne is orphaned as a child, his parents murdered in front of him in a dark alley in Gotham City. He spends his days in philanthropy and his nights prowling the streets, dressed like a bat, striking fear into the hearts of criminals throughout the city. Photographer Vicki Vale has arrived in the city, pursuing speculative reports of a mysterious 'Bat-Man'. Meanwhile, crime boss Carl Grissom attempts to stronghold both the city and its government through threats and blackmail; he both values and is suspicious of Jack Napier, one of his men, whom he sets up to take the fall during a factory burglary. During an encounter with the Batman at the factory, Jack falls into a vat of chemicals, and is reborn as the Joker ('the world's first homicidal artist', as he later calls himself). Batman and the Joker struggle for control of the city and its inhabitants.

Critique

Released in the fiftieth anniversary year of the character's first appearance, Tim Burton's 1989 adaptation of the DC Comics' *Batman* arguably hit all the right blockbuster marks in its attempt to re-invent the mythos on screen for mainstream audiences. *Batman*'s success influenced (and arguably, facilitated) contemporary superhero film adaptations in a variety of ways, from the darker nature of its characters to the ambitious development of multiple merchandising platforms; the film also fundamentally changed the perspective of a media generation who were mostly familiar with Batman through the campy 1960s' television series starring Adam West. Though the success seemed instant, it was not: the *Batman* property endured a long development process that had begun soon after the success of Richard Donner's *Superman* (1978), which had itself redefined comic book-to-film adaptation. Many scripts, actors and directors were considered, but Warner Bros hired an unlikely candidate in Tim Burton and cast an even more surprising lead with Michael Keaton. Before any fans knew the tone and approach of the production, they sent 50,000 protest letters to Warner Bros complaining about the choice of Burton and Keaton, who both had primarily been known for offbeat comedies.

Anton Furst's stunning production design gives the film an almost period 1930s' feel, but time and setting are wisely never specified. Danny Elfman's music score drives characters and events in the film perhaps more than the direction or performances. The thin line between the tortured and unstable psychology of characters like Batman and the Joker is nicely drawn out in the film, both through dialogue and cinematography: When Vicki Vale confronts Batman about his mysterious nature, he attempts to differentiate himself by calling the Joker 'psychotic'. Vale replies, 'There are some people who say the same thing about you'. Lit by a singular beam showing us only his eyes, we get a brief glimpse into the Bat's soul, and it is indeed disturbing.

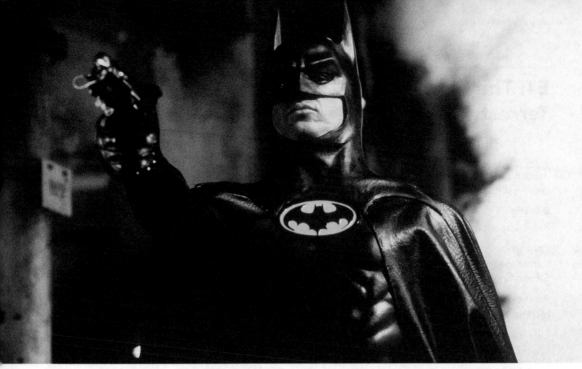

Batman, 1989, Warner Bros/DC Comics.

In the months leading up to the film's release in June, one could not escape the bat-symbol as you walked out your door each morning; 'Batmania' had taken hold, and the film and its tie-in products were mercilessly marketed to all age groups and demographics. Additionally, Prince's soundtrack for the film (promoted with a track called 'Batdance' which contained audio elements and melodies from both the current film and the classic 1960s' television series) actively promoted the movie to MTV audiences. The film redefined merchandising for film, inspiring a new generation of blockbusters with the ability to net significant additional profits from toys and ancillary products, including home video and animated series. Though George Lucas's original *Star Wars* trilogy had seemingly invented this concept, *Batman* solidified it. Setting a new opening-weekend box-office record, the film would also solidify the industry's focus on first weekend grosses as a defining factor in franchise birth or renewal; *Batman* also displayed extraordinary profitability on home video.

Burton was given more freedom in directing a sequel, *Batman Returns* (1992), but Warner Bros received complaints from parents and children's groups for some of its sadistic content. Burton and Michael Keaton departed the franchise, but Burton retained a producer credit on the next two installments directed by Joel Schumacher, which took the franchise into more thematically-aloof and aesthetically-colourful directions. Michael Gough's Alfred and Pat Hingle's Commissioner Gordon remained the only casting constants throughout this initial four-film series. Warner Bros and director Christopher Nolan successfully 'rebooted' the film franchise in 2005 with *Batman Begins*, which explored the origins of the caped crusader in greater detail.

Michael S Duffy

ET: The Extra-Terrestrial

Studio/Distributor:
Amblin Entertainment
Universal Pictures

Director:
Steven Spielberg

Producers:
Kathleen Kennedy
Steven Spielberg

Screenwriter:
Melissa Mathison

Cinematographer:
Allen Daviau

Art Director:
Jackie Carr

Composer:
John Williams

Editor:
Carol Littleton

Duration:
115 minutes (1982, original
theatrical release)
120 minutes (2002, theatrical
re-release Twentieth Anniversary
edition)

Genre:
Science Fiction

Cast:
Dee Wallace
Henry Thomas
Drew Barrymore
Robert MacNaughton
Peter Coyote

Year:
1982

Synopsis

Under a starry sky, little stocky aliens looking like gnomes
are busy digging up and gathering plant samples near their
spaceship. One of them wanders away from the group to
explore the forest. Surprised by the sudden arrival of humans
on the site, the wanderer is abandoned by his friends, and
left alone on this unknown planet. Near the forest lives a boy
named Elliot. Terrified, but soon fascinated by the creature
prowling around the house, Elliot welcomes his new friend
in his residence. He asks his elder brother Mike and his little
sister Gertie to keep the secret of his presence from their
mother. As days go by, a mysterious psycho-physiological
relation links our two main protagonists. During his time alone
in the house, ET, the name given to him by Elliot, gathers
different kinds of objects and tools in order to build a com-
munication device that will allow him to send a message to
his friends. However, the net is tightening around them. The
humans discover the location of ET, who becomes sick. Time
is now running out for Elliot and his family; have ET's friends
received the message to come and rescue him?

Critique

One of the most personal movies from Spielberg, *ET: The
Extra-Terrestrial* is a modern tale which has proven to be time-
less. Themes such as brotherhood, family ties and the transi-
tion to adulthood remain universal. The new 2002 version
released for the Twentieth Anniversary has kept the movie
up-to-date. ET underwent a digital make up to attenuate its
puppet look, and some physical actions, such as arm move-
ments, were retouched. Spielberg reinserted one of the most
enjoyable moments of the movie: the bathroom scene in
which Elliot compares his height with ET in front of the mirror.

Some disapproved of those slight aesthetic improvements
but what about the 'ethical' ones, like digitally replacing all
the guns held by agents with walky-talkies during the final
chase? It seems that nostalgia does not rhyme with the cur-
rent political correctness in which America is deeply soaked.
Thus, government agents cannot hold guns anymore when
they are chasing after kids in the streets, particularly in a
movie now rated PG in the United States – although the same
movie was rated G in 1982.

Many commentators have the tendency to reduce *ET* to a
simple Christian tale. Indeed, *ET*'s plot can easily leave that
impression at first (a being coming from the sky to teach
us love, peace and tolerance). And yet, the story goes way
beyond the simple evangelical tale. In fact, *ET* deals with
very real issues which need to be put into context. In 1982,
Americans were just emerging from a recession leaving many
families badly hit (bankruptcies and/or divorces). In *ET*, Elliot

is the the second child of a divorced couple. His mother is striving to regain her dignity as a woman. She is a single parent who juggles raising her three kids while working full time. The father figure is totally absent, making ET the perfect substitute father figure for Elliot. Considering the sociological context prevailing at that time in the United States, one might infer that American spectators easily related to Elliot's family and ET's reassuring charm, especially in this period where everyone was seeking financial and psychological security.

Spielberg is well known for portraying dysfunctional families. His previous movies *Sugarland Express* (1974) and *Close Encounters of the Third Kind* (1977) are eloquent examples. However, even though Spielbergian characters tend to move away from their family, as if they were dislocated from its very core, they always end up going back. Whether it is *Indiana Jones and the Temple of Doom* (1984), *Indiana Jones and the Kingdom of the Crystal Skull* (2008), *The Color Purple* (1985), *Munich* (2005), *Hook* (1991) or *AI* (2001), the family is at heart of almost all of Spielberg works.

ET set a milestone in cinema history by splitting science fiction works into two periods. Before *ET* in Hollywood, extra-terrestrials were traditionally pernicious invaders (for instance, as in *The Thing from Another World* [1951] or *Invasion of the Body Snatchers* [1956]). Even *Close Encounters*, which builds on our natural fear of the 'other', blurs the line, making it hard to tell whether the aliens are hostile until the very end. But *ET* breaks that 'tradition'. The extra-terrestrial was neither an almighty invader nor a 'destroyer of worlds', but just a peaceful and 'benevolent' being (see Geraghty & Janicker, 2004).

Marc Joly-Corcoran

References

Geraghty, L & Janicker, R (2004), '"Now That's What I Call a Close Encounter!": The Role of the Alien in Science Fiction Film, 1977–2001', *Scope: An On-line Journal of Film Studies*, November.

Jaws

Studio/Distributor:
Universal Pictures

Director:
Steven Spielberg

Synopsis

During a night swim a girl is attacked by something mysterious hidden in the darkness of the ocean. The remains of her body are found the next morning, raising the suspicion of a shark attack – a calamity for the peaceful community of Amity Island who are about to welcome 4th of July tourists to their sandy beaches. In order to protect the business of the Island, the new chief of the policy, Martin Brody, accepts the mayor's suggestion to not inform the population about what

Producers:

David Brown

Richard D Zanuck

Screenwriters:

Peter Benchley

Carl Gottlieb

Cinematographer:

Bill Butler

Art Director:

Joseph Alves Jr

Editor:

Verna Fields

Duration:

124 minutes

Genre:

Horror

Cast:

Roy Scheider

Robert Shaw

Richard Dreyfuss

Lorraine Gary

Murray Hamilton

Carl Gottlieb

Year:

1975

has happened and to keep the beaches open. After a second attack, which causes the death of a child, Brody embarks with a mercenary-hunter (Quint) and an oceanographer (Matt Hooper) to kill the animal. It will be the beginning of a hard battle between three men and an enormous White Shark.

Critique

Jaws is often defined as a modern version of the Moby Dick story re-told through the lenses of the horror and thriller genres. This may be true, yet it has roots deep within film history and the peculiarities of its Hollywood production are more articulated than one might thinks. For instance, *Jaws* evokes the tradition of the cinematographic monster (King Kong, Godzilla, the Wolfman, etc), exploring the trope of nature as threat (as seen in *The Birds* from 1963) and alludes to a supernatural world that only a few years before captured the attention of a mass audience (*Rosemary's Baby* in 1968 and *The Exorcist* in 1973). Beyond these cinematographic echoes, what *Jaws* offers to its audience is the return to an ancient world with its rituals and values: the hunt, the struggle between man and nature, the opposition between good and evil, life and death, and homosocial friendship in the face of a hostile environment.

This ambitious project was given to a young Steven Spielberg, who had previously directed only two feature films. Spielberg was excited by the idea of replicating the schema his own film *Duel* (the David versus Goliath story) in a new scenario (not on land but in the water). He mixed the evergreen appeal of the previously-mentioned archetypical elements, inserting them within the framework of contemporary America. The choice of the release date at the beginning of the summer, when people start to go the beach for their holidays, helped intensify the film's appeal – making *Jaws* an extraordinary success at the worldwide box office. Within a few weeks it became the first film to overcome the $100 million threshold that nobody thought could be beaten. Today, *Jaws* is considered the first blockbuster movie. It established the rules for a successful Hollywood renaissance: a film plot based on a best-selling novel and a target group younger than in the past. But *Jaws* was something new, too.

From an industrial perspective, it represents a turning point for the American film industry because it successfully inaugurated two strategies still widely and successfully used in the blockbuster domain: the saturation of theatres in the opening weekend and film promotion through an intensive television advertising campaign. *Jaws* opened in 409 theatres (a record for that time) which became 675 in the sixth week, and, for its opening, Universal purchased at least one thirty-second advert on every prime time network television during the evening of the three days preceding the premiere. The film experience offered *Jaws'* appeal, based on the image of

the shark, and the special effects used to bring it to life on screen represents a return to the 'Cinema of Attractions'. *Jaws* does not necessarily offer an intellectual adventure, but the opportunity to experience a magic moment that immediately satisfies spectator-desire to see something great, unusual, and genuinely scary. In sum, the power of Hollywood film to to captivate and entertain.

Marco Cucco

The Lord of the Rings: The Fellowship of the Ring

Studio/Distributor:
New Line Cinema

Director:
Peter Jackson

Producers:
Peter Jackson
Barry Osborne

Screenwriters:
Peter Jackson
Phillipa Boyens
Fran Walsh

Cinematographer:
Andrew Lesney

Art Director:
Dan Hennah

Editor:
John Gilbert

Duration:
178 minutes

Genre:
Fantasy

Cast:
Elijah Wood
Sean Astin
Billy Boyd
Dominic Monaghan

Synopsis

A magic ring of great power makes its way, via his uncle Bilbo, into the unlikely hands of a young Hobbit called Frodo Baggins. The ring not only renders its wearer invisible but is also revealed to be a formidably powerful object created by the dark lord, Sauron, to rule and corrupt Middle Earth. On the urging of Gandalf, a wise wizard, Frodo leaves his idyllic home in Hobbiton to carry the ring across Middle Earth to the fires of the volcano in which it was made and there to destroy the ring and thus rid the land of evil. Sauron, however, has become aware of the whereabouts of the ring and has sent his minions, the Ring Wraiths, to hunt for it. Saruman, a former friend of Gandalf, has turned to evil and is also hunting the ring. Frodo is accompanied on his journey by his loyal friend, Samwise Gamgee, and, at the elf stronghold of Rivendell, is joined by a diverse range of companions, including an elf and a dwarf, who make up the eponymous fellowship. Their journey takes them through a diverse range of landscapes, from snowy mountains to deep mines, and sees them fighting and defeating a variety of enemies, orcs, goblins and even the threat of betrayal from within the fellowship. As the first film in a trilogy, the conclusion is necessarily open-ended. The fellowship dissolves amidst heroism, treachery and sacrifice, as Frodo continues his quest, aided only by his first companion, Sam, whilst the three remaining heroes set off in pursuit of the orcs who have kidnapped their friends.

Critique

As with *Star Wars* (1977), *The Lord of the Rings* resists level-headed critical appreciation. This is not only because of its fervid fan base but because it spawned so many imitators of radically-varying quality. It is almost difficult to recall that this initial instalment presented audiences with a refreshing rethinking of a moribund genre. Based on JRR Tolkien's popular classic and foundational text of the fantasy genre, the film dispatches or ignores many fantasy clichés, as its wizards fight each other without resorting to lightening bolts, the humour is witty, rather than cute and the violence achieves a genuine

Ian McKellan
Viggo Mortensen
Orlando Bloom
John Rhys-Davies
Sean Bean
Liv Tyler
Ian Holm
Hugo Weaving
Christopher Lee

Year:

2001

grittiness, perhaps inspired by Peter Jackson's background in grungy low-budget horror. Benefitting undoubtedly from the increasingly-sophisticated technology available, the film-makers also showed a willingness to blend old techniques (such as miniatures) with state-of-the-art CGI innovation. Jackson, formerly a cult director of the aforementioned over-the-top horror fare and the astonishing sui generis *Heavenly Creatures* (1994), masterfully blends studio-created environments with surprising and fresh-looking location work in New Zealand. His camera movement and editing succeed in imbuing the epic with a much-needed kinetic drive. Much of this innovation and original thinking, however, was in itself to turn rapidly into cliché as the decade progressed through a plethora of fantasy cinema offerings, complete with soaring helicopter camera work and armies clashing on plains.

This flight to fantasy also profited from its timeliness as it inaugurated a decade which, perhaps in reaction to the horrors of world terrorism and the murky contradictions of the resulting war on terror, found the moral simplicities and wish-fulfilment of Middle Earth, Harry Potter and Narnia increasingly attractive. The story presents us with the comfortingly-defined binaries of good and evil. Conflicts within the camp of good are resolved with relative ease, Dwarf versus Elf racism is predictably overcome, and even those who are tempted to fall, Bilbo's junkie withdrawal from the ring and Boromir's temporary insanity are momentary slips which are quickly rectified. The one character that turned permanently from good, Saruman, is played by Christopher Lee and therefore seems generically predestined to his role as the only visible bad guy of the piece (Sauron being merely a large disembodied fiery eye and a growling voice). The film accelerates Tolkien's dipping narrative of alternating danger with comfort, peril alleviated with sanctuary, by removing some of the sanctuaries provided by the book and injecting a genuine feeling of dread which builds as the relentless pursuit continues. The performances are convincing and the actors, like the screenwriters, opt to take Tolkien's sub-Shakespearean speech patterns seriously, meticulously pronouncing the correct place names and the Elvish characters speaking their own subtitled language. Made contemporaneously, the *Lord of the Rings* trilogy acquired a unique consistency. Notwithstanding this, with the surprise factor as the initial film and with its pared down unidirectional quest plot, *The Fellowship of the Ring* is the most satisfying of the series, avoiding the flabbiness of the later films.

John Bleasdale

Star Wars

Studio/Distributor:

Lucasfilm
20th Century Fox

Director:

George Lucas

Producer:

Gary Kurtz

Screenwriter:

George Lucas

Cinematographer:

Gilbert Taylor

Art Directors:

Leslie Dilley
Norman Reynolds

Editors:

Richard Chew
Paul Hirsch
George Lucas
Marcia Lucas

Duration:

121 minutes

Genre:

Science Fiction

Cast:

Mark Hamill
Harrison Ford
Carrie Fisher
Peter Cushing
Alec Guinness
Peter Mayhew
Anthony Daniels
Kenny Baker
David Prowse

Year:

1977

Synopsis

Star Wars, subtitled *Episode IV: A New Hope*, is both the first instalment of George Lucas's space opera trilogy and fourth film in his epic series of six charting the futuristic history of a galaxy far, far away. Amidst the war between the evil Empire and heroic Rebellion, the plot centres on a teenage farm boy who dreams of joining the resistance and becoming a pilot like his father. After acquiring the two service droids R2-D2 and C-3PO, bought by his uncle to help on the farm, Luke Skywalker finds that one of the droids carries a plea for help directed to Obi-Wan (Ben) Kenobi from the rebel Princess Leia. Luke and Kenobi join forces and hire Han Solo, with co-pilot Chewbacca, to help them save her. En route, Luke learns the ways of the force and thus starts on the road to becoming a Jedi Knight. Discovering that the princess is held captive on the Death Star the heroes attempt to rescue her and put the Empire's deadliest weapon out of action. Success comes at a price, as Luke witnesses the death of Kenobi at the hands of the evil Darth Vader. Escaping to a rebel base, he joins the Rebellion on a mission to destroy the Death Star, with Solo and Chewbacca joining the dogfight. With the target in sight, Luke follows the guidance of his Jedi mentor and finally harnesses the power of the force to defeat evil.

Critique

At the heart of the film's popularity and longevity is a solid foundation from which the *Star Wars* narrative has sprung. Myth, Lucas's bread and butter, has been central to the story of its success. Whether it be the myth of the Hero with a Thousand Faces first discussed by Joseph Campbell in 1949, which posits that all myths from around the world share a similar structure of a hero that ventures out into the world, undertakes tasks and returns with certain powers and gifts, or whether the myth is personal, connected to how fans become fans, remembering that life-changing moment when they first watched *Star Wars* and were hooked, the function of myth in *Star Wars* is to pull us in and keep us entertained.

Using Jungian psychology one can see 'film as a primary myth and thus a key reflection of cultural identity' (Telotte 2001). For Jung, the individual was central, their personal journey on the path of individuation – learning about the human environment and gaining self-knowledge – leads to a realization and formation of the self (Telotte 2001: 48). For characters such as the cowboy or superhero who act primarily on their own there is a point in a film when the self is activated, perhaps triggered by scenes of personal disaster, such as losing a loved one or assuming their superpowers for the first time, and they embark on their own personal mission to attain individuation: This definitive moment in *Star Wars* is

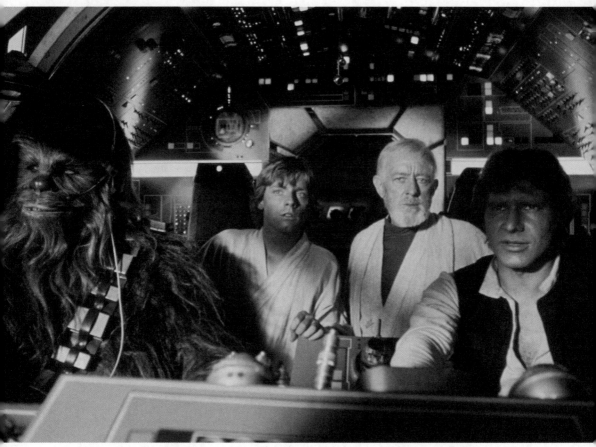

Star Wars Episode IV: A New Hope, 1977, Lucasfilm/20th Century Fox.

perhaps one of the most remembered in cinema history, when Luke Skywalker decides to go with Ben Kenobi and learn to become a Jedi after he sees his aunt and uncle killed at the hands of the Empire (see Galipeau 2001: 33–4).

That scene, taken as a microcosm of how a single event can spur people into action, clearly shows the extent to which George Lucas used myth to bring back hope to a nation when it seemed in short supply in 1977. His vision was to resurrect the myths and legends that once defined America but had since been forgotten because people had more pressing social problems to deal with: the economy was at an all-time low, the Vietnam War had just finished with no clear victor, and Watergate caused scandal within a government that had already lost public confidence. The nation was in definite need of a cultural tonic that would inspire people and speak to their concerns and at the same time 'offer some timeless wisdom' (Henderson 1997: 6). Lucas was responding to his own social times and acted upon the contemporary issues that faced America in the seventies. *Star Wars* is a hopeful

story, where Jedi faith in the Force offers those battling the evil Empire the possibility of redemption. For David Wilkinson, Lucas gave the nation 'hope that all things will be good in the end' and that hope was 'located in the transcendent, that is, the Force, working through the response of people' (Wilkinson 2000: 96).

As a result, the mythic and futuristic times offered by the *Star Wars* universe offer a way out of dealing with contemporary life; it is not because audiences want to live in a mythic past but rather history and myth offer a better template to fantasize about and create the future. Brooks Landon's claim that science fiction is not about 'what the future might hold, but the inevitable hold of the present over the future' makes clear that it is the present that determines what constitutes our science fiction (Landon 1991: 239). Therefore, *Star Wars* uses myth as a means to counteract the turmoil and uncertainty of that present American, and perhaps global, society.

Lincoln Geraghty

References

Galipeau, S (2001) *The Journey of Luke Skywalker: An Analysis of Modern Myth and Symbol*, Chicago and La Salle: Open Court.

Henderson, M (1997) *Star Wars: The Magic of Myth*, New York: Bantam Books.

Landon, B (1991) 'Bet On It: Cyber/video/punk/performance', in L McCaffery (ed), *Storming the Reality Studio*, Durham: Duke University Press, pp. 239–44.

Telotte, JP (2001) *Science Fiction Film*, New York: Cambridge University Press.

Wilkinson, D (2000) *The Power of the Force: The Spirituality of the Star Wars Films*, Oxford: Lion Publishing.

Superman

Studio/Distributor:

Alexander Salkind
Warner Bros

Director:

Richard Donner

Producers:

Alexander Salkind
Ilya Salkind
Pierre Spengler
Michael Thau (2000 restoration)

Synopsis

On the planet Krypton, Jor-El serves judgment on a group of criminals, and attempts to warn the ruling council that their planet is in danger. His warnings come too late as the planet begins to break apart; but Jor-El and his wife Lara have prepared an escape vessel for their baby son Kal-El, whom they launch into space and on a path to Earth just before Krypton explodes. Kal-El's ship crashes in Smallville, Kansas, and he is raised with human, compassionate values by Jonathan and Martha Kent, who decide to call him Clark. When he grows up, Clark Kent travels to the Arctic, where he assembles a 'Fortress of Solitude' with technology from his home planet. After learning further lessons from Jor-El via a programmed hologram, Clark establishes himself as a mild-mannered reporter in Metropolis, and adopts the alternate public

Screenwriters:

Jerry Siegel
Joel Shuster
Mario Puzo
David Newman
Leslie Newman
Robert Benton
Tom Mankiewicz

Cinematographer:

Geoffrey Unsworth

Art Director:

Ernest Archer

Editors:

Stuart Baird
Michael Ellis
Michael Thau (2001 Director's
Cut)

Duration:

143 minutes (international)
151 minutes (2000 restoration)

Genre:

Science Fiction/Superhero/
Adventure

Cast:

Marlon Brando
Gene Hackman
Christopher Reeve
Margot Kidder
Ned Beatty
Jackie Cooper
Glenn Ford

Year:

1978

persona of Superman, fighting for truth, justice, and the American way against common criminals and masterminds such as Lex Luthor. He also meets and falls in love with fellow reporter Lois Lane.

Critique

Producers Alexander and Ilya Salkind and Pierre Spengler acquired theatrical rights to Superman during the early 1970s, and shot two films back-to-back at Pinewood Studios in England (director Donner left midway through production of the second film). Brando and Hackman's attachment guaranteed early interest, but Reeve's performance in the title role and John Williams' memorable score helped make *Superman* a classic of its genre. Essentially divided into three acts, the first section of the film introduces us to Superman's birth parents Jor-El and Lara, the unstable nature of the planet Krypton, and its subsequent explosion. The second act concentrates on Kal-El/Clark Kent's arrival and childhood in Smallville, and his eventual departure to the Arctic to construct the Fortress of Solitude (a visually-stunning 'second home' assembled with ice crystals), and the last section of the film depicts the grown-up Kent making a name for himself as both a reporter and superhero in Metropolis. Reeve was relatively unknown at the time, and brings a sincere humanity to the Kent/Superman character that has not been matched by any actor since; he deftly handles drama, comedy and action – often all in one scene (and Reeve's flying sequences remain impressive). Hackman portrays Lex Luthor as a criminal genius and credible menace with occasional comedic undertones, and Brando's Jor-el is the ultimate father figure. 'This is no fantasy', he intones in the opening lines of the film, 'no careless product of wild imagination'.

Superman is still seen as the model to follow for most contemporary film-makers adapting similar genre material. Williams' score continues to be referenced in contemporary media depictions of the character, including the semi-sequel *Superman Returns* (2006) and the long-running television series *Smallville* (2001–2011), which chronicles Clark Kent's early years before he adopts the Superman persona. The crystal design aesthetic for the Fortress of Solitude has also endured (even in contemporary video game adaptations such as the corporate crossover *Mortal Kombat vs. DC Universe* [2008]).

Richard Lester's *Superman II* (1980) had a lighter, campier sensibility than the first film, but its Kryptonian villains were well-characterized and the drama efficiently delivered. *Superman III* (1983) was a failure, however; it featured comedian Richard Pryor in a central role, but Hackman's Luthor was mysteriously absent. A spin-off featuring Superman's cousin, *Supergirl* (1984), was equally unsuccessful, but Menahem Golan and Yoram Globus managed to produce one more film with Reeve, *Superman IV: The Quest for Peace* (1987).

After many failed attempts to restart the franchise, Warner Bros hired Bryan Singer to direct the $200 million-budgeted *Superman Returns*, which opened to decent critical reviews but deeply-divided fans, and was not financially or creatively successful enough to warrant a sequel. Connecting his film to the previous franchise, Singer negotiated with Brando's estate to utilize and re-composite footage of the actor for a short scene in the Fortress of Solitude. As a tie-in of sorts, Warner Bros gave Donner the opportunity to re-assemble a 'new' version of *Superman II* which contained a large amount of previously-unreleased footage, including significant scenes with Brando. Production of further films has been complicated by legal conflicts involving the heirs and estates of Jerry Siegel and Joe Shuster, who are attempting to (re)assert their rights to the character(s).

Michael S Duffy

Titanic

Studio/Distributor:
Lightstorm Entertainment
20th Century Fox
Paramount Pictures

Director:
James Cameron

Producers:
James Cameron
Jon Landau

Screenwriter:
James Cameron

Cinematographer:
Russell Carpenter

Art Director:
Peter Lamont

Composer:
James Horner

Editors:
Conrad Buff
James Cameron
Richard A Harris

Duration:
194 minutes

Synopsis

A group of treasure hunters are searching the Titanic's wreckage in order to find a legendary diamond buried in the depths. An old lady recognizes herself in a portrait found in the wreckage when it is shown on TV by the hunters; she contacts them and, telling her story, she goes back to 1912, to the dock of Southampton where the Titanic is leaving. She is beautiful, rich and unhappy when she gets on the ship, and she meets Jack, a young artist. They immediately fall in love, but the ship hits an iceberg and begins to sink; meanwhile, Jack is framed by Rose's fiancée and chained in the Titanic's hold. Rose desperately tries to free Jack, but the sinking seems to end all their dreams and hopes.

Critique

James Cameron has always played with the future, imagining the realities of times yet to come. Cameron links the projection of his imaginative tools to the possibilities offered by cinematographic technology, trying to find the appropriate visual tools that can give the audience the coordinates necessary for a more-than-simply-amazing journey inside the imagined or foreseen worlds.

In Cameron's view, technology and its cinematographic application is not a simple consequence of the narrative necessities he intends to develop in the movie: the anticipated visualization, the mental pre-envisioning of the entire visual environment he desires to create, asks of technology all the necessary possibilities that are needed to transform the foreseen images into filmic reality. Thus, Cameron has always deployed visual metaphors of digital technology, moving from

Genre:

Romance/Disaster film/Historial film

Cast:

Kate Winslet

Leonardo Di Caprio

Bill Paxton

Year:

1997

the biological to the inorganic in a continuous contamination and hybridization between the traditional cinematographic image and the narrative stabilities of the visual dimension.

But it is with *Titanic* that the productive dialectic between the mechanical and the human which Cameron has built throughout his filmography reaches its theoretical peak: for the first time he leaves the usual futuristic and dystopic settings and goes back into the past. The worldwide success of *Titanic* was the occasion for a radical rethinking of cinematic language, a sort of summary of the twentieth century that projects Cameron's cinema into the arms of the following millennium. Realized at the end of the 1990s, using the highest level of visual technology available at that time, *Titanic* goes back to the beginning of the century to find in the sinking of the great transatlantic ship the symbolic turn of a century that begins with a traumatic event. The failure of the technological civilization, paired with the extraordinary adoption of the best available cinematographic technology, represents Cameron's paradoxical experiment: the will to characterize the failure of human control over technology through the triumph of the absolute power exerted by a visionary man and his crew upon an historical fact and its visual transposition, its hi-tech actualization.

What Cameron questions in *Titanic* is the possibility of technology to exist outside of human responsibility, and this key theoretical issue of the whole twentieth century is displayed while the absolute perfection of the digital visual effects is adopted in order to reach the strongest emotional response in the long sequence of the wreck, and an astonishing level of philological sharpness in the entire movie. The apotheosis of the digital images is sought by Cameron because it seems an essential instrument in the denial of the catastrophic humanism that considers technology as antithetical to authenticity.

The miracle of *Titanic* is that this profound reflection about a 'problematic technology' does not emerge from a science-fiction movie but, rather, shines through the essentiality of the love story between the rich and bored Rose and the exuberant and poor Jack. Their love stays at the centre of a vertiginous narrative that involves dozens of secondary characters; the focus of the narrative is strongly anchored in the adventures of the young couple (their falling in love, the canonical obstacles of a trans-social love, the menace of death) and Cameron succeeds precisely because *Titanic* re-writes the rules of the disaster movie, contaminating it with melodrama and never dispersing the narrative core of the story. Going back into the past (of human history, of cinematic structures) offers Cameron the occasion for a sharper visit to the beginning of the future he investigates in every movie: he discovers the moment when humanity understands it is just an engine that needs to interact with other, non organic, engines in order to create the complex machines necessary for imagining every possible future.

Franco Marineo

Transformers

Studio/Distributor:
DreamWorks SKG
Paramount Pictures

Director:
Michael Bay

Producers:
Lorenzo di Bonaventura
Tom DeSanto
Don Murphy
Ian Bryce
Steven Spielberg

Screenwriters:
Roberto Orci
Alex Kurtzman

Cinematographer:
Mitchell Amundsen

Art Directors:
Sean Haworth
Beat Frutiger
Kevin Kavanaugh

Synopsis

At a US air base in Qatar an unidentified helicopter metamorphosizes into a robot that decimates military personnel and vehicles in an attempt to access classified computer files; in Los Angeles a geeky teenager Sam Witwicky buys a second-hand car that soon develops a mind of its own. The explanation for both these events is that competing alien robots have unleashed themselves on an unsuspecting planet. The Autobots and the Decepticons are disguised in plain sight as terrestrial vehicles, their long-running war about to be fought out across human cities and territories. Both sides are searching for the 'All Spark', an ancient cube that can either give life or destroy it, which lies lost somewhere on Earth. Sam holds the key to the cube's location: aided by various branches of the US military and Mikaela, feisty classmate and object of his affection, he must fight to save the planet from this destructive robot war.

Critique

Transformers paints its narrative of teenagers caught up in a war between alien robots with a broad brush. Characterization and plot points are sketched in quickly, interposing moments of often wryly-humorous human interaction (the stuttering and false starts of teenage flirtation, parental obsessions with neat gardens and dressing the family pet in 'bling' outfits) with impossibly-complex computer-generated

Transformers, 2007, Dreamworks.

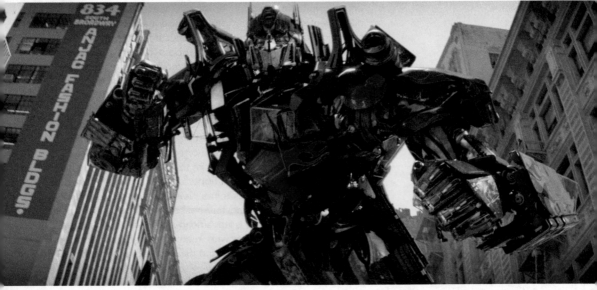

Editors:

Paul Rubell

Glen Scantlebury

Thomas A Muldoon

Duration:

144 minutes

Genre:

Science Fiction/Action

Cast:

Shia LaBeouf

Megan Fox

Josh Duhamel

Tyrese Gibson

Jon Voight

John Turturro

Peter Cullen

Year:

2007

robotic transformations and frenetic, loud, extended action sequences. Exaggerating an existing facet of the action genre, this is a film in thrall to the brute force and high technology of modern military machines, but also to the chrome, headlights and horsepower of the automobile, which find their fetishized manifestation in the Autobots' and Decepticons' glittering, reflective vehicular surfaces. Knowing nods to the America's cultural obsession with owning, racing and decorating cars find a visual correlation in the 'trans-former' robots themselves, who (in some pointed product placement) select as their disguises gleaming vehicles from sought-after automobile companies, upgrading their body-work at will. The fast-talking teenager anchoring the action is a descendant of the wisecracking heroes of *Die Hard* (1988) and *Lethal Weapon* (1987), his youth reflective of the diversifying age range of the male action hero in recent years as ageing stars such as Sly Stallone and Bruce Willis jostle for position with younger actors such as Tom Cruise and Jason Statham and fresh-faced newcomers like LaBeouf. Transported from the banality of everyday life to a situation in which his actions will decide the fate of millions, Sam's nar-rative trajectory and youthfulness also connect him to Lucas and Spielberg's more family-oriented blockbusters of the late 1970s and early 1980s, and the 'geek-as-hero' wishfulfilments of films like *War Games* (1983) and *The Matrix* (1999).

Michael Bay is often derided for the expansive audio-visual spectacles that punctuate his films, and his alleged descrip-tion of his approach as 'fucking the frame' has become famous through frequent repetition by disdainful reviewers and bloggers. But the words simply mark him as one of the more enthusiastically vulgar proponents of a mode of big-budget, mainstream-Hollywood film-making that seeks prod-uct differentiation through large-scale spectacle and overt displays of state-of-the-art digital image manipulation. In a clear example of blockbuster economic imperatives at work, the action sequences present the robots from the 1980s' toy franchise source in ever-more extended and elaborately computer-generated transformations and battle interactions, pushing at the boundaries of visual comprehensibility and spectator engagement in the process. The film also typifies the ideological opportunism of many contemporary US block-busters, progressive elements sitting uncomfortably along-side reactionary aspects that are often played for laughs. The carefully multiracial casting of the US soldiers, including Latino and African-American fighters, co-exists with the racial stereotyping of a range of minor characters; car salesman Bobby Bolivia (Bernie Mac) and hacker Glen Whitmann (Anthony Anderson) are both African-Americans with some-what abusive relationships with 'mammies' that monitor their lives, while US soldiers are put at risk by a disinterested Indian call-centre worker (Ravi Patel) who obstructs their emergency call to the Pentagon. *Transformers'* gender politics are no less

problematic: Sam's love interest Mikaela is feisty, assertive, and a knowledgeable car mechanic, but she is persistently positioned as a sexual object both for Sam and the lingering camera.

Transformers is, then, a typically conservative, brash, energetic and occasionally wry example of the contemporary action-blockbuster formula. Noisier than the rest of the pack though it may have been on its release, its principle of 'more is more' was not new, and continues to shape the aesthetics of subsequent blockbusters as they seek to maximize their box office takings and ancillary markets ever further.

Lisa Purse

Allen, RC & Gomery, D (1985) *Film History: Theory and Practice*, Boston: McGraw-Hill.

Belton, J (1994) *American Cinema/American Culture*, New York: McGraw-Hill.

Bordwell, D, Thompson, K & Staiger, J (1985) *The Classical Hollywood Cinema: Film Style and Mode of Production to 1960*, London: Routledge.

Dyer, R (1998) *Stars*, London: BFI Publishing.

Gomery, D (1992) *Shared Pleasures: A History of Movie Presentation in the United States*, London: BFI Publishing.

Gomery, D (2005) *The Coming of Sound: A History*, London: Routledge.

Grainge, P, Jancovich, M, & Monteith, S (2007) *Film Histories: An Introduction and Reader*, Edinburgh: Edinburgh University Press.

Grieveson, L (2004) *Policing Cinema: Movies and Censorship in Early Twentieth-Century America*, Berkeley: University of California Press.

Sklar, R (1994) *Movie-Made America: A Cultural History of America Movies* (revised ed) New York: Vintage.

Thompson, K & Bordwell, D (2003) *Film History: An Introduction* (2nd edition) Boston: McGraw-Hill.

Waller, G (ed) (2001) *Moviegoing in America: A Sourcebook in the History of Film Exhibition*, Oxford: Blackwell.

Directors

Clint Eastwood

Cornell, D (2009) *Clint Eastwood and Issues of American Masculinity*, New York: Fordham University Press.

Hughes, H (2009) *Aim for the Heart: The Films of Clint Eastwood*, London: IB Tauris.

Kitses, J (2004) *Horizons West: Directing the Western From John Ford to Clint Eastwood*, London: BFI Publishing.

Munn, M (1992) *Clint Eastwood: Hollywood's Loner*, London: Robson.

Schickel, R (2010) *Clint: A Retrospective*, New York: Sterling Publishing Co Inc.

John Ford

Cowie, P (2004) *John Ford and the American West*, New York: Harry N Abrams, Inc.

Eyman, S (1999) *Print the Legend: The Life and Times of John Ford*, Baltimore, MD: Johns Hopkins University Press.

Gallagher, T (1986) *John Ford: The Man and His Films*, Berkeley, CA: University of California Press.
McBride, J (2001) *Searching for John Ford: A Life*, New York: St Martin's Press.
Studlar, G & Bernstein, M (eds) (2001) *John Ford Made Westerns: Filming the Legend in the Sound Era*, Bloomington, IN: Indiana University Press.

DW Griffith
Barry, I (1965) *DW Griffith: American Film Master*, Garden City, NY: Doubleday.
Gunning, T (1991) *DW Griffith and the Origins of American Narrative Film: The Early Years at Biograph*, Urbana, IL: University of Illinois Press.
Henderson, RM (1971) *DW Griffith: The Years at Biograph*, London: Secker and Warburg.
Pearson, RE (1992) *Eloquent Gestures: The Transformation of Performance Style in the Griffith Biograph Films*, Berkeley, CA: University of California Press.
Schickel, R (2004) *DW Griffith: An American Life*, New York: Limelight Editions.

Steven Spielberg
Buckland, W (2006) *Directed by Steven Spielberg: Poetics of the Contemporary Hollywood Blockbuster*, London: Continuum.
Friedman, LD (2006) *Citizen Spielberg*, Urbana, IL: University of Illinois Press.
Gordon, A (2008) *Empire of Dreams: The Science Fiction and Fantasy Films of Steven Spielberg*, Lanham, MD: Rowman & Littlefield.
Morris, N (2007) *The Cinema of Steven Spielberg: Empire of Light*, London: Wallflower.
Wasser, F (2009) *Spielberg's America*, Cambridge: Polity Press.

Genre
Altman, R (1999) *Film/Genre*, London: BFI Publishing.
Geraghty, L & Jancovich, M (eds) (2008) *The Shifting Definitions of Genre: Essays on Labeling Films, Television Shows and Media*, Jefferson, NC: McFarland Publishers.
Grant, BK (ed) (2003) *Film Genre Reader III*, Austin, TX: University of Texas Press.
Neale, S (2000) *Genre and Hollywood*, London: Routledge.
Schatz, T (1981) *Hollywood Genres: Formulas, Film-making and the Studio System*, Boston: McGraw-Hill.

Westerns

Buscombe, E & Pearson, RE (eds) (1998) *Back in the Saddle Again: New Essays on the Western*, London: BFI Publishing.

Coyne, M (1997) *The Crowded Prairie: American National Identity in the Hollywood Western*, London: IB Tauris.

McGee, P (2007) *From Shane to Kill Bill: Rethinking the Western*, Oxford: Blackwell.

Saunders, J (2001) *The Western Genre*, London: Wallflower.

Walker, J (2001) *Westerns: Films through History*, London: Routledge.

Crime Films

Grieveson, L, Sonnet, E & Stanfield, P (eds) (2005) *Mob Culture: Hidden Histories of the American Gangster Film*, New Brunswick, NJ: Rutgers University Press.

Mason, F (2002) *American Gangster Cinema: From Little Caesar to Pulp Fiction*, Basingstoke: Palgrave.

Munby, J (1999) *Public Enemies, Public Heroes: Screening the Gangster from Little Caesar to Touch of Evil*, Chicago, IL: University of Chicago Press.

Shadoian, J (2003) *Dreams and Dead Ends: The American Gangster Film* (2nd edition) Oxford: Oxford University Press.

Spicer, A (2002) *Film Noir*, Harlow: Pearson Education.

Science Fiction

Cornea, C (2007) *Science Fiction Cinema: Between Fantasy and Reality*, Edinburgh: Edinburgh University Press.

Geraghty, L (2009) *American Science Fiction Film and Television*, Oxford: Berg.

Redmond, S (ed) (2004) *Liquid Metal: The Science Fiction Film Reader*, London: Wallflower.

Sobchack, V (1998) *Screening Space: The American Science Fiction Film*, New Brunswick, NJ: Rutgers University Press.

Telotte, JP (2001) *Science Fiction Film*, Cambridge: Cambridge University Press.

Horror

Heffernan, K (2004) *Ghouls, Gimmicks and Gold: Horror Films and the American Movie Business*, Durham, NC: Duke University Press.

Jancovich, M (1992) *Horror*, London: BT Batsford.

Lowenstein, A (2005) *Shocking Representation: Historical Trauma, National Cinema, and the Modern Horror Film*, New York: Columbia University Press.

Tudor, A (1989) *Monsters and Mad Scientists: A Cultural History of the Horror Movie*, Oxford: Basil Blackwell.

Worland, R (2007) *The Horror Film: An Introduction*, Oxford: Blackwell.

Comedy

Beach, C (2002) *Class, Language, and American Film Comedy*, Cambridge: Cambridge University Press.

Jenkins, H (1992) *What Made Pistachio Nuts?: Early Sound Comedy and the Vaudeville Aesthetic*, New York: Columbia University Press.

King, G (2002) *Film Comedy*, London: Wallflower.

Krutnik, F (ed) (2003) *Hollywood Comedians: The Film Reader*, London: Routledge.

Rickman, G (ed) (2001) *The Film Comedy Reader*, New York: Limelight Editions.

Historical Films

Barta, T (ed) (1998) *Screening the Past: Film and the Representation of History*,
 Westport, CT: Praeger.
Burgoyne, R (2008) *The Hollywood Historical Film*, Oxford: Blackwell.
McCrisken, A & Pepper, A (2005) *American History and Contemporary
 Hollywood Film*, Edinburgh: Edinburgh University Press.
Richards, J (2008) *Hollywood's Ancient Worlds*, London: Continuum.
Russell, J (2007) *The Historical Epic and Contemporary Hollywood: From Dances
 With Wolves to Gladiator*, London: Continuum.

Musicals

Bergman, A (1972) *We're in the Money: Depression American and Its Films*, New
 York: Harper & Row.
Dyer, R (2002) 'Entertainment and Utopia', in S Cohan (ed) *Hollywood Musicals:
 The Film Reader*, London: Routledge, pp. 19–30.
Feuer, J. (1993) *The Hollywood Musical* (2nd edition) London: MacMillan.
Jones, JB (2003) *Our Musicals, Ourselves: A Social History of the American
 Musical Theatre*, Hanover, NH: Brandeis University Press.
Marshall, B & Stilwell, R (eds) (2000) *Musicals: Hollywood and Beyond*, Exeter:
 Intellect.

War Films

Basinger, J (2003) *The World War II Combat Film: Anatomy of a Genre*,
 Middletown, CT: Wesleyan University Press.
Doherty, T (1999) *Projections of War: Hollywood, American Culture, and World
 War II*, New York: Columbia University Press.
Slocum, JD (ed) (2006) *Hollywood and War: The Film Reader*, London:
 Routledge.
Weber, C (2005) *Imagining America at War: Morality, Politics and Film*, London:
 Routledge.
Westwell, G (2006) *War Cinema: Hollywood on the Front Line*, London:
 Wallflower.

Dramas

Byers, J (1991) *All that Hollywood Allows: Re-reading Gender in 1950s
 Melodrama*, London: Routledge.
Cohan, S & Hark, IR (eds) (1997) *The Road Movie Book*, Oxford: Routledge.
Klinger, B (1994) *Melodrama and Meaning: History, Culture and the Films of
 Douglas Sirk*, Bloomington, IN: Indiana University Press.
Lang, R (1989) *American Film Melodrama: Griffith, Vidor, Minnelli*, Princeton,
 NJ: Princeton University Press.
Walters, J (2008) *Alternative Worlds in Hollywood Cinema: Resonance Between
 Realms*, Bristol: Intellect.

Romance

Abbott, S & Jermyn, D (eds) (2009) *Falling in Love Again: Romantic Comedy in
 Contemporary Cinema*, London: IB Tauris.
Evans, PW & Deleyto, C (eds) (1998) *Terms of Endearment: Hollywood Romantic
 Comedy of the 1980s and 1990s*, Edinburgh: Edinburgh University Press.
Jeffers McDonald, T (2007) *Romantic Comedy: Boy Meets Girls Meets Genre*,
 London: Wallflower.

Rubinfeld, MD (2001) *Bound to Bond: Gender, Genre, and the Hollywood Romantic Comedy*, Westport, CT: Praeger.

Thomas, D (2000) *Beyond Genre: Melodram, Comedy and Romance in Hollywood Film*, Moffat: Cameron & Hollis.

Animation

Barrier, M (1999) *Hollywood Cartoons: American Animation in its Golden Age*, New York: Oxford University Press.

McQuillan, M & Byrne, E (1999) *Deconstructing Disney*, London: Pluto Press.

Wells, P (2002a) *Animation and America*, Edinburgh: Edinburgh University Press.

Wells, P (2002b) *Animation: Genre and Authorship*, London: Wallflower.

Wells, P (1998) *Undertstanding Animation*, London: Routledge.

Blockbusters

Greenberg, J (2008) *From Betamax to Blockbuster: Video Stores and the Invention of Movies on Video*, Cambridge, MA: MIT Press.

King, G (2000) *Spectacular Narratives: Hollywood in the Age of the Blockbuster*, London: IB Tauris.

Sandler, KS & Studlar, G (eds) (1998) *Titanic: Anatomy of a Blockbuster*, New Brunswick, NJ: Rutgers University Press.

Stringer, J (ed) (2003) *Movie Blockbusters*, London: Routledge.

Wyatt, J (1994) *High Concept: Movies and Marketing in Hollywood*, Austin, TX: University of Texas Press.

AMERICAN HOLLYWOOD CINEMA ONLINE

Ain't It Cool News
http://www.aintitcool.com
Off-beat site that gives fans the insider knowledge of the latest Hollywood blockbuster.

Box Office Guru
http://www.boxofficeguru.com
A valuable resource for those who want to know how their favourite film performed at the box office.

Bright Lights Film Journal
http://www.brightlightsfilm.com
A mix of academic and popular criticism of both past and present film.

Cinemas of America
http://cinematreasures.org/
A valuable site dedicated to archiving history about America's lost cinemas and saving existing ones from demolition.

Directory of World Cinema
http://worldcinemadirectory.org/
Intellect's online repository for global cinema containing valuable information about the latest national releases and classics from a bygone age.

Entertainment Weekly
http://www.ew.com/ew
The Hollywood gossip machine that keeps fans up to date about the latest celebrity scandal.

Film-Philosophy.com
http://www.film-philosophy.com/index.php/f-p
An international scholarly journal dedicated to the philiosophical reading of film.

The Hollywood Reporter
http://www.hollywoodreporter.com/hr/film/index.jsp
More news and reviews from inside the Hollywood dream factory.

The Internet Movie Database
http://www.imdb.com
The leading website dedicated to the cataloguing of national and international film and television.

Jump Cut
http://www.ejumpcut.org/
An online scholarly journal that analyses contemporary film and media.

The Motion Picture Association of America
http://www.mppa.org/
The MPPA website with information on the latest film releases in America, ratings system and film legistlation.

Scope: An Online Journal of Film Studies
http://www.scope.nottingham.ac.uk
A scholarly journal edited by staff and students at the University of Nottingham which publishes articles, reviews and conference up dates.

Screening the Past
http://www.latrobe.edu.au/screeningthepast
The online scholarly journal based in Australia dedicated to the study of film history.

Screensite
http://www.screensite.org
A valuable online resource for teachers and students of film studies.

Senses of Cinema
http://www.sensesofcinema.com
An online film journal that looks at film from a more eclectic perspective.

Variety
http://www.variety.com
Online version of the Hollywood trade paper with the latest news on all things connected to the world of media entertainment.

Questions

1. In which year did Edwin S Porter direct *The Great Train Robbery*?
2. What does the term 'runaway production' mean?
3. With which two other actors did Charlie Chaplin and DW Griffith form the studio United Artists in 1919?
4. Marilyn Monroe was fired from her last film before completion; what was its name?
5. For which film did Frank Sinatra receive an Oscar and BAFTA nomination for his performance in 1955?
6. What film marked Clint Eastwood's directorial debut?
7. Why was Clint Eastwood's 2004 best director Oscar for *Million Dollar Baby* especially noteworthy?
8. Which Utah location was the site of many of John Ford's Westerns?
9. Anne Bancroft starred in Ford's last movie; what was its name?
10. After Biograph, to which studio did DW Griffith move?
11. What incident at aged 10 made Griffith want to make a mark on the world?
12. Which of Steven Spielberg's three historical films of the mid-nineties was not based on World War II?
13. In what year did Spielberg have success with both *Poltergeist* and *ET*?
14. What was the name of the star of over 300 short Westerns between 1910 and 1915?
15. Which two films provided completely opposite depictions of George Armstrong Custer?
16. What was the last Western to win the Oscar for best film before *Dances With Wolves*?
17. Mario Puzo's novel about a family of immigrant gangsters was adapted to become which seminal crime film trilogy?
18. 2006's *The Departed* was a reworking of which Hong Kong crime thriller?
19. James M Cain's *Double Indemnity* (1944) was reputedly based on which 1927 murder case?
20. What is the name of the Swiss artist whose work inspired the design for the creature in *Alien*?
21. Frank Lloyd Wright provided input into the design of the flying saucer in which 1951 science fiction film?
22. Which writer connects *The Twilight Zone* (1959–1964) and *Planet of the Apes* (1968)?

23. Which horror film remained unavailable for home viewing in the UK until 1999?
24. Which role had Mia Farrow just played before becoming Rosemary Woodhouse?
25. In which year was Stephen King's original novel *The Shining* published?
26. Whose Keystone Company developed early comedy film in Hollywood?
27. Which American city provides the backdrop for Ferris Bueller's truancy and was the home of director John Hughes?
28. What job do we see Robin Williams' character performing at the start of *Mrs Doubtfire*?
29. Cecil B DeMille produced historical films for which Hollywood studio in the 1930s?
30. *Forrest Gump*'s Robert Zemeckis directed which science fiction time-travel trilogy?
31. Where did Paul Greengrass film his 9/11 movie *United 93*?
32. Musicals that include song and dance routines as realistic components of the film such as in auditions or rehearsals are called what?
33. Who choreographed *West Side Story*?
34. What was the name of Disney's sequel to *The Wizard of Oz*?
35. On whose *Heart of Darkness* was *Apocalypse Now* based?
36. Along with *Glory* and *The Last Samurai*, which two other historical films has Edward Zwick directed?
37. What was Oliver Stone's 1989 follow up to *Platoon*?
38. Which university provides the setting for Will Hunting's transformation from janitor to genius?
39. Who sang the title song to *Philadelphia*?
40. Which US state does Louise refuse to go near in her escape from the law with Thelma?
41. Woody Allen's seventh film won him a best director Oscar; what was it?
42. Disney's *Beauty and the Beast* (1991) is based on the fairytale and which other French adaptation?
43. Nora Ephron, director of *Sleepless in Seattle* (1993), helmed another Meg Ryan and Tom Hanks film; what was it?
44. Sound was used for the first time by Disney in which early cartoon?
45. Who composed the music for Tim Burton's *The Nightmare Before Christmas*?
46. Whose Bush-like mantra, 'I was elected to lead, not to read', was uttered in *The Simpsons Movie*?
47. Which film is considered the first Hollywood blockbuster?
48. Who are Superman's parents?
49. Michael Bay and Steven Spielberg joined forces to make which 2007 blockbuster?
50. By what other name was the Production Code of 1930, created to regulate the content of Hollywood films, commonly known?

Answers

1. 1903
2. A film financed largely by American companies but made outside of Hollywood
3. Mary Pickford and Douglas Fairbanks
4. *Something's Got to Give* (1962)
5. *The Man with the Golden Arm*
6. *Play Misty for Me* (1971)
7. He became the oldest recipient of the award
8. Monument Valley
9. *Seven Women* (1966)
10. Mutual Film Corporation
11. The death of his father
12. *Amistad* (1997)
13. 1982
14. 'Broncho Billy' Anderson
15. *They Died With Their Boots On* (1941) and *Little Big Man* (1970)
16. *Cimarron* (1931)
17. *The Godfather*
18. *Infernal Affairs* (2002)
19. Ruth Snyder was executed after being convicted for persuading her lover to kill her husband to claim on his insurance policy.
20. HR Giger
21. *The Day the Earth Stood Still*
22. Rod Serling
23. *The Exorcist* (1973)
24. Allison MacKenzie in *Peyton Place* (1966)
25. 1977
26. Mack Sennett's
27. Chicago
28. Voice actor
29. Paramount
30. *Back to the Future*
31. Pinewood Studios
32. Backstage musicals
33. Jerome Robbins
34. *Return to Oz* (1985)
35. Joseph Conrad
36. *Legends of the Fall* (1994) and *Defiance* (2008)
37. *Born on the Fourth of July*
38. MIT (Massachusetts Institute of Technology)
39. Bruce Springsteen
40. Texas
41. *Annie Hall* (1977)
42. *La Belle et La Bête* (1946)
43. *You've Got Mail* (1998)
44. *Steamboat Willie* (1929)
45. Danny Elfman
46. President Arnold Schwarzenegger's
47. *Jaws* (1975)
48. Jor-El and Lara from the Planet Krypton
49. *Transformers*
50. The Hays Code

The Editor

Lincoln Geraghty is Principal Lecturer in Film Studies and Subject Leader for Media Studies in the School of Creative Arts, Film and Media at the University of Portsmouth. He received his PhD in American Studies from the University of Nottingham in 2005. He serves as editorial advisor for *The Journal of Popular Culture, Reconstruction*, and *Atlantis*, with interests in science fiction film and television, fandom, and collecting in popular culture. He is author of *Living with Star Trek: American Culture and the Star Trek Universe* (2007) and *American Science Fiction Film and Television* (2009) and the editor of *The Influence of Star Trek on Television, Film and Culture* (2008); with Mark Jancovich *The Shifting Definitions of Genre: Essays on Labeling Film, Television Shows and Media* (2008); and *Channeling the Future: Essays on Science Fiction and Fantasy Television* (2009). As well as serving as Editor for the *Directory of World Cinema: American Hollywood* he is editing a collection on the TV series *Smallville* to be published by Scarecrow and writing a monograph on cult fan collectors and nostalgia for Routledge.

Contributors

Gary Bettinson is editor of *Directory of World Cinema: China* (2011) and co-author (with Richard Rushton) of *What is Film Theory? An Introduction to Contemporary Debates* (2010). Other publications include essays in Warren Buckland (ed) *Puzzle Films: Complex Storytelling in Contemporary Cinema* (2009); Francois-Xavier Gleyzon (ed) *David Lynch/In Theory* (2010); *New Review of Film and Television Studies*; and *Film Studies: An International Review*.

Adam Bingham began studying film in 1999 and worked through nine years of a formal education in Film Studies, both undergraduate and post-graduate. In 2003, he began writing professionally for the Canadian-based film journal *CineAction* and has published material, both online and in print, in journals such as *Cineaste, Sight and Sound, Electric Sheep, Senses of Cinema, Asian Cinema* and *Screen*. His particular areas of interest and research are postwar Japanese documentaries, the Japanese new wave director Yoshida Kiju, transnational genre and Hong Kong cinema, and the political exigencies of Eastern European cinema.

John Bleasdale studied at Liverpool University, gaining his PhD there. He has written articles on literature and film for such internet sites as Romanticism on

the Net and film-philosophy.com. He teaches at Ca Foscari University in Venice, Italy and is currently writing on Terrence Malick.

John Caro is currently Assistant Head for the School of Creative Arts, Film & Media at the University of Portsmouth. A graduate of Northumbria University's Media Production programme, in 2001 he completed an MA in Film and Video at Toronto's York University. He has directed and produced numerous short films, screening his work at Raindance and the International Tel-Aviv Film Festival. From 1983 to 1987 he was a set decorator at Pinewood Studios, working on such films as *Aliens* and *Full Metal Jacket*. More recently, his essay on the re-imagined *Battlestar Galatica* series, co-authored with Dylan Pank, appeared in Lincoln Geraghty (ed) *Channeling the Future* (2009).

Marco Cucco has a PhD in political economy of cinema from the University of Lugano (Switzerland). Currently he is teaching assistant and research fellow at the Institute of Media and Journalism at the same university, where he also coordinates the MA in Media Management. In the last years he focused his research interests on the blockbuster movie as historical, economic and cultural phenomenon. He is author of a book on the blockbusters (*Il film blockbuster. Storia e caratteristiche delle grandi produzioni hollywoodiane*) and articles published by *Media, Culture & Society, European Journal of Communication* and *Studies in Communication Sciences*.

Rob Dennis is a freelance writer and teacher of film and media, based in London. He has contributed to the *Directory of World Cinema: American Independent* (2010), as well as to *Vertigo* magazine and various film festival websites.

Ruth Doughty is a Senior Lecturer in Film Studies at the University of Portsmouth. Her research interests include African-American Cinema, Film Music and Theory. She co-edited *Sound and Music in Film and Visual Media* (2008) and *Film: The Essential Study Guide* (2008). She has more recently co-authored the book *Introduction to Film Theory: Theoretical and Critical Perspectives* (Forthcoming). She is one of the co-founding editors of the peer-reviewed Intellect journal *Transnational Cinemas*.

Michael S Duffy has an MA in Cinema Studies from New York University and a PhD in Film Studies from the University of Nottingham, and is currently an adjunct professor in film and media studies at Towson University in Maryland. His work has largely focused on the impact of industry and technology on the screen, and film-makers, feature films or television during the period of transition from practical to digital technology. He has presented at numerous international conferences and chaired panels relating to special/visual effects and science fiction. He has articles in preparation on the digital posthumous nature of Brandon Lee and his father, Bruce Lee, and on director Guillermo del Toro's organic and aesthetic approaches to film-making as well as on New Zealand's regional digital appropriation during the 1990s. He is currently exploring histories and theories of special/visual effects, and also looking at the industry's treatment of actors' posthumous performances.

Emma Dyson is an Associate Senior Lecturer in Media Studies at the University of Portsmouth specializing in teaching horror in media forms, with an interest in

global horror, particularly focused on the figure of the Zombie. Her PhD, completed in 2009, is entitled 'A Strange Body of Work: The Cinematic Zombie'.

Laurie N Ede works as a Principal Lecturer in Film and Media at the University of Portsmouth. He has written extensively on a range of film-related subjects, with a particular interest in film aesthetics, British film history and non-mainstream American cinema, and published *British Film Design: A History* (2010).

Dan Fleming is Professor of Screen and Media Studies at the University of Waikato in New Zealand. The author of books on media education, children's popular culture and film, Dan has taught in Ireland, Scotland, Brazil and Japan.

Lucy Fraser teaches at Birmingham City University and the University of Worcester. She has recently submitted her PhD thesis on David Lynch to the University of Birmingham. Areas that particularly interest her include the uncanny, film narrative and representations of the family in film.

Craig Frost is a PhD candidate in the Film and Television Studies department at Monash University, Melbourne. His current research project investigates contemporary American horror cinema and its position within theoretical discourses such as genre theory, post 9/11 American culture, reception studies, and the representation of onscreen violence and torture. He has had articles published in the online Italian journal *Cinemascope*, and most recently in the peer-reviewed online journal *Colloquy*. Craig's other fields of research include the shift in television reception through the advancement of DVD technology and altered forms of television narratology within popular culture.

Vincent M Gaine's PhD (awarded in 2009 by the University of East Anglia), 'Existential Mann: Existentialism and Social Engagement in the Films of Michael Mann', analyses the critique of existentialism performed by Michael Mann's films. He has published on 'The Digital Noir of *Collateral*' and 'The Re-Mediation of Public Figures in *The Insider* and *Ali*'. He is currently working on studies of *Avatar*'s critical reception, philosophy in the films of Christopher Nolan, and the Bourne trilogy as a post 9/11 text. His research interests include film and philosophy, contemporary Hollywood, genre and auteurship.

David Garland is Senior Lecturer in Media Studies in the School of Creative Arts, Film and Media at the University of Portsmouth. He has previously taught writing, film and media in both the US and the UK, including the University of Southern California, Ithaca College and Coventry University. He wrote his MA thesis on the Hollywood Novel and his doctoral dissertation on David Letterman. His published work and conference presentations range from European to American film and television, reflecting particular research interests in critical theory, comedy and the talk show.

Carrie Giunta is a doctoral candidate in philosophy at the University of Dundee, Scotland. Her interests are: Film Philosophy, Silent Cinema, Continental Philosophy, with particular emphasis on the concept of listening and the work of Jean-Luc Nancy.

Simone Gristwood has a PhD in Cultural Research from Lancaster University. Her thesis explored the connections between photography and artificial intelligence

through debates around visual art. Her research is focused on digital culture, and she has an interest in digital animation and its history. She has previously worked on the AHRC funded CACHe project at Birkbeck, and has recently been a visiting researcher at the Lansdown Centre for Electronic Arts at Middlesex University. She will soon be working for ZKM on the recently-acquired Hiroshi Kawano archive, and researching for a book chapter about early Japanese computer art.

Lesley Harbidge is Award Leader and Senior Lecturer in Film Studies at the University of Glamorgan, Cardiff. She has wide research interests across contemporary film and television comedy, and has contributed chapters to Stacey Abbott and Deborah Jermyn (eds), *Falling in Love Again: The Contemporary Romantic Comedy* (2008), and to Judith Batalion (ed), *Live Audiences* (forthcoming). She recently organized a Symposium on TV's *Gavin and Stacey* and is currently working on a manuscript of American performer Steve Martin.

Annabelle Honess Roe is a lecturer in Film Studies at the University of Surrey. Her research focuses on animation, documentary and the media industries and she is currently working on a book-length study of animated documentaries. She has published on animation, documentary, British film and the relationship between Britain and Hollywood, in journals and edited collections. She regularly contributes reviews to *Film International* and *Animation: An Interdisciplinary Journal*.

Michael Honig is a PhD candidate in Film and Television at Monash University, Melbourne. His thesis is on Asian Horror Cinema, the J-horror genre and Western reception of the films.

Laurence Janicker is a retired Anglican clergyman. He taught in primary schools in London and Melbourne before becoming a parish priest in the UK, 1985–2008. He boasts a lifelong love of film of all genres, with a recently-added conversion to musicals. Film analysis and critique figured significantly from the Film Club he belonged to as a boy at Grammar School in the 1960s. *Mamma Mia!* had a profound effect on his critical appreciation of the musical form.

Rebecca Janicker is a PhD student in the School of American and Canadian Studies at the University of Nottingham, with a thesis focusing on the haunted-house motif in American Gothic fiction. She has published on Stephen King in *US Studies Online* and the *European Journal of American Culture* and HP Lovecraft in *Extrapolation* as well as on the Gothic fiction of Richard Matheson and Robert Bloch. She is an Associate Senior Lecturer in Film and Media at the University of Portsmouth.

Claire Jenkins was awarded a PhD in film and television studies in 2009 from Warwick University. The thesis, a culmination of undergraduate and postgraduate research, was entitled 'Family Entertainment: Representations of the American Family in Contemporary Hollywood' and analysed the representation of the American nuclear family within mainstream films, placing this within a wider socio-political context. Her main research interests are Hollywood cinema, the family, gender, race and sexuality, and superheroes, having presented papers on the superhero family at conferences in the UK and USA.

Marc Joly-Corcoran is a part-time lecturer and PhD candidate in Film Studies at the University of Montreal. His academic interests range from Fan Studies to Reception Studies, as long as it is related with the experience of the movie-goers. All his work is intended to answer this simple question: How does the strong affect the cinema spectator felt during the viewing engage them when reappropriating their own and significant experience?

Alexia Kannas is completing a PhD in Film & Television Studies at Monash University, Melbourne, on the Italian *giallo* film. Her research interests include exploitation and cult cinema, genre theory and film sound. She is the author of *Deep Red* (forthcoming) and co-editor of *B for Bad Cinema: Aesthetics, Politics and Cultural Value* (forthcoming).

Victoria Kearley holds an MA in Film Studies from the University of Southampton where she is currently studying for a PhD in Film. The representation of Hispanic masculinity in contemporary Hollywood cinema is the subject of her doctoral thesis, which considers how popular genre conventions can reconfigure tradi-tional conceptions of race, gender and sexuality within mainstream cinema. Her research interests include action and adventure cinema, particularly the films of Robert Rodriguez; the family film as a contemporary film genre; and images of masculinity in contemporary US television. She is currently organizing a post-graduate seminar series examining the bio-pic as a twenty-first-century film and television genre.

Abigail Keating is a PhD candidate in Film Studies at University College Cork, Ireland. Her doctoral thesis, entitled 'Locating the Transnational: Representa-tions and Aesthetics of the City in Contemporary European Cinema', focuses on representations of European cities under the rubric of transnationalism, and from aesthetic and sociological perspectives. Her publications, past and forthcom-ing, include: a review in *Film-Philosophy*; a chapter on contemporary cinematic Dublin in an edited collection addressing 'glocal' Ireland; and a journal article on Italian documentary. She also teaches film studies part-time at University College Cork. Her research interests include: space, place and the city in film; aesthetics; film theory; European, Irish and Transnational cinema; new media; non-fiction and amateur cinema.

James Leggott lectures on film and television at Northumbria University. He is the author of *Contemporary British Cinema: From Heritage to Horror* (2008) and a number of book chapters and journal articles on aspects of British film and television culture, including reality television, social realist cinema, the work of the Amber film collective, and science fiction.

David Lusted taught film studies at Southampton Solent University after working in universities in London, Reading, Winchester and Warwick. Previously, he taught in primary, secondary, further and adult education before joining the British Film Institute as an Education Officer. His first commitment was to educa-tion in film, television and media studies, in which capacity he lectured in several European countries and twice toured Australia. He writes on aspects of popular cultural history – most recently on literary adaptations, the Boulting Brothers, male melodrama, and the Ninja Turtles. Publications include *The Western* (2003); *The Television Studies Book*, co-edited with Christine Geraghty (1997); *The Media Studies Book* (1992); and *Raymond Williams: Film TV Culture* (1989).

Franco Marineo is Lecturer of Film History and New Media Aesthetics at the Fine Arts Academy of Palermo, Italy, and he also is film critic for the monthly magazine *Duellanti*. His books include *Face/On: La narrazione e il volto cinematografico* (2005) and *Il cinema dei Coen* (1999). He has contributed to GianPiero Brunetta (ed) *Dizionario dei registi del cinema mondiale* (2004–2006) and Gianni Canova (ed) *Enciclopedia del cinema: Garzantina* (2002). He is a PhD candidate in Computing, Communications and Electronics at the University of Plymouth (Planetary Collegium), UK.

John Marmysz teaches philosophy at the College of Marin. His philosophical interests focus on the problem of nihilism and its various cultural manifestations. He is the author of *Laughing at Nothing: Humor as a Response to Nihilism* (2003) and *The Path of Philosophy: Truth, Wonder and Distress* (forthcoming). He is co-editor (with Scott Lukas) of *Fear, Cultural Anxiety and Transformation: Horror, Science Fiction, and Fantasy Films Remade* (2009).

Cristelle Maury holds an agrégation in English and is an associate professor at the Université Toulouse Le Mirail, France where she teaches English, American civilization and film analysis. Her doctoral thesis was on the representations of masculinity in American film noir and is the author of several articles on American cinema. She is currently working on the links between film noir and film melodrama and is also interested in the use of audio-visual techniques in foreign-language acquisition.

James Merchant currently works for the film distributor Revolver Entertainment. He is also a regular contributor to *Electric Sheep* magazine and the horror-related website EatMyBrains.com.

Josh Nelson is a lecturer within the fields of Visual Media and Cultural Studies. In 2008 his PhD thesis, entitled, 'Ruptures & Regenerations: Violence, Trauma, and Male Subjectivity in American Cinema (1976–2004)', was nominated for a Chancellor's Prize. He is currently working on a number of forthcoming publications.

Van Norris is Senior Lecturer in Film and Media Studies at the School of Creative Art Film and Media, University of Portsmouth. He is currently completing a PhD thesis: 'Drawing on the British Tradition: Comedy and Social Attitudes within British Television Animation'. His research interests lie in Mainstream animation history and theory, American and British graphic narratives and British and American comedy forms and he has also published work on science fiction television and music soundtracks.

Richard Nowell has taught at the University of Heidelberg in Germany and at the University of East Anglia, UK, where he also received his doctorate. He is the author of the forthcoming monograph *Blood Money: A History of the First Teen Slasher Film Cycle* (2010) and his work on the conduct, strategies and output of the American film industry has also been published in the *Directory of World Cinema: American Independent* (Vol. 2) and the *Journal of Film and Video*.

Dylan Pank graduated from Northumbria University in 1998 with a BA (Hons) in Media Production. Whilst there, he directed a number of short films, including the first project at that university to be entirely shot and edited digitally. Subsequently he worked for five years at Istanbul Bilgi University in Turkey as a techni-

cian and instructor, while also working on many short films and documentary projects. His work has featured in films that have been screened and won awards at festivals around the world. Since 2003 he has been Tutor in Video Production Skills at the University of Portsmouth, and has recently completed his MA. He regularly organizes short film screenings in Portsmouth and is secretary for the committee of the *Portsmouth Screen: Film and New Media Festival*.

Lisa Purse is a Lecturer in Film in the Department of Film, Theatre & Television at the University of Reading. Her research interests focus on the relationship between film style and the politics of representation in post-studio mainstream and independent US cinema, and she has published a number of essays on digital effects in film. She is the author of 'Reading the Digital' (2011) in the Close-Up series edited by Doug Pye and John Gibbs, and is currently writing a book on contemporary US action cinema for Edinburgh University Press.

Anna Cooper Sloan is a PhD candidate in the Department of Film and Television Studies, University of Warwick. She is completing a thesis on the imperial gaze in Hollywood films of the postwar period, focusing particularly on 'travelogue romances' in which an American travels abroad to Europe. She also has interests in masculinities/male melodramas, American film comedy, and the philosophy of Stanley Cavell. Her article titled 'Representative Men: Masculinity, Psychotherapy and Moral Perfectionism in *Good Will Hunting*' is forthcoming in *Film Philosophy*. She has also given papers at several conferences in both Britain and her native United States and published reviews in the online journal *Alternate Takes*. In addition to her work in Film Studies, Anna holds degrees in philosophy and music.

Esther Sonnet is Head of the School of Creative Arts, Film and Media at the University of Portsmouth. Drawing on extensive teaching and research experience within the fields of fiction, film, media, feminism and cultural studies, she has published widely in journals and edited collections on a range of topics including feminist film epistemology, Tank Girl, Hal Hartley, contemporary adaptation of Jane Austen's *Emma*, female authorship of popular erotic fiction, aging Hollywood actresses in the 60s/70s, single mothers and 'uncanny' film, crime fiction and film, film history and Hollywood gangster cycles as well as on Marilyn Monroe and the teleology of film stardom. Current monographs in preparation are *Marked Women: Desire & Transgression in the Hollywood Crime Film 1929-41* and *Feminism & Pulp: Hollywood Film, Adaptation & Women's Crime Writing 1939-60*.

David Sterritt is chairman of the National Society of Film Critics, film critic of *Tikkun*, chief book critic of *Film Quarterly*, editorial board member of *Cinema Journal* and *Quarterly Review of Film and Video*, and adjunct professor at Columbia University and the Maryland Institute College of Art. His books include *The Films of Alfred Hitchcock*; and *Mad to Be Saved: The Beats, the '50s, and Film*; and his writing has appeared in *Cahiers du cinéma*, *The New York Times*, *The Journal of Aesthetics and Art Criticism*, *The Huffington Post*, and many other publications.

Jonathan Stubbs is currently Assistant Professor in the Faculty of Communication at Cyprus International University, Nicosia. His research focuses on the representation of history in American and British cinema, the cultural and economic

relationships between the British and American film industries, and the depiction of imperialism in cinema. He has published articles in *The Historical Journal of Film, Radio and Television*, *The Journal of British Cinema and Television*, and *Exemplaria: A Journal of Theory in Medieval and Renaissance Studies*. He is currently preparing a monograph examining the relationship between historical cinema and genre to be published in 2011.

Dominic Symonds holds a PhD from London University. His research focuses on post-structuralist approaches to the musical. Alongside colleague George Burrows, he is editor of *Studies in Musical Theatre* and founded the international conference Song, Stage and Screen. He co-edited Volume 19.1 of *Contemporary Theatre Review* and is co-editor of the proposed publication *Music/theatre: experience, performance, and emergences by the music theatre working group of the International Federation for Theatre Research*. He has chapters published in J. Chris Westgate (ed) *Brecht, Broadway and United States Theatre* (2007), *The Oxford Handbook of the American Musical* (2007) and *The Oxford Handbook of Sondheim Studies* (forthcoming).

Carl Wilson is writing a PhD on the work of Charlie Kaufman at Brunel University. He has lectured internationally on film and television, and has contributed to *Scope: The Online Journal of Film Studies*; *The Essential Sopranos Reader* (2010); PopMatters.com; and the *Directory of World Cinema: American Independent* (2010).

Constantine Verevis is senior lecturer in Film and Television in the School of English, Communications and Performance Studies at Monash University, Melbourne. He is author of *Film Remakes* (2006) and co-editor of *Second Takes: Critical Approaches to the Film Sequel* (2010).

Martin Zeller-Jacques is a research student in the Department of Theatre, Film and Television at the University of York. His work in film focuses on gender and genre in Westerns and War films. In addition, he is currently working on a study of endings in contemporary American television narratives.

FILMOGR

Alien (1979)	91
American Beauty (1999)	228
American Pie (1999)	130
Annie Hall (1977)	229
Apocalypse Now (1979)	192
Batman (1989)	266
Beauty and the Beast (1991)	231
Ben-Hur (1959)	149
The Birth of a Nation (1915)	150
Bonnie and Clyde (1967)	68
Brokeback Mountain (2005)	48
Broken Blossoms (1919)	233
Chicago (2002)	171
Close Encounters of the Third Kind (1977)	93
Dances With Wolves (1990)	49
The Day the Earth Stood Still (1951)	95
Demon Seed (1977)	98
The Departed (2006)	69
Double Indemnity (1944)	71
Dracula (1931)	111
Duck Soup (1933)	132
ET: The Extra-Terrestrial (1982)	268
The Exorcist (1973)	113
Falling Down (1993)	211
Fantasia (1940)	245
Ferris Bueller's Day Off (1986)	134
Flags of Our Fathers (2006)	194
Forrest Gump (1994)	153
42nd Street (1933)	173
Frankenstein (1931)	115
Galaxy Quest (1999)	135
Gladiator (2000)	154
Glory (1989)	195
The Godfather (1972)	73
Gone With the Wind (1939)	156
Good Will Hunting (1997)	213

Gran Torino (2008)	214
Grease (1978)	174
The Great Dictator (1940)	137
Guadalcanal Diary (1943)	198
Jarhead (2005)	200
Jaws (1975)	269
The Jazz Singer (1927)	176
Kramer vs Kramer (1979)	216
LA Confidential (1997)	75
The Lady Eve (1941)	139
The Last Samurai (2003)	158
Letters from Iwo Jima (2006)	201
Little Big Man (1970)	51
Little Caesar (1930)	78
Lord of the Rings, The: Fellowship of the Ring (2001)	271
Love Story (1970)	235
Malcolm X (1992)	160
Mamma Mia! (2008)	178
Manhattan (1979)	238
The Matrix (1999)	99
Mrs Doubtfire (1993)	140
The Nightmare Before Christmas (1993)	247
Ocean's Eleven (1960)	81
Ocean's Eleven (2001)	83
On the Waterfront (1954)	218
Open Range (2003)	53
Philadelphia (1993)	219
Planet of the Apes (1968)	101
Platoon (1986)	203
Poltergeist (1982)	117
Rosemary's Baby (1968)	118
Saving Private Ryan (1998)	205
Schindler's List (1993)	163
Scream (1996)	120
The Searchers (1956)	54
The Shining (1980)	121

Shrek (2001)	249
The Silence of the Lambs (1991)	124
The Simpsons Movie (2007)	251
Sleepless in Seattle (1993)	239
Snow White and the Seven Dwarfs (1937)	253
Some Like it Hot (1959)	142
The Sound of Music (1965)	180
South Park: Bigger, Longer & Uncut (1999)	255
Stagecoach (1939)	59
Star Trek: The Motion Picture (1979)	103
Star Wars (1977)	273
Strangers on a Train (1951)	86
Superman (1978)	275
Sweeney Todd: The Demon Barber of Fleet Street (2007)	182
The Terminator (1984)	104
Terminator 2: Judgment Day (1991)	105
Thelma & Louise (1991)	222
Titanic (1997)	277
Toy Story (1995)	256
Transformers (2007)	279
Ulzana's Raid (1972)	59
Unforgiven (1992)	60
United 93 (2006)	165
UP (2009)	258
WALL-E (2008)	260
West Side Story (1961)	184
The Wild Bunch (1969)	62
The Wizard of Oz (1939)	186